THE
PRINCIPLES OF ART

BY

R. G. COLLINGWOOD

OXFORD UNIVERSITY PRESS
LONDON OXFORD NEW YORK

OXFORD UNIVERSITY PRESS

Oxford London Glasgow
New York Toronto Melbourne Wellington
Nairobi Dar es Salaam Cape Town
Kuala Lumpur Singapore Jakarta Hong Kong Tokyo
Delhi Bombay Calcutta Madras Karachi

First published by the Clarendon Press, 1938
First issued as an Oxford University Press paperback, 1958

printing, last digit: 29 28 27 26 25

PREFACE

THIRTEEN years ago I wrote, at the request of the Clarendon Press, a small book called *Outlines of a Philosophy of Art.* When that book went out of print early in the present year, I was asked either to revise it for a new edition or to replace it with another. I chose the latter course, not only because I have changed my mind on some things in the meantime, but also because the situation both of art and of aesthetic theory in this country has changed as well. There has been at any rate the beginning of what may prove an important revival in the arts themselves. Fashions which before the War seemed firmly entrenched, in spite of their obvious bankruptcy, and which even in 1924 were only moth-eaten, and hardly yet even beginning to be replaced by others, have begun to disappear, and new ones are growing up instead.

We have in this way a new drama, taking the place of the old 'slice of life' entertainment, in which the author's chief business was to represent everyday doings of ordinary people as the audience believed them to behave, and the actor's chief function to take a cigarette from his case, tap it, and put it between his lips. We have a new poetry, and we have a new way of painting. We have some very interesting experiments in a new way of writing prose. These things are gradually establishing themselves; but they are much hampered by rags and tatters of moribund theory which still encumber and intimidate the minds of people who ought to be welcoming the new developments.

At the same time, we have a new and very lively, if somewhat chaotic, growth of aesthetic theory and criticism, written mostly not by academic philosophers or amateurs of art, but by poets, dramatists, painters, and sculptors themselves. This is the reason for the appearance of the present book. As long as the theory of art was chiefly pursued in this country by academic philosophers, I should

not have thought it worth my time or my publisher's money to write upon it at such length as I have written here. But the recent development of literature on the subject shows that artists themselves are now interested in it (a thing which in England has not happened for over a century); and it is to contribute in my own way to this development, and thus indirectly to the new movement in the arts themselves, that I publish this work.

For I do not think of aesthetic theory as an attempt to investigate and expound eternal verities concerning the nature of an eternal object called Art, but as an attempt to reach, by thinking, the solution of certain problems arising out of the situation in which artists find themselves here and now. Everything written in this book has been written in the belief that it has a practical bearing, direct or indirect, upon the condition of art in England in 1937, and in the hope that artists primarily, and secondarily persons whose interest in art is lively and sympathetic, will find it of some use to them. Hardly any space is devoted to criticizing other people's aesthetic doctrines; not because I have not studied them, nor because I have dismissed them as not worth considering, but because I have something of my own to say, and think the best service I can do to a reader is to say it as clearly as I can.

Of the three parts into which it is divided, Book I is chiefly concerned to say things which any one tolerably acquainted with artistic work knows already; the purpose of this being to clear up our minds as to the distinction between art proper, which is what aesthetic is about, and certain other things which are different from it but are often called by the same name. Many false aesthetic theories are fairly accurate accounts of these other things, and much bad artistic practice comes from confusing them with art proper. These errors in theory and practice should disappear when the distinctions in question are properly apprehended.

In this way a preliminary account of art is reached; but a second difficulty is now encountered. This preliminary

account, according to the schools of philosophy now most fashionable in our own country, cannot be true; for it traverses certain doctrines taught in those schools and therefore, according to them, is not so much false as nonsensical. Book II is therefore devoted to a philosophical exposition of the terms used in this preliminary account of art, and an attempt to show that the conceptions they express are justified in spite of the current prejudice against them; are indeed logically implied even in the philosophies that repudiate them.

The preliminary account of art has by now been converted into a philosophy of art. But a third question remains. Is this so-called philosophy of art a mere intellectual exercise, or has it practical consequences bearing on the way in which we ought to approach the practice of art (whether as artists or as audience) and hence, because a philosophy of art is a theory as to the place of art in life as a whole, the practice of life? As I have already indicated, the alternative I accept is the second one. In Book III, therefore, I have tried to point out some of these practical consequences by suggesting what kinds of obligation the acceptance of this aesthetic theory would impose upon artists and audiences, and in what kinds of way they could be met.

R. G. C.

WEST HENDRED, BERKSHIRE

22 *September* 1937

CONTENTS

I

INTRODUCTION

§ 1. *The Two Conditions of an Aesthetic Theory*

THE business of this book is to answer the question: What is art?

A question of this kind has to be answered in two stages. First, we must make sure that the key word (in this case 'art') is a word which we know how to apply where it ought to be applied and refuse where it ought to be refused. It would not be much use beginning to argue about the correct definition of a general term whose instances we could not recognize when we saw them. Our first business, then, is to bring ourselves into a position in which we can say with confidence 'this and this and this are art; that and that and that are not art'.

This would be hardly worth insisting upon, but for two facts: that the word 'art' is a word in common use, and that it is used equivocally. If it had not been a word in common use, we could have decided for ourselves when to apply it and when to refuse it. But the problem we are concerned with is not one that can be approached in that way. It is one of those problems where what we want to do is to clarify and systematize ideas we already possess; consequently there is no point in using words according to a private rule of our own, we must use them in a way which fits on to common usage. This again would have been easy, but for the fact that common usage is ambiguous. The word 'art' means several different things; and we have to decide which of these usages is the one that interests us. Moreover, the other usages must not be simply jettisoned as irrelevant. They are very important for our inquiry; partly because false theories are generated by failure to distinguish them, so that in expounding one usage we must give a certain attention to others; partly because confusion between the

various senses of the word may produce bad practice as well as bad theory. We must therefore review the improper senses of the word 'art' in a careful and systematic way; so that at the end of it we can say not only 'that and that and that are not art', but 'that is not art because it is pseudo-art of kind A; that, because it is pseudo-art of kind B; and that, because it is pseudo-art of kind C'.

Secondly, we must proceed to a definition of the term 'art'. This comes second, and not first, because no one can even try to define a term until he has settled in his own mind a definite usage of it: no one can define a term in common use until he has satisfied himself that his personal usage of it harmonizes with the common usage. Definition necessarily means defining one thing in terms of something else; therefore, in order to define any given thing, one must have in one's head not only a clear idea of the thing to be defined, but an equally clear idea of all the other things by reference to which one defines it. People often go wrong over this. They think that in order to construct a definition or (what is the same thing) a 'theory' of something, it is enough to have a clear idea of that one thing. That is absurd. Having a clear idea of the thing enables them to recognize it when they see it, just as having a clear idea of a certain house enables them to recognize it when they are there; but defining the thing is like explaining where the house is or pointing out its position on the map; you must know its relations to other things as well, and if your ideas of these other things are vague, your definition will be worthless.

§ 2. *Artist-aestheticians and Philosopher-aestheticians*

Since any answer to the question 'What is art?' must divide itself into two stages, there are two ways in which it is liable to go wrong. It may settle the problem of usage satisfactorily but break down over the problem of definition; or it may deal competently with the problem of definition but fail over the problem of usage. These two kinds of

failure may be described respectively as knowing what you are talking about, but talking nonsense; and talking sense but not knowing what you are talking about. The first kind gives us a treatment which is well informed and to the point, but messy and confused; the second, one which is neat and tidy, but irrelevant.

People who interest themselves in the philosophy of art fall roughly into two classes: artists with a leaning towards philosophy and philosophers with a taste for art. The artist-aesthetician knows what he is talking about. He can discriminate things that are art from things that are pseudo-art, and can say what these other things are: what it is that prevents them from being art, and what it is that deceives people into thinking that they are art. This is art-criticism, which is not identical with the philosophy of art, but only with the first of the two stages that go to make it up. It is a perfectly valid and valuable activity in itself; but the people who are good at it are not by any means necessarily able to achieve the second stage and offer a definition of art. All they can do is to recognize it. This is because they are content with too vague an idea of the relations in which art stands to things that are not art: I do not mean the various kinds of pseudo-art, but things like science, philosophy, and so forth. They are content to think of these relations as mere differences. To frame a definition of art, it is necessary to think wherein precisely these differences consist.

Philosopher-aestheticians are trained to do well just the thing that artist-aestheticians do badly. They are admirably protected against talking nonsense: but there is no security that they will know what they are talking about. Hence their theorizing, however competent in itself, is apt to be vitiated by weakness in its foundation of fact. They are tempted to evade this difficulty by saying: 'I do not profess to be a critic; I am not equal to adjudging the merits of Mr. Joyce, Mr. Eliot, Miss Sitwell, or Miss Stein; so I will stick to Shakespeare and Michelangelo and Beethoven. There is plenty to say about art if one bases it only on the

acknowledged classics.' This would be all right for a critic; but for a philosopher it will not do. Usage is particular, but theory is universal, and the truth at which it aims is *index sui et falsi*. The aesthetician who claims to know what it is that makes Shakespeare a poet is tacitly claiming to know whether Miss Stein is a poet, and if not, why not. The philosopher-aesthetician who sticks to classical artists is pretty sure to locate the essence of art not in what makes them artists but in what makes them classical, that is, acceptable to the academic mind.

Philosophers' aesthetic, not having a material criterion for the truth of theories in their relation to the facts, can only apply a formal criterion. It can detect logical flaws in a theory and therefore dismiss it as false; but it can never acclaim or propound any theory as true. It is wholly unconstructive; *tamquam virgo Deo consecrata, nihil parit*. Yet the fugitive and cloistered virtue of academic aesthetic is not without its uses, negative though they are. Its dialectic is a school in which the artist-aesthetician or critic can learn the lessons that will show him how to advance from art-criticism to aesthetic theory.

§ 3. *The Present Situation*

The division between artist-aestheticians and philosopher-aestheticians corresponds fairly well with the facts as they stood half a century ago, but not with the facts of to-day. In the last generation, and increasingly in the last twenty years, the gulf between these two classes has been bridged by the appearance of a third class of aesthetic theorists: poets and painters and sculptors who have taken the trouble to train themselves in philosophy or psychology or both, and write not with the airs and graces of an essayist or the condescension of a hierophant, but with the modesty and seriousness of a man contributing to a discussion in which others beside himself are speaking, and out of which he hopes that truths not yet known even to himself will emerge.

This is one aspect of a profound change in the way in

which artists think of themselves and their relation to other people. In the later nineteenth century the artist walked among us as a superior being, marked off even by his dress from common mortals; too high and ethereal to be questioned by others, too sure of his superiority to question himself, and resenting the suggestion that the mysteries of his craft should be analysed and theorized about by philosophers and other profane persons. To-day, instead of forming a mutual admiration society whose serene climate was broken from time to time by unedifying storms of jealousy, and whose aloofness from worldly concerns was marred now and then by scandalous contact with the law, artists go about like other men, pursuing a business in which they take no more than a decent pride, and criticizing each other publicly as to their ways of doing it. In this new soil a new growth of aesthetic theory has sprung up; rich in quantity and on the whole high in quality. It is too soon to write the history of this movement, but not too late to contribute to it; and it is only because such a movement is going on that a book like this can be published with some hope of its being read in the spirit in which it is written.

§ 4. *History of the Word 'Art'*

In order to clear up the ambiguities attaching to the word 'art', we must look to its history. The aesthetic sense of the word, the sense which here concerns us, is very recent in origin. *Ars* in ancient Latin, like τέχνη in Greek, means something quite different. It means a craft or specialized form of skill, like carpentry or smithying or surgery. The Greeks and Romans had no conception of what we call art as something different from craft; what we call art they regarded merely as a group of crafts, such as the craft of poetry (ποιητικὴ τέχνη, *ars poetica*), which they conceived, sometimes no doubt with misgivings, as in principle just like carpentry and the rest, and differing from any one of these only in the sort of way in which any one of them differs from any other.

It is difficult for us to realize this fact, and still more so to realize its implications. If people have no word for a certain kind of thing, it is because they are not aware of it as a distinct kind. Admiring as we do the art of the ancient Greeks, we naturally suppose that they admired it in the same kind of spirit as ourselves. But we admire it as a kind of art, where the word 'art' carries with it all the subtle and elaborate implications of the modern European aesthetic consciousness. We can be perfectly certain that the Greeks did not admire it in any such way. They approached it from a different point of view. What this was, we can perhaps discover by reading what people like Plato wrote about it; but not without great pains, because the first thing every modern reader does, when he reads what Plato has to say about poetry, is to assume that Plato is describing an aesthetic experience similar to our own. The second thing he does is to lose his temper because Plato describes it so badly. With most readers there is no third stage.

Ars in medieval Latin, like 'art' in the early modern English which borrowed both word and sense, meant any special form of book-learning, such as grammar or logic, magic or astrology. That is still its meaning in the time of Shakespeare: 'lie there, my art', says Prospero, putting off his magic gown. But the Renaissance, first in Italy and then elsewhere, re-established the old meaning; and the Renaissance artists, like those of the ancient world, did actually think of themselves as craftsmen. It was not until the seventeenth century that the problems and conceptions of aesthetic began to be disentangled from those of technic or the philosophy of craft. In the late eighteenth century the disentanglement had gone so far as to establish a distinction between the fine arts and the useful arts; where 'fine' arts meant, not delicate or highly skilled arts, but 'beautiful' arts (*les beaux arts, le belle arti, die schöne Kunst*). In the nineteenth century this phrase, abbreviated by leaving out the epithet and generalized by substituting the singular for the distributive plural, became 'art'.

At this point the disentanglement of art from craft is theoretically complete. But only theoretically. The new use of the word 'art' is a flag placed on a hill-top by the first assailants; it does not prove that the hill-top is effectively occupied.

§ 5. *Systematic Ambiguity*

To make the occupation effective, the ambiguities attaching to the word must be cleared away and its proper meaning brought to light. The proper meaning of a word (I speak not of technical terms, which kindly godparents furnish soon after birth with neat and tidy definitions, but of words in a living language) is never something upon which the word sits perched like a gull on a stone; it is something over which the word hovers like a gull over a ship's stern. Trying to fix the proper meaning in our minds is like coaxing the gull to settle in the rigging, with the rule that the gull must be alive when it settles: one must not shoot it and tie it there. The way to discover the proper meaning is to ask not, 'What do we mean?' but, 'What are we trying to mean?' And this involves the question 'What is preventing us from meaning what we are trying to mean?'

These impediments, the improper meanings which distract our minds from the proper one, are of three kinds. I shall call them obsolete meanings, analogical meanings, and courtesy meanings.

The obsolete meanings which every word with a history is bound to possess are the meanings it once had, and retains by force of habit. They form a trail behind the word like that of a shooting star, and divide themselves according to their distance from it into more and less obsolete. The very obsolete are not a danger to the present use of the word; they are dead and buried, and only the antiquary wishes to disinter them. But the less obsolete are a very grave danger. They cling to our minds like drowning men, and so jostle the present meaning that we can only distinguish it from them by the most careful analysis.

The analogical meanings arise from the fact that when we want to discuss the experience of other people we can only do so in our own language. Our own language has been invented for the purpose of expressing our own experience. When we use it for discussing other people's we assimilate their experience to our own. We cannot talk in English about the way in which a negro tribe thinks and feels without making them appear to think and feel like Englishmen; we cannot explain to our negro friends in their own language how Englishmen think and feel without making it appear to them that we think and feel like themselves.[1] Or rather, the assimilation of one kind of experience to another goes smoothly for a time, but sooner or later a break comes, as when we try to represent one kind of curve by means of another. When that happens, the person whose language is being used thinks that the other has gone more or less mad. Thus in studying ancient history we use the word 'state' without scruple as a translation of πόλις. But the word 'state', which comes to us from the Italian Renaissance, was invented to express the new secularized political consciousness of the modern world. The Greeks had no such experience; their political consciousness was religious and political in one; so that what they meant by πόλις was something which looks to us like a confusion of Church and State. We have no words for such a thing, because we do not possess the thing. When we use for it words like 'state', 'political', and so forth, we are using them not in their proper sense, but in an analogical sense.

Courtesy meanings arise from the fact that the things we give names to are the things we regard as important. Whatever may be true of scientific technicalities, words in a living language are never used without some practical and

[1] 'Let the reader consider any argument that would utterly demolish all Zande claims for the power of the oracle. If it were translated into Zande modes of thought [which is the same thing as saying, if it were translated into the Zande language] it would serve to support their entire structure of belief.' Evans-Pritchard, *Witchcraft, Oracles and Magic among the Azande* (1937), pp. 319–20.

emotional colouring, which sometimes takes precedence of its descriptive function. People claim or disclaim such titles as gentleman, or Christian, or communist, either descriptively, because they think they have or have not the qualities these titles connote; or emotionally, because they wish to possess or not to possess these qualities, and that irrespectively of whether they know what they are. The two alternatives are very far from being mutually exclusive. But when the descriptive motive is overshadowed by the emotional one, the word becomes a courtesy title or discourtesy title as the case may be.

§ 6. *Plan of Book I*

Applying this to the word 'art', we find its proper meaning hedged about with well-established obsolete, analogical, and courtesy meanings. The only obsolete meaning of any importance is that which identifies art with craft. When this meaning gets tangled up with the proper one, the result is that special error which I call the technical theory of art: the theory that art is some kind of craft. The question then, of course, arises: What kind of craft is it? and here is vast scope for controversy between rival views as to its differentia. To that controversy this book will contribute nothing. The question is not whether art is this or that kind of craft, but whether it is any kind at all. And I do not propose even to refute the theory that it is some kind of craft. It is not a matter that stands in need of demonstration. We all know perfectly well that art is not craft; and all I wish to do is to remind the reader of the familiar differences which separate the two things.

Analogically, we use the word 'art' of many things which in certain ways (important ways, no doubt) resemble what we call art in our own modern European world, but in other ways are unlike it. The example which I shall consider is magical art. I will pause to explain what this means.

When the naturalistic animal-paintings and sculptures of the upper palaeolithic age were discovered in the last century, they were hailed as representing a newly found school of art. Before long, it was realized that this description implied a

certain misunderstanding. To call them art implied the
assumption that they were designed and executed with the
same purpose as the modern works from which the name
was extended to them; and it was found that this assumption
was false. When Mr. John Skeaping, whose manner is
obviously indebted to these palaeolithic predecessors, makes
one of his beautiful animal-drawings, he frames it under
glass, exhibits it in a place of public resort, expects people to
go and look at it, and hopes that somebody will buy it, take
it home, and hang it up to be contemplated and enjoyed by
himself and his friends. All modern theories of art insist
that what a work of art is for is to be thus contemplated.
But when an Aurignacian or Magdalenian painter made
such a drawing he put it where nobody lived, and often
where people could never get near it at all without great
trouble, and on some special occasion; and it appears that
what he expected them to do was to stab it with spears or
shoot arrows at it, after which, when it was defaced, he was
ready to paint another on the top of it.

If Mr. Skeaping hid his drawings in a coal-cellar and
expected anybody who found them to shoot them full of
bullet-holes, aesthetic theorists would say that he was no
artist, because he intended his drawings for consumption,
as targets, and not for contemplation, as works of art. By
the same argument, the palaeolithic paintings are not works
of art, however much they may resemble them: the resem-
blance is superficial; what matters is the purpose, and the
purpose is different. I need not here go into the reasons
which have led archaeologists to decide that the purpose
was magical, and that these paintings were accessories in
some kind of ritual whereby hunters prefigured and so
ensured the death or capture of the animals depicted.[1]

A similar magical or religious function is recognizable
elsewhere. The portraits of ancient Egyptian sculpture were

[1] English readers who want to go into the question may consult Count
Bégouen, 'The Magical Origin of Prehistoric Art', in *Antiquity*, iii (1929),
pp. 5–19, and Baldwin Brown, *The Art of the Cave-Dweller* (1928).

not designed for exhibition and contemplation; they were hidden away in the darkness of the tomb, unvisited, where no spectator could see them, but where they could do their magical work, whatever precisely that was, uninterrupted. Roman portraiture was derived from the images of ancestors which, keeping watch over the domestic life of their posterity, had a magical or religious purpose to which their artistic qualities were subservient. Greek drama and Greek sculpture began as accessories of religious cult. And the entire body of medieval Christian art shows the same purpose.

The terms 'art', 'artist', 'artistic', and so forth are much used as courtesy titles. When we consider in bulk the things which claim them, but, on the whole, claim them without real justification, it becomes apparent that the thing which most constantly demands and receives the courtesy title of art is the thing whose real name is amusement or entertainment. The vast majority of our literature in prose and verse, our painting and drawing and sculpture, our music, our dancing and acting, and so forth, is quite plainly and often quite explicitly designed to amuse, but is called art. Yet we know that there is a distinction. The gramophone trade, a recent one which has the outspokenness of an *enfant terrible*, actually states the distinction, or tries to, in its catalogues. Nearly all its records are issued frankly as amusement music; the small remainder is marked off as 'connoisseur's records' or the like. Painters and novelists make the same distinction, but not so publicly.

This is a fact of great interest for the aesthetic theorist, because, unless he grasps it, it may debauch his conception of art itself by causing him to identify art proper with amusement; and of equal interest to the historian of art, or rather of civilization as a whole, because it concerns him to understand the place which amusement occupies in relation to art and to civilization in general.

Our first business, then, is to investigate these three kinds of art falsely so called. When that has been done, we must see what there is left to be said about art proper.

BOOK I
ART AND NOT ART

II

ART AND CRAFT

§ 1. *The Meaning of Craft*

THE first sense of the word 'art' to be distinguished from art proper is the obsolete sense in which it means what in this book I shall call craft. This is what *ars* means in ancient Latin, and what τέχνη means in Greek: the power to produce a preconceived result by means of consciously controlled and directed action. In order to take the first step towards a sound aesthetic, it is necessary to disentangle the notion of craft from that of art proper. In order to do this, again, we must first enumerate the chief characteristics of craft.

(1) Craft always involves a distinction between means and end, each clearly conceived as something distinct from the other but related to it. The term 'means' is loosely applied to things that are used in order to reach the end, such as tools, machines, or fuel. Strictly, it applies not to the things but to the actions concerned with them: manipulating the tools, tending the machines, or burning the fuel. These actions (as implied by the literal sense of the word means) are passed through or traversed in order to reach the end, and are left behind when the end is reached. This may serve to distinguish the idea of means from two other ideas with which it is sometimes confused: that of part, and that of material. The relation of part to whole is like that of means to end, in that the part is indispensable to the whole, is what it is because of its relation to the whole, and may exist by itself before the whole comes into existence; but when the whole exists the part exists too, whereas, when the end exists, the means have ceased to exist. As for the idea of material, we shall return to that in (4) below.

(2) It involves a distinction between planning and execution. The result to be obtained is preconceived or thought out before being arrived at. The craftsman knows what he

wants to make before he makes it. This foreknowledge is absolutely indispensable to craft: if something, for example stainless steel, is made without such foreknowledge, the making of it is not a case of craft but an accident. Moreover, this foreknowledge is not vague but precise. If a person sets out to make a table, but conceives the table only vaguely, as somewhere between two by four feet and three by six, and between two and three feet high, and so forth, he is no craftsman.

(3) Means and end are related in one way in the process of planning; in the opposite way in the process of execution. In planning the end is prior to the means. The end is thought out first, and afterwards the means are thought out. In execution the means come first, and the end is reached through them.

(4) There is a distinction between raw material and finished product or artifact. A craft is always exercised upon something, and aims at the transformation of this into something different. That upon which it works begins as raw material and ends as finished product. The raw material is found ready made before the special work of the craft begins.

(5) There is a distinction between form and matter. The matter is what is identical in the raw material and the finished product; the form is what is different, what the exercise of the craft changes. To describe the raw material as raw is not to imply that it is formless, but only that it has not yet the form which it is to acquire through 'transformation' into finished product.

(6) There is a hierarchical relation between various crafts, one supplying what another needs, one using what another provides. There are three kinds of hierarchy: of materials, of means, and of parts. (a) The raw material of one craft is the finished product of another. Thus the silviculturist propagates trees and looks after them as they grow, in order to provide raw material for the felling-men who transform them into logs; these are raw material for the saw-mill which transforms them into planks; and these, after a further process

of selection and seasoning, become raw material for a joiner. (*b*) In the hierarchy of means, one craft supplies another with tools. Thus the timber-merchant supplies pit-props to the miner; the miner supplies coal to the blacksmith; the black-smith supplies horseshoes to the farmer; and so on. (*c*) In the hierarchy of parts, a complex operation like the manufacture of a motor-car is parcelled out among a number of trades: one firm makes the engine, another the gears, another the chassis, another the tyres, another the electrical equipment, and so on; the final assembling is not strictly the manufacture of the car but only the bringing together of these parts. In one or more of these ways every craft has a hierarchical character; either as hierarchically related to other crafts, or as itself consisting of various heterogeneous operations hier-archically related among themselves.

Without claiming that these features together exhaust the notion of craft, or that each of them separately is peculiar to it, we may claim with tolerable confidence that where most of them are absent from a certain activity that activity is not a craft, and, if it is called by that name, is so called either by mistake or in a vague and inaccurate way.

§ 2. *The Technical Theory of Art*

It was the Greek philosophers who worked out the idea of craft, and it is in their writings that the above distinctions have been expounded once for all. The philosophy of craft, in fact, was one of the greatest and most solid achievements of the Greek mind, or at any rate of that school, from Socrates to Aristotle, whose work happens to have been most completely preserved.

Great discoveries seem to their makers even greater than they are. A person who has solved one problem is inevitably led to apply that solution to others. Once the Socratic school had laid down the main lines of a theory of craft, they were bound to look for instances of craft in all sorts of likely and unlikely places. To show how they met this temptation, here yielding to it and there resisting it, or first yielding to it

and then laboriously correcting their error, would need a long
essay. Two brilliant cases of successful resistance may,
however, be mentioned: Plato's demonstration (*Republic*,
330 D–336 A) that justice is not a craft, with the pendant
(336 E–354 A) that injustice is not one either; and Aristotle's
rejection (*Metaphysics*, Λ) of the view stated in Plato's
Timaeus, that the relation between God and the world is a
case of the relation between craftsman and artifact.

When they came to deal with aesthetic problems, however,
both Plato and Aristotle yielded to the temptation. They
took it for granted that poetry, the only art which they dis-
cussed in detail, was a kind of craft, and spoke of this craft
as ποιητικὴ τέχνη, poet-craft. What kind of craft was this?

There are some crafts, like cobbling, carpentering, or
weaving, whose end is to produce a certain type of artifact;
others, like agriculture or stock-breeding or horse-breaking,
whose end is to produce or improve certain non-human
types of organism; others again, like medicine or education
or warfare, whose end is to bring certain human beings into
certain states of body or mind. But we need not ask which
of these is the genus of which poet-craft is a species, because
they are not mutually exclusive. The cobbler or carpenter
or weaver is not simply trying to produce shoes or carts or
cloth. He produces these because there is a demand for
them; that is, they are not ends to him, but means to the end
of satisfying a specific demand. What he is really aiming at
is the production of a certain state of mind in his customers,
the state of having these demands satisfied. The same
analysis applies to the second group. Thus in the end these
three kinds of craft reduce to one. They are all ways of
bringing human beings into certain desired conditions.

The same description is true of poet-craft. The poet
is a kind of skilled producer; he produces for consumers;
and the effect of his skill is to bring about in them certain
states of mind, which are conceived in advance as desirable
states. The poet, like any other kind of craftsman, must
know what effect he is aiming at, and must learn by

experience and precept, which is only the imparted experience of others, how to produce it. This is poet-craft, as conceived by Plato and Aristotle and, following them, such writers as Horace in his *Ars Poetica*. There will be analogous crafts of painting, sculpture, and so forth; music, at least for Plato, is not a separate art but is a constituent part of poetry.

I have gone back to the ancients, because their thought, in this matter as in so many others, has left permanent traces on our own, both for good and for ill. There are suggestions in some of them, especially in Plato, of a quite different view; but this is the one which they have made familiar, and upon which both the theory and the practice of the arts has for the most part rested down to the present time. Present-day fashions of thought have in some ways even tended to reinforce it. We are apt nowadays to think about most problems, including those of art, in terms either of economics or of psychology; and both ways of thinking tend to subsume the philosophy of art under the philosophy of craft. To the economist, art presents the appearance of a specialized group of industries; the artist is a producer, his audience consumers who pay him for benefits ultimately definable in terms of the states of mind which his productivity enables them to enjoy. To the psychologist, the audience consists of persons reacting in certain ways to stimuli provided by the artist; and the artist's business is to know what reactions are desired or desirable, and to provide the stimuli which will elicit them.

The technical theory of art is thus by no means a matter of merely antiquarian interest. It is actually the way in which most people nowadays think of art; and especially economists and psychologists, the people to whom we look (sometimes in vain) for special guidance in the problems of modern life.

But this theory is simply a vulgar error, as anybody can see who looks at it with a critical eye. It does not matter what kind of craft in particular is identified with art. It does not matter what the benefits are which the artist is regarded

as conferring on his audience, or what the reactions are which he is supposed to elicit. Irrespectively of such details, our question is whether art is any kind of craft at all. It is easily answered by keeping in mind the half-dozen characteristics of craft enumerated in the preceding section, and asking whether they fit the case of art. And there must be no chopping of toes or squeezing of heels; the fit must be immediate and convincing. It is better to have no theory of art at all, than to have one which irks us from the first.

§ 3. Break-down of the Theory

(1) The first characteristic of craft is the distinction between means and end. Is this present in works of art? According to the technical theory, yes. A poem is means to the production of a certain state of mind in the audience, as a horseshoe is means to the production of a certain state of mind in the man whose horse is shod. And the poem in its turn will be an end to which other things are means. In the case of the horseshoe, this stage of the analysis is easy: we can enumerate lighting the forge, cutting a piece of iron off a bar, heating it, and so on. What is there analogous to these processes in the case of a poem? The poet may get paper and pen, fill the pen, sit down and square his elbows; but these actions are preparatory not to composition (which may go on in the poet's head) but to writing. Suppose the poem is a short one, and composed without the use of any writing materials; what are the means by which the poet composes it? I can think of no answer, unless comic answers are wanted, such as 'using a rhyming dictionary', 'pounding his foot on the floor or wagging his head or hand to mark the metre', or 'getting drunk'. If one looks at the matter seriously, one sees that the only factors in the situation are the poet, the poetic labour of his mind, and the poem. And if any supporter of the technical theory says 'Right: then the poetic labour is the means, the poem the end', we shall ask him to find a blacksmith who can make a horseshoe by sheer labour, without forge, anvil, hammer,

or tongs. It is because nothing corresponding to these exists in the case of the poem that the poem is not an end to which there are means.

Conversely, is a poem means to the production of a certain state of mind in an audience? Suppose a poet had read his verses to an audience, hoping that they would produce a certain result; and suppose the result were different; would that in itself prove the poem a bad one? It is a difficult question; some would say yes, others no. But if poetry were obviously a craft, the answer would be a prompt and un-hesitating yes. The advocate of the technical theory must do a good deal of toe-chopping before he can get his facts to fit his theory at this point.

So far, the prospects of the technical theory are not too bright. Let us proceed.

(2) The distinction between planning and executing cer-tainly exists in some works of art, namely those which are also works of craft or artifacts; for there is, of course, an overlap between these two things, as may be seen by the example of a building or a jar, which is made to order for the satisfaction of a specific demand, to serve a useful pur-pose, but may none the less be a work of art. But suppose a poet were making up verses as he walked; suddenly finding a line in his head, and then another, and then dissatisfied with them and altering them until he had got them to his liking: what is the plan which he is executing? He may have had a vague idea that if he went for a walk he would be able to compose poetry; but what were, so to speak, the measure-ments and specifications of the poem he planned to compose? He may, no doubt, have been hoping to compose a sonnet on a particular subject specified by the editor of a review; but the point is that he may not, and that he is none the less a poet for composing without having any definite plan in his head. Or suppose a sculptor were not making a Madonna and child, three feet high, in Hoptonwood stone, guaranteed to placate the chancellor of the diocese and obtain a faculty for placing it in the vacant niche over a certain church door;

but were simply playing about with clay, and found the clay under his fingers turning into a little dancing man: is this not a work of art because it was done without being planned in advance?

All this is very familiar. There would be no need to insist upon it, but that the technical theory of art relies on our forgetting it. While we are thinking of it, let us note the importance of not over-emphasizing it. Art as such does not imply the distinction between planning and execution. But (*a*) this is a merely negative characteristic, not a positive one. We must not erect the absence of plan into a positive force and call it inspiration, or the unconscious, or the like. (*b*) It is a permissible characteristic of art, not a compulsory one. If unplanned works of art are possible, it does not follow that no planned work is a work of art. That is the logical fallacy[1] that underlies one, or some, of the various things called romanticism. It may very well be true that the only works of art which can be made altogether without a plan are trifling ones, and that the greatest and most serious ones always contain an element of planning and therefore an element of craft. But that would not justify the technical theory of art.

(3) If neither means and end nor planning and execution can be distinguished in art proper, there obviously can be no reversal of order as between means and end, in planning and execution respectively.

(4) We next come to the distinction between raw material and finished product. Does this exist in art proper? If so, a poem is made out of certain raw material. What is the raw material out of which Ben Jonson made *Queene and Huntresse*,

[1] It is an example of what I have elsewhere called the fallacy of precarious margins. Because art and craft overlap, the essence of art is sought not in the positive characteristics of all art, but in the characteristics of those works of art which are not works of craft. Thus the only things which are allowed to be works of art are those marginal examples which lie outside the overlap of art and craft. This is a precarious margin because further study may at any moment reveal the characteristics of craft in some of these examples. See *Essay on Philosophical Method*.

chaste, and faire? Words, perhaps. Well, what words?
A smith makes a horseshoe not out of all the iron there is, but
out of a certain piece of iron, cut off a certain bar that he
keeps in the corner of the smithy. If Ben Jonson did any-
thing at all like that, he said: 'I want to make a nice little
hymn to open Act v, Scene vi of *Cynthia's Revels*. Here is
the English language, or as much of it as I know; I will use
thy five times, *to* four times, *and, bright, excellently,* and
goddesse three times each, and so on.' He did nothing like
this. The words which occur in the poem were never before
his mind as a whole in an order different from that of the
poem, out of which he shuffled them till the poem, as we have
it, appeared. I do not deny that by sorting out the words,
or the vowel sounds, or the consonant sounds, in a poem
like this, we can make interesting and (I believe) important
discoveries about the way in which Ben Jonson's mind
worked when he made the poem; and I am willing to allow
that the technical theory of art is doing good service if it
leads people to explore these matters; but if it can only
express what it is trying to do by calling these words or
sounds the materials out of which the poem is made, it is
talking nonsense.

But perhaps there is a raw material of another kind: a
feeling or emotion, for example, which is present to the
poet's mind at the commencement of his labour, and which
that labour converts into the poem. 'Aus meinem grossen
Schmerzen mach' ich die kleinen Lieder', said Heine; and
he was doubtless right; the poet's labour can be justly
described as converting emotions into poems. But this con-
version is a very different kind of thing from the conversion
of iron into horseshoes. If the two kinds of conversion were
the same, a blacksmith could make horseshoes out of his
desire to pay the rent. The something more, over and above
that desire, which he must have in order to make horseshoes
out of it, is the iron which is their raw material. In the poet's
case that something more does not exist.

(5) In every work of art there is something which, in

some sense of the word, may be called form. There is, to be
rather more precise, something in the nature of rhythm,
pattern, organization, design, or structure. But it does not
follow that there is a distinction between form and matter.
Where that distinction does exist, namely, in artifacts, the
matter was there in the shape of raw material before the
form was imposed upon it, and the form was there in
the shape of a preconceived plan before being imposed upon
the matter; and as the two coexist in the finished product
we can see how the matter might have accepted a different
form, or the form have been imposed upon a different
matter. None of these statements applies to a work of art.
Something was no doubt there before a poem came into
being; there was, for example, a confused excitement in the
poet's mind; but, as we have seen, this was not the raw
material of the poem. There was also, no doubt, the impulse
to write; but this impulse was not the form of the unwritten
poem. And when the poem is written, there is nothing in it
of which we can say, 'this is a matter which might have taken
on a different form', or 'this is a form which might have
been realized in a different matter'.

When people have spoken of matter and form in con-
nexion with art, or of that strange hybrid distinction, form
and content, they have in fact been doing one of two things,
or both confusedly at once. Either they have been assi-
milating a work of art to an artifact, and the artist's work to
the craftsman's; or else they have been using these terms
in a vaguely metaphorical way as means of referring to distinc-
tions which really do exist in art, but are of a different kind.
There is always in art a distinction between what is expressed
and that which expresses it; there is a distinction between
the initial impulse to write or paint or compose and the
finished poem or picture or music; there is a distinction
between an emotional element in the artist's experience and
what may be called an intellectual element. All these deserve
investigation; but none of them is a case of the distinction
between form and matter.

(6) Finally, there is in art nothing which resembles the hierarchy of crafts, each dictating ends to the one below it, and providing either means or raw materials or parts to the one above. When a poet writes verses for a musician to set, these verses are not means to the musician's end, for they are incorporated in the song which is the musician's finished product, and it is characteristic of means, as we saw, to be left behind. But neither are they raw materials. The musician does not transform them into music; he sets them to music; and if the music which he writes for them had a raw material (which it has not), that raw material could not consist of verses. What happens is rather that the poet and musician collaborate to produce a work of art which owes something to each of them; and this is true even if in the poet's case there was no intention of collaborating.

Aristotle extracted from the notion of a hierarchy of crafts the notion of a supreme craft, upon which all hierarchical series converged, so that the various 'goods' which all crafts produce played their part, in one way or another, in preparing for the work of this supreme craft, whose product could, therefore, be called the 'supreme good'.[1] At first sight, one might fancy an echo of this in Wagner's theory of opera as the supreme art, supreme because it combines the beauties of music and poetry and drama, the arts of time and the arts of space, into a single whole. But, quite apart from the question whether Wagner's opinion of opera as the greatest of the arts is justified, this opinion does not really rest on the idea of a hierarchy of arts. Words, gestures, music, scenery are not means to opera, nor yet raw materials of it, but parts of it; the hierarchies of means and materials may therefore be ruled out, and only that of parts remains. But even this does not apply. Wagner thought himself a supremely great artist because he wrote not only his music but his words, designed his scenery, and acted as his own producer. This is the exact opposite of a system like that by which motor-cars are made, which owes its hierarchical character to the

[1] *Nicomachean Ethics*, beginning: 1094 a 1–b 10.

fact that the various parts are all made by different firms, each specializing in work of one kind.

§ 4. *Technique*

As soon as we take the notion of craft seriously, it is perfectly obvious that art proper cannot be any kind of craft. Most people who write about art to-day seem to think that it is some kind of craft; and this is the main error against which a modern aesthetic theory must fight. Even those who do not openly embrace the error itself, embrace doctrines implying it. One such doctrine is that of artistic technique.

The doctrine may be stated as follows. The artist must have a certain specialized form of skill, which is called technique. He acquires his skill just as a craftsman does, partly through personal experience and partly through sharing in the experience of others who thus become his teachers. The technical skill which he thus acquires does not by itself make him an artist; for a technician is made, but an artist is born. Great artistic powers may produce fine works of art even though technique is defective; and even the most finished technique will not produce the finest sort of work in their absence; but all the same, no work of art whatever can be produced without some degree of technical skill, and, other things being equal, the better the technique the better will be the work of art. The greatest artistic powers, for their due and proper display, demand a technique as good in its kind as they are in their own.

All this, properly understood, is very true; and, as a criticism of the sentimental notion that works of art can be produced by any one, however little trouble he has taken to learn his job, provided his heart is in the right place, very salutary. And since a writer on art is for the most part addressing himself not to artists, but to amateurs of art, he does well to insist on what every artist knows, but most amateurs do not: the vast amount of intelligent and purposeful labour, the painful and conscientious self-discipline,

that has gone to the making of a man who can write a line as Pope writes it, or knock a single chip off a single stone like Michelangelo. It is no less true, and no less important, that the skill here displayed (allowing the word skill to pass for the moment unchallenged), though a necessary condition of the best art, is not by itself sufficient to produce it. A high degree of such skill is shown in Ben Jonson's poem; and a critic might, not unfruitfully, display this skill by analysing the intricate and ingenious patterns of rhythm and rhyme, alliteration, assonance, and dissonance, which the poem contains. But what makes Ben Jonson a poet, and a great one, is not his skill to construct such patterns but his imaginative vision of the goddess and her attendants, for whose expression it was worth his while to use that skill, and for whose enjoyment it is worth our while to study the patterns he has constructed. Miss Edith Sitwell, whose distinction both as poet and critic needs no commendation, and whose analyses of sound-pattern in poetry are as brilliant as her own verse, has analysed in this way the patterns constructed by Mr. T. S. Eliot, and has written warmly of the skill they exemplify; but when she wishes conclusively to compare his greatness with the little-ness of certain other poets who are sometimes ridiculously fancied his equals, she ceases to praise his technique, and writes, 'here we have a man who has talked with fiery angels, and with angels of a clear light and holy peace, and who has "walked amongst the lowest of the dead"'.[1] It is this experience, she would have us understand, that is the heart of his poetry; it is the 'enlargement of our experience' by his own (a favourite phrase of hers, and one never used without illumination to her readers) that tells us he is a true poet; and however necessary it may be that a poet should have technical skill, he is a poet only in so far as this skill is not identified with art, but with something used in the service of art.

This is not the old Greco-Roman theory of poet-craft,

[1] *Aspects of Modern Poetry*, ch. v and p. 251.

but a modified and restricted version of it. When we examine it, however, we shall find that although it has moved away from the old poet-craft theory in order to avoid its errors, it has not moved far enough.

When the poet is described as possessing technical skill, this means that he possesses something of the same nature as what goes by that name in the case of a technician proper or craftsman. It implies that the thing so called in the case of a poet stands to the production of his poem as the skill of a joiner stands to the production of a table. If it does not mean this, the words are being used in some obscure sense; either an esoteric sense which people who use them are deliberately concealing from their readers, or (more probably) a sense which remains obscure even to themselves. We will assume that the people who use this language take it seriously, and wish to abide by its implications.

The craftsman's skill is his knowledge of the means necessary to realize a given end, and his mastery of these means. A joiner making a table shows his skill by knowing what materials and what tools are needed to make it, and being able to use these in such a way as to produce the table exactly as specified.

The theory of poetic technique implies that in the first place a poet has certain experiences which demand expression; then he conceives the possibility of a poem in which they might be expressed; then this poem, as an unachieved end, demands for its realization the exercise of certain powers or forms of skill, and these constitute the poet's technique. There is an element of truth in this. It is true that the making of a poem begins in the poet's having an experience which demands expression in the form of a poem. But the description of the unwritten poem as an end to which his technique is means is false; it implies that before he has written his poem he knows, and could state, the specification of it in the kind of way in which a joiner knows the specification of a table he is about to make. This is always true of a craftsman; it is therefore true of an artist in those

cases where the work of art is also a work of craft. But it is wholly untrue of the artist in those cases where the work of art is not a work of craft; the poet extemporizing his verses, the sculptor playing with his clay, and so forth. In these cases (which after all are cases of art, even though possibly of art at a relatively humble level) the artist has no idea what the experience is which demands expression until he has expressed it. What he wants to say is not present to him as an end towards which means have to be devised; it becomes clear to him only as the poem takes shape in his mind, or the clay in his fingers.

Some relic of this condition survives even in the most elaborate, most reflective, most highly planned works of art. That is a problem to which we must return in another chapter: the problem of reconciling the unreflective spontaneity of art in its simplest forms with the massive intellectual burden that is carried by great works of art such as the *Agamemnon* or the *Divina Commedia*. For the present, we are dealing with a simpler problem. We are confronted with what professes to be a theory of art in general. To prove it false we need only show that there are admitted examples of art to which it does not apply.

In describing the power by which an artist constructs patterns in words or notes or brush-marks by the name of technique, therefore, this theory is misdescribing it by assimilating it to the skill by which a craftsman constructs appropriate means to a preconceived end. The patterns are no doubt real; the power by which the artist constructs them is no doubt a thing worthy of our attention; but we are only frustrating our study of it in advance if we approach it in the determination to treat it as if it were the conscious working-out of means to the achievement of a conscious purpose, or in other words technique.

§ 5. *Art as a Psychological Stimulus*

The modern conception of artistic technique, as stated or implied in the writings of critics, may be unsuccessful;

but it is a serious attempt to overcome the weaknesses of the old poet-craft theory, by admitting that a work of art as such is not an artifact, because its creation involves elements which cannot be subsumed under the conception of craft; while yet maintaining that there is a grain of truth in that theory, because among the elements involved in the creation of a work of art there is one which can be thus subsumed, namely, the artist's technique. We have seen that this will not do; but at least the people who put it forward have been working at the subject.

The same cannot be said about another attempt to re-habilitate the technical theory of art, namely, that of a very large school of modern psychologists, and of critics who adopt their way of speaking. Here the entire work of art is conceived as an artifact, designed (when a sufficient degree of skill is present to justify the word) as means to the realiza-tion of an end beyond it, namely, a state of mind in the artist's audience. In order to affect his audience in a certain way, the artist addresses them in a certain manner, by placing before them a certain work of art. In so far as he is a com-petent artist, one condition at least is fulfilled: the work of art does affect them as he intends it should. There is a second condition which may be fulfilled: the state of mind thus aroused in them may be in one way or another a valuable state of mind; one that enriches their lives, and thus gives him a claim not only on their admiration but also on their gratitude.

The first thing to notice about this stimulus-and-reaction theory of art is that it is not new. It is the theory of the tenth book of Plato's *Republic*, of Aristotle's *Poetics*, and of Horace's *Ars Poetica*. The psychologists who make use of it have, knowingly or unknowingly, taken over the poet-craft doctrine bodily, with no suspicion of the devastating criticism it has received at the hands of aestheticians in the last few centuries.

This is not because their views have been based on a study of Plato and Aristotle, to the neglect of more modern authors.

It is because, like good inductive scientists, they have kept
their eye on the facts, but (a disaster against which inductive
methods afford no protection) the wrong facts. Their theory
of art is based on a study of art falsely so called.

There are numerous cases in which somebody claiming
the title of artist deliberately sets himself to arouse certain
states of mind in his audience. The funny man who lays
himself out to get a laugh has at his command a number of
well-tried methods for getting it; the purveyor of sob-stuff
is in a similar case; the political or religious orator has a
definite end before him and adopts definite means for
achieving it, and so on. We might even attempt a rough
classification of these ends.[1] First, the 'artist's' purpose may
be to arouse a certain kind of emotion. The emotion may be
of almost any kind; a more important distinction emerges
according as it is aroused simply for its own sake, as an enjoy-
able experience, or for the sake of its value in the affairs of
practical life. The funny man and the sob-stuff monger fall
on one side in this division, the political and religious orator
on the other. Secondly, the purpose may be to stimulate
certain intellectual activities. These again may be of very
various kinds, but they may be stimulated with either of two
motives: either because the objects upon which they are
directed are thought of as worth understanding, or because
the activities themselves are thought of as worth pursuing,
even though they lead to nothing in the way of knowledge
that is of importance. Thirdly, the purpose may be to
stimulate a certain kind of action; here again with two
kinds of motive: either because the action is conceived as
expedient, or because it is conceived as right.

Here are six kinds of art falsely so called; called by that
name because they are kinds of craft in which the practi-

[1] The reason why I call it a rough classification is because you cannot
really 'stimulate intellectual activities', or 'stimulate certain kinds of action',
in a man. Anybody who says you can, has not thought about the conditions
under which alone these things can arise. Foremost among these conditions
is this: that they must be absolutely spontaneous. Consequently they cannot
be responses to stimulus.

tioner can by the use of his skill evoke a desired psychological reaction in his audience, and hence they come under the obsolete, but not yet dead and buried, conception of poet-craft, painter-craft, and so forth; falsely so called, because the distinction of means and end, upon which every one of them rests, does not belong to art proper.

Let us give the six their right names. Where an emotion is aroused for its own sake, as an enjoyable experience, the craft of arousing it is amusement; where for the sake of its practical value, magic (the meaning of that word will be explained in chapter IV). Where intellectual faculties are stimulated for the mere sake of their exercise, the work designed to stimulate them is a puzzle; where for the sake of knowing this or that thing, it is instruction. Where a certain practical activity is stimulated as expedient, that which stimulates it is advertisement or (in the current modern sense, not the old sense) propaganda; where it is stimulated as right, exhortation.

These six between them, singly or in combination, pretty well exhaust the function of whatever in the modern world wrongfully usurps the name of art. None of them has anything to do with art proper. This is not because (as Oscar Wilde said, with his curious talent for just missing a truth and then giving himself a prize for hitting it) 'all art is quite useless', for it is not; a work of art may very well amuse, instruct, puzzle, exhort, and so forth, without ceasing to be art, and in these ways it may be very useful indeed. It is because, as Oscar Wilde perhaps meant to say, what makes it art is not the same as what makes it useful. Deciding what psychological reaction a so-called work of art produces (for example, asking yourself how a certain poem 'makes you feel') has nothing whatever to do with deciding whether it is a real work of art or not. Equally irrelevant is the question what psychological reaction it is meant to produce.

The classification of psychological reactions produced by poems, pictures, music, or the like is thus not a classification of kinds of art. It is a classification of kinds of pseudo-art.

But the term 'pseudo-art' means something that is not art but is mistaken for art; and something that is not art can be mistaken for it only if there is some ground for the mistake: if the thing mistaken for art is akin to art in such a way that the mistake easily arises. What must this kinship be? We have already seen in the last chapter that there may be a combination of, for example, art with religion, of such a kind that the artistic motive, though genuinely present, is subordinated to the religious. To call the result of such a combination art, *tout court*, would be to invite the reply, 'it is not art but religion'; that is, the accusation that what is simply religion is being mistaken for art. But such a mistake could never in fact be made. What happens is that a combination of art and religion is elliptically called art, and then characteristics which it possesses not as art but as religion are mistakenly supposed to belong to it as art.

So here. These various kinds of pseudo-art are in reality various kinds of use to which art may be put. In order that any of these purposes may be realized, there must first be art, and then a subordination of art to some utilitarian end. Unless a man can write, he cannot write propaganda. Unless he can draw, he cannot become a comic draughts-man or an advertisement artist. These activities have in every case developed through a process having two phases. First, there is writing or drawing or whatever it may be, pursued as an art for its own sake, going its own way and developing its own proper nature, caring for none of these things. Then this independent and self-sufficient art is broken, as it were, to the plough, forced aside from its own original nature and enslaved to the service of an end not its own. Here lies the peculiar tragedy of the artist's position in the modern world. He is heir to a tradition from which he has learnt what art should be; or at least, what it cannot be. He has heard its call and devoted himself to its service. And then, when the time comes for him to demand of society that it should support him in return for his devotion to a purpose which, after all, is not his private

purpose but one among the purposes of modern civilization, he finds that his living is guaranteed only on condition that he renounces his calling and uses the art which he has acquired in a way which negates its fundamental nature, by turning journalist or advertisement artist or the like; a degradation far more frightful than the prostitution or enslavement of the mere body.

Even in this denatured condition the arts are never mere means to the ends imposed upon them. For means rightly so called are devised in relation to the end aimed at; but here, there must first be literature, drawing, and so forth, before they can be turned to the purposes described. Hence it is a fundamental and fatal error to conceive art itself as a means to any of these ends, even when it is broken to their service. It is an error much encouraged by modern tendencies in psychology, and influentially taught at the present day by persons in a position of academic authority; but after all, it is only a new version, tricked out in the borrowed plumage of modern science, of the ancient fallacy that the arts are kinds of craft.

If it can deceive even its own advocates, that is only because they waver from one horn of a dilemma to the other. Their theory admits of two alternatives. Either the stimulation of certain reactions in its audience is the essence of art, or it is a consequence arising out of its essence in certain circumstances. Take the first alternative. If art is art only so far as it stimulates certain reactions, the artist as such is simply a purveyor of drugs, noxious or wholesome; what we call works of art are nothing but a section of the Pharmacopoeia.[1] If we ask on what principle that branch can be distinguished from others, there can be no answer.

This is not a theory of art. It is not an aesthetic but an anti-aesthetic. If it is presented as a true account of its advocates' experience, we must accept it as such; but with the implication that its advocates have no aesthetic experience whatever, or at least none so robust as to leave a mark on

[1] Cf. D. G. James, *Scepticism and Poetry* (1937).

their minds deep enough to be discernible when they turn
their eyes inward and try to recognize its main features.[1]
It is, of course, quite possible to look at pictures, listen to
music, and read poetry without getting any aesthetic ex-
perience from these things; and the exposition of this
psychological theory of art may be illustrated by a great
deal of talk about particular works of art; but if this is really
connected with the theory, it is no more to be called art-
criticism or aesthetic theory than the annual strictures in
The Tailor and Cutter on the ways in which Academy portrait-
painters represent coats and trousers. If it attempts to
develop itself as a method of art-criticism, it can only
(except when it forgets its own principles) rely on anti-
aesthetic standards, as when it tries to estimate the objective
merits of a given poem by tabulating the 'reactions' to it of
persons from whom the poet's name has been concealed,
irrespective of their skill or experience in the difficult busi-
ness of criticizing poetry; or by the number of emotions,
separately capable of being recorded by the psychologist and
severally regarded by him as valuable, which it evokes in a
single hearer.

On this horn of the dilemma art disappears altogether.
The alternative possibility is that the stimulating of certain
reactions should be regarded not as the essence of art but
as a consequence arising in certain conditions out of the
nature of that essence. In that case, art survives the analysis,
but only at the cost of making it irrelevant, as a pharmaco-
logist's account of the effect of a hitherto unanalysed drug
would be irrelevant to the question of its chemical com-
position. Granted that works of art in certain conditions do
stimulate certain reactions in their audience, which is a fact;
and granted that they do so not because of something other
than their nature as works of art, but because of that nature

[1] Dr. I. A. Richards is at present the most distinguished advocate of the
theory I am attacking. I should never say of him that he has no aesthetic
experience. But in his writings he does not discuss it; he only reveals it from
time to time by things he lets slip.

itself, which is an error; it will even so not follow that light is thrown on that nature itself by the study of these reactions.

Psychological science has in fact done nothing towards explaining the nature of art, however much it has done towards explaining the nature of certain elements of human experience with which it may from time to time be associated or confused. The contribution of psychology to pseudo-aesthetic is enormous; to aesthetic proper it is nil.

§ 6. *Fine Art and Beauty*

The abandonment of the technical theory of art involves the abandonment of a certain terminology, which consists in describing art proper by the name of 'fine art'. This terminology implies that there is a genus art, divided into two species, the 'useful arts' and the 'fine arts'. The 'useful arts' are crafts like metallurgy, weaving, pottery, and so forth; that is, the phrase means 'arts (i.e. crafts) devoted to making what is useful'. This implies that the genus art is conceived as craft, and that the phrase 'fine arts' means 'crafts devoted to making what is fine, i.e. beautiful'. That is to say, the terminology in question is intended to commit any one who uses it to the technical theory of art.

Happily, the term 'fine art', except in a few archaic phrases, is obsolete; but whether this is due to a general repudiation of the ideas it expresses, or only to the convenience of abbreviating it into 'art', is not so clear. Some of those ideas, at any rate, do not seem to have died out; and it would be well to look into them here.

1. The phrase implies that art and manufacture, to use current modern equivalents for the old terms 'fine arts' and 'useful arts', are species of one genus: both essentially activities productive of artifacts, but differing in the qualities which these artifacts are meant to possess. This is an error which must be eradicated from our minds with all possible care. In doing this we must disabuse ourselves of the notion that the business of an artist consists in producing a special kind of artifacts, so-called 'works of art' or *objets d'art*, which

are bodily and perceptible things (painted canvasses, carved stones, and so forth). This notion is nothing more nor less than the technical theory of art itself. We shall have, later on, to consider in some detail what it is that the artist, as such and essentially, produces. We shall find that it is two things. Primarily, it is an 'internal' or 'mental' thing, something (as we commonly say) 'existing in his head' and there only: something of the kind which we commonly call an experience. Secondarily, it is a bodily or perceptible thing (a picture, statue, &c.) whose exact relation to this 'mental' thing will need very careful definition. Of these two things, the first is obviously not anything that can be called a work of art, if work means something made in the sense in which a weaver makes cloth. But since it is the thing which the artist as such primarily produces, I shall argue that we are entitled to call it 'the work of art proper'. The second thing, the bodily and perceptible thing, I shall show to be only incidental to the first. The making of it is therefore not the activity in virtue of which a man is an artist, but only a subsidiary activity, incidental to that. And consequently this thing is a work of art, not in its own right, but only because of the relation in which it stands to the 'mental' thing or experience of which I spoke just now. There is no such thing as an *objet d'art* in itself; if we call any bodily and perceptible thing by that name or an equivalent we do so only because of the relation in which it stands to the aesthetic experience which is the 'work of art proper'.

2. The phrase 'fine art' further implies that the bodily or perceptible work of art has a peculiarity distinguishing it from the products of useful art, viz. beauty. This is a conception which has become very much distorted in the course of many centuries' speculation on aesthetic theory, and we must try to get it straight. The word does not belong to the English language as such, but to the common speech of European civilization (*le beau*, *il bello*, *bellum*; the last used as an equivalent of τὸ καλόν). If we go back to the Greek, we find that there is no connexion at all between beauty and art.

Plato has a lot to say about beauty, in which he is only systematizing what we find implied in the ordinary Greek use of the word. The beauty of anything is, for him, that in it which compels us to admire and desire it: το καλόν is the proper object of ἔρως, 'love'. The theory of beauty is thus, in Plato, connected not with the theory of poetry or any other art, but primarily with the theory of sexual love, secondly with the theory of morals (as that for the sake of which we act when action is at its highest potency; and Aristotle similarly, of a noble action, says that it is done 'for beauty's sake', τοῦ καλοῦ ἕνεκα), and thirdly with the theory of knowledge, as that which lures us onward in the path of philosophy, the quest of truth. To call a thing beautiful in Greek, whether ordinary or philosophical Greek, is simply to call it admirable or excellent or desirable. A poem or painting may certainly receive the epithet, but only by the same kind of right as a boot or any other simple artifact. The sandals of Hermes, for example, are regularly called beautiful by Homer, not because they are conceived as elegantly designed or decorated, but because they are conceived as jolly good sandals which enable him to fly as well as walk.

In modern times there has been a determined attempt on the part of aesthetic theorists to monopolize the word and make it stand for that quality in things in virtue of which when we contemplate them we enjoy what we recognize as an aesthetic experience. There is no such quality; and the word, which is a perfectly respectable word in current usage, means not what the aesthetic theorists want it to mean but something quite different and much more like what τὸ καλόν means in Greek. I shall deal with these points in the reverse order.

(a) The words 'beauty', 'beautiful', as actually used, have no aesthetic implication. We speak of a beautiful painting or statue, but this only means an admirable or excellent one. Certainly the total phrase 'a beautiful statue' conveys an implication of aesthetic excellence, but the aesthetic part of this implication is conveyed not by the word 'beautiful' but

by the word 'statue'. The word 'beautiful' is used in such a case no otherwise than as it is used in such phrases as 'a beautiful demonstration' in mathematics or 'a beautiful stroke' at billiards. These phrases do not express an aesthetic attitude in the person who uses them towards the stroke or the demonstration; they express an attitude of admiration for a thing well done, irrespective of whether that thing is an aesthetic activity, an intellectual activity, or a bodily activity.

We speak of things as beautiful, with no less frequency and no less accuracy, when their excellence is one that appeals only to our senses: a beautiful saddle of mutton or a beautiful claret. Or when their excellence is that of well-devised and well-made means to an end: a beautiful watch or a beautiful theodolite. When we speak of natural things as beautiful, it may, of course, be with reference to the aesthetic experiences which we sometimes enjoy in connexion with them; for we do enjoy such experiences in connexion with natural objects, as we enjoy them in connexion with *objets d'art*, and, I think, enjoy them in both cases in precisely the same way. But it need not be with reference to aesthetic experience; it may equally well be with reference to the satisfaction of some desire or the arousing of some emotion. A beautiful woman ordinarily means one whom we find sexually desirable; a beautiful day, one which gives us the kind of weather we need for some purpose or other, or just for some reason like; a beautiful sunset or a beautiful night, one that fills us with certain emotions, and we have seen that such emotional reactions have nothing to do with aesthetic merit. The question was acutely raised by Kant, how far our attitude towards the song of a bird is an aesthetic one, and how far it is a feeling of sympathy towards a little fellow creature. Certainly we often call our fellow creatures beautiful by way of saying that we love them, and that not only sexually. The bright eyes of a mouse or the fragile vitality of a flower are things that touch us to the heart, but they touch us with the love that life feels for life, not with a judgement of their

aesthetic excellence. A very great deal of what we express by calling natural things beautiful has nothing whatever to do with aesthetic experience. It has to do with that other kind of experience which Plato called ἔρως.

Modern aestheticians who want to connect the idea of beauty with the idea of art will say to all this either that the word is 'correctly' used when it is used in connexion with aesthetic experience and 'incorrectly' on other occasions, or that it is 'ambiguous', having both an aesthetic use and a non-aesthetic. Neither position is tenable. The first is one of those all too frequent attempts on the part of philosophers to justify their own misuse of a word by ordering others to misuse it in the same way. We ought not, they say, to call a grilled steak beautiful. But why not? Because they want us to let them monopolize the word for their own purposes. Well, it does not matter to anybody but themselves, because nobody will obey them. But it matters to themselves, because the purpose for which they want it, as we shall see in the next paragraph, is to talk nonsense. The second alternative is simply untrue. There is no ambiguity. The word 'beauty', wherever and however it is used, connotes that in things by virtue of which we love them, admire them, or desire them.

(b) When these aestheticians want to use the word as a name for the quality in things by virtue of which we enjoy an aesthetic experience in connexion with them, they want to use it as a name for something non-existent. There is no such quality. The aesthetic experience is an autonomous activity. It arises from within; it is not a specific reaction to a stimulus proceeding from a specific type of external object. Some of those who want to use the word 'beauty' in this way are quite aware of this, and indeed preach it as a doctrine under the name of the subjectivity of beauty; not realizing that if this doctrine is accepted their own motive for wresting the word 'beauty' from its proper sense disappears. For to say that beauty is subjective means that the aesthetic experiences which we enjoy in connexion with certain things arise not from any quality that they possess,

which if they did possess it would be called beauty, but from our own aesthetic activity.

To sum up: aesthetic theory is the theory not of beauty but of art. The theory of beauty, if instead of being brought (as it rightly was by Plato) into connexion with thé theory of love it is brought into connexion with aesthetic theory, is merely an attempt to construct an aesthetic on a 'realistic' basis, that is, to explain away the aesthetic activity by appeal to a supposed quality of the things with which, in that experience, we are in contact; this supposed quality, invented to explain the activity, being in fact nothing but the activity itself, falsely located not in the agent but in his external world.

ART AND REPRESENTATION

§ 1. *Representation and Imitation*

IF art proper is not any kind of craft, it cannot be representative. For representation is a matter of skill, a craft of a special kind. If the last chapter has established the bankruptcy of the technical theory of art, the present chapter is in logical strictness unnecessary, for its purpose will be to demonstrate that art proper is not and cannot be representative. But the idea of representation has played too important a part in the history of aesthetic to permit this summary treatment. I therefore propose to waive the above argument, forget the relation between representation and craft, and treat the representational theory of art as if it were a separate theory. As a matter of fact, most of what was written and said about art in the nineteenth century was written and said, not about art proper, but about representation; with the assumption, of course, that it was for that reason about art. Serious artists and critics are trying in these days to go behind that assumption; but they are finding it very difficult, because the general public has by now learnt to take the same assumption as gospel truth. Let that fact, then, serve to justify the publication of this chapter.

Representation must be distinguished from imitation. A work of art is imitative in virtue of its relation to another work of art which affords it a model of artistic excellence; it is representative in virtue of its relation to something in 'nature', that is, something not a work of art.

Imitation also is a craft; and therefore a so-called work of art, in so far as it is imitative, is a work of art falsely so called. At the present time there is little need to insist on this. Plenty of people paint and write and compose in a spirit of the purest imitation, and make a name for themselves as painters or writers or musicians solely owing to their success

in copying the manner of some one whose reputation is assured; but both they and their public know that in so far as their work is of this kind it is a sham, and it would be a waste of our time to prove it. The opposite thesis would be better worth developing. Originality in art, meaning lack of resemblance to anything that has been done before, is sometimes nowadays regarded as an artistic merit. This, of course, is absurd. If the production of something deliberately designed to be like existing works of art is mere craft, equally so, and for the same reason, is the production of something designed to be unlike them. There is a sense in which any genuine work of art is original; but originality in that sense does not mean unlikeness to other works of art. It is a name for the fact that this work of art is a work of art and not anything else.

§ 2. *Representative Art and Art Proper*

The doctrine that all art is representative is a doctrine commonly attributed to Plato and Aristotle[1]; and something like it was actually held by theorists of the Renaissance and the seventeenth century. Later, it was generally maintained that some kinds of art were representative and others not. To-day, the only tolerable view is that no art is representative. At any rate, this is the view of most artists and critics whose opinion is worth taking; but what exactly is asserted and what exactly denied by people who express it, nobody quite knows.

The view that art proper is not representative, which is the view here maintained, does not imply that art and representation are incompatible. As in the case of art and craft, they overlap. A building or a cup, which is primarily an artifact or product of craft, may be also a work of art; but what makes it a work of art is different from what makes it an artifact. A representation may be a work of art; but what makes it a representation is one thing, what makes it a work of art is another.

[1] But falsely attributed. See the following Section.

A portrait, for example, is a work of representation. What the patron demands is a good likeness; and that is what the painter aims, and successfully, if he is a competent painter, at producing. It is not a difficult thing to do; and we may reasonably assume that in portraits by great painters such as Raphael, Titian, Velazquez, or Rembrandt it has been done. But, however reasonable the assumption may be, it is an assumption and nothing more. The sitters are dead and gone, and we cannot check the likeness for ourselves. If, therefore, the only kind of merit a portrait could have were its likeness to the sitter, we could not possibly distinguish, except where the sitter is still alive and unchanged, between a good portrait and a bad. I knew a wealthy art-collector who would never collect portraits, for this very reason. He maintained that since the business of a portrait-painter was to produce a likeness, there was no way of distinguishing a good portrait from a bad when once the sitter was dead. He was a very good stockbroker.

None the less, we do distinguish; and our ability to do so is due to the fact that although, in ordering a portrait, the patron is ordering not a work of art but a likeness, the painter in supplying his demand may have given him more than be bargained for: a likeness and a work of art as well. Of course, in one sense, every portrait must be a work of art. We have already seen how in the advertisement artist there is an artistic motive present, but 'denatured' and subordinated to an end which, being alien to the artist as such, is from the artistic point of view a base end. The portrait-painter is in the same case. He must first of all be an artist before he can subordinate his artistic powers to the end of portraiture. Where the subordination is complete, the portrait-painter has satisfied his patron's demand for a good likeness, but has sacrificed his life as an artist in doing so. Thus a commercial portrait, such as most of those one sees on the walls of exhibitions, is in one sense a work of art and in one sense not a work of art: it is a work in which artistic motives are

genuinely present, but denatured by subordination to a non-artistic end, the end of representation.

In calling a portrait a work of art we mean something more than this. We mean that in addition to the artistry which the painter has subordinated to the business of producing a likeness, there is a further artistry which has risen superior to that business. First of all, the painter has used the fact that he can paint as means to the production of a likeness; then he has used the fact that he is producing a likeness as an opportunity for producing a work of art. There is no need for the reader to puzzle his head over this statement. Either he knows what I am talking about or he does not. If he can detect for himself the difference between a commercial portrait, intended simply to satisfy a patron's demand for a good likeness, such as those by the well-known artists Mr. A and Mr. B, and a portrait in which the artistic motive has triumphed over the representational, like those by Mr. X and Mr. Y, we can get ahead. If he cannot, he lacks the experience on which the writer of a book like this is asking him to reflect.

What is here said of a portrait or representation of an individual human being applies equally to representations of other individuals, such as Snowdon from Capel Curig, the Thames at Pangbourne, or the Death of Nelson. And it makes no difference (as we shall see later on) whether the individual is historically or topographically 'real', like Nelson or Snowdon, or 'imaginary', like Mr. Tobias Shandy or Jacob's Room.

It makes no difference, again, whether the representation is individualized or generalized. A portrait aims at individualized representation; but Aristotle in the case of drama and Sir Joshua Reynolds in the case of painting have pointed out (quite correctly, in spite of Ruskin's disapproval) that there is such a thing as generalizing representation. The patron who buys a picture of a fox-hunt or a covey of partridges does not buy it because it represents that fox-hunt or that covey and not another; he buys it because it represents

a thing of that kind. And the painter who caters for that market is quite aware of this, and makes his covey or his fox-hunt a 'typical' one, that is, he represents what Aristotle called 'the universal'. Ruskin thought that generalizing representation could never produce good art; but it can; not because it is representation, nor because it is generalizing representation, but because it can be raised to the level of art proper through being handled by a real artist. Even Ruskin could see this where Turner was concerned. The prejudice which he expressed against generalizing representation was merely a typical piece of English nineteenth-century romanticism, attempting to dislodge the 'universal' out of art in order to dissociate art from the intellect, whose influence on art was supposed to make it frigid, unemotional, and therefore inartistic.

§ 3. *Plato and Aristotle on Representation*

Most modern writers on aesthetics attribute to Plato the syllogism 'imitation is bad; all art is imitative; therefore all art is bad', where imitation means what I am here calling representation. Hence, they go on, Plato 'banishes art from his city'. I will not document my assertion. There is no need to pillory a few offenders for a crime that is almost universal.[1]

This Platonic 'attack on art' is a myth whose vitality throws a lurid light on the scholarship of those who have invented and perpetuated it. The facts are (i) that 'Socrates' in Plato's *Republic* divides poetry into two kinds, one representative and the other not (392 D); (ii) that he regards certain kinds of representative poetry as amusing (ἡδύς) but for various reasons undesirable, and banishes these kinds only of representative poetry not merely from the schoolroom of his young guardians but from the entire city (398 A); (iii) that later in the dialogue he expresses satisfaction with his original division (595 A); (iv) reinforces his attack, this time

[1] I am involved in it myself; see an article on 'Plato's Philosophy of Art', in *Mind*, N.S. xxxiv, 154–72. It is especially an English error, and goes back at least to Jowett's translation of Plato (1872). Outside England it has infected Croce; I suspect, through Bosanquet's *History of Aesthetic*.

extended to the entire field of representative poetry, with new arguments (595 C–606 D); (v) and banishes all representative poetry, but retains certain specified kinds of poetry as not representative (607 A).

It is, of course, anachronistic to attribute to Plato the modern conception of 'art', or any views that involve this conception. He is writing not about art but about poetry, with painting brought in by the way for purposes of illustration. But this is not what I complain of. Substitute 'poetry' for 'art' in the first paragraph above, and the statements will still be altogether untrue.

The myth about Plato's banishing the artist (or poet) from his ideal city is derived from a misunderstanding of *Republic*, 398 A: 'We should reverence him as something holy and marvellous and delightful: we should tell him that there is not any one like him in our city—and that there is not allowed to be; and we should anoint him with myrrh and crown him with a diadem and send him away to another city, and for our own part continue to employ for our welfare's sake a drier and less amusing poet and story-teller, who should represent to us the discourse of a good man.' The misinterpreters of Plato assure us that the victim of this banishment is the poet as such. If they had read the sentence to the end as I have quoted it, they would have seen that he could not be that; he must be some one kind of poet; and if they had remembered what went before, they would realize what kind of poet he was: not even the representative poet as such, but the entertainer who (admittedly with marvellous skill and very amusingly) represents trivial or disgusting things: the kind of person who makes farm-yard noises and the like (396 B). At this stage of the argument (Book III) not only some kinds of poet, but even some kinds of representative poet, are explicitly retained in the city: namely, those who 'represent the discourse of a good man'.

In the tenth book Plato's position has changed. But it has not changed in the direction of regarding all poetry as representative. The change is that whereas in Book III some

representative poetry is banished because what it represents is trivial or evil, in Book X all representative poetry is banished because it is representative. This is clear from the first few lines of the book, where Socrates congratulates himself on having decided 'to banish all such poetry as is representative' (τὸ μηδαμῇ παραδέχεσθαι αὐτῆς ὅση μιμητική). It never entered Plato's head that any reader could think this implied the banishment of all poetry; for when (607 A) Socrates says 'the only kind of poetry we must admit is hymns to the gods and praises of good men', no character is made to protest: 'But was not *all* poetry to be excluded?'

Tragedy and comedy were kinds of poetry which Plato classified as representative. When he wrote Book III, it seems that he intended to admit into his republic a certain kind of drama, more or less Aeschylean, I suppose, in character. When he wrote Book X, his view had hardened. All drama must go, and he finds himself left with that kind of poetry whose chief representative is Pindar.

If any one will read the first half of Book X[1] with an un-prejudiced eye, he will see that Plato never tells his reader either that he wishes to attack all forms of poetry, or that he regards poetry in general as representative. He will see that, about fifty times over, Plato uses the verb μιμεῖσθαι, 'represent', or some cognate word with especial care so as never to let the reader forget that he is discussing representative poetry only, and not poetry in general.[2] He

[1] In Greek; for our translations are not to be trusted. For example, in a recent translation by a high authority, he will find the sentence οὐ μέντοι πω τό γε μέγιστον κατηγορήκαμεν αὐτῆς (605 C: 'we have not yet stated our chief accusation against it', i.e. against representation; for the whole context is about μίμησις, cf. the phrase τὸν μιμητικὸν ποιητήν 605 B, seven lines above), mistranslated 'we have not yet brought our chief count against poetry', as if αὐτῆς referred to some mention, in the context, of ποιητική in general.

[2] In a very few passages, it is true, Plato writes of 'poets' or 'poetry' without the express qualification 'representative', although the sense might seem to require it (e.g. 600 E 5, 601 A 4, 606 A 6, and especially 607 B 2, 6). In every case except one, the qualification is obviously implied in the context. The one exception (607 B 6), though a very interesting passage, is not one that affects the present discussion.

will see that the elaborate attack on Homer is directed against him not as the king of poets in general but against him as the king of tragedians (this is emphasized once at the beginning of the attack and again at the end: 598 D, τήν τε τραγῳδίαν καὶ τὸν ἡγεμόνα αὐτῆς Ὅμηρον: 607 Α, Ὅμηρον ποιητικώτατον εἶναι καὶ πρῶτον τῶν τραγῳδοποιῶν). He will see that a distinction is carefully made between the representative poet and the 'good' poet (598 Ε, τὸν ἀγαθὸν ποιητήν . . . εἰδότα ἄρα ποιεῖν, by contrast with μιμητής; the next sentence, explaining that what the ἀγαθὸς ποιητής does is to 'discourse', makes it clear that the good ποιητής who is contrasted with the 'representer' here means not a good craftsman or artisan but a good poet. In 605 D, again, it is said that when Homer or a tragedian causes us to bewail the misfortune of the hero he represents, we praise him 'as a good poet'; but this, Socrates goes on (605 Ε), is undeserved praise). Finally, he will see that at the end of the whole argument, when Socrates seems half to relent and promises to hear with sympathy whatever can be said in defence of the accused, the old distinction is still insisted upon: the accused is never poetry, but 'poetry for pleasure's sake, i.e. representation' (ἡ πρὸς ἡδονὴν ποιητικὴ καὶ ἡ μίμησις, 607 C; 'poetry of this kind' τῆς τοιαύτης ποιήσεως, 607 Ε).

I am not defending Plato or reading into him my own aesthetic doctrines. I think that in fact he was guilty of a serious confusion in identifying representative poetry with amusement poetry, whereas amusement art is only one kind of representative art, the other kind being magical art. What Plato wanted to do, as I shall explain in the fifth chapter, was to put the clock back and revert from the amusement art of the Greek decadence to the magical art of the archaic period and the fifth century. But by attacking representative poetry he was using the wrong means for effecting this result (if, indeed, it could have been effected at all). He did not apply the Socratic method with enough vigour; had he done so, he would have pulled himself up with the question, 'How can I discuss representative poetry

(τῆς ποιήσεως ὅση μιμητική) before I have made up my mind what poetry is in itself?'

This failure to raise the fundamental question no doubt partly explains why Plato's argument has been so widely and so completely misunderstood. But it does not explain the misunderstanding entirely, still less excuse it. The reason why modern readers have taken Plato's attack on representative amusement poetry (ἡ πρὸς ἡδονὴν ποιητικὴ καὶ ἡ μίμησις) for an attack on poetry as such is that their own minds are fogged by a theory—the current vulgar theory—identifying art as such with representation. Bringing this theory with them to Plato's text, they read it into that text in spite of all that Plato can do to prevent them.

As long as this current vulgar theory dominates the minds of classical scholars, it is no use expecting them to understand what it really is that Plato is saying. But that is no reason why a protest should not be made against what has become a crying scandal in the world of classical scholarship.

The reader will perhaps wish to ask, What of Aristotle? Did not he think of art as essentially representative?

He makes it clear at the beginning of the *Poetics* that he did not. He there accepts Plato's familiar distinction between representative and non-representative art; maintaining, for example, that some kinds of music are representative but not all. It is true that he does not altogether follow Plato as to where the line between them should be drawn. In the case of poetry he regards one kind (dithyramb) as representative which Plato had classified as non-representative, and one (epic) as wholly representative which Plato had classified as representative only in part. But he agrees with Plato that drama is representative; that the function of representative art is to arouse emotion; and that therefore drama is essentially a means of arousing emotion. In the case of tragedy, this emotion is a combination of pity and fear. He further agreed with Plato in thinking that the emotions aroused in the mind of a spectator by a dramatic performance are emotions of a kind which (at any rate in the violent degree to

which they are aroused in the theatre) impede the due per-
formance of everyday activities. He nevertheless deliber-
ately took upon himself the task which Socrates had left, in
Republic 607 D, to 'her champions, men who are not poets but
lovers of poetry—the task of speaking on her behalf in prose
and arguing that she is not only pleasant but wholesome for
a city and for the life of man'. 'She' here, as the context
shows, is not poetry but 'poetry for pleasure's sake, that is,
representation' (607 c). Aristotle is claiming the place of
such a champion, and the *Poetics* (or rather, that small part of
it which is something more than a set of hints to amateur
playwrights) is offered as the prose speech Socrates asked for.

The *Poetics* is therefore in no sense a Defence of Poetry;
it is a Defence of Poetry for Pleasure's Sake, or Representa-
tive Poetry. The method is a simple and familiar one. The
defence admits all the facts alleged by the prosecution, but
turns them to the accused's credit. This is effected by
carrying the psychological analysis of the effect of amuse-
ment art on its audience one stage further, beyond the point
where Plato had left it. Tragedy generates in the audience
emotions of pity and fear. A mind heavily charged with
these emotions is thereby unfitted for practical life. So far
Aristotle and Plato are in agreement. Plato proceeds at once
to his conclusion: therefore tragedy is detrimental to the
practical life of its audience. (The reader will remember
that the argument was never intended to concern itself with
tragedy in its religious or magical form, to which it would be
wholly irrelevant, still less with tragedy as a form of art
proper: but only with tragedy as a form of amusement.)
Aristotle inserts one further step in the analysis. The
emotions generated by tragedy, he observes, are not in fact
allowed to remain burdening the mind of the audience.
They are discharged in the experience of watching the
tragedy. This emotional defecation or 'purging' (κάθαρσις)
leaves the audience's mind, after the tragedy is over, not
loaded with pity and fear but lightened of them. The effect
is thus the opposite of what Plato had supposed.

Aristotle's analysis is perfectly correct and highly important, though (of course) not as a contribution to the theory of art, but as a contribution to the theory of amusement. But whether he has answered Plato's real objections to amusement art is another question altogether. Plato's discussion of amusement art is only an incident in the *Republic* as a whole. The *Republic* deals with a vast variety of subjects; but it is not an encyclopaedia or a *summa*; it is concentrated upon a single problem, and the various subjects it deals with are brought in and discussed only so far as they illuminate that problem. The problem is the decadence of the Greek world: its symptoms, its causes, and its possible remedies. Among its symptoms, as Plato rightly contended, was the supersession of the old magico-religious art by a new amusement art. Plato's discussion of poetry is rooted in a lively sense of realities: he knows the difference between the old art and the new—the kind of difference that there is between the Olympia pediments and Praxiteles—and he is trying to analyse it. His analysis is imperfect. He thinks that the new art of the decadence is the art of an over-excited, over-emotionalized world; but it is really the exact opposite. It is really the 'art' of an emotionally defecated world, a world whose inhabitants feel it flat and stale. The art, in fact, of a Waste Land. Aristotle, with another generation's experience of the fourth century to instruct him, corrects Plato on the facts. But he has lost Plato's sense of their significance. He no longer feels the contrast between the greatness of the fifth century and the decadence of the fourth. Plato, on the threshold of Greece's decay, looks forward prophetically into the gloom and throws all the energies of his heroic mind into the task of averting it. Aristotle, a native of the new Hellenistic world, sees no gloom. But it is there.

§ 4. *Literal and Emotional Representation*

Let us look back at the case of a portrait, from which we started. What is the patron demanding, and what is the painter supplying, under the name of a 'good likeness'? It

is generally supposed that to speak of a painting as like the original means that the painting, as a pattern of colours, resembles the pattern of colours that appears to a person looking at the original. But this is not at all what is meant.

The true definition of representative art is not that the artifact resembles an original (in which case I call the representation literal), but that the feeling evoked by the artifact resembles the feeling evoked by the original (I call this emotional representation). When a portrait is said to be like the sitter, what is meant is that the spectator, when he looks at the portrait, 'feels as if' he were in the sitter's presence. This is what the representative artist as such is aiming at. He knows how he wants to make his audience feel, and he constructs his artifact in such a way that it will make them feel like that. Up to a point, this is done by representing the object literally; but beyond that point it is done by skilful departure from literal representation. The skill in question, like any other form of skill, is a matter of devising means to a given end, and is acquired empirically, by observing how certain artifacts affect certain audiences, and thus through experience (which may in part be other people's experience communicated by instruction) becoming able to produce in one's audience the kind of effect one wants to produce.

It is, therefore, not a mark of incompetence in the representative artist that his works are not literally exact copies of their originals. Had that been so, the camera would have beaten the portrait-painter on his own ground; whereas the reverse is the case; photographic portraits are always more or less 'faked' on principles borrowed from the portrait-painter. For the portrait-painter does not want to produce a literal likeness.[1] He deliberately leaves out some things that he sees, modifies others, and introduces some which he

[1] This point has been well put by Van Gogh. 'Dis à Serret *que je serais désespéré si mes figures étaient bonnes,* dis-lui que je ne les *veux* pas académiquement correctes, dis-lui que je veux dire que si on photographiait un homme qui bêche, *il ne bêcherait certainement pas.* Dis-lui que je trouve les figures de Michel-Ange admirables, quoique les jambes soient décidément trop longues, les hanches et les cuisses trop larges . . . les vrais peintres . . . ne peignent pas

does not see in his sitter at all. And all this is done systema-
tically and skilfully, so as to produce something that the
patron will think 'like' the original. People and things look
different to us according to the emotion we feel in looking
at them. A wild animal of which we are afraid looks larger
than it would if we were not afraid of it; its teeth and claws
are especially magnified. A mountain on which we imagine
ourselves climbing looks exaggeratedly steep and rugged.
A person of whom we stand in awe seems to have large and
piercing eyes. Photographs or literally accurate drawings
of these things will be emotionally unlike them; and a tactful
painter will put in the appropriate exaggerations and so
produce an emotionally correct likeness; correct, that is, for
the particular audience he has in mind.

Representation in art is thus not the same thing as
naturalism. Naturalism is not even identical with literal
representation as such, but only with the literal representa-
tion of that common-sense world of things as they appear to
a normal and healthy eye which we call nature. Breughel's
pictures of animal-demons, Strindberg's *Spook Sonata*, Poe's
thrillers, Beardsley's fantastic drawings, surrealist paintings,
are strictly and literally representational; but the world they
represent is not the common-sense world, it is the world of
delirium, an abnormal or even insane world permanently
inhabited, no doubt, only by the insane, but visited on occa-
sion by all of us.

Roughly speaking, we may distinguish three degrees of
representation. First, a naïve or almost non-selective repre-
sentation, which attempts (or seems to attempt) the im-
possible task of complete literalness. We find examples in
palaeolithic animal-painting or Egyptian portrait-sculpture;
though it is well to remember that these things are a great
deal more sophisticated than we are apt to suppose. Secondly,
it is found that the same emotional effect can be produced,
perhaps even more successfully, by bold selection of im-

les choses telles qu'elles sont, . . . mais comme eux . . . les sentent.' *Lettres*,
ed. Philippart (1937), p. 128.

portant or characteristic features and suppression of all else. What is meant by calling these features important or characteristic is simply that they are found capable by themselves of evoking the emotional response. For example: suppose an artist wanted to reproduce the emotional effect of a ritual dance in which the dancers trace a pattern on the ground. The modern traveller would photograph the dancers as they stand at a given moment. A conventional modern artist, with a mind debauched by naturalism, would draw them in the same kind of way. This would be a silly thing to do, because the emotional effect of the dance depends not on any instantaneous posture but on the traced pattern. The sensible thing would be to leave out the dancers altogether, and draw the pattern by itself.

This is certainly the explanation of much 'primitive' art which at first sight appears altogether non-representative: spirals, mazes, plaits and so forth. I think that, for example, it may possibly be the explanation of the strange curvilinear designs which are so characteristic of pre-Christian Celtic art in the La Tène period. These patterns produce a powerful and very peculiar emotional effect, which I can best describe as a mixture of voluptuousness and terror. This effect is certainly not accidental. The Celtic artists knew what they were doing; and I imagine that they produced this emotional reaction for religious or magical reasons. I conjecture that the state of mind may originally have been evoked by the dance-patterns of their religious ceremonies, and that the patterns we possess may be representations of these.

An artifact representing its original in this second degree is sometimes, by psycho-analysts and others, called a 'symbol' of the original. The word is a misleading one. It suggests a difference in kind between a symbol and a copy or transcript, whereas the difference between the two things is one of degree; and it suggests that the choice of a symbol is effected by some kind of agreement or compact in which certain persons agree to use the thing so called for certain purposes; for that is what the word 'symbol' means. Nothing

of that sort takes place here. What does take place is a selective literal representation, empirically found to be an effective means of emotional representation.

People sometimes talk as if 'selection' were an essential part of every artist's work. This is a mistake. In art proper there is no such thing; the artist draws what he sees, expresses what he feels, makes a clean breast of his experience, concealing nothing and altering nothing. What these people are discussing, when they talk about selection, is not the theory of art proper but the theory of representative art of the second degree, which they mistake for art proper.

The third degree abandons literal representation altogether; but the work is still representative, because it aims, this time with a single eye, at emotional representation. Thus music, in order to be representative, need not copy the noises made by bleating sheep, an express locomotive at speed, or a rattle in the throat of a dying man. The pianoforte accompaniment of Brahms's song *Feldeinsamkeit* does not make noises in the least degree resembling those heard by a man lying in deep grass on a summer's day and watching the clouds drift across the sky; but it does make noises which evoke a feeling remarkably like that which a man feels on such an occasion. The erotic music of a modern dance-band may or may not consist of noises like those made by persons in a state of sexual excitement, but it does most powerfully evoke feelings like those proper to such a state. If any reader is offended at my suggesting an identity in principle between Brahms and jazz, I am sorry the suggestion offends him, but I make it deliberately.

ART AS MAGIC

§ 1. *What magic is not:* (i) *pseudo-science*

REPRESENTATION, we have seen, is always means to an end. The end is the re-evocation of certain emotions. According as these are evoked for their practical value or for their own sake, it is called magic or amusement.

My use of the term 'magic' in this connexion is certain to cause difficulty; but I cannot avoid it, for reasons which I hope will become clear. I must therefore see to it that the difficulty does not amount to misunderstanding, at any rate in the case of readers who wish to understand.

The word 'magic' as a rule carries no definite significance at all. It is used to denote certain practices current in 'savage' societies, and recognizable here and there in the less 'civilized' and less 'educated' strata of our own society, but it is used without any definite conception of what it connotes; and therefore, if some one asserts that, for example, the ceremonies of our own church are magical, neither he nor any one else can say what the assertion means, except that it is evidently intended to be abusive; it cannot be described as true or false. What I am here trying to do is to rescue the word 'magic' from this condition in which it is a meaningless term of abuse, and use it as a term with a definite meaning.

Its degradation into a term of abuse was the work of a school of anthropologists whose prestige has been deservedly great. Two generations ago, anthropologists set themselves the task of scientifically studying the civilizations different from our own which had been lumped together under the unintelligently depreciatory (or, at times, unintelligently laudatory) name of savage. Prominent among the customs of these civilizations they found practices of the kind which by common consent were called magical. As scientific

students, it was their business to discover the motive of these practices. What, they asked themselves, is magic for?

The direction in which they looked for an answer to this question was determined by the prevailing influence of a positivistic philosophy which ignored man's emotional nature and reduced everything in human experience to terms of intellect, and further ignored every kind of intellectual activity except those which, according to the same philosophy, went to the making of natural science. This prejudice led them to compare the magical practices of the 'savage' (civilized men, they rashly assumed, had none, except for certain anomalous things which these anthropologists called survivals) with the practices of civilized man when he uses his scientific knowledge in order to control nature. The magician and the scientist, they concluded, belong to the same genus. Each is a person who attempts to control nature by the practical application of scientific knowledge. The difference is that the scientist actually possesses scientific knowledge, and consequently his attempts to control nature are successful: the magician possesses none, and therefore his attempts fail. For example, irrigating crops really makes them grow; but the savage, not knowing this, dances at them in the false belief that his example will encourage in the crops a spirit of emulation, and induce them to grow as high as he jumps. Thus, they concluded, magic is at bottom simply a special kind of error: it is erroneous natural science. And magical practices are pseudo-scientific practices based on this error.[1]

This theory of magic as pseudo-science is an extraordinarily confused piece of thinking. It would not be worth our while here to disentangle with anything like completeness the tissue of blunders and prejudices on which it rests; I shall content myself with two criticisms.

[1] This theory was propounded by Sir Edward Tylor in 1871 (*Primitive Culture*, ch. iv). The fact that it is still taught in our own time by Sir James Frazer (*The Golden Bough*, passim.) has been a disaster to contemporary anthropology and all the studies connected with it.

1. It was excusable in Locke to classify savages with idiots as a kind of persons incapable of logical thinking, for Locke and his contemporaries knew practically nothing about them. But it was very far from excusable in nineteenth-century anthropologists, who knew that the peoples they called savage, even apart from the intellectual power exhibited by their habit of devising extremely complex political, legal, and linguistic systems, understood enough of the connexions between causes and effects in nature to perform delicate operations in metallurgy, agriculture, stock-breeding, and so forth. A man who can grasp the relation of causes and effects sufficiently to make a hoe out of crude iron ore is not the scientific imbecile that Tylor's theory, and the grotesque elaborations it has received at the hands of French psychologists, would lead us to believe.

2. Even if he were, the theory does not fit the facts it was devised to explain. Here is one of them. A 'savage', in order to prevent his nail-clippings from falling into the hands of an enemy, destroys them with meticulous care. When the anthropologist asks him why, he explains that his purpose is to prevent the enemy from using them as a magical weapon against himself; for if they were maliciously destroyed with the proper ceremonies, the destruction would spread to the body from which they had been cut. The anthropologist, anxious to see why his informant entertains a belief so obviously groundless (for a simple experiment, he is convinced, would have shown its falsity), thinks out a hypothesis to explain it; and the hypothesis at which he arrives is that the 'savage' believes in a 'sympathetic' connexion between the nail-clippings and the body from which they have been severed, such that their destruction automatically injures that body.

This second belief is equally groundless, and therefore itself stands in need of explanation. The English anthropologists, good honest men, did not observe this; but their more logical French colleagues did, and proceeded to elaborate an entire theory of 'primitive mentality', showing that the 'savage' has a quite peculiar type of mind, not at all

like ours; it does not argue logically like a Frenchman's, it does not acquire knowledge through experience like an Englishman's, it thinks (if you can call it thinking) by the methodical development of what, from our point of view, is a kind of lunacy.

This extraordinary fabric of theory, whose influence on anthropological science has been hardly more malign than its influence on the practical relations between Europeans and the peoples whom they please to call savage, is based on a simple blunder. The fact which it would serve to explain if it were true is not the observed fact. The observed fact is that the 'savage' destroys his own nail-clippings. The theory is that he believes in a 'mystical' connexion (to use the French adjective) between these nail-clippings and his own body, such that their destruction is injurious to himself. But, if he believed this, he would regard his own destruction of his nail-clippings as suicide. He does not so regard it; therefore he does not believe in the alleged 'mystical' connexion, and the grounds on which he has been credited with a 'primitive mentality' disappear.

Simple though it is, the blunder is not innocent. It masks a half-conscious conspiracy to bring into ridicule and contempt civilizations different from our own; and, in particular, civilizations in which magic is openly recognized. Anthropologists would of course indignantly deny this; but under cross-examination their denials would break down. The fact from which we started was that a 'savage' destroys his nail-clippings to prevent an enemy from destroying them with certain magical ceremonies. The anthropologist next says to himself: 'My informant tells me he is afraid of some one's doing two things simultaneously: destroying these nail-clippings, and performing certain ceremonies. Now, he must know as well as I do that the ceremonies are mere hocus-pocus. There is nothing to be afraid of there. Consequently he must be afraid of the destruction of the nail-clippings.' Some such work as this must have been going on in the anthropologist's mind; for if it had not, he would

not have based his theory on a pseudo-fact (fear of the destruction of nail-clippings as such) instead of basing it on the genuine fact which he had correctly observed (fear of that destruction when, and only when, accompanied by magical ceremonies). The motive power behind this substitution is the anthropologist's conviction that the ceremonies which would accompany the destruction of the nail-clippings are 'mere hocus-pocus' and could not possibly hurt any one. But these ceremonies are the one and only magical part of the whole business. The alleged theory of magic has been constructed by manipulating the facts so that all magical elements are left out of them. In other words, the theory is a thinly disguised refusal to study magic at all.

Anthropologists of the present day have very little use for the Tylor–Frazer theory, or for Lévy-Bruhl's psychological embroidery of it. They are far more intimately acquainted with the facts of 'savage' life than the men who invented and elaborated that theory; far more intimately, indeed, than the best-informed of the field-workers on whom these theorists depended for their data. In consequence they know too much about magical practices to believe that they can be explained on positivistic principles as symptoms of disorder in the machine of inductive thinking. But this movement of expert opinion away from the Tylor–Frazer theory has been almost[1] silent; and one result of it has been, strangely, to confirm that theory in the mind of the general public. For the increasing vigour of recent anthropological work has created a demand outside expert circles for anthropological literature; and this has been satisfied by finding in *The Golden Bough* an inexhaustible scrap-heap of good reading. The public, mistaking it for a monument of massive thought, is beginning to adopt the pseudo-science theory of magic, just when anthropologists are beginning to forget it.

[1] Not altogether. Cf. e.g. Malinowski's Durham lectures (1936) on *The Foundations of Faith and Morals*, p. 5: 'The conception, for instance, of primitive magic as a "false scientific technique" does not do justice to its cultural value.'

§ 2. *What Magic is not:* (ii) *Neurosis*

Not so much an alternative to the Tylor–Frazer theory of magic, but rather a specialized development of it, has been put forward by Freud, in the third chapter of *Totem and Taboo* (Eng. tr. by Brill, 1919). Lévy-Bruhl had already tackled the problem of explaining why the 'savage's' mind should work in so extraordinary a way, and from our point of view so irrational a way, as is implied by the Tylor–Frazer theory. He explained it by saying that savages have a peculiar kind of mind which does work that way (*La Mentalité primitive*, ed. 1, 1913; this original edition bore the title *Les Fonctions mentales dans les sociétés inférieures*). The argument of this book is a very curious piece of 'metaphysics' in the Comtian sense: that is, the attempt to explain facts by inventing occult entities. The nature of a person's 'mentality' is in itself completely unknowable: it is only knowable in its manifestations, the ways in which he thinks and acts. It is no use, therefore, trying to explain his thinking and acting in an odd way by the hypothesis that he has an odd kind of 'mentality'; for this hypothesis is unverifiable. Lévy-Bruhl has in fact given us a perfect up-to-date example of the method by which, according to Molière, medical students in seventeenth-century Montpellier were taught to reason.

[*Candidate*] Mihi domandatur a docto doctore
Causam et rationem quare
Opium facit dormire.
A quoi respondeo:
Quia est in eo
Vertus dormitiva,
Cuius est natura
Sensus assoupire.

[*Chorus of examiners*] Bene bene bene bene respondere.
Dignus dignus est entrare
In nostro docto corpōre.

Freud, on the contrary, is nothing if not scientific. He realizes that the scientist's business is to connect facts not

with occult entities, but with other facts. Asking himself
the same question as Lévy-Bruhl, 'Why should savages think
in so odd a way?', he answers it by bringing the supposed
facts of magic into relation with those of compulsion-
neurosis as studied by himself in his own patients. A child,
he points out, satisfies its wishes by means of sensory halluci-
nations; that is, it creates satisfying sensations by the centri-
fugal excitement of its sensory organs. The savage does
something not identical with this, but similar to it. He
satisfies his wishes by performing an act representing the
state of things for which he wishes; in other words, by
creating motor hallucinations (op. cit., p. 140). To illustrate,
Freud quotes a patient of his own, a compulsion-neurotic,
who believed that if he thought of a man, the man was
thereby transported to the place; if he cursed a man, the
man died; and so on. This, he observes, amounts to believing
in the omnipotence of one's thought: to believing that what-
ever one thinks takes place simply because one thinks it.
This curious psychological condition, Freud suggests, is the
condition which underlies magical practices.

This will not do at all. It might serve to explain magic if
magic were something totally different from what it is; but
it has no bearing on the actual facts. For magic consists
essentially in a system of practices, a technique. No magician
believes that he can get what he wants by merely wanting it,
or that things come about because he thinks of them as
happening. On the contrary: it is because he knows that
there is no immediate connexion of this kind between wish
and fulfilment (and is therefore unlike Freud's patient pre-
cisely in the point wherein Freud compares them) that he
invents or adopts this technique as a middle term to connect
the two things.

Later, Freud seems to be dimly aware of this, and to
realize that a theory of magic which leaves out all reference
to magical practices is not very satisfactory. So he brings
them in by saying that compulsion-neurotics, because they
are alarmed by their own omnipotence, protect themselves

against it by devising formulae and rituals whose function is to prevent their thoughts and wishes from coming true (p. 146). These, he says, are the 'counterpart' of the magician's ritual actions. But the two cases no more resemble one another than a lightning-conductor resembles a dynamo. The compulsion-neurotic, being rather cracked, thinks that his wishes immediately fulfil themselves. Having method in his madness, he proceeds to invent means of breaking this immediate connexion, and earthing the power of his thought harmlessly. The 'savage', being a sensible man, knows that wishes do not immediately fulfil themselves. He therefore invents means by which to fulfil them.

The problem for any theory of magic is: What kind of wishes must these be, for actions of the kind we call magical to serve as means towards their fulfilment? Freud has not even touched that problem. He has simply burked it by failing to keep his mind on the peculiarities actually to be found in magical activity, and by instituting a comparison between the psychology of magic and the wholly different psychology of compulsion-ritual. The question which arises (I shall not pursue it here) is: What force is at work in the scientific consciousness of modern Europeans which makes it so hard for them to think straight about magic? Why should hard-headed Englishmen and Scotsmen like Tylor and Frazer, when they come to tackle it, blind themselves to the very facts they are trying to explain? Why should an acute and philosophical Frenchman like Lévy-Bruhl, when he starts theorizing about it, talk like one of Molière's prize idiots? Why should Freud, the greatest psychologist of our age, react to it by losing all his power of distinguishing one kind of psychological function from its opposite? Are we so civilized that savagery is too remote from us to be comprehensible? Or are we so terrified of magic that we simply dare not think straight about it?

The second alternative is at least a possibility. And I mention it because it is a possibility against which we must be on our guard. If we, as 'civilized' people, are really

terrified of magic, this terror will be a thing we shall not care to avow. It will show itself partly (this is the only part that immediately concerns myself and the reader) in the shape of a very strong disinclination to think about the subject in a cool and logical manner. It will therefore put every possible obstacle in the way of our accepting a true theory of magic, if one is offered us. With this warning, I will try to state such a theory.

§ 3. *What Magic Is*

The only profitable way of theorizing about magic is to approach it from the side of art. The similarities between magic and applied science, on which the Tylor–Frazer theory rests, are very slight, and the dissimilarities are great. The magician as such is not a scientist; and if we admit this, and call him a bad scientist, we are merely finding a term of abuse for the characteristics that differentiate him from a scientist, without troubling to analyse those characteristics. The similarities between magic and neurosis, on which the Freudian theory rests, are just as strong or as weak as one pleases; for neurosis is a negative term, covering many different kinds of departure from our rough-and-ready standard of mental health; and there is no reason why one item in the list of qualifications demanded by a standard of mental health should not be a disbelief in magic. But the similarities between magic and art are both strong and intimate. Magical practices invariably contain, not as peripheral elements but as central elements, artistic activities like dances, songs, drawing, or modelling. Moreover, these elements have a function which in two ways resembles the function of amusement. (i) They are means to a preconceived end, and are therefore not art proper but craft. (ii) This end is the arousing of emotion.

(i) That magic is essentially means to a preconceived end is, I think, obvious; and equally obvious that what is thus used as means is always something artistic, or rather (since, being used as means to an end, it cannot be art proper) quasi-artistic.

(ii) That the end of magic is always and solely the arousing of certain emotions is less obvious; but every one will admit that this is at least sometimes and partially its end. The use of the bull-roarer in Australian initiation-ceremonies is intended, partly at least, to arouse certain emotions in the candidates for initiation and certain others in uninitiated persons who may happen to overhear it. A tribe which dances a war-dance before going to fight its neighbours is working up its warlike emotions. The warriors are dancing themselves into a conviction of their own invincibility. The various and complicated magic which surrounds and accompanies the agriculture of a peasant society expresses that society's emotions towards its flocks and herds, its crops, and the instruments of its labour; or rather, evokes in its members at each critical point in the calendar that emotion, from among all these, which is appropriate to the corresponding phase of its annual work.

But although magic arouses emotion, it does this in quite another way than amusement. Emotions aroused by magical acts are not discharged by those acts. It is important for the practical life of the people concerned that this should not happen; and magical practices are magical precisely because they have been so designed that it shall not happen. The contrary is what happens: these emotions are focused and crystallized, consolidated into effective agents in practical life. The process is the exact opposite of a catharsis. There, the emotion is discharged so that it shall not interfere with practical life; here it is canalized and directed upon practical life.

I am suggesting that these emotional effects, partly on the performers themselves, partly on others favourably or unfavourably affected by the performance, are the only effects which magic can produce, and the only ones which, when intelligently performed, it is meant to produce. The primary function of all magical acts, I am suggesting, is to generate in the agent or agents certain emotions that are considered necessary or useful for the work of living; their

secondary function is to generate in others, friends or enemies of the agent, emotions useful or detrimental to the lives of these others.

To any one with sufficient psychological knowledge to understand the effect which our emotions have on the success or failure of our enterprises, and in the production or cure of diseases, it will be clear that this theory of magic amply accounts for its ordinary everyday employment in connexion with the ordinary everyday activities of the people who believe in it. Such a person thinks, for example, that a war undertaken without the proper dances would end in defeat; or that if he took his axe to the forest without doing the proper magic first, he would not succeed in cutting down a tree. But this belief does not imply that the enemy is defeated or the tree felled by the power of the magic as distinct from the labour of the 'savage'. It means that, in warfare or woodcraft, nothing can be done without morale; and the function of magic is to develop and conserve morale; or to damage it. For example, if an enemy spied upon our war-dance and saw how magnificently we did it, might he not slink away and beg his friends to submit without a battle? Where the purpose of magic is to screw our courage up to the point of attacking, not a rock or a tree, but a human enemy, the enemy's will to encounter us may be fatally weakened by the magic alone. How far this negative emotional effect might produce diseases of various kinds or even death is a question about which no student of medical psychology will wish to dogmatize.

One step beyond this type of case brings us to cases in which 'savages' believe, or seem to believe, that magic can do things which we 'civilized' men believe to be impossible, like making rain or stopping earthquakes. I am quite prepared to think that they do entertain such beliefs; savages are no more exempt from human folly than civilized men, and are no doubt equally liable to the error of thinking that they, or the persons they regard as their superiors, can do what in fact cannot be done. But this error is not the essence of magic;

it is a perversion of magic. And we should be careful how we attribute it to the people we call savages, who will one day rise up and testify against us. A peasant whose crops fail because he has mismanaged them through idleness generally blames the weather. If magical practices cured his idleness, there would be nothing to blame the weather for. It is a serious question whether the real function of rain-making magic, so called, may not be to cheer up the cultivator and induce him to work harder, rain or no rain. Similarly, magic which is described as intended to stop earthquakes or floods or the like should be carefully examined in order to decide whether its true purpose is to avert these natural calamities, or to produce in men an emotional state of willingness to bear them with fortitude and hope. If the second answer proves right, these things too fall into line with the theory of magic I am here maintaining; if the first, they will have to be called not magic but perversions of magic.

If we ask how magic produces these emotional effects, the answer is easy. It is done by representation. A situation is created (the warriors brandish their spears, the peasant gets out his plough, and so forth, when no battle is being fought and no seed is being sown) representing the practical situation upon which emotion is to be directed. It is essential to the magical efficacy of the act that the agent shall be conscious of this relation, and shall recognize what he is doing as a war-dance, a plough-ritual, or the like. This is why, on first approaching the ritual, he must have it explained to him, either by word of mouth (which may take the form of initiatory instruction, or of an explanatory speech or song forming part of the ritual itself) or by such close mimicry that mistake is impossible.

Magic is a representation where the emotion evoked is an emotion valued on account of its function in practical life, evoked in order that it may discharge that function, and fed by the generative or focusing magical activity into the practical life that needs it. Magical activity is a kind of

dynamo supplying the mechanism of practical life with the emotional current that drives it. Hence magic is a necessity for every sort and condition of man, and is actually found in every healthy society. A society which thinks, as our own thinks, that it has outlived the need of magic, is either mistaken in that opinion, or else it is a dying society, perishing for lack of interest in its own maintenance.

§ 4. *Magical Art*

A magical art is an art which is representative and therefore evocative of emotion, and evokes of set purpose some emotions rather than others in order to discharge them into the affairs of practical life. Such an art may be good or bad when judged by aesthetic standards, but that kind of goodness or badness has little, if any, connexion with its efficacy in its own proper work. The brilliant naturalism of the admittedly magical palaeolithic animal paintings cannot be explained by their magical function. Any kind of scrawl or smudge would have served the purpose, if the neophyte on approaching it had been solemnly told that it 'was' a bison. When magical art reaches a high aesthetic level, this is because the society to which it belongs (not the artists alone, but artists and audience alike) demands of it an aesthetic excellence quite other than the very modest degree of competence which would enable it to fulfil its magical function. Such an art has a double motive. It remains at a high level only so long as the two motives are felt as absolutely coincident. As soon as a sculptor thinks to himself 'surely it is a waste of labour to finish this portrait with such care, when it is going to be shut up in a tomb as soon as it leaves my hand', the two motives have come apart in his mind. He has conceived the idea that something short of his best work, in the aesthetic sense of that phrase, would satisfy the needs of magic; and decadence at once begins. Indeed, it has begun already; for ideas of that kind only come up into consciousness long after they have begun to influence conduct.

The change of spirit which divides Renaissance and modern art from that of the Middle Ages consists in the fact that medieval art was frankly and definitely magical, while Renaissance and modern art was not. I say 'was' not, because the climax of this non-magical or anti-magical period in the history of art was reached in the late nineteenth century, and the tide is now visibly turning. But there were always eddies in the tide-stream. There were cross-currents even in the nineties, when English literary circles were dominated by a school of so-called aesthetes professing the doctrine that art must not subserve any utilitarian end but must be practised for its own sake alone. This cry of art for art's sake was in some ways ambiguous; it did not, for example, distinguish art proper from amusement, and the art which its partisans admired and practised was in fact a shameless amusement art, amusing a select and self-appointed clique; but in one way it was perfectly definite: it ruled out magical art altogether. Into the perfumed and stuffy atmosphere of this china-shop burst Rudyard Kipling, young, nervous, short-sighted, and all on fire with the notion of using his very able pen to evoke and canalize the emotions which in his Indian life he had found to be associated with the governing of the British Empire. The aesthetes were horrified, not because they disapproved of imperialism, but because they disapproved of magical art; Kipling had blundered right up against their most cherished taboo. What was worse, he made a huge success of it. Thousands of people who knew those emotions as the steam in the engine of their daily work took him to their hearts. But Kipling was a morbidly sensitive little man, and the rebuff he had met with from the aesthetes blasted the early summer of his life. Henceforth he was torn between two ideals, and could pursue neither with undivided allegiance.

To-day the boot is on the other leg. It is Kipling, and not Wilde, whose principles are in favour. Most of our leading young writers have reverted to magical art; and this reversion is by far the most conspicuous fact in English art

to-day. To the aesthetician it is unimportant that this new
magical literature is the propaganda no longer of imperialism
but of communism. It is unimportant to him (though very
important to the politician) that, of the two warring creeds
which are dividing the inheritance of nineteenth-century
liberalism, communism appears to have tongue, eyes, and
fingers, and fascism only teeth and claws. What is important
to the aesthetician is the re-emergence of a very old kind of
aesthetic consciousness: one which reverses the painfully
taught lesson of nineteenth-century criticism, and instead of
saying 'never mind about the subject; the subject is only a
corpus vile on which the artist has exercised his powers, and
what concerns you is the artist's powers and the way in
which he has here displayed them', says 'the artist's powers
can be displayed only when he uses them upon a subject
that is worthy of them'. This new aesthetic consciousness
involves a two-eyed stance. It regards the subject as an
integral element in the work of art; it holds that, in order to
appreciate any given work of art, one must be interested in its
subject for its own sake, as well as in the artist's handling of it.

To the aesthetician trained in a nineteenth-century school,
these are words of horror. To take them seriously would
mean looking forward to an age of artistic decadence and
barbarism: an age when the infinitely difficult quest of
artistic perfection will be shelved in favour of an easy pro-
paganda; when artists will be judged not on their artistic
merits but on their conformity with the political and moral
and economic dogmas accepted by the society to which they
belong; when the hard-won freedom of modern art will be
thrown away, and obscurantism will reign supreme.

I will not pursue this question further. In another place
we shall have to consider it seriously. For the present, we
will simply register the facts that a recrudescence of magical
art is going on before our eyes, and that aesthetic theorists
and critics are in two minds how to take it.

I spoke of a recrudescence. But it appears as a recrudes-
cence only if we take a very snobbish or high-brow view of

what constitutes art. The self-elected circle of artists and *littérateurs* have no monopoly of artistic production. Outside that circle we have had two vigorous streams at least of artistic tradition since the Renaissance; and in each case the magical quality of the art is unmistakable.

First, there is the native art of the poor: in particular, that rustic or peasant art which goes by the patronizing name of folk-art. This folk-art, consisting of songs and dances and stories and dramas which in this country (with its tradition of a patronizing contempt for the poor) were allowed to perish almost completely[1] before 'educated' persons had become aware of their existence, was largely magical in its origin and motive. It was the magical art of an agricultural people.

Secondly, there are the traditional low-brow arts of the upper classes. Of these (since their nature is very often misunderstood) it will be necessary to speak in greater detail. I refer to such things as the prose of the pulpit, the verse of hymns, the instrumental music of the military band and the dance band, the decoration of drawing-rooms, and so forth. I can see the high-brow reader pulling a face and hear him cry 'This, God help us, is not art at all'. I know; but it is magic; and now that the relation between art and magic is becoming an important problem once more, no longer to be dismissed with a facile negation, it concerns the aesthetician to find that magic has been flourishing, unrecognized but omnipresent, among the leaders (as they think themselves) of a society whose claim to enlightenment is based on its belief that it has given magic up altogether.

The case of religious art *eo nomine*, with its hymns and ceremonies and ritual acts, hardly needs analysis. Obviously its function is to evoke, and constantly re-evoke, certain emotions whose discharge is to be effected in the activities of everyday life. In calling it magical I am not denying its claim to the title religious. Now that we have given up using the word 'magic' as a term of abuse, and have decided what

[1] By 1893, 140 'fairy tales' had been collected in England; few others have been found since. In 1870–90, France and Italy yielded over 1,000 each.

it means, no one need fasten it upon things because he dislikes them, or hesitate to use it for things which he respects. Magic and religion are not the same thing, for magic is the evocation of emotions that are needed for the work of practical life, and a religion is a creed, or system of beliefs about the world, which is also a scale of values or system of conduct. But every religion has its magic, and what is commonly called 'practising' a religion is practising its magic.

Equally obvious, or hardly less so, is the case of patriotic art, whether the patriotism be national or civic or attached to a party or class or any other corporate body: the patriotic poem, the school song, the portraits of worthies or statues of statesmen, the war-memorial, the pictures or plays recalling historic events, military music, and all the innumerable forms of pageantry, procession, and ceremonial whose purpose is to stimulate loyalty towards country or city or party or class or family or any other social or political unit. All these are magical in so far as they are meant to arouse emotions not discharged there and then, in the experience that evokes them, but canalized into the activities of everyday life and modifying those activities in the interest of the social or political unit concerned.

Another group of examples may be found in the rituals which we commonly call sport. Fox-hunting and amateur football are primarily not amusements, practised for the sake of harmless entertainment; not means of physical training, intended to develop bodily strength and skill; they are ritual activities, undertaken as social duties and surrounded by all the well-known marks and trappings of magic: the ritual costume, the ritual vocabulary, the ritual instruments, and above all the sense of electedness, or superiority over the common herd, which always distinguishes the initiate and the hierophant. And in saying this I am not saying anything new. The ordinary man[1] has already reflected sufficiently on these things to have formed a just appreciation of their

[1] And the anthropologist is quite familiar with my point. Cf. A. M. Hocart, *The Progress of Man* (1933).

purpose. He regards them as methods of what he calls 'training character', whose function is to fit their devotees for the work of living, and in particular for the work of living in that station to which it has pleased God to call them. These sports, we are told, inculcate a team-spirit, a sense of fair play, a habit of riding straight and taking one's fences like a man. In other words, they generate certain emotions destined to be discharged in certain kinds of everyday situations, without which these situations would not be faced in a becoming manner. They are the magical part of the religion of being a gentleman. And even their harshest critics do not deny this. They do not say that these sports are not magical, or that their magic is not efficacious. What they say is that the emotions generated by this traditional English upper-class magic are not the emotions that best equip a man to live effectively in the world as it exists to-day.

As a last group of examples, we will consider the ceremonies of social life: such things as weddings, funerals, dinner-parties, dances; forms of pageantry (and therefore, potentially at least, forms of art) which decorate in their fashion the private lives of modern civilized men and women. All these are in essence magical. They all involve dressing up, and a dressing-up which is done not for amusement, and not for the gratification of individual taste, but according to a prescribed pattern, often very uncomfortable, and always so designed as to emphasize the solemnity of the occasion. This is what anthropologists call the ritual dress of the initiate. They all involve prescribed forms of speech and at any rate the rudiments of a ritual vocabulary. They all involve ritual instruments: a ring, a hearse, a peculiar and complicated outfit of knives and forks and glasses, each with its prescribed function. Almost always they involve the use of flowers of prescribed kinds, arranged in a prescribed manner, offerings to the genius of the ritual. They always involve a prescribed demeanour, a ritual gaiety or a ritual gloom.

As for their purpose, each one is consciously and explicitly

aimed at arousing certain emotions which are meant to fructify in the later business of practical life.

The pageantry of marriage has nothing to do with the fact, when it is a fact, that the principals are in love with each other. On that subject it is dumb; and this is why many persons deeply in love detest it as an insult to their passion, and undergo it only because they are forced into it by the opinion of their families. Its purpose is to create an emotional motive for maintaining a partnership of a certain kind, not the partnership of lovers but the partnership of married people, recognized as such by the world, whether love is present or no.

The funeral is an emotional reorientation of a different kind. The mourners are not, essentially, making a public exhibition of their grief; they are publicly laying aside their old emotional relation to a living person and taking up a new emotional relation to that same person as dead. The funeral is their public undertaking that they are going to live in future without him. How difficult an undertaking to fulfil completely, which of us knows his own heart well enough to say?

The ceremonial of a dinner-party is intended to create or renew a bond, not of understanding or interest or policy, but simply of emotion, among the diners, and more particularly between the host and each several guest. It consolidates and crystallizes a sentiment of friendship, at best making each feel what a charming person the other is, and at worst, that he is not such a bad fellow after all. It would be a poor dinner-party in which these feelings were not to some extent evoked, and did not to some extent survive the party itself.

The dance has always been magical; and so it still is among ourselves. In its modern and 'civilized' form it is essentially a courtship-ritual. Its intention is to arouse in the young of each sex an interest in some member of the other sex, to be selected in the ritual act itself from among the persons qualified by birth and upbringing (that is to say,

by proper initiations undergone at the various critical stages
of life) to unite together in matrimony. This interest, so far
from being satisfied and therefore exhausted in the dance
itself, is intended to fructify in a future partnership. At
bottom, as our more outspoken grandmothers quite correctly
put it, a ball is the occasion on which girls find husbands.

True to type, all these magical ceremonies are represen-
tative. They literally, though selectively, represent the
practical activities they are intended to promote. Like the
war-dance and the plough-ritual, they are 'symbolic' in
the sense of that word defined under protest at the end of
Chapter III, § 4. Thus, in marriage, the principals join
hands and walk arm-in-arm through the company, to sym-
bolize their partnership in the eyes of the world. At a
funeral, the mourners leave the dead behind them to sym-
bolize their renunciation of the emotional attitude which
they maintained towards him in life. At a dinner party,
host and guest eat the same food to symbolize the sense of
intimacy and friendliness that is to pervade their more
sympathetic future relations. At a dance the embrace of
partners is a symbol for the embrace of love.

Regarded from the strictly aesthetic point of view, all
these rituals are in general as mediocre as an average
Academy portrait, and for the same reason. The artistic
motive is present in them all; but it is enslaved and denatured
by its subordination to the magical. Hymn-tunes and
patriotic songs do not as a rule inspire respect in a musician.
A ballet-master is not likely to feel much enthusiasm for a
meet of foxhounds or a cricket-match. The stage manage-
ment of a wedding or dinner-party is seldom of high quality;
and a professional dancer would have little praise for what
goes on at a fashionable ball. But this is of a piece with the
strictly magical character of these rituals: or rather, with the
representative character of which their magical character is
one specific form. They are not art proper, any more than
a portrait or a landscape. Like these things, they have a
primary function which is wholly non-aesthetic: the function

of generating specific emotions. Like them, they may in the hands of a true artist (who is never to be thought of as separable from a public that demands true art) become art as well; and if the artistic and magical motives are felt as one motive, this is bound to happen, as it happened among the Aurignacian and Magdalenian cave-men, the ancient Egyptians, the Greeks, and the medieval Europeans. It can never happen so long as the motives are felt as distinct, as among ourselves they invariably are.

Note on § 2.—The immediate subject of this book brings me into contact only with Chapter III of Freud's *Totem and Taboo.* The reader will perhaps pardon me if I add that everything I have said about that chapter applies *mutatis mutandis* to the rest. The fallacies are inherent in the principle which actuated Freud in writing the book: the principle of 'applying the view-points and results of psycho-analysis to unexplained problems of racial psychology'. In plainer English, this means explaining the oddities of savage belief and behaviour by analogy with oddities observed by psycho-analysts in their patients. But 'savage' ,here, means only 'belonging to any civilization markedly different from that of modern Europe'; and the 'oddities' of savage belief and behaviour are only such points as seem odd to a modern European, i.e. the points in which that difference consists. So, in still plainer English, Freud's programme is to reduce the differences between non-European and European civilizations to differences between mental disease and mental health. Is it surprising that 'the savage hits back'?

This is not the place to lay bare in detail the quibbles and sophistries by which Freud persuades himself (and others too, apparently) that his programme has been carried out. My purpose in this note is to remark that a person who can attempt to equate the difference between civilizations with the difference between mental disease and mental health, in other words to reduce the historical problem of the nature of civilization to a medical problem, is a person whose views on all problems connected with the nature of civilization will be false in proportion as he sticks honestly to his attempt, and dangerously false in proportion as his prestige in his own field stands high. Among these problems is that of the nature of art.

V

ART AS AMUSEMENT

§ 1. *Amusement Art*

IF an artifact is designed to stimulate a certain emotion, and
if this emotion is intended not for discharge into the occupa-
tions of ordinary life, but for enjoyment as something of value
in itself, the function of the artifact is to amuse or entertain.
Magic is useful, in the sense that the emotions it excites
have a practical function in the affairs of every day; amuse-
ment is not useful but only enjoyable, because there is a
watertight bulkhead between its world and the world of
common affairs. The emotions generated by amusement
run their course within this watertight compartment.

Every emotion, dynamically considered, has two phases
in its existence: charge or excitation, and discharge. The
discharge of an emotion is some act done at the prompting
of that emotion, by doing which we work the emotion off
and relieve ourselves of the tension which, until thus dis-
charged, it imposes upon us. The emotions generated by an
amusement must be discharged, like any others; but they
are discharged within the amusement itself. This is in fact
the peculiarity of amusement. An amusement is a device
for the discharge of emotions in such a way that they shall
not interfere with the concerns of practical life. But since
practical life is only definable as that part of life which is not
amusement, this statement, if meant for a definition, would
be circular. We must therefore say: to establish a distinction
between amusement and practical life[1] is to divide experi-
ence into two parts, so related that the emotions generated
in the one are not allowed to discharge themselves in the
other. In the one, emotions are treated as ends in them-
selves; in the other, as forces whose operation achieves cer-

[1] Aestheticians who discuss the relation between two mutually exclusive
things called 'Art' and 'Life' are really discussing this distinction.

tain ends beyond them. The first part is now called amusement, the second part practical life.

In order that emotion may be discharged without affecting practical life, a make-believe situation must be created in which to discharge it. This situation will of course be one which 'represents' (cf. Chapter III, § 4) the real situation in which the emotion would discharge itself practically. The difference between the two, which has been indicated by calling them respectively real and make-believe, is simply this: the so-called make-believe situation is one in which it is understood that the emotion discharged shall be 'earthed', that is, shall not involve the consequences which it would involve under the conditions of practical life. Thus, if one man expresses hatred for another by shaking his fist at him, threatening him, and so forth, he will ordinarily be regarded as a dangerous character, dangerous in particular to the man he has threatened, who will therefore take steps of one kind or another to protect himself: perhaps by appeasing the first, perhaps by attacking him and overpowering him, perhaps by obtaining police protection. If it is understood that nothing of this sort is to be done, that life is to go on exactly as if nothing had happened, then the situation in which the anger was expressed is called a make-believe situation.

Situations of this kind resemble those created by magic in being representative, that is, in evoking emotions like those evoked by the situations they are said to represent. They differ in being 'unreal' or 'make-believe'; that is, in that the emotions they evoke are intended to be earthed instead of overflowing into the situations represented. This element of make-believe is what is known as (theatrical) 'illusion', an element peculiar to amusement art, and never found either in magic or in art proper. If in a magical ritual one says of a painting 'this is a bison', or of a wax figure 'this is my enemy', there is no illusion. One knows perfectly well the difference between the two things. The make-believe of amusement art differs radically, again, from the so-called make-believe of childish games, which is not amusement but

a very serious kind of work, which we call make-believe by way of assimilating it to something that occurs in our adult experience. Calling it by that misdescriptive name, we patronizingly license the child to go on with it; so that the child can work at the really urgent problems of its own life unhampered by the interference which would certainly be forthcoming if adults knew what it was doing.

Comparisons have often been made, sometimes amounting to identification, between art and play. They have never thrown much light on the nature of art, because those who have made them have not troubled to think what they meant by play. If playing means amusing oneself, as it often does, there is no important resemblance between play and art proper; and none between play and representative art in its magical form; but there is more than a mere resemblance between play and amusement art. The two things are the same. If playing means taking part in ritual games, art proper bears little resemblance to that, and amusement art even less; but such games, as we have already seen, not only resemble magic, they are magic. But there is another thing we call play: that mysterious activity which occupies the waking and working lives of children. It is not amusement, though we adults may amuse ourselves by imitating it, and even on privileged occasions taking part in it. It is not magic, though in some ways rather like it. Perhaps it is a good deal like art proper. Giambattista Vico, who knew a lot both about poetry and about children, said that children were 'sublime poets', and he may have been right. But no one knows what children are doing when they play; it is far easier to find out what poets are doing when they write, difficult though that is; and even if art proper and children's play are the same thing, no light is thrown for most of us on art proper by saying so.[1]

[1] Dr. Margaret Lowenfeld (*Play in Childhood*, 1935) has devised a method for exploring the unknown world of children's play, and has made strange discoveries about the relation of this play to the child's health. My own interpretation of her discoveries may be expressed by saying that they suggest an identity between 'play' in children and art proper. On the

There is a hedonistic theory of art: open, like all forms of hedonism, to the objection that even if the function of art is to give 'delight' (as many good artists have said), still this delight is not pleasure in general but pleasure of a particular kind. When this objection has been met, the theory is a fair enough account of amusement art. The artist as purveyor of amusement makes it his business to please his audience by arousing certain emotions in them and providing them with a make-believe situation in which these emotions can be harmlessly discharged.

The experience of being amused is sought not for the sake of anything to which it stands as means, but for its own sake. Hence, while magic is utilitarian, amusement is not utilitarian but hedonistic. The work of art, so called, which provides the amusement, is, on the contrary, strictly utilitarian. Unlike a work of art proper, it has no value in itself; it is simply means to an end. It is as skilfully constructed as a work of engineering, as skilfully compounded as a bottle of medicine, to produce a determinate and preconceived effect, the evocation of a certain kind of emotion in a certain kind of audience; and to discharge this emotion within the limits of a make-believe situation. When the arts are described in terms implying that they are essentially forms of skill, the reference, as the terms are ordinarily used nowadays, is to this utilitarian character of amusement art. When the spectator's reception of them is described in psychological terms as a reaction to stimulus, the reference is the same. Theoretically, in both cases, the reference might be to the magical type of representation; but in the modern world that is generally ignored. For the student of modern aesthetic, it is a good rule, whenever he hears or reads statements about art which seem odd or perverse or untrue, to ask whether their oddity (or apparent oddity) may not be due to a confusion between art proper and amusement;

relation between art and health of mind (involving health of body so far as psychological causes may impair or improve bodily health), I shall have something to say later on (Chapter X, § 7; Chapter XII, § 3).

a confusion either in the mind of their authors, or in his own.

§ 2. *Profit and Delight*[1]

Magical function and amusement function in a work of art are of course mutually exclusive, so far as a given emotion in a given audience at a given moment is concerned. You cannot arouse in your audience a certain emotion (say, hatred of the Persians) and arrange at one and the same moment for its discharge in an amusement form, by raising a laugh at their expense, and in a practical form, by burning down their houses. But the emotion aroused by any given representation is never simple; it is always a more or less complicated stream or pattern of different emotions; and it is not necessary that all these should be provided with the same kind of discharge. In a general way, some are discharged practically, others earthed; the artist, if he knows his job, arranging which shall be discharged in this way, which in that. So Horace: *omne tulit punctum qui miscuit utile dulci*; where the *utile* is the discharge of an emotion into practice, the *dulce* its discharge in the make-believe of amusement. 'We do not write these novels merely to amuse', says Captain Marryat in *Midshipman Easy*; and goes on to boast that he has used his novels not unsuccessfully in the past to advocate reforms in naval administration. Mr. Bernard Shaw is another devout follower of Horace. There has never been any damned nonsense about art with him; he has careered through life most successfully as an entertainer, careful always to keep a few ball cartridges among his blank, and send his audience home indignant about the way people treat their wives, or something like that. But although he follows the same tradition as Marryat, it is doubtful whether he could claim an equal record of success as a pamphleteer. The difference is not so much between one writer and another as between one age and another. In the hundred years that

[1] The ends of all, who for the *Scene* doe write
Are, or should be, to profit, and delight.
 B. Jonson, *Epicœne, or the Silent Woman*.

have elapsed since *Midshipman Easy* was published, the ability of both artists and public to mix a dose of magic with their amusement has sensibly declined. Mr. Galsworthy began his career by putting so much *utile* and so little *dulce* into his stage-puddings that only very determined stomachs could digest them at all. So he gave up playing with magic, and specialized in entertaining a rather grim class of readers with the doings of the Forsyte family.

People who are not really competent in magic, as the fairy-tales wisely tell us, should be careful to leave it alone. One of the typical features of late nineteenth- and early twentieth-century literature is the way in which sound knockabout entertainers like Jerome K. Jerome or successful ginger-beer merchants like Mr. A. A. Milne suddenly come over all solemn, pull themselves together, and decide to become good influences in the lives of their audience. Nothing quite like it had ever happened before. It is a curious and un-pleasant instance of the decline in taste which the nineteenth century brought in its train.

In general, the representational artist urgently needs to be a man of taste, in the sense that he must, on pain of profes-sional disaster, know what emotions to excite. Unless he means to act as a magician, like Timotheus in Dryden's ode, and excite passions which those who feel them cannot discharge in anything short of practical acts, he must choose passions which, in the case of this particular audience, will submit to make-believe gratification. There is always a danger that, when once an emotion has been aroused, it may break down the watertight bulkhead and overflow into practical life; but it is the aim of both the amuser and the amused that this disaster shall not happen, and that by a loyal co-operation the bulkhead shall remain intact. The artist must steer a middle course. He must excite emotions which are closely enough connected with his audience's practical life for their excitation to cause lively pleasure; but not so closely connected that a breach of the bulkhead is a serious danger. Thus, a play in which a foreign nation is

held up to ridicule will not amuse an audience in whom
there is no sense of hostility towards that nation; but neither
will it amuse one in whom this hostility has come near to
boiling-point. A smoking-room story which amuses middle-
aged clubmen would not amuse an old man who had
out-grown sexual desire, nor a young man in whom it was
agonizingly strong.

§ 3. *Examples of Amusement Art*

The emotions which admit of being thus played upon for
purposes of amusement are infinitely various; we shall take
a few examples only. Sexual desire is highly adaptable to
these purposes; easily titillated, and easily put off with make-
believe objects. Hence the kind of amusement art which at
its crudest and most brutal is called pornography is very
common and very popular. Not only the representation of
nudity which reappeared in European painting and sculpture
at the Renaissance, when art as magic was replaced by art
as amusement, but the novel, or story based on a sexual
motive, which dates from the same period, is essentially an
appeal to the sexual emotions of the audience, not in order
to stimulate these emotions for actual commerce between
the sexes, but in order to provide them with make-believe
objects and thus divert them from their practical goal in the
interests of amusement. The extent to which this make-
believe sexuality has affected modern life can hardly be
believed until the fact has been tested by appeal to the
circulating libraries, with their flood of love-stories; the
cinema, where it is said to be a principle accepted by almost
every manager that no film can succeed without a love-
interest; and above all the magazine and newspaper, where
cover-designs, news-items, fiction, and advertisement are
steeped in materials of the same kind: erotic stories, pictures
of pretty girls variously dressed and undressed, or (for the
female reader) of attractive young men: pornography
homoeopathically administered in doses too small to shock
the desire for respectability, but quite large enough to

produce the intended effect. Small wonder that Monsieur Bergson has called ours an 'aphrodisiac civilization'. But the epithet is not quite just. It is not that we worship Aphrodite. If we did, we should fear these make-believes as a too probable cause of her wrath. An aphrodisiac is taken with a view to action: photographs of bathing girls are taken as a substitute for it. The truth may rather be that these things reveal a society in which sexual passion has so far decayed as to have become no longer a god, as for the Greeks, or a devil, as for the early Christians, but a toy: a society where the instinctive desire to propagate has been weakened by a sense that life, as we have made it, is not worth living, and where our deepest wish is to have no posterity.

The case of sexual fantasy is peculiar, because it seems in this way to have got out of hand, and thus to betray something amiss with our civilization as a whole. There are plenty of other cases where this complication is absent. For example, much pleasure may be derived from the emotion of fear; and to-day this is provided by a galaxy of talent devoted to writing stories of terrible adventure. The 'thriller', to give the thing its current name, is not new. We find it on the Elizabethan stage, in the charnel-house sculpture of seventeenth-century tombs (the Last Judgements of medieval art were aimed not at making flesh creep but at reforming sinful lives), in the novels of Mrs. Radcliffe and 'Monk' Lewis, in the engravings of Doré, and, raised to the level of art proper, in the first movement of Beethoven's Fifth Symphony and the Finale of Mozart's *Don Giovanni*. Among ourselves, the spread of literacy has begotten upon the old penny dreadful a monstrous progeny of hair-raising fiction concerned with arch-criminals, gunmen, and sinister foreigners. Why the ghost story, once so valuable for this purpose, has lost its efficacy, although heathenish rites, with much explicit bloodshed and even more hinted obscenity, are still in lively demand, is a curious problem for the historian of ideas.

The detective story, the most popular form of amusement offered by the profession of letters to the modern public, is

based partly on appeal to the reader's fear, but partly on a rich medley of other emotions. In Poe the element of fear was exceedingly strong, and either because of his influence, or because of something ingrained in the civilization of the United States, the present-day American detective story shows a stronger inclination towards that type than those of any other nation. American corpses are the bloodiest and most horribly mangled; American police the most savage in their treatment of suspects.[1] Another emotion of great importance in such stories is the delight in power. In what may be called the Raffles period, this was gratified by inviting the reader to identify himself with a gallant and successful criminal; nowadays the identification is with the detective. A third is the intellectual excitement of solving a puzzle; a fourth, the desire for adventure, that is to say, the desire to take part in events as unlike as possible to the dreary business of actual everyday life. Members of the scholastic and clerical professions from time to time express a belief that young people who read these stories, and see films resembling them, are thereby incited to a career of crime. This is bad psychology. There is no evidence that stories of crime are the favourite reading of habitual criminals. In point of fact, those who constantly read them are on the whole thoroughly law-abiding folk; and this is only natural, for the constant earthing of certain emotions, by arousing and discharging them in make-believe situations, makes it less likely that they will discharge themselves in practical life.

No one has yet taken up the detective story and raised it to the level of genuine art. Miss Sayers, indeed, has given reasons why this cannot be done. Perhaps one reason is the mixture of motives which this *genre* has traditionally accepted as inevitable. A mixture of motives is, on the whole, favourable to good amusement, but it can never produce art proper.

[1] Cf. Superintendent Kirk: '. . . I couldn't rightly call them a mellering influence to a man in my line. I read an American story once, and the way the police carried on—well, it didn't seem right to me.' Dorothy L. Sayers, *Busman's Honeymoon*, p. 161.

Malice, the desire that others, especially those better than ourselves, should suffer, is a perpetual source of pleasure to man; but it takes different shapes. In Shakespeare and his contemporaries, bullying in its most violent form is so common that we can only suppose the average playgoer to have conceived it as the salt of life. There are extreme cases like *Titus Andronicus* and *The Duchess of Malfi*, where torture and insult form the chief subject-matter; cases like *Volpone* or *The Merchant of Venice*, where the same motive is veiled by a decent pretence that the suffering is deserved; and cases like *The Taming of the Shrew*, where it is rationalized as a necessary step to domestic happiness. The same motive crops out so repeatedly in passages like the baiting of Malvolio or the beating of Pistol, passages wholly unconnected with the plot of the play, so far as these plays have a plot, that it has obviously been dragged in to meet a constant popular demand. The theme is raised to the level of art proper here and there in Webster, in a few of Shakespeare's tragedies, and above all in Cervantes.

In a society which has lost the habit of overt bullying, the literature of violence is replaced by the literature of cattishness. Our own circulating libraries are full of what is grandiloquently called satire on the social life of our time; books whose popularity rests on the fact that they give the reader an excuse for ridiculing the folly of youth and the futility of age, despising the frivolity of the educated and the grossness of the uneducated, gloating over the unhappiness of an ill-assorted couple, or triumphing over the feebleness of a henpecked merchant prince. To the same class of pseudo-art (they are certainly not history) belong the biographies of cattishness, whose aim is to release the reader from the irksome reverence he has been brought up to feel for persons who were important in their day.

If the Elizabethan was by temperament a bully, the Victorian was by temperament a snob. Literature dealing with high life at once excites and in fancy gratifies the social ambition of readers who feel themselves excluded from it;

and a great part of the Victorian novelist's work was devoted
to making the middle classes feel as if they were sharing in
the life of the upper. Nowadays, when 'society' has lost its
glamour, a similar place is taken by novels and films dealing
with millionaires, criminals, film-stars, and other envied
persons. There is even a literature catering for the snobbery
of culture: books and films about Beethoven, Shelley, or,
combining two forms of snobbery in one, a lady in high
station who wins fame as a painter.

There are cases in which we find, not a mixture of amuse-
ment and magic, but a wavering between the two. A con-
siderable literature exists devoted to sentimental topography:
books about the charm of Sussex, the magic of Oxford,
picturesque Tyrol, or the glamour of old Spain. Are these
intended merely to recall the emotions of returned travellers
and to make others feel as if they had travelled, or are they
meant as an invocation—I had almost said, to call fools into
a circle? Partly the one and partly the other; if the choice
had been decisively made, literature of this kind would be
better than it is. Similar cases are the sentimental literature
of the sea, addressed to landsmen, and of the country,
addressed to town-dwellers; folk-songs as sung not in pubs
and cottages but in drawing-rooms; pictures of horses and
dogs, deer and pheasants, hung in billiard-rooms partly as
charms to excite the sportsman, partly as substitutes for sport.
There is no reason why works of this kind should not be
raised to the level of art, though cases in which that has
happened are exceedingly rare. If it is to happen, there is
one indispensable condition: the ambiguity of motive must
first be cleared up.

§ 4. *Representation and the Critic*

The question may here be raised, how the practice of art-
criticism is affected by identifying art with representation
in either of its two forms. The critic's business, as we have
already seen, is to establish a consistent usage of terms: to
settle the nomenclature of the various things which come

before him competing for a given name, saying, 'this is art, that is not art', and, being an expert in this business, performing it with authority. A person qualified so to perform it is called a judge; and judgement means verdict, the authoritative announcement that, for example, a man is innocent or guilty. Now, the business of art-criticism has been going on ever since at least the seventeenth century; but it has always been beset with difficulties. The critic knows, and always has known, that in theory he is concerned with something objective. In principle, the question whether this piece of verse is a poem or a sham poem is a question of fact, on which every one who is properly qualified to judge ought to agree. But what he finds, and always has found, is that in the first place the critics as a rule do not agree; in the second place, their verdict is as a rule reversed by posterity; and in the third place it is hardly ever welcomed and accepted as useful either by the artists or by the general public.

When the disagreements of critics are closely studied, it becomes evident that there is much more behind them than mere human liability to form different opinions about the same thing. The verdict of a jury in court, as judges are never tired of telling them, is a matter of opinion; and hence they sometimes disagree. But if they disagreed in the kind of way in which art-critics disagree, trial by jury would have been experimented with only once, if that, before being abolished for ever. The two kinds of disagreement differ in that the juror, if the case is being handled by a competent judge, has only one point at which he can go wrong. He has to give a verdict, and the judge tells him what the principles are upon which he must give it. The art-critic also has to give a verdict; but there is no agreement between him and his colleagues as to the principles on which it must be given.

This divergence of principle is not due to unsolved philosophical problems. It does not arise from divergences between rival theories of art. It arises at a point in thought which is prior to the formation of any aesthetic theory what-

ever. The critic is working in a world where most people, when they speak of a good painting or a good piece of writing, mean simply that it pleases them, and pleases specifically in the way of amusement. The simpler and more vulgar make no bones about this; I don't know what's good, they say, but I know what I like. The more refined and artistic reject this idea with horror. It makes no difference whether you like it or not, they retort; the question is whether it is good. The protest is in principle perfectly right; but in practice it is humbug. It implies that whereas the so-called art of the vulgar is not art but only amusement, about which there is of course no objective goodness or badness but only the fact that a given thing amuses or does not amuse a given audience, the art of more refined persons is not amusement but art proper. This is simply snobbery. There is no difference in attitude between the people who go to see Gracie Fields and the people who go to see Ruth Draper except that, having been differently brought up, they are amused by different things. The cliques of artists and writers consist for the most part of a racket selling amusement to people who at all costs must be prevented from thinking themselves vulgar, and a conspiracy to call it not amusement but art.

The people who fancy themselves altogether above the vulgar level of amusement art, but are actually disporting themselves in that level and nowhere else, call their own amusements good art in so far as they find them amusing. The critic is therefore in a false position. He is committed, in so far as he himself belongs to these people and shares their shibboleths, to treating what is in fact a question of their likes and dislikes, their taste in amusements, as if it were that totally different thing, a question of merits and demerits in a given artist's work. And even that way of putting it makes his task seem easier than it really is. If these refined persons formed a perfectly compact psychological mob, what amused one would amuse all, as the same joke may please all members of a mess or a common-room. But in so far as their only

bond is the negative one of refinement, which only means being unlike the people they regard as vulgar, they cannot as a whole exhibit a compact mob-psychology, and different fractions will be amused by different things. The critic's task is now hopeless, because the reasons why some people belonging to these circles call a book or a picture good will be the very same reasons why others, equally entitled to life, liberty, and the pursuit of amusement, will call it bad. And even if a certain kind of taste may for a time dominate the whole, or a large part of it, this is sure to be succeeded by another, from whose point of view the things that amused the earlier will be said to 'date'; a very curious word, which nicely blows the gaff of all this sham criticism; for if it had been a question of genuine art—'voyons, Monsieur, le temps ne fait rien à l'affaire'.

The critic is generally despised, but he ought rather to be pitied. The villains of the piece are the self-styled artists. They have assured him that they are doing something which it will be worth his while to study, and have then done something else, on which no critic would waste an hour's thought. If the gigantic ramp by which the trade in genteel amusements passes itself off as art were once for all exposed, the critics could either come out frankly as the advertisement writers which many of them are, or stop bothering about sham art and concentrate, as some of them already do, on the real thing.

So long as art is identified with amusement, criticism is impossible; and the fact of its having been so long and so valiantly attempted is a remarkable proof of the tenacity with which the modern European consciousness sticks to its point that there is such a thing as art, and that some day we shall learn how to distinguish it from the amusement trade.[1]

[1] It is hardly necessary to remark that the amusement racket has succeeded in corrupting quite a number of academic and other theoretical writers who base their aesthetic, or rather anti-aesthetic, on the identification of art with that which evokes a certain kind of emotion; with the consequence that 'beauty' is 'subjective', Man (and what a man!) is the measure of all things, and the critics, not (presumably) being Men but only heroes who have held

If art is identified with magic, the same conclusion follows;
but this conclusion, in a society where magic is at all vigorous,
may easily be masked by the substitution of a false objec-
tivity for a true objectivity, an empirical generality for a
strict universality. A matter of fact, as that this person did
this act, or that this thing is a poem, is valid for everybody at
every time and place. The 'goodness' or 'beauty' of a 'work
of art', if goodness or beauty means power of exciting certain
emotions in the person using the word, has no such validity;
it exists only in relation to the person in whom these emo-
tions are aroused. It may happen that the same work will
arouse the same emotions in others; but this will happen on a
considerable scale only when the society in which it occurs
thinks it necessary to its welfare.

That phrase is susceptible, we may note in passing, of
two interpretations. (1) On a biological view of society, a
society will consist of animals of a certain kind which through
the action of such causes as heredity all possess a certain
type of psychological organization. Owing to the uniformity
of this organization, a stimulus of a specific kind will produce
in all members of the society a specific type of emotion. The
emotion will be necessary to the welfare of the society,
because it is part and parcel of the psychological organization
whose identity in all members of the society constitutes its
principle of unity; and in so far as its members are conscious
of this principle they will see that this emotional unanimity
is necessary to their corporate existence, as a biological fact
on which that existence depends. (2) On an historical view
of society, a society will consist of persons who through com-
munication by language have worked out a certain way of
living together. So far as each one of them feels his own
interests as bound up with those of the society, everything
which forms part of this common way of living will have to
him an emotional value, the strength of this emotion being the
force that binds the society together. In that case, anything

a key-position of the civilized world for two centuries and a half against
overwhelming odds, find that the pass has been sold behind their backs.

intimately connected with their common way of living will arouse in all members of the society the same type of emotional response.

On either view, therefore, wherever there is a society of any kind, there will be certain established forms of corporate magic, whereby certain standard stimuli evoke certain standard emotional responses from all its members. If these stimuli are called 'works of art', they are conceived as possessing a 'goodness' or 'beauty' which in fact is merely their power to evoke these responses. In so far as the society is really a society, the appropriate response is really evoked in all its members, and if they misuse words in this way, they will all agree that the 'work of art' is 'good' or 'beautiful'. But this agreement is only an empirical generality, holding good within the society because the society just consists of those persons who share it. Enemies without, or even mere foreigners, and traitors within, will just as necessarily disagree. So long as magic is taken for art, these agreements and disagreements will be taken for criticism; and in any given society it will be thought the mark of a good critic to insist that the common magic of the society is good art.

Reduced to these terms, criticism becomes nugatory. In this country and at the present time there is not much danger of the reduction. There are not many people, or if there are they are not influential, who think we ought to support home industries by taking pains to bestow special admiration on English poetry or English music or English painting because it is English; or even that a decent patriotism should prevent us from criticizing the words or music of *God Save the King* or the annual Academy portraits of the Royal Family. But mistakes are often made by inverting the same misconception. As we saw at the end of the preceding chapter, many things which are or might be called art, even among ourselves and to-day, are in fact a combination of art and magic in which the predominant motive is magical. What is demanded of them is that they should discharge a magical function, not an artistic one. If a musical critic tells

us that *God Save the King* is a bad tune, well and good; it is a matter on which he has a right to speak. Perhaps after all the Elizabethans were wrong to think John Bull a competent musician. But if he goes on to tell us that we ought on that account to replace it with a new national anthem by a better composer, he is confusing an artistic question with a magical one. To condemn magic for being bad art is just as foolish as to praise art for being good magic. And when we find an artist trying to convince us that our public statues, for example, are artistically bad and ought on that account to be demolished, we cannot help wondering whether he is a fool or a knave: a fool for not knowing these things to be primarily magic, valuable for their magical qualities and not at all for their artistic, or a knave for knowing this perfectly well, but concealing it in order to use his own artistic prestige as a stalking-horse behind which he can make a treacherous attack on the emotions which bind our society together.

§ 5. *Amusement in the Modern World*

We have already seen that amusement implies a bifurcation of experience into a 'real' part and a 'make-believe' part, and that the make-believe part is called amusement in so far as the emotions aroused in it are also discharged in it and are not allowed to overflow into the affairs of 'real' life.

This bifurcation is no doubt as ancient as man himself; but in a healthy society it is so slight as to be negligible. Danger sets in when by discharging their emotions upon make-believe situations people come to think of emotion as something that can be excited and enjoyed for its own sake, without any necessity to pay for it in practical consequences. Amusement is not the same thing as enjoyment; it is enjoyment which is had without paying for it. Or rather, without paying for it in cash. It is put down in the bill and has to be paid for later on. For example, I get a certain amount of fun out of writing this book. But I pay for it as I get it, in wretched drudgery when the book goes badly, in seeing the long summer days

vanish one by one past my window unused, in knowing that there will be proofs to correct and index to make, and at the end black looks from the people whose toes I am treading on. If I knock off and lie in the garden for a day and read Dorothy Sayers, I get fun out of that too; but there is nothing to pay. There is only a bill run up, which is handed in next day when I get back to my book with that Monday-morning feeling. Of course, there may be no Monday-morning feeling: I may get back to the book feeling fresh and energetic, with my staleness gone. In that case my day off turned out to be not amusement but recreation. The difference between them consists in the debit or credit effect they produce on the emotional energy available for practical life.

Amusement becomes a danger to practical life when the debt it imposes on these stores of energy is too great to be paid off in the ordinary course of living. When this reaches a point of crisis, practical life, or 'real' life, becomes emotionally bankrupt; a state of things which we describe by speaking of its intolerable dullness or calling it a drudgery. A moral disease has set in, whose symptoms are a constant craving for amusement and an inability to take any interest in the affairs of ordinary life, the necessary work of livelihood and social routine. A person in whom the disease has become chronic is a person with a more or less settled conviction that amusement is the only thing that makes life worth living. A society in which the disease is endemic is one in which most people feel some such conviction most of the time.

A moral (or in modern jargon a psychological) disease may or may not be fatal to the person suffering from it; he may be driven to suicide, as the only release from *taedium vitae*, or he may try to escape it by going in for crime or revolution or some other exciting business, or he may take to drink or drugs, or simply allow himself to be engulfed in a slough of dullness, a dumbly accepted life in which nothing interesting ever happens, tolerable only when he does not think how intolerable it is. But moral diseases have this peculiarity, that they may be fatal to a society in which they

are endemic without being fatal to any of its members. A society consists in the common way of life which its members practise; if they become so bored with this way of life that they begin to practise a different one, the old society is dead even if no one noticed its death.

This is perhaps not the only disease from which societies may die, but it is certainly one of them. It is certainly, for example, the disease from which Greco-Roman society died. Societies may die a violent death, like the Inca and Aztec societies which the Spaniards destroyed with gunpowder in the sixteenth century; and it is sometimes thought by people who have been reading historical thrillers that the Roman Empire died in the same way, at the hands of barbarian invaders. That theory is amusing but untrue. It died of disease, not of violence, and the disease was a long-growing and deep-seated conviction that its own way of life was not worth preserving.

The same disease is notoriously endemic among ourselves. Among its symptoms are the unprecedented growth of the amusement trade, to meet what has become an insatiable craving; an almost universal agreement that the kinds of work on which the existence of a civilization like ours most obviously depends (notably the work of industrial operatives and the clerical staff in business of every kind, and even that of the agricultural labourers and other food-winners who are the prime agents in the maintenance of every civilization hitherto existing) is an intolerable drudgery; the discovery that what makes this intolerable is not the pinch of poverty or bad housing or disease but the nature of the work itself in the conditions our civilization has created; the demand arising out of this discovery, and universally accepted as reasonable, for an increased provision of leisure, which means opportunity for amusement, and of amusements to fill it; the use of alcohol, tobacco, and many other drugs, not for ritual purposes, but to deaden the nerves and distract the mind from the tedious and irritating concerns of ordinary life; the almost universal confession that boredom, or lack of

interest in life, is felt as a constant or constantly recurring state of mind; the feverish attempts to dispel this boredom either by more amusement or by dangerous or criminal occupations; and finally (to cut the catalogue short) the discovery, familiar *mutatis mutandis* to every bankrupt in the last stages of his progress, that customary remedies have lost their bite and that the dose must be increased.

These symptoms are enough to alarm any one who thinks about the future of the world in which he is living; enough to alarm even those whose thought for the future goes no farther than their own lifetime. They suggest that our civilization has been caught in a vortex, somehow connected with its attitude towards amusement, and that some disaster is impending which, unless we prefer to shut our eyes to it and perish, if we are to perish, in the dark, it concerns us to understand.

A history of amusement in Europe would fall into two chapters. The first, entitled *panem et circenses*, would deal with amusement in the decadent world of antiquity, the shows of the Roman theatre and amphitheatre, taking over their material from the religious drama and games of the archaic Greek period; the second, called *le monde où l'on s'amuse*, would describe amusement in the Renaissance and modern ages, at first aristocratic, furnished by princely artists to princely patrons, then transformed by degrees through the democratization of society into the journalism and cinema of to-day, and always visibly drawing its material from the religious painting and sculpture and music, architecture and pageantry and oratory, of the Middle Ages.

The first chapter would begin with Plato. Plato's observations about poetry and the other arts are difficult for us to understand, not, as historians of thought generally assume, because 'aesthetic was in its infancy' and Plato's thoughts about it inchoate and confused; still less, as others fancy, because Plato was a philistine with no interest in art; but because the issues with which he was dealing were not the familiar problems of academic art-philosophy which we

expect them to be, but issues of a quite different kind, highly relevant to our own practical situation. Plato lived at a time when the religious art of the earlier Greeks, such as the Olympian sculptures and the Aeschylean drama, had decisively given way to the new amusement art of the Hellenistic age. He saw in this change not only the loss of a great artistic tradition and the coming of an artistic decadence, but also a danger to civilization as a whole. He grasped the distinction between magical art and amusement art, and attacked amusement art with all the power of his logic and eloquence.

Modern readers, prejudiced by the current nineteenth-century identification of art with amusement, have commonly misinterpreted Plato's attack on amusement as an attack on art, have taken upon themselves to resent it in the name of sound aesthetic theory, and have praised Aristotle for a juster appreciation of the value of art. In fact, however, Plato and Aristotle do not differ so very much in their views on poetry, except at one point. Plato saw that amusement art arouses emotions which it does not direct to any outlet in practical life; and wrongly inferred that its excessive development would breed a society overcharged with purposeless emotions. Aristotle saw that this did not follow, because the emotions generated by amusement art are discharged by the amusement itself. Plato's error on this point led him to think that the evils of a world given over to amusement could be cured by controlling or abolishing amusements. But when the vortex has once established itself, that cannot be done; cause and effect are now interlocked in a vicious circle, which will mend itself wherever you break it; what began as the cause of the disease is now only a symptom, which it is useless to treat.[1]

The dangers to civilization foreseen by Plato's prophetic thought were a long time maturing. Greco-Roman society

[1] It should be added that in both Plato and Aristotle, and especially in Plato, the genuine problems of aesthetic are not wholly absent from the discussion; they lurk in the background, and from time to time loom up and overshadow those of amusement art.

was vigorous enough to go on paying the interest on the accumulating debt out of the energies of its everyday life for six or seven centuries. But from Plato onwards its life was a rearguard action against emotional bankruptcy. The critical moment was reached when Rome created an urban proletariat whose only function was to eat free bread and watch free shows. This meant the segregation of an entire class which had no work to do whatever; no positive function in society, whether economic or military or administrative or intellectual or religious; only the business of being supported and being amused. When that had been done, it was only a question of time until Plato's nightmare[1] of a consumer's society came true: the drones set up their own king, and the story of the hive came to an end.

Once a class had been created whose only interest lay in amusement, it acted as an abscess which by degrees drew away all emotional energies from the affairs of real life. Nothing could arrest the spread of amusement; no one, though many tried, could regenerate it by infusing into it a new spirit of religious purpose or artistic austerity. The vortex revolved, through manifestations now wholly forgotten except by a few curious scholars, until a new consciousness grew up for which practical life was so interesting that organized amusement was no longer needed. The consciousness of the old civilization, now bifurcated down to its very foundations, fell to pieces before the onslaught of this new unified consciousness, and theatre and amphitheatre were deserted by a world that had become Christian. The Middle Ages had begun, and a new magico-religious art was born: this time, an art serving those emotions which went to the invigorating and perpetuating of Christian society.

The second chapter would begin with the fourteenth

[1] *Republic*, 573 A–B. Cf. Rostovtzeff, *Social and Economic History of the Roman Empire*, ch. ix–xi. I have worked out the consequences for one province of the Roman Empire in *Oxford History of England*, i (1937), ch. xii–xiii; cf. especially p. 207.

century, when merchants and princes began to change the whole character of artistic work by diverting it from the Church's use to their own personal service. It would show how, from a quite early stage, this new movement provoked violent hostility, such as that which drove Savonarola to burn Michelangelo's picture; and how this hostility was drawn into the service of the Reformation until it became, unlike the so-called 'puritanism' of Plato, even more bitter against magical art than against amusement art. It would show how the tradition of this hostility entered into the main stream of modern civilization through its inheritance by nonconformist bankers and manufacturers, the class which became dominant in the modern world; and how that event drove the artistic consciousness of the modern world, at the very moment when it was liberating itself from the shackles of amusement, into the position of something outcast and persecuted.

It would show how the new plutocracy, entrenched in their hereditary anti-artistic point of view, came with their new social and political domination to ape the ways of the gentry they had displaced; how in the course of this process they made a truce with the arts on condition that the arts should accept once more the status of amusements; and how the new dominant classes persuaded themselves to reconcile their enjoyment of these amusements with a religious principle according to which there was no room in life for anything but work. The effect on both parties was disastrous. The artists, who had struggled from the seventeenth to the early nineteenth century to work out a new conception of art, detaching it from the ideas of amusement and magic alike, and thus liberating themselves from all service, whether of church or of patron, stifled these thoughts, spared themselves the labour of developing their new conception to the height of its potentialities, and put on again the servant's liveries they had thrown aside. But they had changed for the worse, as always happens when revolted slaves go back to slavery. Their old masters had been, according to their

lights, liberal and encouraging patrons, anxious for the best their servants could give them. The new masters wanted something far short of that. There was to be no danger of a new Restoration comedy or a Chaucerian or Shakespearian freedom of speech. Bowdler was king. And so the nineteenth century went on its way, with a constant decline in artistic standards as compared with those of its early years, until by degrees (since slaves come to learn the desires their lords disown) respectable people began to think of art as not only an amusement but a shady one.

The masters, too, were the worse for it. Conscience allowed no place in their lives for amusement; and by accepting the arts as amusements they were touching the forbidden thing. The gospel of work ceased to hold them. They got into the habit of deserting their business on making a fortune, and 'retiring' into a state of pseudo-gentility, distinguished from real gentility not by their pronunciation or their table-manners, which were no odder than those of many a squire, but by the fact that they had no duties to the community, whether military or administrative or magical, such as occupied the real gentry. They had nothing to do but amuse themselves, and many of them did so by collecting pictures and so forth as the eighteenth-century nobility had set them example. The art-galleries of northern towns are there in evidence. But the poor, who are always the last guardians of a tradition, knew that the curse of God rested on idleness, and spoke of three generations from clogs to clogs.

That was the first stage in the formation of the vortex. The second, far graver, was the corruption of the poor themselves. Until close on the end of the nineteenth century, the rustic population of England had an art of its own, rooted in the distant past but still alive with creative vigour: songs and dances, seasonal feasts and dramas and pageantry, all of magical significance and all organically connected with agricultural work. In a single generation this was wiped out of existence by the operation of two causes: the Education

Act of 1870, which, as imposing on the countryman an education modelled on town-dwellers' standards, was one stage in the slow destruction of English rural life by the dominant industrial and commercial class; and the 'agricultural depression', to give that vague and non-committal name to the long series of events, partly accidental and partly deliberate, which between 1870 and 1900 wrecked the prosperity of the English agricultural population.[1]

A similar process was going on among the poor of the towns. They too had a vital and flourishing folk-art of the same magical type; they too were deprived of it by the organized forces of the law acting as the secular arm of the ruling industrialists' puritanism. This is not the place for a narrative of the long persecution; it is enough to say that by about 1900 town and country alike had been properly purged of the magical art that had come to be known as folklore, except for a few harmless and pitiful survivals. The attack on magical art was over. The mind of the poor was a house empty, swept, and garnished.

Then came amusement art. Football—mushroom amusement growth of what had, till lately, been a ritual practised on religious feast-days in north-country towns—came first; then came the cinema and the wireless; and the poor, throughout the country, went amusement mad. But another event was happening at the same time. Increased production combined with the break-down of economic organization led to the appearance of an unemployed class, forced unwillingly into a parasitic condition, deprived of the magical arts in which their grandfathers took their pleasure fifty years ago, left functionless and aimless in the community, living only to accept *panem et circenses*, the dole and the films.

Historical parallels are blind guides. There is no certainty that our civilization is tracing a path like that of the later Roman Empire. But the parallel, so far as it has yet developed, is alarmingly close. The disaster may be

[1] Cf. R. C. K. Ensor, *Oxford History of England*, vol. xiv (1936), ch. iv, ix.

preventible, but the danger is real. Is there anything we can do?

There are certain things we need not try to do. Plato's remedy is no use. A dictator might try to close the cinemas, shut down the wireless except for the transmission of his own voice, confiscate the newspapers and magazines, and in every possible way block the supplies of amusement. But no such attempts would succeed, and no one clever enough to become dictator would be fool enough to make them.

The highbrow remedy is no use. The masses of cinema goers and magazine readers cannot be elevated by offering them, instead of these democratic amusements, the aristocratic amusements of a past age. This is called bringing art to the people, but that is clap-trap; what is brought is still amusement, very cleverly designed by a Shakespeare or a Purcell to please an Elizabethan or Restoration audience, but now, for all its genius, far less amusing than Mickey Mouse or jazz except to people laboriously trained to enjoy it.

The folk-song remedy is no use. English folk-art was a magical art, whose value to its possessors lay not in its aesthetic merits (critics who quarrel about these merits need not offer us their views) but in its traditional connexion with the works and days of their calendar. Its possessors have been robbed of it. The tradition has been broken. You cannot mend a tradition, and you would be foolish to give it back broken. Remorse is useless. There is nothing to be done except face the fact.

The gunman's remedy is no use. We need not buy revolvers and rush off to do something drastic. What we are concerned with is the threatened death of a civilization. That has nothing to do with my death or yours, or the deaths of any people we can shoot before they shoot us. It can be neither arrested nor hastened by violence. Civilizations die and are born not with waving of flags or the noise of machine-guns in the streets, but in the dark, in a stillness, when no

one is aware of it. It never gets into the papers. Long afterwards a few people, looking back, begin to see that it has happened.

Then let us get back to our business. We who write and read this book are persons interested in art. We live in a world where most of what goes by that name is amusement. Here is our garden. It seems to need cultivating.

ART PROPER: (1) AS EXPRESSION

§ 1. *The New Problem*

We have finished at last with the technical theory of art, and with the various kinds of art falsely so called to which it correctly applies. We shall return to it in the future only so far as it forces itself upon our notice and threatens to impede the development of our subject.

That subject is art proper. It is true that we have already been much concerned with this; but only in a negative way. We have been looking at it so far as was necessary in order to exclude from it the various things which falsely claimed inclusion in it. We must now turn to the positive side of this same business, and ask what kinds of things they are to which the name rightly belongs.

In doing this we are still dealing with what are called questions of fact, or what in the first chapter were called questions of usage, not with questions of theory. We shall not be trying to build up an argument which the reader is asked to examine and criticize, and accept if he finds no fatal flaw in it. We shall not be offering him information which he is asked to accept on the authority of witnesses. We shall be trying as best we can to remind ourselves of facts well known to us all: such facts as this, that on occasions of a certain kind we actually do use the word art or some kindred word to designate certain kinds of thing, and in the sense which we have now isolated as the proper sense of the word. Our business is to concentrate our attention on these usages until we can see them as consistent and systematic. This will be our work throughout this chapter and the next. The task of defining the usages thus systematized, and so constructing a theory of art proper, will come later.

An appeal to facts is scientifically fertile only if the inquirer knows what precisely the questions are which he hopes

that the appeal will answer. Our preliminary task, therefore, is to define the questions which the collapse of the technical theory has left confronting us. 'That is easy,' some one may suggest; 'the technical theory having collapsed, we begin again at the beginning, with the same question once more before us: What is art?'

This is a complete misunderstanding. To a person who knows his business as scientist, historian, philosopher, or any kind of inquirer, the refutation of a false theory constitutes a positive advance in his inquiry. It leaves him confronted, not by the same old question over again, but by a new question, more precise in its terms and therefore easier to answer. This new question is based on what he has learned from the theory he has refuted. If he has learned nothing, this proves either that he is too foolish (or too indolent) to learn, or that by an unfortunate error of judgement he has been spending time on a theory so idiotic that there is nothing to be learnt from it. Where the refuted theory, even though untrue as a whole, is not completely idiotic, and where the person who has refuted it is reasonably intelligent and reasonably painstaking, the upshot of his criticism can always be expressed in some such form as this: 'The theory is untenable as regards its general conclusions; but it has established certain points which must henceforth be taken into account.'

It is easy to take up this attitude in, for example, historical studies, where distinctions like that between the discovery of a document and the interpretation put upon it are fairly obvious, so that one historian criticizing the work of another may say that he was altogether wrong in his general view of a certain event, but the documents relating to it which he discovered are a permanent addition to knowledge. In the case of philosophical studies it is less easy, partly because there are powerful motives for not even trying to do it. Philosophers, especially those with an academic position, inherit a long tradition of arguing for the sake of arguing; even if they despair of reaching the truth, they think it a

matter of pride to make other philosophers look foolish. A hankering for academic reputation turns them into a kind of dialectical bravoes, who go about picking quarrels with their fellow philosophers and running them through in public, not for the sake of advancing knowledge, but in order to decorate themselves with scalps. It is no wonder that the subject they represent has been brought into discredit with the general public and with students who have been trained to care less for victory than for truth.

An erroneous philosophical theory is based in the first instance not on ignorance but on knowledge. The person who constructs it begins by partially understanding the subject, and goes on to distort what he knows by twisting it into conformity with some preconceived idea. A theory which has commended itself to a great many intelligent people invariably expresses a high degree of insight into the subject dealt with, and the distortion to which this has been subjected is invariably thoroughgoing and systematic. It therefore expresses many truths, but it cannot be dissected into true statements and false statements; every statement it contains has been falsified; if the truth which underlies it is to be separated out from the falsehood, a special method of analysis must be used. This consists in isolating the preconceived idea which has acted as the distorting agent, reconstructing the formula of the distortion, and re-applying it so as to correct the distortion and thus find out what it was that the people who invented or accepted the theory were trying to say. In proportion as the theory has been more widely accepted, and by more intelligent persons, the likelihood is greater that the results of this analysis will be found useful as a starting-point for further inquiries.

This method will now be applied to the technical theory of art. The formula for the distortion is known from our analysis of the notion of craft in Chapter II, § 1. Because the inventors of the theory were prejudiced in favour of that notion, they forced their own ideas about art into conformity with it. The central and primary characteristic of craft is the

distinction it involves between means and end. If art is to
be conceived as craft, it must likewise be divisible into means
and end. We have seen that actually it is not so divisible;
but we have now to ask why anybody ever thought it was.
What is there in the case of art which these people mis-
understood by assimilating it to the well-known distinction
of means and end? If there is nothing, the technical theory
of art was a gratuitous and baseless invention; those who
have stated and accepted it have been and are nothing but
a pack of fools; and we have been wasting our time thinking
about it. These are hypotheses I do not propose to adopt.

(1) This, then, is the first point we have learnt from our
criticism: that there is in art proper a distinction resembling
that between means and end, but not identical with it.

(2) The element which the technical theory calls the end
is defined by it as the arousing of emotion. The idea of
arousing (i.e. of bringing into existence, by determinate
means, something whose existence is conceived in advance
as possible and desirable) belongs to the philosophy of craft,
and is obviously borrowed thence. But the same is not true
of emotion. This, then, is our second point. Art has some-
thing to do with emotion; what it does with it has a certain
resemblance to arousing it, but is not arousing it.

(3) What the technical theory calls the means is defined
by it as the making of an artifact called a work of art. The
making of this artifact is described according to the terms
of the philosophy of craft: i.e. as the transformation of a given
raw material by imposing on it a form preconceived as a plan
in the maker's mind. To get the distortion out of this we
must remove all these characteristics of craft, and thus we
reach the third point. Art has something to do with making
things, but these things are not material things, made by im-
posing form on matter, and they are not made by skill. They
are things of some other kind, and made in some other way.

We now have three riddles to answer. For the present,
no attempt will be made to answer the first: we shall treat
it merely as a hint that the second and third should be treated

separately. In this chapter, accordingly, we shall inquire into the relation between art and emotion; in the next, the relation between art and making.

§ 2. *Expressing Emotion and Arousing Emotion*

Our first question is this. Since the artist proper has something to do with emotion, and what he does with it is not to arouse it, what is it that he does? It will be remembered that the kind of answer we expect to this question is an answer derived from what we all know and all habitually say; nothing original or recondite, but something entirely commonplace.

Nothing could be more entirely commonplace than to say he expresses them. The idea is familiar to every artist, and to every one else who has any acquaintance with the arts. To state it is not to state a philosophical theory or definition of art; it is to state a fact or supposed fact about which, when we have sufficiently identified it, we shall have later to theorize philosophically. For the present it does not matter whether the fact that is alleged, when it is said that the artist expresses emotion, is really a fact or only supposed to be one. Whichever it is, we have to identify it, that is, to decide what it is that people are saying when they use the phrase. Later on, we shall have to see whether it will fit into a coherent theory.

They are referring to a situation, real or supposed, of a definite kind. When a man is said to express emotion, what is being said about him comes to this. At first, he is conscious of having an emotion, but not conscious of what this emotion is. All he is conscious of is a perturbation or excitement, which he feels going on within him, but of whose nature he is ignorant. While in this state, all he can say about his emotion is: 'I feel . . . I don't know what I feel.' From this helpless and oppressed condition he extricates himself by doing something which we call expressing himself. This is an activity which has something to do with the thing we call language: he expresses himself by speaking. It has also something to do with consciousness: the emotion expressed is an emotion of whose nature the person who feels

it is no longer unconscious. It has also something to do with
the way in which he feels the emotion. As unexpressed, he
feels it in what we have called a helpless and oppressed way;
as expressed, he feels it in a way from which this sense of
oppression has vanished. His mind is somehow lightened
and eased.

This lightening of emotions which is somehow connected
with the expression of them has a certain resemblance to the
'catharsis' by which emotions are earthed through being
discharged into a make-believe situation; but the two things
are not the same. Suppose the emotion is one of anger. If
it is effectively earthed, for example by fancying oneself
kicking some one down stairs, it is thereafter no longer
present in the mind as anger at all: we have worked it off
and are rid of it. If it is expressed, for example by putting
it into hot and bitter words, it does not disappear from the
mind; we remain angry; but instead of the sense of oppression
which accompanies an emotion of anger not yet recognized as
such, we have that sense of alleviation which comes when we
are conscious of our own emotion as anger, instead of being
conscious of it only as an unidentified perturbation. This is
what we refer to when we say that it 'does us good' to express
our emotions.

The expression of an emotion by speech may be addressed
to some one; but if so it is not done with the intention of
arousing a like emotion in him. If there is any effect which
we wish to produce in the hearer, it is only the effect which
we call making him understand how we feel. But, as we have
already seen, this is just the effect which expressing our
emotions has on ourselves. It makes us, as well as the people
to whom we talk, understand how we feel. A person arous-
ing emotion sets out to affect his audience in a way in which
he himself is not necessarily affected. He and his audience
stand in quite different relations to the act, very much as
physician and patient stand in quite different relations to-
wards a drug administered by the one and taken by the other.
A person expressing emotion, on the contrary, is treating

himself and his audience in the same kind of way; he is making his emotions clear to his audience, and that is what he is doing to himself.

It follows from this that the expression of emotion, simply as expression, is not addressed to any particular audience. It is addressed primarily to the speaker himself, and secondarily to any one who can understand. Here again, the speaker's attitude towards his audience is quite unlike that of a person desiring to arouse in his audience a certain emotion. If that is what he wishes to do, he must know the audience he is addressing. He must know what type of stimulus will produce the desired kind of reaction in people of that particular sort; and he must adapt his language to his audience in the sense of making sure that it contains stimuli appropriate to their peculiarities. If what he wishes to do is to express his emotions intelligibly, he has to express them in such a way as to be intelligible to himself; his audience is then in the position of persons who overhear[1] him doing this. Thus the stimulus-and-reaction terminology has no applicability to the situation.

The means-and-end, or technique, terminology too is inapplicable. Until a man has expressed his emotion, he does not yet know what emotion it is. The act of expressing it is therefore an exploration of his own emotions. He is trying to find out what these emotions are. There is certainly here a directed process: an effort, that is, directed upon a certain end; but the end is not something foreseen and preconceived, to which appropriate means can be thought out in the light of our knowledge of its special character. Expression is an activity of which there can be no technique.

§ 3. *Expression and Individualization*

Expressing an emotion is not the same thing as describing it. To say 'I am angry' is to describe one's emotion, not to

[1] Further development of the ideas expressed in this paragraph will make it necessary to qualify this word and assert a much more intimate relation between artist and audience; see pp. 311–36.

express it. The words in which it is expressed need not contain any reference to anger as such at all. Indeed, so far as they simply and solely express it, they cannot contain any such reference. The curse of Ernulphus, as invoked by Dr. Slop on the unknown person who tied certain knots, is a classical and supreme expression of anger; but it does not contain a single word descriptive of the emotion it expresses.

This is why, as literary critics well know, the use of epithets in poetry, or even in prose where expressiveness is aimed at, is a danger. If you want to express the terror which something causes, you must not give it an epithet like 'dreadful'. For that describes the emotion instead of expressing it, and your language becomes frigid, that is inexpressive, at once. A genuine poet, in his moments of genuine poetry, never mentions by name the emotions he is expressing.

Some people have thought that a poet who wishes to express a great variety of subtly differentiated emotions might be hampered by the lack of a vocabulary rich in words referring to the distinctions between them; and that psychology, by working out such a vocabulary, might render a valuable service to poetry. This is the opposite of the truth. The poet needs no such words at all; the existence or non-existence of a scientific terminology describing the emotions he wishes to express is to him a matter of perfect indifference. If such a terminology, where it exists, is allowed to affect his own use of language, it affects it for the worse.

The reason why description, so far from helping expression, actually damages it, is that description generalizes. To describe a thing is to call it a thing of such and such a kind: to bring it under a conception, to classify it. Expression, on the contrary, individualizes. The anger which I feel here and now, with a certain person, for a certain cause, is no doubt an instance of anger, and in describing it as anger one is telling truth about it; but it is much more than mere anger: it is a peculiar anger, not quite like any anger that I ever felt before, and probably not quite like any anger I shall ever

feel again. To become fully conscious of it means becoming
conscious of it not merely as an instance of anger, but as this
quite peculiar anger. Expressing it, we saw, has something
to do with becoming conscious of it; therefore, if being fully
conscious of it means being conscious of all its peculiarities,
fully expressing it means expressing all its peculiarities. The
poet, therefore, in proportion as he understands his business,
gets as far away as possible from merely labelling his
emotions as instances of this or that general kind, and takes
enormous pains to individualize them by expressing them
in terms which reveal their difference from any other
emotion of the same sort.

This is a point in which art proper, as the expression of
emotion, differs sharply and obviously from any craft whose
aim it is to arouse emotion. The end which a craft sets out
to realize is always conceived in general terms, never
individualized. However accurately defined it may be, it is
always defined as the production of a thing having charac-
teristics that could be shared by other things. A joiner,
making a table out of these pieces of wood and no others,
makes it to measurements and specifications which, even if
actually shared by no other table, might in principle be
shared by other tables. A physician treating a patient for a
certain complaint is trying to produce in him a condition
which might be, and probably has been, often produced in
others, namely, the condition of recovering from that com-
plaint. So an 'artist' setting out to produce a certain emotion
in his audience is setting out to produce not an individual
emotion, but an emotion of a certain kind. It follows that
the means appropriate to its production will be not individual
means but means of a certain kind: that is to say, means
which are always in principle replaceable by other similar
means. As every good craftsman insists, there is always a
'right way' of performing any operation. A 'way' of acting
is a general pattern to which various individual actions may
conform. In order that the 'work of art' should produce its
intended psychological effect, therefore, whether this effect

be magical or merely amusing, what is necessary is that it should satisfy certain conditions, possess certain characteristics: in other words be, not this work and no other, but a work of this kind and of no other.

This explains the meaning of the generalization which Aristotle and others have ascribed to art. We have already seen that Aristotle's *Poetics* is concerned not with art proper but with representative art, and representative art of one definite kind. He is not analysing the religious drama of a hundred years before, he is analysing the amusement literature of the fourth century, and giving rules for its composition. The end being not individual but general (the production of an emotion of a certain kind) the means too are general (the portrayal, not of this individual act, but of an act of this sort; not, as he himself puts it, what Alcibiades did, but what anybody of a certain kind would do). Sir Joshua Reynolds's idea of generalization is in principle the same; he expounds it in connexion with what he calls 'the grand style', which means a style intended to produce emotions of a certain type. He is quite right; if you want to produce a typical case of a certain emotion, the way to do it is to put before your audience a representation of the typical features belonging to the kind of thing that produces it: make your kings very royal, your soldiers very soldierly, your women very feminine, your cottages very cottagesque, your oak-trees very oakish, and so on.

Art proper, as expression of emotion, has nothing to do with all this. The artist proper is a person who, grappling with the problem of expressing a certain emotion, says, 'I want to get this clear.' It is no use to him to get something else clear, however like it this other thing may be. Nothing will serve as a substitute. He does not want a thing of a certain kind, he wants a certain thing. This is why the kind of person who takes his literature as psychology, saying 'How admirably this writer depicts the feelings of women, or bus-drivers, or homosexuals . . .', necessarily misunderstands every real work of art with which he comes into contact,

and takes for good art, with infallible precision, what is not art at all.

§ 4. *Selection and Aesthetic Emotion*

It has sometimes been asked whether emotions can be divided into those suitable for expression by artists and those unsuitable. If by art one means art proper, and identifies this with expression, the only possible answer is that there can be no such distinction. Whatever is expressible is expressible. There may be ulterior motives in special cases which make it desirable to express some emotions and not others; but only if by 'express' one means express publicly, that is, allow people to overhear one expressing oneself. This is because one cannot possibly decide that a certain emotion is one which for some reason it would be undesirable to express thus publicly, unless one first becomes conscious of it; and doing this, as we saw, is somehow bound up with expressing it. If art means the expression of emotion, the artist as such must be absolutely candid; his speech must be absolutely free. This is not a precept, it is a statement. It does not mean that the artist ought to be candid, it means that he is an artist only in so far as he is candid. Any kind of selection, any decision to express this emotion and not that, is inartistic not in the sense that it damages the perfect sincerity which distinguishes good art from bad, but in the sense that it represents a further process of a non-artistic kind, carried out when the work of expression proper is already complete. For until that work is complete one does not know what emotions one feels; and is therefore not in a position to pick and choose, and give one of them preferential treatment.

From these considerations a certain corollary follows about the division of art into distinct arts. Two such divisions are current: one according to the medium in which the artist works, into painting, poetry, music, and the like; the other according to the kind of emotion he expresses, into tragic, comic, and so forth. We are concerned with the second.

If the difference between tragedy and comedy is a difference between the emotions they express, it is not a difference that can be present to the artist's mind when he is beginning his work; if it were, he would know what emotion he was going to express before he had expressed it. No artist, therefore, so far as he is an artist proper, can set out to write a comedy, a tragedy, an elegy, or the like. So far as he is an artist proper, he is just as likely to write any one of these as any other; which is the truth that Socrates was heard expounding towards the dawn, among the sleeping figures in Agathon's dining-room.[1] These distinctions, therefore, have only a very limited value. They can be properly used in two ways. (1) When a work of art is complete, it can be labelled *ex post facto* as tragic, comic, or the like, according to the character of the emotions chiefly expressed in it. But understood in that sense the distinction is of no real importance. (2) If we are talking about representational art, the case is very different. Here the so-called artist knows in advance what kind of emotion he wishes to excite, and will construct works of different kinds according to the different kinds of effect they are to produce. In the case of representational art, therefore, distinctions of this kind are not only admissible as an *ex post facto* classification of things to which in their origin it is alien; they are present from the beginning as a determining factor in the so-called artist's plan of work.

The same considerations provide an answer to the question whether there is such a thing as a specific 'aesthetic emotion'. If it is said that there is such an emotion independently of its expression in art, and that the business of

[1] Plato, *Symposium*, 223 D. But if Aristodemus heard him correctly, Socrates was saying the right thing for the wrong reason. He is reported as arguing, not that a tragic writer as such is also a comic one, but that ὁ τέχνῃ τραγῳδοποιός is also a comic writer. Emphasis on the word τέχνῃ is obviously implied; and this, with a reference to the doctrine (*Republic*, 333 E—334 A) that craft is what Aristotle was to call a potentiality of opposites, i.e. enables its possessor to do not one kind of thing only, but that kind and the opposite kind too, shows that what Socrates was doing was to assume the technical theory of art and draw from it the above conclusion.

artists is to express it, we must answer that such a view is nonsense. It implies, first, that artists have emotions of various kinds, among which is this peculiar aesthetic emotion; secondly, that they select this aesthetic emotion for expression. If the first proposition were true, the second would have to be false. If artists only find out what their emotions are in the course of finding out how to express them, they cannot begin the work of expression by deciding what emotion to express.

In a different sense, however, it is true that there is a specific aesthetic emotion. As we have seen, an unexpressed emotion is accompanied by a feeling of oppression; when it is expressed and thus comes into consciousness the same emotion is accompanied by a new feeling of alleviation or easement, the sense that this oppression is removed. It resembles the feeling of relief that comes when a burdensome intellectual or moral problem has been solved. We may call it, if we like, the specific feeling of having successfully expressed ourselves; and there is no reason why it should not be called a specific aesthetic emotion. But it is not a specific kind of emotion pre-existing to the expression of it, and having the peculiarity that when it comes to be expressed it is expressed artistically. It is an emotional colouring which attends the expression of any emotion whatever.

§ 5. *The Artist and the Ordinary Man*

I have been speaking of 'the artist', in the present chapter, as if artists were persons of a special kind, differing somehow either in mental endowment or at least in the way they use their endowment from the ordinary persons who make up their audience. But this segregation of artists from ordinary human beings belongs to the conception of art as craft; it cannot be reconciled with the conception of art as expression. If art were a kind of craft, it would follow as a matter of course. Any craft is a specialized form of skill, and those who possess it are thereby marked out from the rest of mankind. If art is the skill to amuse people, or in

general to arouse emotions in them, the amusers and the amused form two different classes, differing in their respectively active and passive relation to the craft of exciting determinate emotions; and this difference will be due, according to whether the artist is 'born' or 'made', either to a specific mental endowment in the artist, which in theories of this type has gone by the name of 'genius', or to a specific training.

If art is not a kind of craft, but the expression of emotion, this distinction of kind between artist and audience disappears. For the artist has an audience only in so far as people hear him expressing himself, and understand what they hear him saying. Now, if one person says something by way of expressing what is in his mind, and another hears and understands him, the hearer who understands him has that same thing in his mind. The question whether he would have had it if the first had not spoken need not here be raised; however it is answered, what has just been said is equally true. If some one says 'Twice two is four' in the hearing of some one incapable of carrying out the simplest arithmetical operation, he will be understood by himself, but not by his hearer. The hearer can understand only if he can add two and two in his own mind. Whether he could do it before he heard the speaker say those words makes no difference. What is here said of expressing thoughts is equally true of expressing emotions. If a poet expresses, for example, a certain kind of fear, the only hearers who can understand him are those who are capable of experiencing that kind of fear themselves. Hence, when some one reads and understands a poem, he is not merely understanding the poet's expression of his, the poet's, emotions, he is expressing emotions of his own in the poet's words, which have thus become his own words. As Coleridge put it, we know a man for a poet by the fact that he makes us poets. We know that he is expressing his emotions by the fact that he is enabling us to express ours.

Thus, if art is the activity of expressing emotions, the

reader is an artist as well as the writer. There is no distinction of kind between artist and audience. This does not mean that there is no distinction at all. When Pope wrote that the poet's business was to say 'what all have felt but none so well express'd', we may interpret his words as meaning (whether or no Pope himself consciously meant this when he wrote them) that the poet's difference from his audience lies in the fact that, though both do exactly the same thing, namely express this particular emotion in these particular words, the poet is a man who can solve for himself the problem of expressing it, whereas the audience can express it only when the poet has shown them how. The poet is not singular either in his having that emotion or in his power of expressing it; he is singular in his ability to take the initiative in expressing what all feel, and all can express.

§ 6. *The Curse of the Ivory Tower*

I have already had occasion to criticize the view that artists can or should form a special order or caste, marked off by special genius or special training from the rest of the community. That view, we have seen, was a by-product of the technical theory of art. This criticism can now be reinforced by pointing out that a segregation of this kind is not only unnecessary but fatal to the artist's real function. If artists are really to express 'what all have felt', they must share the emotions of all. Their experiences, the general attitude they express towards life, must be of the same kind as that of the persons among whom they hope to find an audience. If they form themselves into a special clique, the emotions they express will be the emotions of that clique; and the consequence will be that their work becomes intelligible only to their fellow artists. This is in fact what happened to a great extent during the nineteenth century, when the segregation of artists from the rest of mankind reached its culmination.

If art had really been a craft, like medicine or warfare, the effect of this segregation would have been all to the good,

for a craft only becomes more efficient if it organizes itself into the shape of a community devoted to serving the interests of the public in a specialized way, and planning its whole life with an eye to the conditions of this service. Because it is not a craft, but the expression of emotions, the effect was the opposite of this. A situation arose in which novelists, for example, found themselves hardly at their ease except in writing novels about novelists, which appealed to nobody except other novelists. This vicious circle was most conspicuous in certain continental writers like Anatole France or D'Annunzio, whose subject-matter often seemed to be limited by the limits of the segregated clique of 'intellectuals'. The corporate life of the artistic community became a kind of ivory tower whose prisoners could think and talk of nothing except themselves, and had only one another for audience.

Transplanted into the more individualistic atmosphere of England, the result was different. Instead of a single (though no doubt subdivided) clique of artists, all inhabiting the same ivory tower, the tendency was for each artist to construct an ivory tower of his own: to live, that is to say, in a world of his own devising, cut off not only from the ordinary world of common people but even from the corresponding worlds of other artists. Thus Burne-Jones lived in a world whose contents were ungraciously defined by a journalist as 'green light and gawky girls'; Leighton in a world of sham Hellenism; and it was the call of practical life that rescued Yeats from the sham world of his youthful Celtic twilight, forced him into the clear air of real Celtic life, and made him a great poet.

In these ivory towers art languished. The reason is not hard to understand. A man might easily have been born and bred within the confines of a society as narrow and specialized as any nineteenth-century artistic coterie, thinking its thoughts and feeling its emotions because his experience contained no others. Such a man, in so far as he expressed these emotions, would be genuinely expressing his own

experience. The narrowness or wideness of the experience which an artist expresses has nothing to do with the merits of his art. A Jane Austen, born and bred in an atmosphere of village gossip, can make great art out of the emotions that atmosphere generates. But a person who shuts himself up in the limits of a narrow coterie has an experience which includes the emotions of the larger world in which he was born and bred, as well as those of the little society he has chosen to join. If he decides to express only the emotions that pass current within the limits of that little society, he is selecting certain of his emotions for expression. The reason why this inevitably produces bad art is that, as we have already seen, it can only be done when the person selecting already knows what his emotions are; that is, has already expressed them. His real work as an artist is a work which, as a member of his artistic coterie, he repudiates. Thus the literature of the ivory tower is a literature whose only possible value is an amusement value by which persons imprisoned within that tower, whether by their misfortune or their fault, help themselves and each other to pass their time without dying of boredom or of home-sickness for the world they have left behind; together with a magical value by which they persuade themselves and each other that imprisonment in such a place and in such company is a high privilege. Artistic value it has none.

§ 7. *Expressing Emotion and Betraying Emotion*

Finally, the expressing of emotion must not be confused with what may be called the betraying of it, that is, exhibiting symptoms of it. When it is said that the artist in the proper sense of that word is a person who expresses his emotions, this does not mean that if he is afraid he turns pale and stammers; if he is angry he turns red and bellows; and so forth. These things are no doubt called expressions; but just as we distinguish proper and improper senses of the word 'art', so we must distinguish proper and improper senses of the word 'expression', and in the context of a discussion

about art this sense of expression is an improper sense. The characteristic mark of expression proper is lucidity or intelligibility; a person who expresses something thereby becomes conscious of what it is that he is expressing, and enables others to become conscious of it in himself and in them. Turning pale and stammering is a natural accompaniment of fear, but a person who in addition to being afraid also turns pale and stammers does not thereby become conscious of the precise quality of his emotion. About that he is as much in the dark as he would be if (were that possible) he could feel fear without also exhibiting these symptoms of it.

Confusion between these two senses of the word 'expression' may easily lead to false critical estimates, and so to false aesthetic theory. It is sometimes thought a merit in an actress that when she is acting a pathetic scene she can work herself up to such an extent as to weep real tears. There may be some ground for that opinion if acting is not an art but a craft, and if the actress's object in that scene is to produce grief in her audience; and even then the conclusion would follow only if it were true that grief cannot be produced in the audience unless symptoms of grief are exhibited by the performer. And no doubt this is how most people think of the actor's work. But if his business is not amusement but art, the object at which he is aiming is not to produce a preconceived emotional effect on his audience but by means of a system of expressions, or language, composed partly of speech and partly of gesture, to explore his own emotions: to discover emotions in himself of which he was unaware, and, by permitting the audience to witness the discovery, enable them to make a similar discovery about themselves. In that case it is not her ability to weep real tears that would mark out a good actress; it is her ability to make it clear to herself and her audience what the tears are about.

This applies to every kind of art. The artist never rants. A person who writes or paints or the like in order to blow off steam, using the traditional materials of art as means for

exhibiting the symptoms of emotion, may deserve praise as an exhibitionist, but loses for the moment all claim to the title of artist. Exhibitionists have their uses; they may serve as an amusement, or they may be doing magic. The second category will contain, for example, those young men who, learning in the torment of their own bodies and minds what war is like, have stammered their indignation in verses, and published them in the hope of infecting others and causing them to abolish it. But these verses have nothing to do with poetry.

Thomas Hardy, at the end of a fine and tragic novel in which he has magnificently expressed his sorrow and indignation for the suffering inflicted by callous sentimentalism on trusting innocence, spoils everything by a last paragraph fastening his accusation upon 'the president of the immortals'. The note rings false, not because it is blasphemous (it offends no piety worthy of the name), but because it is rant. The case against God, so far as it exists, is complete already. The concluding paragraph adds nothing to it. All it does is to spoil the effect of the indictment by betraying a symptom of the emotion which the whole book has already expressed; as if a prosecuting counsel, at the end of his speech, spat in the prisoner's face.

The same fault is especially common in Beethoven. He was confirmed in it, no doubt, by his deafness; but the cause of it was not his deafness but a temperamental inclination to rant. It shows itself in the way his music screams and mutters instead of speaking, as in the soprano part of the Mass in D, or the layout of the opening page in the *Hammer-klavier* Sonata. He must have known his failing and tried to overcome it, or he would never have spent so many of his ripest years among string quartets, where screaming and muttering are almost, one might say, physically impossible. Yet even there, the old Adam struts out in certain passages of the *Grosse Fuge*.

It does not, of course, follow that a dramatic writer may not rant in character. The tremendous rant at the end of

The Ascent of F6, like the Shakespearian[1] ranting on which it is modelled, is done with tongue in cheek. It is not the author who is ranting, but the unbalanced character he depicts; the emotion the author is expressing is the emotion with which he contemplates that character; or rather, the emotion he has towards that secret and disowned part of himself for which the character stands.

[1] Shakespeare's characters rant (1) when they are characters in which he takes no interest at all, but which he uses simply as pegs on which to hang what the public wants, like Henry V; (2) when they are meant to be despicable, like Pistol; or (3) when they have lost their heads, like Hamlet in the graveyard.

ART PROPER: (2) AS IMAGINATION

§ 1. *The Problem Defined*

THE next question in the programme laid down at the beginning of the preceding chapter was put in this way: What is a work of art, granted that there is something in art proper (not only in art falsely so called) to which that name is applied, and that, since art is not craft, this thing is not an artifact? It is something made by the artist, but not made by transforming a given raw material, nor by carrying out a preconceived plan, nor by way of realizing the means to a preconceived end. What is this kind of making?

Here are two questions which, however closely they are connected, we shall do well to consider separately. We had better begin with the artist, and put the second question first. I shall therefore begin by asking: What is the nature of this making which is not technical making, or, if we want a one-word name for it, not fabrication? It is important not to misunderstand the question. When we asked what expression was, in the preceding chapter, it was pointed out that the writer was not trying to construct an argument intended to convince the reader, nor to offer him information, but to remind him of what (if he is a person whose experience of the subject-matter has been sufficient to qualify him for reading books of this kind) he knows already. So here. We are not asking for theories but for facts. And the facts for which we are asking are not recondite facts. They are facts well known to the reader. The order of facts to which they belong may be indicated by saying that they are the ways in which all of us who are concerned with art habitually think about it, and the ways in which we habitually express our thoughts in ordinary speech.

By way of making this clearer, I will indicate the kind of way in which our question cannot be answered. A great

many people who have put to themselves the question 'What is this making, characteristic of the artist, which is not a fabrication?' have sought an answer in some such way as the following: 'This non-technical making is plainly not an accidental making, for works of art could not be produced by accident.[1] Something must be in control. But if this is not the artist's skill, it cannot be his reason or will or consciousness. It must therefore be something else; either some controlling force outside the artist, in which case we may call it inspiration, or something inside him but other than his will and so forth. This must be either his body, in which case the production of a work of art is at bottom a physiological activity, or else it is something mental but unconscious, in which case the productive force is the artist's unconscious mind.'

Many imposing theories of art have been built on these foundations. The first alternative, that the artist's activity is controlled by some divine or at least spiritual being that uses him as its mouthpiece, is out of fashion to-day, but that is no reason why we should refuse it a hearing. It does at least fit the facts better than most of the theories of art nowadays current. The second alternative, that the artist's work is controlled by forces which, though part of himself and specifically part of his mind, are not voluntary and not conscious, but work in some mental cellar unseen and unbidden by the dwellers in the house above, is extremely

[1] I am talking of quite sensible people. There are others; some of them have denied this proposition, pointing out that if a monkey played with a typewriter for long enough, rattling the keys at random, there is a calculable probability that within a certain time he would produce, purely by accident, the complete text of Shakespeare. Any reader who has nothing to do can amuse himself by calculating how long it would take for the probability to be worth betting on. But the interest of the suggestion lies in the revelation of the mental state of a person who can identify the 'works' of Shakespeare with the series of letters printed on the pages of a book bearing that phrase as its title; and thinks, if he can be said to think at all, that an archaeologist of 10,000 years hence, recovering a complete text of Shakespeare from the sands of Egypt but unable to read a single word of English, would possess Shakespeare's dramatic and poetic works.

popular; not among artists, but among psychologists and their numerous disciples, who handle the theory with a great deal of confidence and seem to believe that by its means the riddle of art has at last been solved.[1] The third alternative was popular with the physiological psychologists of the last century, and Grant Allen still remains its best exponent.

It would be waste of time to criticize these theories. The question about them is not whether they are good or bad, considered as examples of theorizing; but whether the problem which they are meant to solve is one that calls for theorizing in order to solve it. A person who cannot find his spectacles on the table may invent any number of theories to account for their absence. They may have been spirited away by a benevolent deity, to prevent him from over-working, or by a malicious demon, to interfere with his studies, or by a neighbouring mahatma, to convince him that such things can be done. He may have unconsciously made away with them himself, because they unconsciously remind him of his oculist, who unconsciously reminds him of his father, whom he unconsciously hates. Or he may have pushed them off the table while moving a book. But these theories, however ingenious and sublime, are premature if the spectacles should happen to be on his nose.

Theories professing to explain how works of art are constructed by means of hypotheses like these are based on recollecting that the spectacles are not on the table, and overlooking the fact that they are on the nose. Those who put them forward have not troubled to ask themselves whether we are in point of fact familiar with a kind of activity productive of results and under the agent's voluntary

[1] Mr. Robert Graves (*Poetic Unreason*, 1925) is almost the only practising man of letters or artist in this country who has come forward to back up the psychologists. Generally speaking, the judgement of literary men on the qualifications of the people who advocate this theory is sufficiently represented by Dr. I. A. Richards: 'To judge by the published work of Freud upon Leonardo da Vinci or of Jung upon Goethe (e.g. *The Psychology of the Unconscious*, p. 305) psycho-analysts tend to be peculiarly inept as critics' (*Principles of Literary Criticism*, ed. 5, 1934, pp. 29–30).

control, which has none of the special characteristics of craft. If they had asked the question, they must have answered it in the affirmative. We are perfectly familiar with activities of this kind; and our ordinary name for them is *creation*.

§ 2. *Making and Creating*

Before we ask what in general are the occasions on which we use this word, we must forestall a too probable objection to the word itself. Readers suffering from theophobia will certainly by now have taken offence. Knowing as they do that theologians use it for describing the relation of God to the world, victims of this disease smell incense whenever they hear it spoken, and think it a point of honour that it shall never sully their lips or ears. They will by now have on the tips of their tongues all the familiar protests against an aesthetic mysticism that raises the function of art to the level of something divine and identifies the artist with God. Perhaps some day, with an eye on the Athanasian Creed, they will pluck up courage to excommunicate an arithmetician who uses the word three. Meanwhile, readers willing to understand words instead of shying at them will recollect that the word 'create' is daily used in contexts that offer no valid ground for a fit of *odium theologicum*. If a witness in court says that a drunken man was creating a noise, or that a dance club has created a nuisance, if an historian says that somebody or other created the English navy or the Fascist state, if a publicist says that secret diplomacy creates international distrust, or the chairman of a company says that increased attention to advertisement will create an increased demand for its produce, no one expects a little man at the back of the room to jump up and threaten to leave unless the word is withdrawn. If he did, the stewards would throw him out for creating a disturbance.

To create something means to make it non-technically, but yet consciously and voluntarily. Originally, *creare* means to generate, or make offspring, for which we still use its compound 'procreate,' and the Spaniards have *criatura*, for

a child. The act of procreation is a voluntary act, and those who do it are responsible for what they are doing; but it is not done by any specialized form of skill. It need not be done (as it may be in the case of a royal marriage) as a means to any preconceived end. It need not be done (as it was by Mr. Shandy senior) according to any preconceived plan. It cannot be done (whatever Aristotle may say) by imposing a new form on any pre-existing matter. It is in this sense that we speak of creating a disturbance or a demand or a political system. The person who makes these things is acting voluntarily; he is acting responsibly; but he need not be acting in order to achieve any ulterior end; he need not be following a preconceived plan; and he is certainly not transforming anything that can properly be called a raw material. It is in the same sense that Christians asserted, and neo-Platonists denied, that God created the world.

This being the established meaning of the word, it should be clear that when we speak of an artist as making a poem, or a play, or a painting, or a piece of music, the kind of making to which we refer is the kind we call creating. For, as we already know, these things, in so far as they are works of art proper, are not made as means to an end; they are not made according to any preconceived plan; and they are not made by imposing a new form upon a given matter. Yet they are made deliberately and responsibly, by people who know what they are doing, even though they do not know in advance what is going to come of it.

The creation which theologians ascribe to God is peculiar in one way and only one. The peculiarity of the act by which God is said to create the world is sometimes supposed to lie in this, that God is said to create the world 'out of nothing', that is to say, without there being previously any matter upon which he imposes a new form. But that is a confusion of thought. In that sense, all creation is creation out of nothing. The peculiarity which is really ascribed to God is that in the case of his act there lacks not only a

prerequisite in the shape of a matter to be transformed, but any prerequisite of any kind whatsoever. This would not apply to the creation of a child, or a nuisance, or a work of art. In order that a child should be created, there must be a whole world of organic and inorganic matter, not because the parents fabricate the child out of this matter, but because a child can come into existence, as indeed its parents can exist, only in such a world. In order that a nuisance should be created, there must be persons capable of being annoyed, and the person who creates the nuisance must already be acting in a manner which, if modified this way or that, would annoy them. In order that a work of art should be created, the prospective artist (as we saw in the preceding chapter) must have in him certain unexpressed emotions, and must also have the wherewithal to express them. In these cases, where creation is done by finite beings, it is obvious that these beings, because finite, must first be in circumstances that enable them to create. Because God is conceived as an infinite being, the creation ascribed to him is conceived as requiring no such conditions.

Hence, when I speak of the artist's relation to his works of art as that of a creator, I am not giving any excuse to unintelligent persons who think, whether in praise or dispraise of my notions, that I am raising the function of art to the level of something divine or making the artist into a kind of God.

§ 3. *Creation and Imagination*

We must proceed to a further distinction. All the things taken above as examples of things created are what we ordinarily call real things. A work of art need not be what we should call a real thing. It may be what we call an imaginary thing. A disturbance, or a nuisance, or a navy, or the like, is not created at all until it is created as a thing having its place in the real world. But a work of art may be completely created when it has been created as a thing whose only place is in the artist's mind.

Here, I am afraid, it is the metaphysician who will take offence. He will remind me that the distinction between real things and things that exist only in our minds is one to which he and his fellows have given a great deal of attention. They have thought about it so long and so intently that it has lost all meaning. Some of them have decided that the things we call real are only in our minds; others that the things we describe as being in our minds are thereby implied to be just as real as anything else. These two sects, it appears, are engaged in a truceless war, and any one who butts in by using the words about which they are fighting will be set upon by both sides and torn to pieces.

I do not hope to placate these gentlemen. I can only cheer myself up by reflecting that even if I go on with what I was saying they cannot eat me. If an engineer has decided how to build a bridge, but has not made any drawings or specifications for it on paper, and has not discussed his plan with any one or taken any steps towards carrying it out, we are in the habit of saying that the bridge exists only in his mind, or (as we also say) in his head. When the bridge is built, we say that it exists not only in his head but in the real world. A bridge which 'exists only in the engineer's head' we also call an imaginary bridge; one which 'exists in the real world' we call a real bridge.

This may be a silly way of speaking; or it may be an unkind way of speaking, because of the agony it gives to metaphysicians; but it is a way in which ordinary people do speak, and ordinary people who speak in that way know quite well what kind of things they are referring to. The metaphysicians are right in thinking that difficult problems arise from talking in that way; and I shall spend the greater part of Book II in discussing these problems. Meanwhile, I shall go on 'speaking with the vulgar'; if metaphysicians do not like it they need not read it.

The same distinction applies to such things as music. If a man has made up a tune but has not written it down or sung it or played it or done anything which could make it public

property, we say that the tune exists only in his mind, or only in his head, or is an imaginary tune. If he sings or plays it, thus making a series of audible noises, we call this series of noises a real tune as distinct from an imaginary one.

When we speak of making an artifact we mean making a real artifact. If an engineer said that he had made a bridge, and when questioned turned out to mean that he had only made it in his head, we should think him a liar or a fool. We should say that he had not made a bridge at all, but only a plan for one. If he said he had made a plan for a bridge and it turned out that he had put nothing on paper, we should not necessarily think he had deceived us. A plan is a kind of thing that can only exist in a person's mind. As a rule, an engineer making a plan in his mind is at the same time making notes and sketches on paper; but the plan does not consist of what we call the 'plans', that is, the pieces of paper with these notes and sketches on them. Even if he has put complete specifications and working drawings on paper, the paper with these specifications and drawings on it is not the plan; it only serves to tell people (including himself, for memory is fallible) what the plan is. If the specifications and drawings are published, for example in a treatise on civil engineering, any one who reads the treatise intelligently will get the plan of that bridge into his head. The plan is therefore public property, although by calling it public we mean only that it can get into the heads of many people; as many as read intelligently the book in which the specifications and drawings are published.

In the case of the bridge there is a further stage. The plan may be 'executed' or carried out; that is to say, the bridge may be built. When that is done, the plan is said to be 'embodied' in the built bridge. It has begun to exist in a new way, not merely in people's heads but in stone or concrete. From being a mere plan existing in people's heads, it has become the form imposed on certain matter. Looking back from that point of view, we can now say that the engineer's plan was the form of the bridge without its matter,

or that when we describe him as having the plan in his mind we might equally have described him as having in mind the form of the finished bridge without its matter.

The making of the bridge is the imposing of this form on this matter. When we speak of the engineer as making the plan, we are using the word 'make' in its other sense, as equivalent to create. Making a plan for a bridge is not imposing a certain form on a certain matter; it is a making that is not a transforming, that is to say, it is a creation. It has the other characteristics, too, that distinguish creating from fabricating. It need not be done as means to an end, for a man can make plans (for example, to illustrate a text-book of engineering) with no intention of executing them. In such a case the making of the plan is not means to composing the text-book, it is part of composing the text-book. It is not means to anything. Again, a person making a plan need not be carrying out a plan to make that plan. He may be doing this; he may for instance have planned a text-book for which he needs an example of a reinforced concrete bridge with a single span of 150 feet, to carry a two-track railway with a roadway above it, and he may work out a plan for such a bridge in order that it may occupy that place in the book. But this is not a necessary condition of planning. People sometimes speak as if everybody had, or ought to have, a plan for his whole life, to which every other plan he makes is or ought to be subordinated; but no one can do that.

Making an artifact, or acting according to craft, thus consists of two stages. (1) Making the plan, which is creating. (2) Imposing that plan on certain matter, which is fabricating. Let us now consider a case of creating where what is created is not a work of art. A person creating a disturbance need not be, though of course he may be, acting on a plan. He need not be, though of course he may be, creating it as means to some ulterior end, such as causing a government to resign. He cannot be transforming a pre-existing material, for there is nothing out of which a

disturbance can be made; though he is able to create it only because he already stands, as a finite being always does stand, in a determinate situation; for example, at a political meeting. But what he creates cannot be something that exists only in his own mind. A disturbance is something in the minds of the people disturbed.

Next, let us take the case of a work of art. When a man makes up a tune, he may and very often does at the same time hum it or sing it or play it on an instrument. He may do none of these things, but write it on paper. Or he may both hum it or the like, and also write it on paper at the same time or afterwards. Also he may do these things in public, so that the tune at its very birth becomes public property, like the disturbance we have just considered. But all these are accessories of the real work, though some of them are very likely useful accessories. The actual making of the tune is something that goes on in his head, and nowhere else.

I have already said that a thing which 'exists in a person's head' and nowhere else is alternatively called an imaginary thing. The actual making of the tune is therefore alternatively called the making of an imaginary tune. This is a case of creation, just as much as the making of a plan or a disturbance, and for the same reasons, which it would be tedious to repeat. Hence the making of a tune is an instance of imaginative creation. The same applies to the making of a poem, or a picture, or any other work of art.

The engineer, as we saw, when he made his plan in his own head, may proceed to do something else which we call 'making his plans'. His 'plans', here, are drawings and specifications on paper, and these are artifacts made to serve a certain purpose, namely to inform others or remind himself of the plan. The making of them is accordingly not imaginative creation; indeed, it is not creation at all. It is fabrication, and the ability to do it is a specialized form of skill, the craft of engineer's draughtsmanship.

The artist, when he has made his tune, may go on to do something else which at first sight seems to resemble this:

he may do what is called publishing it. He may sing or play it aloud, or write it down, and thus make it possible for others to get into their heads the same thing which he has in his. But what is written or printed on music-paper is not the tune. It is only something which when studied intelligently will enable others (or himself, when he has forgotten it) to construct the tune for themselves in their own heads.

The relation between making the tune in his head and putting it down on paper is thus quite different from the relation, in the case of the engineer, between making a plan for a bridge and executing that plan. The engineer's plan is embodied in the bridge: it is essentially a form that can be imposed on certain matter, and when the bridge is built the form is there, in the bridge, as the way in which the matter composing it is arranged. But the musician's tune is not there on the paper at all. What is on the paper is not music, it is only musical notation. The relation of the tune to the notation is not like the relation of the plan to the bridge; it is like the relation of the plan to the specifications and drawings; for these, too, do not embody the plan as the bridge embodies it, they are only a notation from which the abstract or as yet unembodied plan can be reconstructed in the mind of a person who studies them.

§ 4. *Imagination and Make-believe*

Imagination, like art itself, is a word with proper and improper meanings. For our present purpose it will be enough to distinguish imagination proper from one thing that is often improperly so called: a thing already referred to under the name of make-believe.

Make-believe involves a distinction between that which is called by this name and that which is called real; and this distinction is of such a kind that the two exclude one another. A make-believe situation can never be a real situation, and vice versa. If, being hungry, I 'imagine' myself to be eating, this 'bare imagination of a feast' is a make-believe situation which I may be said to create for myself imaginatively; but

this imaginative creation has nothing to do with art proper, though it has much to do with certain kinds of art falsely so called. It is the motive of all those sham works of art which provide their audiences or addicts with fantasies depicting a state of things in which their desires are satisfied. Dreaming consists to a great extent (some psychologists say altogether) of make-believe in which the dreamer's desires are thus satisfied; day-dreaming even more obviously so; and the sham works of art of which I am speaking are perhaps best understood as an organized and commercialized development of day-dreaming. A story is told of a psychologist who issued a questionnaire to all the girl students in a college, asking them how they spent their time, and learnt from their replies that I forget what vast percentage of it was spent in day-dreaming. He is said to have come to the conclusion that great results could be achieved if all this day-dreaming could be co-ordinated. Quite right; but he overlooked the fact that the thing had already been done, and that Hollywood was there to prove it.

Imagination is indifferent to the distinction between the real and the unreal.[1] When I look out of the window, I see grass to right and left of the mullion that stands immediately before me; but I also imagine the grass going on where this mullion hides it from my sight. It may happen that I also imagine a lawn-mower standing on that part of the lawn. Now, the hidden part of the lawn is really there, the lawnmower is not; but I can detect nothing, either in the way in which I imagine the two things, or in the ways in which they respectively appear to my imagination, which at all corresponds to this distinction. The act of imagining is of course an act really performed; but the imagined object or situation or event is something which need not be real and need not be unreal, and the person imagining it neither imagines

[1] Further development of this point below, in Chapter XIII, § 1, will involve a certain modification of the statement that what is imagined is as such neither real nor unreal. The reader understands, I hope, that everything I say in Book I is avowedly provisional, and that my theory of art is not stated until Book III.

it as real or unreal, nor, when he comes to reflect on his act of imagining, thinks of it as real or unreal. Make-believe, too, is a thing which can be done without reflecting on it. When it is so done, the person who does it is unaware that he is constructing for himself unreal objects or situations or events; but when he reflects, he either discovers that these things are unreal, or else falls into the error of taking them for realities.

There is probably always a motive behind any act of make-believe, namely, the desire for something which we should enjoy or possess if the make-believe were truth. It implies a felt dissatisfaction with the situation in which one actually stands, and an attempt to compensate for this dissatisfaction not by practical means, by bringing a more satisfactory state of things into existence, but by imagining a more satisfactory state of things and getting what satisfaction one can out of that. For imagination proper there is no such motive. It is not because I am dissatisfied with the match-box lying before me on the table that I imagine its inside, whether as full or as empty; it is not because I am dissatisfied with an interrupted grass-plot that I imagine it as continuing where the mullion hides it from my view. Imagination is indifferent, not only to the distinction between real and unreal, but also to the distinction between desire and aversion.

Make-believe presupposes imagination, and may be described as imagination operating in a peculiar way under the influence of peculiar forces. Out of the numerous things which one imagines, some are chosen, whether consciously or unconsciously, to be imagined with peculiar completeness or vividness or tenacity, and others are repressed, because the first are things whose reality one desires, and the second things from whose reality one has an aversion. The result is make-believe, which is thus imagination acting under the censorship of desire; where desire means not the desire to imagine, nor even the desire to realize an imagined situation, but the desire that the situation imagined were real.

A good deal of damage has been done to aesthetic theory by confusing these two things. The connexion between art and imagination has been a commonplace for at least two hundred years;[1] but the confusion between art and amusement has been both reflected and reinforced by a confusion between imagination and make-believe, which culminates in the attempt of the psycho-analysts to subsume artistic creation under their theory (certainly a true theory) of 'fantasies' as make-believe gratifications of desire. This attempt is admirably successful so long as it deals with the art, falsely so called, of the ordinary popular novel or film; but it could not conceivably be applied to art proper. When the attempt is made to base an aesthetic upon it (a thing which has happened lamentably often) the result is not an aesthetic but an anti-aesthetic. This may be because the psychologists who have tried to explain artistic creation by appeal to the notion of 'fantasy' have no idea that there is any such distinction as that between amusement art and art proper, but are merely perpetuating in their own jargon a vulgar misconception, common in the nineteenth century, according to which the artist is a kind of dreamer or day-dreamer, constructing in fancy a make-believe world which if it existed would be, at least in his own opinion, a better or more pleasant one than that in which we live. Competent artists and competent aestheticians have again and again protested against this misconception; but the protest has naturally had no effect on the many people whose experience of so-called art, being limited to the 'art' of organized and commercialized day-dreaming, it faithfully describes. And to this class it would seem that our psycho-analyst aestheticians belong. Or perhaps it is their patients that belong to it. An excessive indulgence in day-dreaming would certainly tend to produce moral diseases like those from which their patients suffer.

[1] The habit of calling aesthetic experience 'the pleasures of the imagination' dates back, I think, to Addison; the philosophical theory of art as imagination, to his contemporary Vico.

§ 5. *The Work of Art as Imaginary Object*

If the making of a tune is an instance of imaginative creation, a tune is an imaginary thing. And the same applies to a poem or a painting or any other work of art. This seems paradoxical; we are apt to think that a tune is not an imaginary thing but a real thing, a real collection of noises; that a painting is a real piece of canvas covered with real colours; and so on. I hope to show, if the reader will have patience, that there is no paradox here; that both these propositions express what we do as a matter of fact say about works of art; and that they do not contradict one another, because they are concerned with different things.

When, speaking of a work of art (tune, picture, &c.), we mean by art a specific craft, intended as a stimulus for producing specific emotional effects in an audience, we certainly mean to designate by the term 'work of art' something that we should call real. The artist as magician or purveyor of amusement is necessarily a craftsman making real things, and making them out of some material according to some plan. His works are as real as the works of an engineer, and for the same reason.

But it does not at all follow that the same is true of an artist proper. His business is not to produce an emotional effect in an audience, but, for example, to make a tune. This tune is already complete and perfect when it exists merely as a tune in his head, that is, an imaginary tune. Next, he may arrange for the tune to be played before an audience. Now there comes into existence a real tune, a collection of noises. But which of these two things is the work of art? Which of them is the music? The answer is implied in what we have already said: the music, the work of art, is not the collection of noises, it is the tune in the composer's head. The noises made by the performers, and heard by the audience, are not the music at all; they are only means by which the audience, if they listen intelligently (not otherwise), can reconstruct for themselves the imaginary tune that existed in the composer's head.

This is not a paradox. It is not something παρὰ Δόξαν, contrary to what we ordinarily believe and express in our ordinary speech. We all know perfectly well, and remind each other often enough, that a person who hears the noises the instruments make is not thereby possessing himself of the music. Perhaps no one can do that unless he does hear the noises; but there is something else which he must do as well. Our ordinary word for this other thing is listening; and the listening which we have to do when we hear the noises made by musicians is in a way rather like the thinking we have to do when we hear the noises made, for example, by a person lecturing on a scientific subject. We hear the sound of his voice; but what he is doing is not simply to make noises, but to develop a scientific thesis. The noises are meant to assist us in achieving what he assumes to be our purpose in coming to hear him lecture, that is, thinking this same scientific thesis for ourselves. The lecture, therefore, is not a collection of noises made by the lecturer with his organs of speech; it is a collection of scientific thoughts related to those noises in such a way that a person who not only hears but thinks as well becomes able to think these thoughts for himself. We may call this the communication of thought by means of speech, if we like; but if we do, we must think of communication not as an 'imparting' of thought by the speaker to the hearer, the speaker somehow planting his thought in the hearer's receptive mind, but as a 'reproduction' of the speaker's thought by the hearer, in virtue of his own active thinking.

The parallel with listening to music is not complete. The two cases are similar at one point, dissimilar at another. They are dissimilar in that a concert and a scientific lecture are different things, and what we are trying to 'get out of' the concert is a thing of a different kind from the scientific thoughts we are trying to 'get out of' the lecture. But they are similar in this: that just as what we get out of the lecture is something other than the noises we hear proceeding from the lecturer's mouth, so what we get out of the concert is

something other than the noises made by the performers. In each case, what we get out of it is something which we have to reconstruct in our own minds, and by our own efforts; something which remains for ever inaccessible to a person who cannot or will not make efforts of the right kind, however completely he hears the sounds that fill the room in which he is sitting.

This, I repeat, is something we all know perfectly well. And because we all know it, we need not trouble to examine or criticize the ideas of aestheticians (if there are any left to-day—they were common enough at one time) who say that what we get out of listening to music, or looking at paintings, or the like, is some peculiar kind of sensual pleasure. When we do these things, we certainly may, in so far as we are using our senses, enjoy sensual pleasures. It would be odd if we did not. A colour, or a shape, or an instrumental timbre may give us an exquisite pleasure of a purely sensual kind. It may even be true (though this is not so certain) that no one would become a lover of music unless he were more susceptible than other people to the sensual pleasure of sound. But even if a special susceptibility to this pleasure may at first lead some people towards music, they must, in proportion as they are more susceptible, take the more pains to prevent that susceptibility from interfering with their power of listening. For any concentration on the pleasantness of the noises themselves concentrates the mind on hearing, and makes it hard or impossible to listen. There is a kind of person who goes to concerts mainly for the sensual pleasure he gets from the sheer sounds; his presence may be good for the box-office, but it is as bad for music as the presence of a person who went to a scientific lecture for the sensual pleasure he got out of the tones of the lecturer's voice would be for science. And this, again, everybody knows.

It is unnecessary to go through the form of applying what has been said about music to the other arts. We must try instead to make in a positive shape the point that has been put negatively. Music does not consist of heard noises,

paintings do not consist of seen colours, and so forth. Of what, then, do these things consist? Not, clearly, of a 'form', understood as a pattern or a system of relations between the various noises we hear or the various colours we see. Such 'forms' are nothing but the perceived structures of bodily 'works of art', that is to say, 'works of art' falsely so called; and these formalistic theories of art, popular though they have been and are, have no relevance to art proper and will not be further considered in this book. The distinction between form and matter, on which they are based, is a distinction belonging to the philosophy of craft, and not applicable to the philosophy of art.

The work of art proper is something not seen or heard, but something imagined. But what is it that we imagine? We have suggested that in music the work of art proper is an imagined tune. Let us begin by developing this idea.

Everybody must have noticed a certain discrepancy between what we actually see when looking at a picture or statue or play and what we see imaginatively; what we actually see when listening to music or speech and what we imaginatively hear. To take an obvious example: in watching a puppet-play we could (as we say) swear that we have seen the expression on the puppets' faces change with their changing gestures and the puppet-man's changing words and tones of voice. Knowing that they are only puppets, we know that their facial expression cannot change; but that makes no difference; we continue to see imaginatively the expressions which we know that we do not see actually. The same thing happens in the case of masked actors like those of the Greek stage.

In listening to the pianoforte, again, we know from evidence of the same kind that we must be hearing every note begin with a *sforzando*, and fade away for the whole length of time that it continues to sound. But our imagination enables us to read into this experience something quite different. As we seem to see the puppets' features move, so we seem to hear a pianist producing a *sostenuto* tone, almost like that of a horn; and in fact notes of the horn and the

pianoforte are easily mistaken one for the other. Still stranger, when we hear a violin and pianoforte playing together in the key, say, of G, the violin's F sharp is actually played a great deal sharper than the pianoforte's. Such a discrepancy would sound intolerably out of tune except to a person whose imagination was trained to focus itself on the key of G, and silently corrected every note of the equally tempered pianoforte to suit it. The corrections which imagination must thus carry out, in order that we should be able to listen to an entire orchestra, beggar description. When we listen to a speaker or singer, imagination is constantly supplying articulate sounds which actually our ears do not catch. In looking at a drawing in pen or pencil, we take a series of roughly parallel lines for the tint of a shadow. And so on.

Conversely, in all these cases imagination works negatively. We disimagine, if I may use the word, a great deal which actually we see and hear. The street noises at a concert, the noises made by our breathing and shuffling neighbours, and even some of the noises made by the performers, are thus shut out of the picture unless by their loudness or in some other way they are too obtrusive to be ignored. At the theatre, we are strangely able to ignore the silhouettes of the people sitting in front of us, and a good many things that happen on the stage. Looking at a picture, we do not notice the shadows that fall on it or, unless it is excessive, the light reflected from its varnish.

All this is commonplace. And the conclusion has already been stated by Shakespeare's Theseus: 'the best in this kind ['works of art', as things actually perceived by the senses] are but shadows, and the worst are no worse if imagination amend them.' The music to which we listen is not the heard sound, but that sound as amended in various ways by the listener's imagination, and so with the other arts.

But this does not go nearly far enough. Reflection will show that the imagination with which we listen to music is something more, and more complex, than any inward ear;

the imagination with which we look at paintings is something more than 'the mind's eye'. Let us consider this in the case of painting.

§ 6. *The Total Imaginative Experience*

The change which came over painting at the close of the nineteenth century was nothing short of revolutionary. Every one in the course of that century had supposed that painting was 'a visual art'; that the painter was primarily a person who used his eyes, and used his hands only to record what the use of his eyes had revealed to him. Then came Cézanne, and began to paint like a blind man. His still-life studies, which enshrine the essence of his genius, are like groups of things that have been groped over with the hands; he uses colour not to reproduce what he sees in looking at them but to express almost in a kind of algebraic notation what in this groping he has felt. So with his interiors; the spectator finds himself bumping about those rooms, circumnavigating with caution those menacingly angular tables, coming up to the persons that so massively occupy those chairs and fending himself off them with his hands. It is the same when Cézanne takes us into the open air. His landscapes have lost almost every trace of visuality. Trees never looked like that; that is how they feel to a man who encounters them with his eyes shut, blundering against them blindly. A bridge is no longer a pattern of colour, as it is for Cotman; or a patch of colour so distorted as to arouse in the spectator the combined emotions of antiquarianism and vertigo, as it is for Mr. Frank Brangwyn; it is a perplexing mixture of projections and recessions, over and round which we find ourselves feeling our way as one can imagine an infant feeling its way, when it has barely begun to crawl, among the nursery furniture. And over the landscape broods the obsession of Mont Saint-Victoire, never looked at, but always felt, as a child feels the table over the back of its head.

Of course Cézanne was right. Painting can never be a visual art. A man paints with his hands, not with his eyes.

The Impressionist doctrine that what one paints is light[1] was a pedantry which failed to destroy the painters it enslaved only because they remained painters in defiance of the doctrine: men of their hands, men who did their work with fingers and wrist and arm, and even (as they walked about the studio) with their legs and toes. What one paints is what can be painted; no one can do more; and what can be painted must stand in some relation to the muscular activity of painting it. Cézanne's practice reminds one of Kant's theory that the painter's only use for his colours is to make shapes visible. But it is really quite different. Kant thought of the painter's shapes as two-dimensional shapes visibly traced on the canvass; Cézanne's shapes are never two-dimensional, and they are never traced on the canvass; they are solids, and we get at them through the canvass. In this new kind of painting the 'plane of the picture' disappears; it melts into nothing, and we go through it.[2]

Vernon Blake, who understood all this very well from the angle of the practising artist, and could explain himself in words like the Irishman he was, told draughtsmen that the plane of the picture was a mere superstition. Hold your pencil vertical to the paper, said he; don't stroke the paper, dig into it; think of it as if it were the surface of a slab of clay in which you were going to cut a relief, and of your pencil as a knife. Then you will find that you can draw something which is not a mere pattern on paper, but a solid thing lying inside or behind the paper.

[1] Anticipated by Uvedale Price as long ago as 1801: 'I can imagine a man of the future, who may be born without the sense of feeling, being able to see nothing but light variously modified' (*Dialogue on the distinct characters of the Picturesque and Beautiful*).

[2] The 'disappearance' of the picture-plane is the reason why, in modern artists who have learnt to accept Cézanne's principles and to carry their consequences a stage further than he carried them himself, perspective (to the great scandal of the man in the street, who clings to the picture-plane as unconsciously and as convulsively as a drowning man to a spar) has disappeared too. The man in the street thinks that this has happened because these modern fellows can't draw; which is like thinking that young men of the Royal Air Force career about in the sky because they can't walk. See p. 153.

In Mr. Berenson's hands the revolution became retrospective. He found that the great Italian painters yielded altogether new results when approached in this manner. He taught his pupils (and every one who takes any interest in Renaissance painting nowadays is Mr. Berenson's pupil) to look in paintings for what he called 'tactile values'; to think of their muscles as they stood before a picture, and notice what happened in their fingers and elbows. He showed that Masaccio and Raphael, to take only two outstanding instances, were painting as Cézanne painted, not at all as Monet or Sisley painted; not squirting light on a canvass, but exploring with arms and legs a world of solid things where Masaccio stalks giant-like on the ground and Raphael floats through serene air.

In order to understand the theoretical significance of these facts, we must look back at the ordinary theory of painting current in the nineteenth century. This was based on the conception of a 'work of art', with its implication that the artist is a kind of craftsman producing things of this or that kind, each with the characteristics proper to its kind, according to the difference between one kind of craft and another. The musician makes sounds; the sculptor makes solid shapes in stone or metal; the painter makes patterns of paint on canvass. What there is in these works depends, of course, on what kind of works they are; and what the spectator finds in them depends on what there is in them. The spectator in looking at a picture is simply seeing flat patterns of colour, and he can get nothing out of the picture except what can be contained in such patterns.

The forgotten truth about painting which was rediscovered by what may be called the Cézanne–Berenson approach to it was that the spectator's experience on looking at a picture is not a specifically visual experience at all. What he experiences does not consist of what he sees. It does not even consist of this as modified, supplemented, and expurgated by the work of the visual imagination. It does not belong to sight alone, it belongs also (and on some occasions

even more essentially) to touch. We must be a little more accurate, however. When Mr. Berenson speaks of tactile values, he is not thinking of things like the texture of fur and cloth, the cool roughness of bark, the smoothness or grittiness of a stone, and other qualities which things exhibit to our sensitive finger-tips. As his own statements abundantly show, he is thinking, or thinking in the main, of distance and space and mass: not of touch sensations, but of motor sensations such as we experience by using our muscles and moving our limbs. But these are not actual motor sensations, they are imaginary motor sensations. In order to enjoy them when looking at a Masaccio we need not walk straight through the picture, or even stride about the gallery; what we are doing is to imagine ourselves as moving in these ways. In short: what we get from looking at a picture is not merely the experience of seeing, or even partly seeing and partly imagining, certain visible objects; it is also, and in Mr. Berenson's opinion more importantly, the imaginary experience of certain complicated muscular movements.

Persons especially interested in painting may have thought all this, when Mr. Berenson began saying it, something strange and new; but in the case of other arts the parallels were very familiar. It was well known that in listening to music we not only hear the noises of which the 'music', that is to say the sequences and combinations of audible sounds, actually consists; we also enjoy imaginary experiences which do not belong to the region of sound at all, notably visual and motor experiences. Everybody knew, too, that poetry has the power of bringing before us not only the sounds which constitute the audible fabric of the 'poem', but other sounds, and sights, and tactile and motor experiences, and at times even scents, all of which we possess, when we listen to poetry, in imagination.

This suggests that what we get out of a work of art is always divisible into two parts. (1) There is a specialized sensuous experience, an experience of seeing or hearing as the case may be. (2) There is also a non-specialized imaginative

experience, involving not only elements homogeneous, after their imaginary fashion, with those which make up the specialized sensuous experience, but others heterogeneous with them. So remote is this imaginative experience from the specialism of its sensuous basis, that we may go so far as to call it an imaginative experience of total activity.

At this point the premature theorist lifts up his voice again. 'See', he exclaims, 'how completely we have turned the tables on the old-fashioned theory that what we get out of art is nothing but the sensual pleasure of sight or hearing! The enjoyment of art is no merely sensuous experience, it is an imaginative experience. A person who listens to music, instead of merely hearing it, is not only experiencing noises, pleasant though these may be. He is imaginatively experiencing all manner of visions and motions; the sea, the sky, the stars; the falling of the rain-drops, the rushing of the wind, the storm, the flow of the brook;[1] the dance, the embrace, and the battle. A person who looks at pictures, instead of merely seeing patterns of colour, is moving in imagination among buildings and landscapes and human forms. What follows? Plainly this: the value of any given work of art to a person properly qualified to appreciate its value is not the delightfulness of the sensuous elements in which as a work of art it actually consists, but the delightfulness of the imaginative experience which those sensuous elements awake in him. Works of art are only means to an end; the end is this total imaginative experience which they enable us to enjoy.'

This attempt to rehabilitate the technical theory depends on distinguishing what we find in the work of art, its actual sensuous qualities, as put there by the artist, from something else which we do not strictly find in it, but rather import into it from our own stores of experience and powers of imagination. The first is conceived as objective, really belonging to the work of art: the second as subjective, belonging not to it but to activities which go on in us when we

[1] Ernest Newman, 'Programme Music', in *Musical Studies* (1905), p. 109.

contemplate it. The peculiar value of this contemplation, then, is conceived as lying not in the first thing but in the second. Any one having the use of his senses could see all the colours and shapes that a picture contains, and hear all the sounds which together make up a symphony; but he would not on that account be enjoying an aesthetic experience. To do that he must use his imagination, and so proceed from the first part of the experience, which is given in sensation, to the second part, which is imaginatively constructed.

This seems to be the position of the 'realistic' philosophers who maintain that what they call 'beauty' is 'subjective'. The peculiar value which belongs to an experience such as that of listening to music or looking at pictures arises, they think, not from our getting out of these things what is really in them, or 'apprehending their objective nature', but from our being stimulated by contact with them to certain free activities of our own. It is in these activities that the value really resides; and although (to use Professor Alexander's word) we may 'impute' it to the music or the picture, it actually belongs not to them but to us.[1]

But we cannot rest in this position. The distinction between what we find and what we bring is altogether too naive. Let us look at it from the point of view of the artist. He presents us with a picture. According to the doctrine just expounded, he has actually put into this picture certain colours which, by merely opening our eyes and looking at it, we shall find there. Is this all he did in painting the picture? Certainly not. When he painted it, he was in possession of an experience quite other than that of seeing the colours he was putting on the canvass; an imaginary experience of total activity more or less like that which we construct for ourselves when we look at the picture. If he knew how to paint, and if we know how to look at a painting, the resemblance between this imaginary experience of his and the imaginary

[1] So Alexander, *Beauty and Other Forms of Value* (1933), pp. 25–6; Carritt, *What is Beauty?* (1932), ch. iv. I am not forgetting that Professor Alexander has a chapter (*op. cit.*, ch. x) on 'The objectivity of Beauty'.

experience which we get from looking at his work is at least as close as that between the colours he saw in the picture and those we see; perhaps closer. But if he paints his picture in such a way that we, when we look at it using our imagination, find ourselves enjoying an imaginary experience of total activity like that which he enjoyed when painting it, there is not much sense in saying that we bring this experience with us to the picture and do not find it there. The artist, if we told him that, would laugh at us and assure us that what we believed ourselves to have read into the picture was just what he put there.

No doubt there is a sense in which we bring it with us. Our finding of it is not something that merely happens to us, it is something we do, and do because we are the right kind of people to do it. The imaginary experience which we get from the picture is not merely the kind of experience the picture is capable of arousing, it is the kind of experience we are capable of having. But this applies equally to the colours. He has not put into the pictures certain colours which we passively find there. He has painted, and seen certain colours come into existence as he paints. If we, looking at his picture afterwards, see the same colours, that is because our own powers of colour-vision are like his. Apart from the activity of our senses we should see no colours at all.

Thus the two parts of the experience are not contrasted in the way in which we fancied them to be. There is no justification for saying that the sensuous part of it is something we find and the imaginary part something we bring, or that the sensuous part is objectively 'there' in the 'work of art', the imaginary part subjective, a mode of consciousness as distinct from a quality of a thing. Certainly we find the colours there in the painting; but we find them only because we are actively using our eyes, and have eyes of such a kind as to see what the painter wanted us to see, which a colour-blind person could not have done. We bring our powers of vision with us, and find what they reveal. Similarly,

we bring our imaginative powers with us, and find what they reveal: namely, an imaginary experience of total activity which we find in the picture because the painter had put it there.

In the light of this discussion let us recapitulate and summarize our attempt to answer the question, what is a work of art? What, for example, is a piece of music?

(1) In the pseudo-aesthetic sense for which art is a kind of craft, a piece of music is a series of audible noises. The psychological and 'realistic' aestheticians, as we can now see, have not got beyond this pseudo-aesthetic conception.

(2) If 'work of art' means work of art proper, a piece of music is not something audible, but something which may exist solely in the musician's head (§ 3).

(3) To some extent it must exist solely in the musician's head (including, of course, the audience as well as the composer under that name), for his imagination is always supplementing, correcting, and expurgating what he actually hears (§ 4).

(4) The music which he actually enjoys as a work of art is thus never sensuously or 'actually' heard at all. It is something imagined.

(5) But it is not imagined sound (in the case of painting, it is not imagined colour-patterns, &c.). It is an imagined experience of total activity (§ 5).

(6) Thus a work of art proper is a total activity which the person enjoying it apprehends, or is conscious of, by the use of his imagination.

§ 7. *Transition to Book II*

Putting together the conclusions of this chapter and the last, we get the following result.

By creating for ourselves an imaginary experience or activity, we express our emotions; and this is what we call art.

What this formula means, we do not yet know. We can annotate it word by word; but only to forestall misunderstandings, thus. 'Creating' refers to a productive activity

which is not technical in character. 'For ourselves' does not exclude 'for others'; on the contrary, it seems to include that; at any rate in principle. 'Imaginary' does not mean anything in the least like 'make-believe', nor does it imply that what goes by that name is private to the person who imagines. The 'experience or activity' seems not to be sensuous, and not to be in any way specialized: it is some kind of general activity in which the whole self is involved. 'Expressing' emotions is certainly not the same thing as arousing them. There is emotion there before we express it. But as we express it, we confer upon it a different kind of emotional colouring; in one way, therefore, expression creates what it expresses, for exactly this emotion, colouring and all, only exists so far as it is expressed. Finally, we cannot say what 'emotion' is, except that we mean by it the kind of thing which, on the kind of occasion we are talking about, is expressed.

This is as far as we can get by the method we have been hitherto using. We have tried, so far, merely to repeat what every one knows; every one, that is, who is accustomed to dealing with art and distinguishing art proper from art falsely so called. We must now begin working on a different line. There are three problems before us: three unknowns in the formula stated above. We do not know what imagination is. We do not know what emotion is. And we do not know what is the nature of the connexion between them, described by saying that imagination expresses emotion.

These problems must be dealt with (and this is what I mean by saying we must work on a different line), not by continuing to concentrate our attention on the special characteristics of aesthetic experience, but by broadening our view, so far as we can, until it covers the general characteristics of experience as a whole. It was explained in the introductory chapter that this is the only way in which we can hope to go beyond the preliminary business of establishing a satisfactory usage of the term art, and approach the problem of defining it.

In Book II, therefore, I shall make a fresh start. I shall

try to work out a theory of imagination and of its place in the structure of experience as a whole, by developing what has already been said about it by well-known philosophers. In doing this I shall make no use whatever of anything contained in Book I. I shall be, as it were, tunnelling from a quite different direction towards the same point which the superficial scratchings of Book I have laid more or less bare. When these two lines of inquiry are complete, they should coincide; and their union should produce a theory of art, to be stated in Book III.

Further note to p. 145, *on perspective and the picture-plane.*—The picture as a bodily thing has of course a 'plane', as one discovers by handling it. But in order to see it as a work of art one stands back and looks at it. When you do that, the picture-plane is no longer present to you as something given in sensation (though even if it were, you could 'disimagine' it; cf. p. 143); it is present to you only as something you imagine by means of tactile (or rather motor) imagination (p. 147). The only universal reasons for doing this are non-aesthetic reasons, connected with your relation to the picture as a bodily thing. When you look at it aesthetically, these reasons disappear. But there may, under certain conditions, be genuinely aesthetic reasons for doing it, namely the following.

The origin of perspective (which is the logical consequence of imagining the picture-plane) was connected with the use of painting as an adjunct to architecture. If the shape of an interior is meant to be looked at aesthetically, and if one of its walls is covered with a painting also meant to be looked at aesthetically, *and if these two aesthetic experiences are meant to be fused into one* (not otherwise), then, since the wall-plane is an element in the architectural design, the picture must be so painted that a spectator's imagination is drawn towards the wall-plane, not away from it. This is why Renaissance painters, acting as interior decorators, revived and elaborated the system of perspective already used by interior decorators at Pompeii and elsewhere in the ancient world. For movable pictures, perspective is mere pedantry.

BOOK II
THE THEORY OF IMAGINATION

THINKING AND FEELING

§ 1. *The Two Contrasted*

OF all the features which our experience presents when we reflect upon it, none is more familiar than the contrast between thinking and feeling. I will try to state some of the characteristics of this contrast.

First, there is a special kind of simplicity about feeling, in contrast with what may be called the bipolarity of thought. Whenever we think we are more or less conscious of a distinction between thinking well and thinking ill, doing the job of thinking successfully or unsuccessfully. The distinctions between right and wrong, good and bad, true and false, are special cases of this bipolarity; it is plain that none of them could arise except in the experience of a thinking being. This is not merely because they are distinctions; nor even merely because they are oppositions. Distinctions and even oppositions can arise in feeling as such: for example the distinction between red and blue, the opposition between hot and cold or pleasant and painful. The distinction or opposition in virtue of which I speak of thought as bipolar is of a quite different kind from these. There is nothing in the case of feeling to correspond with what, in the case of thinking, may be called mis-thinking or thinking wrong. The most general name for this thing is failure. Failure and its opposite, success, imply that the activity which fails or succeeds is not only a 'doing something' but a 'trying to do something', where the word 'trying' refers not to what is called 'conation', but to an activity which sets itself definite tasks, and judges itself as having succeeded or failed by reference to the standards or criteria which it thereby imposes on itself.

Secondly, there is a special kind of privacy about feelings, in contrast with what may be called the publicity of thoughts. A hundred people in the street may all feel cold, but each

person's feeling is private to himself. But if they all think that the thermometer reads 22° Fahrenheit, they are all thinking the same thought: this thought is public to them all. The act of thinking it may or may not be an entirely private act; but a thought in the sense of what we think is not the act of thinking it, and a feeling in the sense of what we feel is not the act of feeling it. In the last paragraph I pointed to a distinction between the act of feeling and the act of thought; in this I am pointing to a distinction between what we feel and what we think. The cold that our hundred people feel is not the physical fact that there are ten degrees of frost; nor is it even something due to that fact, for if one of them had lately been living in a colder climate he would not feel cold in those physical conditions; it is simply a feeling in them, or rather a hundred different feelings, each private to the person who feels it, but each in certain ways like all the rest. But the 'fact' or 'proposition' or 'thought' that there are ten degrees of frost is not a hundred different 'facts' or 'propositions' or 'thoughts'; it is one 'fact' or 'proposition' or 'thought' which a hundred different people 'apprehend' or 'assent to' or 'think'. And what is here said of the relation between different persons in respect of what they feel and think respectively is equally true of the relation between different occasions of feeling and thinking respectively in the life of a single person.

Thirdly, when these two distinctions are taken together the upshot of them can be stated by saying that thoughts can corroborate or contradict each other, but feelings cannot. If some one beside myself thinks that there are ten degrees of frost, we are said to agree in thinking this; and the fact of agreement, though it does not prove me right, makes this more probable. If I think there are ten degrees of frost and some one else thinks not, we are contradicting each other, and one of us must be wrong. But if I feel cold, nothing about this feeling of mine follows from some one else's feeling either cold or warm. He is not agreeing or disagreeing with me.

It has sometimes been said that what we feel is always

something existing here and now, and limited in its existence
to the place and time at which it is felt; whereas what we
think is always something eternal, something having no
special habitation of its own in space and time but existing
everywhere and always. In some sense this is perhaps true.
But for the present we should do well to regard it as an
overstatement, at least so far as the second part of it is
concerned. What we feel is certainly limited in its existence
to the here and now in which we feel it. The experience of
feeling is a perpetual flux in which nothing remains the same,
and what we take for permanence or recurrence is not a
sameness of feeling at different times but only a greater or
less degree of resemblance between different feelings. The
only motive any one can have for denying this, and con-
juring up the metaphysical fairy-tale of a limbo in which all
possible feelings are stored when nobody feels them, is the
panic caused by sophistical attempts to reduce the whole of
experience to feeling and consequently the whole world to
a phantasmagoria of feelings. The right answer to these
sophistries is not 'then we must confer on feelings the attri-
butes proper to thoughts', but, 'there is more in experience
than mere feeling; there is thought as well'.

But in order to point the contrast between feeling and
thinking it is not necessary to assert the eternity of all objects
of thought as such. What is necessary is only to insist that in
thinking we are concerned with something that lasts, even if
it does not last for ever; something that genuinely recurs as a
factor in experience, even if it cannot recur to infinity. We
need not ask whether the fact that there were ten degrees of
frost here on a certain morning is an eternal truth, whatever
that may mean; all we are obliged to maintain is that it is
a truth knowable to more than one person and to the same
person on more than one occasion. If we compare the flux of
feeling to the flow of a river, thought has at least the relative
solidity and permanence of the soil and rocks that make its
channel.

It may be wise here to enter a warning. I have distinguished

the activities of feeling and thinking from what is respectively felt and thought. Words like thought, feeling,
knowledge, experience, have notoriously a double-barrelled
significance. They refer both to the activity of thinking and
to what we think; the activity of feeling and what we feel;
the activity of knowing and what we know; the activity of
experiencing and what we experience. When such words are
used, it is important not to confuse these two halves of their
meaning. My warning is this: it is important, also, to
remember that the relation between the two things referred
to is not the same in all these various cases. Thinking and
feeling are different not only in that what we feel is something
different in kind from what we think, nor also because the act
of thinking is a different kind of act from the act of feeling,
but because the relation between the act of thinking and
what we think is different in kind from the relation between
the act of feeling and what we feel.

§ 2. *Feeling*

If we now consider feeling by itself, we find that there are
two different kinds of experience each of which goes by that
name. First, we say that hot and cold, hard and soft, are
things that we feel; in Scotland they talk of 'feeling' a smell,
plainly in the same sense; and if we liked to extend that
usage we might claim a similar right to speak of 'feeling' a
sound or a colour. We do not actually use the English word
so widely; but we do so use words derived from its Latin
equivalent *sentio*; we describe the specialized activities of
thus 'feeling' colours, sounds, scents, and the like collectively as the senses, and the common activity which is
specialized into them as sensation. Secondly, we speak of
feeling pleasure or pain, anger, fear, and so forth. Here also
we have a general activity of feeling specialized into various
kinds, each with its proper specification of what we feel. It is
not, clearly, of quite the same kind as sensation; to distinguish it, let us call it emotion.

The distinction between these two kinds of feeling is not

the distinction between two species of a common genus, like that between seeing and hearing, or feeling anger and feeling fear. Seeing and hearing are alternative specifications of their common genus sensation, so that an act of seeing is one act of sensation, and an act of hearing is another; if we happen to see and hear at the same time (as we often do, though not always) we are performing two acts of sensation at once. There is a relation between sensation and emotion which is more intimate than this. When an infant is terrified at the sight of a scarlet curtain blazing in the sunlight, there are not two distinct experiences in its mind, one a sensation of red and the other an emotion of fear: there is only one experience, a terrifying red. We can certainly analyse that experience into two elements, one sensuous and the other emotional; but this is not to divide it into two experiences, each independent of the other, like seeing red and hearing the note of a bell.

These two elements, sensuous and emotional, are not merely combined in the experience: they are combined according to a definite structural pattern. This pattern can be described by saying that the sensation takes precedence of the emotion. Precedence here does not mean priority in time. Had that been the case, there would have been two experiences instead of one. Nor is it quite the same as the relation of cause to effect; for emotion is not a mere effect of sensation, it is a distinct and autonomous element in the experience. Nor is it the same as the logical relation of ground to consequent. We do, however, apply to it the word 'because', and say that the child is frightened because it sees the curtain, although seeing the curtain and being frightened are not two separate experiences. Relations of this type, however we choose to describe them, are familiar. I raise my hand from the elbow by contracting the biceps. The contraction of the biceps and the raising of the hand are not two bodily acts, but one. This one act is analysable into these two parts, and of these the muscular contraction takes precedence of the change in the position of the hand (the

hand rises 'because' the biceps contracts), although it is anatomically impossible that the biceps should contract before the hand rose. I shall refer to this precedence of sensation over emotion by describing a given emotion as the 'emotional charge' on the corresponding sensation; or, since it is desirable to distinguish the act of feeling from what we feel, and confine the term sensation to the act of feeling, the corresponding sensum.

It would probably be true to say that every sensum has its own emotional charge. This is difficult to verify in detail to any great extent; partly because it is difficult to stage the necessary tests, since we generally experience a very large number of sensa at once and therefore cannot easily determine whether each of them really has a distinct emotional charge; partly because we are accustomed, for the purposes of everyday life, to attend far more carefully to our sensations than to our emotions.

The habit of 'sterilizing' sensa by ignoring their emotional charge is not equally prevalent among all sorts and conditions of men. It seems to be especially characteristic of adult and 'educated' people in what is called modern European civilization; among them, it is more developed in men than in women, and less in artists than in others. To study the so-called colour-symbolism of the Middle Ages is to see into a world where, even among adult and educated Europeans, the sterilizing of colour-sensa has not taken place: where any one who is conscious of seeing a colour is simultaneously conscious of feeling a corresponding emotion, as is still the case among ourselves with children and artists. In persons who are likely to read this book, the habit of sterilizing sensa has probably become so ingrained that a reader who tries to go behind it will find it very hard to overcome the resistance which hampers him at every move in his inquiry. In so far as he succeeds in recognizing what really happens in himself, I believe he will find that every sensum presents itself to him bearing a peculiar emotional charge, and that sensation and emotion, thus related, are twin

elements in every experience of feeling. In children this is
clearer than in adults, because they have not yet been
educated into the conventions of the society into which they
have been born; in artists clearer than in other adults,
because in order to be artists they must train themselves in
that particular to resist these conventions. Those who are
neither children nor artists can best approach the question
by considering these two types of case, where they will soon,
I think, be convinced that sensa never come uncharged with
emotion; and this may lead them to further experiment upon
themselves and so to the conclusion that the emotionless
sensum, the 'sensum' of current philosophy, is not the actual
sensum as it is experienced, but the product of a process of
sterilization.

Feeling appears to arise in us independently of all thinking,
in a part of our nature which exists and functions below the
level of thought and is unaffected by it. All that we have
said about it, and all that anybody can ever say about it, is
of course discovered (or mis-discovered) by the activity of
thought; but thought seems in this case simply to discover
what was there independently of it, almost as if we were
thinking about the anatomical structure and functioning of
our body, which would no doubt exist and go on whether
we thought or not. Whether this is really so is not a very
easy question to decide. For the present, we must be con-
tent with the provisional answer that it seems so: it seems
that our sensuous-emotional nature, as feeling creatures, is
independent of our thinking nature, as rational creatures,
and constitutes a level of experience below the level of
thought. In calling it lower, I do not mean that it is rela-
tively unimportant in the economy of human life, or that it
constitutes a part of our being which we are entitled to
despise or belittle. I mean that it has (if I am right in my
opinion about it) the character of a foundation upon
which the rational part of our nature is built; laid and con-
solidated, both in the history of living organisms at large
and in the history of each human individual, before the

superstructure of thought was built upon it, and enabling that superstructure to function well by being itself in a healthy condition.

This level of experience, at which we merely feel, in the double sense of that word, i.e. experience sensations together with their peculiar emotional charges, I propose to call the psychical level. In using that name I am alluding to the traditional distinction between 'psyche' or 'soul' and 'spirit', taken as corresponding with my own distinction between feeling and thinking; and also to the word psychology, which implies a claim that the science so designated has as its proper field the study of something properly called psychic: and I hold that the proper business of psychology is to investigate this level of experience, and not the level which is character- ized by thought (see p. 171). I hope I need not apologize for using a word which in some readers' minds may conjure up associations with the Society for Psychical Research.

I shall in this book use the word 'feeling' only with reference to the psychical level of experience, and not as a synonym for emotion generally. This level contains indeed a vast variety of emotions; but only those which are the emotional charges upon sensa. When thought comes into existence (and it is no part of my plan to ask how or why that happens) it brings with it new orders of emotions: emotions that can arise only in a thinker, and only because he thinks in certain ways. These emotions we sometimes call feelings; but in this book I shall avoid so calling them, in order not to confuse them with the peculiar experiences we enjoy at the psychical level.

§ 3. *Thinking*

Feeling provides for thought more than a mere substruc- ture upon which it rests, and about which it may concern itself if it is so disposed. In its primary form, thought seems[1] to be exclusively concerned with it, so that feeling affords its sole and universal subject-matter. This is not to say that

[1] My reason for saying 'seems' and the like, in this section, will be explained in the next.

there may not also be a secondary form of thought; to that question we shall return later. At present, we have to consider the primary form.

When we think the thoughts which we express in such words as 'I am tired', 'It is hot to-day', 'There is a patch of blue', it seems clear that we are thinking about our feelings. We are becoming aware, by an act of attention, of certain feelings which at the moment we have; and we are going on to think of these as standing in certain relations to other feelings, remembered as past or imagined as possible. Thus, to say 'It is hot' is to classify one of my present sensa as a temperature-sensum, to compare it with those kinds of temperature-sensa to which on the whole I am accustomed, and to express the result of the comparison by saying that it comes nearer than they to the hotter end of the scale to which they all belong.

The same thing appears to be true, though not so obviously true, about expressions like 'That is my hat'. The reference to my feelings is here not explicit, but it is perfectly real. When I say that this is my hat, I am stating certain relations between certain feelings that I now have (for example, if I am merely looking at the hat, certain colour-sensa arranged in a certain way) and other feelings which I remember having in the past, for example the feelings to which I should refer by speaking of the 'look' of my hat as I remember it hanging on the peg in my own hall; and I am saying that these relations are of such a kind that the hat at which I am now looking cannot be any other than mine. To describe all these sensa and the relations between them would involve almost infinite complications; but that is no reason for being sceptical about the fact; so familiar a feat as the recognizing of one's own hat is really a very complex achievement, and contains a vast number of thoughts, in each of which an error is possible.

This type of analysis would seem to hold good in the case of all the thinking which is called empirical. Even when we make statements about the shapes or sizes or distances of

bodies, we seem in the last resort to be expressing our thoughts about the relations between sensa, actual and possible. If I say 'These railway lines which look convergent are really parallel', I am first of all attending to a certain pattern of colours which at the moment I see before me; I am then selecting out of this pattern certain stripes of light colour which I identify as the railway metals; I next compare the pattern made by those stripes with two other kinds of pattern, first one made by painting similar stripes parallel to one another, and secondly one made by painting them converging; and lastly, by the admonitory word 'really', I am warning myself that in spite of the resemblance between what I now see and the second of these patterns, I must not think that if I travelled along the metals, measuring the distance between them from time to time, I should get the same kind of result which I get by passing my fingers along the lines of that pattern. Once more, the roughest analysis is almost intolerably complicated, and no analysis, however complicated, would be exhaustive; but this proves, not that the analysis is mistaken, but that thought is quick.

Thus our experience of the world in space and time, the 'world of nature' or 'external' world, which means not the world external to ourselves (for we ourselves are part of it, in so far as 'we' are our bodies; and if 'we' are our minds, there is no sense in speaking of anything as external to *them*) but the world of things external to one another, the world of things scattered in space and time, is an experience partly sensuous (strictly, sensuous-emotional) and partly intellectual: sense being concerned with the colours we see, the sounds we hear, and so forth; and thought, with the relations between these things.

But thought itself, as an element in this kind of experience, is a thing which admits of being thought about; and here arises the secondary form of thought, in which we think not about our feelings, detecting relations between one and another, but about our thoughts: concerning ourselves with the principles according to which the activity of thought in

its primary form investigates the relations between feelings, or (what comes to the same thing) according to which inter-relations exist between what, on such occasions, we think. The propositions asserted by thought in this secondary form may be indifferently described as affirming relations between one act of thinking and another, or between one thing we think and another. They may be called laws of thought, to distinguish them from what are traditionally called laws of nature; but they are not laws of a mysterious transcendent world quite separate from the world of nature or world of sense, they are laws of the second order concerning that world itself. They are arrived at, and at need verified or amended, by appeal not to the sensuous experience of seeing a particular colour or hearing a particular sound on a particular occasion (an experience which, obviously, can help us to formulate or verify or amend only a law of the first order), but to the intellectual experience of thinking in certain ways and finding our thoughts connected in a certain type of order.

This secondary function of thought, or thought of the second order, traditionally distinguished from thought of the first order as 'reason' from 'understanding', 'philosophy' from 'science', and so forth, has been the subject of much futile mystification. As anybody can see, all knowledge is derived from experience; and whatever claims to be knowledge must appeal to experience for its credentials and verification. This is as true of metaphysics, theology, or pure mathematics as it is of railway time-tables or Wisden's *Cricketer's Guide*. But the word 'experience' has acquired a secondary meaning, being sometimes used in philosophical jargon for sensuous experience. In that new sense of the word it is only thoughts of the first order that are concerned with 'experience'[1] and can be tested by appeal to it; thoughts of the second order obviously cannot. How, then, are they verified or checked; and, indeed, how in the first instance are they arrived at? Kant believed that they were known in

[1] This is why thought of the first order is called 'empirical'.

some mysterious way 'independently of experience'. Some modern philosophers, rightly rejecting that mystification, substitute another: maintaining that a sentence in which we express a thought of the second order is not a statement about the subject we are ostensibly discussing, but an announcement declaring the equivalence of two words or phrases in the language in which we propose to discuss it. There is no need to criticize such notions in detail. It is enough to recognize the equivocation upon which they depend: the major premiss that all knowledge is derived from experience (where a thought, no less than a sensation, is implied to be an experience), the minor premiss that a thought is not an experience, and the resulting inference that thought of the second order, which in fact is based on the experience of thinking, is either knowledge in a different and mysterious sense of the word or not knowledge at all.

§ 4. *The Problem of Imagination*

Thought in its primary function was described in the preceding section as concerned with the relations between sensa. But this description gives rise to a difficulty. A sensum is present to our minds only in the corresponding act of sensation. It appears as we perform that act, and disappears as soon as the act is over. It is 'given' in the fact of so appearing; having been given, it is at once taken away.

Now suppose I hold my hand close to the fire for a few seconds, and feel a rapidly increasing warmth. At the moment when the warmth has increased to a painful heat, what I feel is certainly hotter than what I felt a second before. But how do I know that it is hotter? The account already given implies that I have some means of comparing the sensum I feel now with the sensum I felt a second ago. But the sensum I felt a second ago is not now present to me; it has vanished, carried away by the flux of sensation; it is no longer there to be compared with its successor. In the same way, future sensa, possible sensa, other people's sensa, are sensa not present to me here and now, and are therefore not

things whose relations with each other, or with the sensa now present to me, I am in a position to discuss. Hence the phrase 'relations between sensa' is meaningless unless it applies to relations between sensa present to the same person at the same time. Nor does even that limitation entirely justify the phrase; for it seems probable that the act of comparing two simultaneous sensa and considering the relation between them must always occupy a period of time during which these sensa have passed away, giving place to others. The flux of sense, it would seem, destroys any sensum before it has lasted long enough to permit of its relations being studied.

This difficulty is concealed, in current philosophical works where views are maintained resembling those expressed in the earlier part of the foregoing section, by the adoption of a vocabulary in which certain characteristic features of sensa are implicitly denied. Sensa are called 'sense-data', where the term 'data' means not what the word 'given' was just now explained as meaning, but something totally different: it means given and retained, established or fixed like the datum-line of a survey or the data on which a scientific hypothesis is erected, and by reference to which it is tested. And even where the word used is 'sensum', not 'sense-datum', it is used with the same implication. This implication is of course wholly false: it consists in ascribing to sensa exactly the opposite of those characteristics which as sensa they possess. But the false implication is reinforced, as it were hypnotically, by a whole series of other terms. For example, our relation to our sensa is described as 'acquaintance' with them. But you cannot be acquainted with a sensum. To be acquainted with a town or a book or a man is to have come into contact with it or him on a variety of occasions; a person or thing with which one is acquainted is a recurring feature of one's experience, recognized in the recurrence as identical with his or its past self. But sensa neither persist nor recur. Redness may recur, and a man may therefore be acquainted with it; but not this red patch. Grief may recur, and a man

may be acquainted with grief; but this feeling of unhappiness is uniquely present in this act of feeling it, and has never been felt before, however often others like it have been felt. Again, the truth of an empirical proposition is said to be tested by 'appealing' to sensa, that is, by finding out whether in certain circumstances those sensa present themselves to us which would present themselves if the proposition were true; but this implies that I can now know what certain sensa, not present to me, would be like if they were present to me, and can say 'These are, or are not, the sensa I expected', comparing sensa which I now have with some idea of them which I framed in advance of having them; and it should be explained how this is possible.

We are confronted with two alternatives. Either the people who use all this language (including ourselves in the preceding section) are talking the most complete imaginable nonsense, or else they are systematically misusing the word 'sensum' and all its cognates; using it to mean not the momentary and evanescent colours, sounds, scents, and the rest which in sensation we actually 'feel', but something different which these writers mistake or substitute for them. In order to impute an error not too gross to be plausible, let us suppose that there are these other things, and that in certain ways they are very much like sensa, but differ from sensa chiefly in not being wholly fluid and evanescent; so that any one of them may be retained in the mind as an object of attention after the moment of sensation is past, or anticipated before it occurs.

If there is such a class of entities as these, its members are obviously not sensa, and the activity correlative to them is not sensation; but they may very well be the things which are called sensa in the philosophies to which I have referred, and by discovering what kind of things they really are we may be able to reinterpret those philosophies in such a way as to rescue them from the imputation of being sheerly nonsensical.

This will be the task of the next two chapters. I shall there

try to show that there are such things, to be identified with what Hume (whose account of them I shall take as my starting-point) called 'ideas' as distinct from 'impressions'. I shall try to show that there is a special activity of mind correlative to them, and that this is what we generally call imagination, as distinct from sensation on the one hand and intellect on the other. This activity, the φαντασία without which, according to Aristotle, intellection is impossible, the 'blind but indispensable faculty' which, according to Kant, forms the link between sensation and understanding, deserves in my opinion a more thorough study than it has yet received, both for its own sake (in which aspect it provides, as I shall later argue, the basis for a theory of the aesthetic experience) and for the sake of its place in the general structure of experience as a whole, as the point at which the activity of thought makes contact with the merely psychic life of feeling.

Note to p. 164: Psychology, true and false.—It follows from the distinction stated on p. 157 that whereas, in order to study the nature of feeling, it is necessary to ascertain what persons who feel are actually doing, in order to study the nature of thinking it is necessary to ascertain both what persons who think are actually doing and also whether what they are doing is a success or a failure. Thus a science of feeling must be 'empirical' (i.e. devoted to ascertaining and classifying 'facts' or things susceptible of observation), but a science of thought must be 'normative', or (as I prefer to call it) 'criteriological', i.e. concerned not only with the 'facts' of thought but also with the 'criteria' or standards which thought imposes on itself. 'Criteriological' sciences, e.g. logic, ethics, have long been accepted as giving the correct approach to the study of thought. In the sixteenth century the name 'psychology' was invented to designate an 'empirical' science of feeling. In the nineteenth century the idea got about that psychology could not merely supplement the old 'criteriological' sciences by providing a valid approach to the study of feeling, but could replace them by providing an up-to-date and 'scientific' approach to the study of thought. Owing to this misconception there are now in existence two things called 'psychology': a valid and important 'empirical' science (both theoretical and applied) of feeling, and a pseudo-science of thought, falsely professing to deal 'empirically' with things which, as forms of thought, can be dealt with only 'criteriologically'. Its vast and rapidly-growing literature shows all the familiar marks of a pseudo-science (self-contradiction; the enunciation of 'discoveries' which are really platitudes; the appeal to facts which are irrelevant to the problems under discussion; the evasion of criticism on the plea that 'the science is in its infancy', &c.); it is completely discredited among those (historians, &c.) whose business is to study human thought in its actuality; and I make no apology for ignoring and contradicting, in this book and elsewhere, the errors taught by its exponents.

SENSATION AND IMAGINATION

§ 1. *Terminology*

It will be best, before directly attacking the problem raised at the end of the preceding chapter, to consider a distinction which might be thought to offer a safe approach to the theory of imagination. This is the common-sense distinction between, for example, 'really seeing' a patch of colour and 'imagining' one. I raise my head, look out of the window, and 'see' an expanse of green grass. I shut my eyes and, with a conscious effort, 'imagine' the same green expanse, or at any rate a green expanse very much like it. On the first occasion, the colour presents itself to me when I am looking at something that is 'really there'; on the second, it is a 'figment' of my imagination, which somehow generates it in the absence of these conditions.

This common-sense distinction, when we examine it, will be found very obscure; and when at last we are able to say what it means, this will be something very different from what at first sight it seems to mean. The examination will be troublesome and perhaps tedious, but fruitful; for the common-sense distinction expresses (or, one might almost as well say, conceals) a truth of great importance, which we should never clearly understand if we swallowed the common-sense view uncritically; still less, perhaps, if we impatiently dismissed it as nonsense.

We must begin by choosing a terminology in which the common-sense distinction can be easily and not too unnaturally expressed. The terminologies actually in use fall into two groups according as it is desired to emphasize the similarity between the seen and imagined colours (or the acts of seeing and imagining them), or the difference. To the first class belong those in which 'really seeing' and 'imagining' are both called sensation, and what we 'really

see' and 'imagine' are indifferently called sensa or sense-data. In order to distinguish between the two cases, qualifications must then be added: for example, a distinction will be made between veridical and illusory sensa.

In the second type, the words 'sensation' and 'sensum' are confined to the case in which we 'really see', and other words are used for the case in which we 'imagine'; for example, that which we imagine is called an image. Thus we get a neat verbal parallelism between sensing a sensum and imagining an image; but the difficulty then is to find a pair of generic terms, one to cover both sensing and imagining, the other to cover both sensa and images; and to show how these two pairs of specific terms are related to each other and to their respective genera.

My own terminology in this chapter will be as follows. As a generic term to cover both the act of 'really seeing' and the act of 'imagining', I shall use the word 'sensation'. When I need a verb, I shall use the verb 'to sense'.

That which we sense I shall call a 'sensum'. The various species of sensation I shall call 'seeing', 'hearing', 'smelling', &c., and the corresponding species of sensa 'colours', 'sounds', 'scents', &c.; in every case irrespective of the distinction between the two cases distinguished at the beginning of this chapter.

As specific names for those two cases I shall use the terms 'real sensation' (with the verb 'really sense', if it is needed), and 'imagination' (with the verb 'imagine'). The species of real sensation I shall call 'really seeing', 'really hearing', &c. That which we really sense I shall call a 'real sensum', and its species 'real colours', 'real sounds', &c. That which we imagine I shall call an 'imaginary sensum'; its species, 'imaginary colours', 'imaginary sounds', &c.

It may possibly be worth while to forestall a misunderstanding. A reader, bearing in mind such distinctions as that between real diamonds and imitation diamonds, may fancy that something *ex hypothesi* different from real sensation cannot be a kind of sensation, as I have been professing, but

must be something different from sensation, as paste is different from diamond. But I am not using the word 'real' in this way. I am using it as it is used in the phrase 'real property', which does not imply that personal property is property falsely so called, but that the kind of property called real is property *in rebus*, where *res* has the meaning of a physical thing.

My reason for adopting this terminology is, chiefly, that it stands nearer than any other to everyday speech, and therefore begs fewer questions. The philosopher who tries to 'speak with the vulgar and think with the learned' has this advantage over one who adopts an elaborate technical vocabulary: that the use of a special 'philosophical language' commits the user, possibly even against his will, to accepting the philosophical doctrines which it has been designed to express, so that these doctrines are surreptitiously and dogmatically foisted upon every disputant who will consent to use the language: whereas, if the language of every day is used, problems can be stated in a way which does not commit us in advance to a particular solution. This gives the user of common speech an advantage, if what he wants to do is to keep the discussion open and above-board and to get at the truth. For a philosopher whose aim is not truth but victory it is of course a disadvantage; he would be wiser to insist at the start upon using a terminology so designed that all statements couched in it assume the contentions he is anxious to prove. And this in effect is what those philosophers are doing who profess themselves unable to grasp the meaning of this or that statement until it has been translated into their own terminology. To insist that every conversation shall be conducted in one's own language is in men of the world only bad manners; in philosophers it is sophistry as well.

§ 2. *History of the Problem: Descartes to Locke*

The historical background of the problem here to be discussed extends, so far as we need consider it, from Des-

cartes to Kant. The main constructive efforts of medieval philosophy had been based on assuming that sensation in general gives us real acquaintance with the real world; but this assumption was undermined by the sceptics of the sixteenth century, and the problem of distinguishing real sensation from imagination, and thus (without ceasing to experience the latter) guarding against the illusions which arise from mistaking the one for the other, was placed in the forefront of philosophical thought by Descartes.

Descartes, acquiescing to that extent in the views of the sceptics, admitted that by direct inspection there was no way of deciding whether he was really sitting in front of the fire or only dreaming that he was sitting in front of the fire: in our terminology, of distinguishing either between real sensa and the corresponding imaginary sensa, or between real sensation and the corresponding imagination. This is the point of Descartes's doctrine concerning the deceitfulness or untrustworthiness of the senses. He did not deny that there was such a thing as real sensation; what he denied was that we could distinguish it by any test short of mathematical reasoning from imagination; and this denial he made the foundation of his own philosophy, proving as it did that a system based on the assumption that real sensation could be thus distinguished from imagination was vicious from the beginning.

Hobbes accepted the same position and stated it, with his usual trenchancy, in a more downright form. Granted that there is no way of telling real sensation from imagination by direct inspection, and that what we cannot know about them by that method we cannot know at all, since immediacy is an essential feature of our sensuous experience (so he seems to argue), we had better deny the distinction outright, and use the two terms indifferently, as synonyms. That, at any rate, is the view he adopts in the first chapter of *Leviathan*. Sensa, he remarks, are 'fancy, the same waking that sleeping . . . so that sense in all cases is nothing else but original fancy'.

Spinoza agrees rather with Hobbes than with Descartes, and accepts it as a principle that all sensation is imagination, so that *imaginatio* becomes his regular term for sensation (*Ethics*, ii. xvii, scholium). *Imaginatio* is for him not a mode of thought, and in speaking of it he never uses the words *idea* or *percipere*, which with him invariably refer to operations of the intellect; imagination is not an activity but a passivity, and consequently imaginations, just as they contain no truth, 'contain no error' (loc. cit.).

Leibniz is of the same opinion. For him, sensa do indeed deserve the name of idea; but they are ideas of a peculiar kind, ideas essentially confused, which if they could be brought to a state of distinctness would lose their sensuous character and turn into thoughts. In their native sensuousness, therefore, they are a kind of dreams or phantoms; not some of them only, but all of them. It is only with Locke (*Essay*, ii. xxx) that an attempt is made to distinguish 'real ideas' from 'fantastical'. But this is not to say that Locke distinguishes real from imaginary sensa. That he does not do any more than Hobbes and the Cartesians, with whom he agrees that no such distinction exists, though he differs from them as to the reason: they say that all sensa are imaginary, he says that all are real: with his own italics, 'our *simple* Ideas *are all real*'. The only ideas he will allow to be fantastical are certain complex ideas which we form at will by arbitrarily combining simple ones.

The conception of all sensa as real met with no success at the hands of his followers; as we shall see, Berkeley and Hume thought it a matter of urgency to disown it. It has been revived by the neo-realists of our own day; in the case of Professor Alexander, with conscious indebtedness to its author; and it is an idea which well deserves revival as a bold piece of radical empiricism. But Locke was not a radical empiricist; he was a common-sense philosopher who entirely believed in the world of bodies as described by Newton; and consequently this conception could not be made to harmonize with the setting in which he placed it. As it

stands in his text, it is an outrageous sophism. Real ideas he defines as 'such as have a conformity with the real Being and Existence of things, or with their Archetypes'. But when he goes on to say that simple ideas are all real because they 'answer and agree to those powers of things which produce them in our Minds', he has forgotten this; he is treating the proposition that sensa are caused in us by the action of external bodies (the same proposition which, to Hobbes and the Cartesians, had proved them imaginary) as equivalent to the proposition that they are real; in other words, he is substituting, as a definition of 'reality', the relation of effect to cause for the relation of ectype to archetype.

But there is also in Locke the germ of a quite different method for distinguishing real ideas from fantastical. A fantastical idea he describes as one which the mind 'makes to itself'. Complex ideas are sometimes fantastical, because they are sometimes 'voluntary combinations' of simple ones, in which case 'the Mind of Man uses some kind of Liberty' in forming them. Simple ideas can never be fantastical, because they can never be 'Fictions at Pleasure'; the mind 'can make to itself no simple Idea'. Now Locke does not seem to have realized the fact, but these statements made it possible for him to give an account of the way in which we distinguish real from fantastical ideas without any reference to their originals or lack of original. All he had to do was to assume that our powers of what he calls reflection enable us to distinguish a voluntary action from an involuntary *passio*: that we can tell by introspection when we are acting and when we are being acted upon. If so, introspection will serve by itself to distinguish real from imaginary sensa. It will not, of course, detect any difference between the sensa themselves, for sensa are not present to introspection, but only to sensation; but it will detect a difference between the activities by which we sense them. In the one case, the activity will be introspectively recognized as voluntary; in the other, as involuntary: not an *actio* but a *passio*.

This 'introspection theory' (as I shall call it) of the distinc-

tion between real sensation and imagination was not developed by Locke, though any intelligent reader could have developed it from his text, and at least one extremely intelligent reader did so.

§ 3. *Berkeley: the Introspection Theory*

For Berkeley 'ideas of Sense' are distinct from 'ideas of Imagination' (*Principles of Human Knowledge*, i, § 30). The terms are borrowed from Malebranche's *Recherche de la Vérité*; but Malebranche is content to state the difference physiologically, explaining that an idea, which he regards as simply a felt disturbance of our organism, may be due either to the impact of an external body or to a self-initiated change in the organism itself. For Berkeley, this appeal to physiology is a mere evasion. The problem is not to invent a theory accounting for the origin of two different kinds of idea; it is to explain how in point of fact people know, before they come to invent any such theory, to which kind a given idea belongs. The distinction, therefore, must be visible to ordinary people and verifiable by them. That is to say, it must be stated in terms of ideas; no purpose is served by stating it in terms of the relation between ideas and the human organism or in general the physical world. So Berkeley attempts to state it purely in terms of ideas; and lays down the proposition that 'the ideas of Sense are more strong, lively, and distinct than those of the Imagination'.

This might mean either of two things. It might refer to a distinction in something called 'strength' or 'liveliness' between real and imaginary sensa; or it might refer to a distinction (necessarily of a quite different kind, though called by the same name) between the act of real sensation and the act of imagination. In the first case it could hardly mean anything except that a real sound (for instance) is louder than an imaginary one; and that this difference in audible quality is all we mean when we call them respectively real and imaginary. In the second case it would mean that a real sound forces itself upon us in a way in which an

imaginary one does not; a real sound is heard whether we will or no, whereas an imaginary one can be summoned up, banished, or replaced by another at will. Here the difference is not between the sounds, but between the experiences of hearing them; it is a difference appreciable not by the ear, but by the reflective or introspective consciousness in which we are aware of these experiences. It is the second of these positions that Berkeley is maintaining, and so attentive a student of Locke no doubt arrived at it from a study of the passage quoted above.

But it is not a tenable position. The fact that I cannot evoke or control certain ideas at will is according to this doctrine more than an infallible sign of their being real as distinct from imaginary; it is what we mean by calling them real as distinct from imaginary. There are not two facts with a relation between them, there is one fact. But this is not true. There are two different facts, which commonly no doubt are united, but can on occasion occur separately. The extreme case is the hallucination of mental disease, where the patient is obsessed by imaginary sights, sounds, and the like, which he is altogether unable to control; but even in the healthiest organism the same thing is observable. A man who has been horrified by certain sights and sounds cannot for some time banish them from his mind; he continues to imagine the crash, the blood, the cries, for all his efforts to stop. That, on Berkeley's principle, should be proof that he is not imagining them but really seeing them. In fact it only proves that the extent to which we can control our imagination by a deliberate act of will is very limited.

§ 4. *Berkeley: the Relation Theory*

As if dissatisfied with this theory of the distinction, Berkeley at once proceeds to state another, which I shall call the relation theory. Ideas of sense 'have likewise a steadiness, order, and coherence, and are not excited at random, . . . but in a regular train or series. . . . Now the set rules, or established methods, wherein the Mind we depend on excites in

us the ideas of Sense, are called *the laws of Nature*, and these we learn by experience.'

This may be paraphrased as follows. Even if there is no such difference between a real sensation and an imagination, considered by themselves, as might be stated by calling the one involuntary and the other voluntary, there is yet a way in which real and imaginary sensa can be distinguished without appealing to any supposed world of bodies: namely, by considering the relation in which each of them stands to other sensa. The laws of nature are (Berkeley tells us) not laws concerning the relations between bodies or bodily movements or bodily forces, but laws concerning the relations between sensa. To formulate them in terms of body may be convenient, because it is brief; but it is only a short-hand method of putting what, if expressed in full, would turn out to be a statement about the ways in which we have found certain sensa to be related to certain others, and in which we expect like sensa to be related in the future. If we say that matter is indestructible, we mean something like this: if at one time a person has certain sensa of sight and touch, such as are ordinarily referred to by saying that he sees a stone lying in a certain place, then if he continues to watch and to touch he will have other sensa of the kind which we describe by saying either (*a*) that the stone is still there, or (*b*) that it is moving away, or (*c*) that it is breaking up; whereas, if he has the sensa we should describe by saying that the stone has disappeared, it is open to some one to put himself in such a position that he will have further sensa whose relation to these others will be described by saying that he now knows where it has gone to. As our great modern Berkeleian, Lord Russell, puts it, the programme is to resolve propositions about bodies into propositions about sense-data.

Now it is Berkeley's contention that the laws of nature are obeyed by 'ideas of Sense' and not by 'ideas of Imagination'. The former, as Professor Price admirably expresses it, belong to 'families' or groups of sensa connected by fixed

rules determining (for example) what appearance will be presented by a body two feet away to an eye which from three feet away sees it in such and such a manner; and again, how a body so appearing to the eye will feel when touched by the hand. 'Ideas of Imagination', on the contrary, Berkeley thinks to be what Price, following Broad, calls 'wild': they belong to no family; there are no rules according to which they are linked up with other ideas, similar or dissimilar.

This doctrine seems true enough at first sight. Dusk is coming on; I am writing in the window; and glancing back over my shoulder I see something in a darkened corner of the room which looks like a black animal crouching there. Did I really see an animal, or was I imagining it? The procedure which I use in order to answer my question seems to be exactly what Berkeley is suggesting. I begin by appealing to the 'laws of Nature'. If there was really an animal there, either it will stay there or it will go away. I turn on the light and search the place where I saw it. There is no animal there. I search the rest of the room, with the same result. The door is shut, and there is no nook in which it may be hiding, or hole through which it may have escaped. I conclude that it was not a real animal but an imaginary one, or in other words that I was not really seeing but imagining.

That is no doubt very much how we proceed. But it does not really bear out Berkeley's contention. For the imaginary animal does not really disobey the laws of nature. It may disobey some of them, but it obeys others. It is therefore not 'wild'; it belongs to a family, though not the family to which at first we tried to refer it. There is what Berkeley himself calls order about its appearance. My black animal has come before; it comes in the dusk; it comes when I am tired; it comes bringing a slight but perceptible feeling of fear to a person who, as a little boy, was frightened of the dark; in short, though it does not belong to a family which I can describe in physical terms, it plainly does belong to one describable in psychological. And Berkeley seems to be

maintaining that whereas the groups of sensa which would ordinarily be called bodies have pedigrees and obey laws, those which would ordinarily be called minds have none, and conduct themselves in an absolutely lawless (as he calls it, random) manner. But this will not convince any one to-day. No one is entirely satisfied with the state of psychological science; but no one would push his dissatisfaction so far as to contend that the events we call psychological occur without any order or regularity at all.

Can we restate Berkeley's distinction in an improved form by suggesting that 'ideas of Sense' or real sensa are interrelated according to the laws of physics, and 'ideas of Imagination' or imaginary sensa according to those of psychology? No; there are good reasons against that. In the first place, the two sets of laws cannot be so thoroughly disentangled from each other. Real sensa obey psychological laws no less than imaginary ones; and the question whether psychology may not in the end be reducible to physics is still *sub judice*. Secondly, if both sets of laws are learnt by experience, it follows that we can only know what the laws of physics are by studying our real sensa, and what the laws of psychology are by studying our imaginary sensa. We cannot, therefore, begin to ascertain what laws there are, of either kind, unless we can first distinguish with certainty between the different kinds of 'ideas', as we must distinguish ideas of sight from ideas of hearing before we can begin to build up the sciences of optics and acoustics. If we need rules in order to distinguish real sensa from imaginary ones, it cannot be sensation, the undistinguished mixture of real sensation and imagination, that teaches us those rules. And this argument applies equally against the view that imaginary sensa obey laws of their own, and the view that they are completely wild. This is the starting-point of Kant's view, to which we shall come later.

§ 5. *Hume*

It was no doubt this difficulty which led Hume, when he reconsidered the same problem, to drop Berkeley's relation

theory and adopt his introspection theory. Hume attached
great importance to this theory, and expounds it in the open-
ing sentences of his *Treatise of Human Nature*. This was
evidently because, setting himself the task of showing how
all our knowledge is derived from what Berkeley called ideas
of sense and what he himself called 'impressions', he rightly
took it for granted that the whole derivation would be vitiated
unless these could be distinguished from ideas of imagina-
tion, which he called 'ideas'. His first task, therefore, was to
place this distinction on a firm basis. But how? Not in
Locke's manner, by referring back from ideas them-
selves to their 'originals' or 'archetypes', the bodies which
in the one case cause them and in the other do not.
Berkeley's criticism had shown that to be impossible. The
distinction must be a distinction among ideas as such. But
of Berkeley's two theories, the second was unworkable be-
cause it reversed the relation between distinguishing ideas of
sense from ideas of imagination and ascertaining the laws
of nature. The distinction must come first; only when it
is complete can we ascertain what the laws of nature
are. The distinction must therefore depend on a difference,
perceptible by direct inspection, between the two types of
experience.

Thus Hume (unless I misunderstand the whole drift of
his thought) arrived at his own statement of the introspec-
tion theory, as set forth in the first two sentences of his
Treatise. 'All the perceptions of the human mind resolve
themselves into two distinct kinds, which I shall call *im-
pressions* and *ideas*. The difference betwixt these consists
in the degrees of force and liveliness, with which they strike
upon the mind, and make their way into our thought or
consciousness.' His meaning here is the same as that which
we have found Berkeley expressing in the words 'more
strong, lively, and distinct'. He does not mean that, if all
possible sensa of light, for example, are arranged in a scale
of intensity from a dazzling brilliance at one end to invisibility
at the other, there is a point on this scale above which all the

brighter sensa are real sensa, while the dimmer ones below
it are imaginary. The passage in which he makes this clear
is that in which he says 'that idea of red, which we form in
the dark, and that impression which strikes our eyes in
sunshine, differ only in degree, not in nature'. A difference
in brightness or saturation would obviously be a difference
in nature. He refers to a difference not among sensa but
among sensations. When he speaks of the superior force or
liveliness of an impression he means that the act or state of
'perceiving' an 'impression' is one which we find upon
reflection and experiment to be forced upon us even against
our will; by the 'faintness' of an 'idea' he refers to the fact
(or supposed fact) that perceptions of this kind have not
sufficient vigour to force themselves upon us without our
consent, but are subservient to our command. In short, the
distinction between real sensation and imagination is resolved
into the distinction between our inability and our ability of
set purpose to control, excite, suppress, or modify our
sensory experiences.

Hume certainly does not state this doctrine as clearly as
one might wish. In particular, he makes admissions which
contradict it, without attempting to remove the contradic-
tion. 'In sleep, in a fever, in madness, or in any very violent
emotions of soul', he correctly observes that our ideas conform
to the definition he has given of impressions; but he does
not draw either of the possible inferences: that they really
are impressions, or that his definition was faulty. He excuses
himself by pleading that these cases are exceptional; not
noticing that this implies an appeal to the alternative criterion
which he has rejected, namely that of the relation in which
our various experiences stand to each other. The brilliancy
of a sensum of light is a quality immediately given (to what
Locke called sensation) in the sensum itself; its force or
liveliness is a quality of the activity which Hume calls
perceiving it, immediately given as what Locke calls an idea
of reflection in our awareness of that activity; but excep-
tionalness is something we can only attribute to it when we

try to think of it as an instance of a rule determining the relations which our sensa must bear to one another if they are to be regarded as real sensa. Thus the attempt to derive all knowledge from sensation has broken down on the very first page: principles of the kind which Hume proposes to build upon experience have been surreptitiously appealed to at the outset, in order to discriminate those parts of experience which will offer them a secure foundation from those which will not.

And what if the appeal be allowed? Granted that cases of this kind are really exceptional, which modern psychologists would hesitate to grant, yet they are present as genuine facts in the body of human experience. The 'science of MAN', for which Hume in his *Introduction* has claimed such a dominant position at the head of all the sciences, is surely not so unscientific as to content itself with dismissing whole classes of well-attested facts as having no value for the study of its subject, merely because they are less common than others. The exception 'proves' the rule by showing whether the rule is equal to the task of explaining it; if it is not, it is proved false. But Hume's refusal to extend so familiar a principle of method to the science of human nature was not a mere freak on his part; it followed from a general theory, assumed by most modern pre-Kantian philosophers, that you cannot afford to think accurately about human nature, because human nature, owing to the element of freedom in it, is an indeterminate thing, acting at random, so that even the truest statements about it are only true (as Aristotle said about the statements of ethical science) 'for the most part', and exceptions do not matter. It was Kant who first showed that progress in the science of human nature must come, like progress in any other science, by taking exceptions seriously and fastening upon the unusual case (that, for example, of the man who does good to others not in order to win their good opinion, and not because he enjoys doing it, but simply because he thinks it his duty) as the peculiarly instructive one.

§ 6. *Kant*

By these more rigorous principles of method, Kant was prevented from accepting a generalization so riddled with exceptions as that of Hume. On Kant's view as to the structure of experience, if there is any distinction between real and imaginary sensa, it cannot lie in a difference of 'force and liveliness', that is, in the involuntary or voluntary character of the acts by which we 'perceive' them. It must lie elsewhere; and at first sight Kant seems in effect to restate Berkeley's second position, and to place the distinction in the way in which a given sensum is related to others. Reality, according to him, is a category of the understanding, and understanding is thought in its primary function, as concerned with the relations between sensa.

But Kant is not in fact returning to Berkeley. According to Berkeley, the 'laws of nature' are without exception learned from 'experience'; that is, they are all empirical laws, laws of the first order, discovered and verified by noting the relations between sensa. Hume tentatively, and Kant more explicitly, attacked this doctrine, and showed that these first-order laws implied second-order laws, which Kant called 'principles of the understanding'. Now, relatively to the first-order laws of nature, so far as they have been ascertained at any given moment in the history of scientific discovery, this or that sensum may very well be 'wild', in the sense that the laws as yet known give no account of its place in any family. But this cannot be the case relatively to laws of the second order. It is a principle of the understanding that every event must have a cause. No event that comes under our notice can escape this principle. The furthest length to which it can go towards wildness in that direction is a failure on our part to discover what, in particular, its cause is.

Thus Kant's discovery of second-order laws involves the discovery that there are no wild sensa. At the same time, it enables him to explain what we mean when we say that wild sensa exist. We are saying that certain sensa, though

in the light of the second-order laws we know that they must admit of interpretation, have not yet been actually interpreted, and perhaps cannot be interpreted except through the discovery of first-order laws as yet unknown to us.

The theory of imagination thus passes through three distinct stages from Descartes to Kant. (1) To most of the seventeenth-century philosophers it seemed clear that all sensation is simply imagination. The common-sense distinction was simply wiped out, and the existence of anything which could be called real sensation was denied. It was admitted that our sensa are caused by the action upon our bodies of other bodies (of whose existence we were assured not, of course, by sensation but by thought), but the fact that imagination has an external cause does not make it any the less imagination. (2) The English empiricists tried to restate the common-sense distinction, but were unable to reach an agreement: nor did any one of them put forward a theory which could actually (even if itself defensible) be regarded as a defence of that distinction: for none of their theories quite tallied with it. (3) Kant (with important help from Leibniz and Hume) approached the problem along a new line. Instead of trying to conceive real sensa and imaginary sensa as two co-ordinate species of the same genus, the conception which, in spite of the empiricists' attempt to revive it, had been once for all refuted by the Cartesians, he conceived the difference between them as a difference of degree.[1] For him, a real sensum can only mean one which has undergone interpretation by the understanding, which alone has the power to confer the title real; an imaginary sensum will then mean one which has not yet undergone that process.

[1] Here and elsewhere I use this word in the traditional philosophical sense, where differences of degree are understood as involving differences of kind; as in Locke's 'three degrees of knowledge', where each 'degree' is at once a fuller realization of the essence of knowledge than the one below (more certain, less liable to error) and also a fresh kind of knowledge. See *Essay on Philosophical Method,* pp. 54-5, 69-77.

§ 7. 'Illusory Sensa'

The common-sense distinction between real and imaginary sensa, although flatly denied by the Cartesians, retains a certain hold on our thought. When common sense makes a distinction, philosophy is well advised to think it possible that a distinction of some kind exists; but is certainly not obliged to assume that the account of it given by common sense is correct.

If there is anything in the view which we have found implied by Kant, the common-sense distinction can be justified; but it cannot be a distinction between two classes of sensa. This, as we have seen, was admitted even by the English empiricists; but it is not admitted by common sense; and, as we are not bound by the findings of any philosophical school, we must now consider the question directly.

We can do this best by beginning with an analysis of illusory sensa. At first sight, it would seem a satisfactory development of the common-sense view to say that, sensa being in themselves of two kinds, real and imaginary, an illusory sensum is an imaginary one mistaken for a real. If I dream that I am looking at sea, sky, and mountains, the colours I see are imaginary colours, but in so far as the dream contains an element of illusion I take them for real ones. It is this error that converts imaginary sensa into illusory. There is thus no special class of illusory sensa. There is nothing special in these colours, in virtue of which they are illusory; to describe them as illusory is only to say that an error has been made about them. In order to salve our pride as thinkers, we may pretend that the error was due to them, not to ourselves, and accuse them of somehow forcing us to make it. But this is hypocrisy. There can be nothing of such a kind as to force a person who thinks about it into error. And if there were, the error could never be corrected, so that we should never be able to call the thing illusory.

But imaginary sensa are not the only ones about which

mistakes are made. Mistakes of the same general kind are made about real sensa, especially if they present themselves to us in unfamiliar circumstances. When a child or savage (or for that matter a dog or cat) first sees his face in a glass, he is very likely to be deceived, by the resemblance between what he now sees and another person's face seen through a frame or opening, into thinking that he is looking at a face situated behind the plane of the mirror. Actually he is looking at his own face, situated as usual on the front side of his head. He is looking at it under conditions which are unfamiliar to him, but are not at all unfamiliar to myself, who in shaving have no difficulty about correlating what I see in the glass with what I feel in using razor and brush. But the face as seen in the glass is just as illusory to the child or savage as were the sea, sky, or mountains to me in my dream.

We were wrong, therefore, to define illusory sensa as imaginary sensa which we mistake for real ones. Illusory sensa can be defined without referring to the distinction between imaginary and real. Any sensum is illusory in so far as we make an error about it. This error does not consist in mistaking it for a different sensum. Indeed, it is not easy to see how that would be possible. All that there can ever be in a sensum is directly present to us in the act of sensation. We may be mistaken in believing that another person in our circumstances would have a similar one; but we cannot, in seeing a red patch, mistake it for a blue one. The mistakes we make about our sensa are mistakes about their relations with other sensa, possible or expected. The child or savage is not mistaken, when he looks at the glass, in thinking that he sees a certain pattern of colours; he is not mistaken in thinking that it resembles what he sees when he looks at some one else's face two feet away; his mistake lies in thinking that because of these facts he can touch the face he sees by feeling behind the glass. Further experience will teach him that in order to touch it he must feel in front of the glass. That experience is called learning about reflections, and is an

example of what Berkeley calls learning the laws of nature by experience.

An illusory sensum, then, is simply a sensum as to which we make mistakes about the relation in which it stands to other sensa. The conception of illusion disappears, resolved into the conception of error.

§ 8. *'Appearances' and 'Images'*

There are certain other conceptions which must be treated in a similar way. One of these is the conception of appearance.

We say that a distant man 'looks' smaller than one close at hand, or that railway lines 'look' convergent, although the person to whom they so appear knows very well that the two men are of the same height and that the rails are parallel. This is an everyday and untechnical way of speaking. Some philosophers or psychologists would 'explain' it by saying that we must distinguish men, or railway lines, from things they call 'appearances' of men or railway lines; and that when we say a distant man looks smaller than one close at hand, although the two are really the same size, we mean that the appearance of the distant man is smaller than that of the man close at hand, though the two men themselves are of the same size. In the case of the railway lines, they will say that the lines themselves are parallel, but their appearances convergent.

If this is mere perversity in speech, it is pardonable, though undesirable. But if it is theory, we must have no truce with it. If there were really such an 'appearance' directly given in sensation, this would constitute, as it were, an inducement or temptation in sensation itself for us to make a certain error; and this is impossible, for just as no sensation can force us to make a mistake about it, so none can persuade or tempt us to do the same. What we mean when we say that the distant man looks smaller, or that the rails look convergent, was explained in the preceding chapter (p. 166). Briefly, it comes to this: that we are warning our-

selves or others against the error of thinking that because
the pattern of colours we now see resembles the patterns
we have seen on occasions of a certain kind, the further sensa
which we may expect on behaving in certain ways will
continue to show the same kind of resemblance. Thus, as
the phrase 'illusions of sense' or 'illusory sensa' describes
cases in which actual errors are made as to the relations be-
tween sensa, so 'appearances of sense' describes cases in
which care is taken that errors of this kind shall not be made.

The same kind of error is expressed by the use of the
word 'image'. The two errors are similar in that each of
them projects into the sensum, or into a fictitious entity more
or less modelled on the sensum, the mistakes which we make
when we think about it and think confusedly. The victim
of this second delusion will say: 'All this can be better
expressed by using the word "image". If we see one man
farther away than another, or look obliquely down on railway
lines, what we see is an image of the thing at which we are
looking. The image of the distant man is really smaller than
that of the nearer; the images of the metals really converge;
the image of the stick in water is really bent; but it does not
follow that the things are like them. That depends on the
conditions under which the images are formed.'

If this is terminology, it is objectionable; if theory, it is
false. As terminology, it suggests an analogy between the
relation of a sensum to a body and the relation of a photo-
graph or drawing to the object photographed or drawn.
This is objectionable, because there is no such analogy. The
essence of the relation between a drawing and the object
drawn is that they are both visibly present to us as bodies
we perceive, and one is called an image of the other in so far
as it is visibly like it. To call that which we see when we look
at railway lines an image of the railway lines is to suggest
that we see the two things separately, whereas the point of
the theory is that we do not; and to suggest that what we see
is a true copy of the railway lines, whereas the statement made
is that it is not. As theory, it is false, because it introduces

between ourselves and the thing at which we are looking
(i.e. what is visibly present to us as a perceived body) a third
thing, owing to whose interposition we do not see the so-called
object at all; a thing which unless our perceptions are
illusions must be perfectly like the object, and is yet ad-
mitted to be very unlike it. The whole theory is nothing
but an attempt to explain the mistakes we sometimes make
about our sensa by projecting these errors into the sensa
themselves.

§ 9. *Conclusion*

Now let us return to imagination; and begin by observing
that when in ordinary speech we are said to imagine some-
thing, what we imagine is not always something 'not really
there'. A matchbox lies before me. Three of its sides are
turned towards me, and these are the only ones I really see.
But I imagine the other three; one yellow and black, one
blue, and one brown. I also imagine the inside, with
matches lying in it. I imagine the feel of it, and the smell
of its brown sides with their coating of phosphorus com-
pound. These things are all really there, pretty much as I
imagine them. Moreover (this is a point Kant has made),
it is only so far as I imagine them that I am aware of the
matchbox as a solid body at all. A person who could really
see, but could not imagine, would see not a solid world of
bodies, but merely (as Berkeley has it) 'various colours
variously disposed'. Thus, as Kant says, imagination is an
'indispensable function' for our knowledge of the world
around us.

This must be granted; but it may still be urged that in
cases of another kind what we imagine is mere phantoms,
things without reality. I am not quite sure what this means.
When I look at a rainbow, I do not think that I am looking
at an arched and painted structure, over which men might
climb and against which swallows might nest, standing upon
two plots of ground at its two ends. I think I am looking
at rain (though certainly I can see no drops of it) lit by the

sunlight and breaking its whiteness into colours. When I say this, I am rejecting one interpretation of my sensa and embracing another. The rainbow is 'really there' not in one sense but in two. As a sensum or arrangement of sensa, it is really there in the sense that I see it; and in that sense my imaginary beast in the dark corner of the room is really there, and so are the snakes of delirium tremens. In the other sense of the phrase, what is really there is the rain and the sunshine, that is, the things in terms of which I interpret my sensa.

A person suffering from a bilious attack may see a pattern of zigzag or embattled lines floating before his eyes. When I walk uphill too fast, I see in the centre of my field of vision a nebulous and granular patch of green light, bright in the middle and fading into red at the edges. I suppose it to have some connexion with the labouring of my heart, as the other is connected with digestive trouble. Are these things 'really there'? In the first sense, yes; they are sensa actually seen. In the second sense, an answer can be given only when we have interpreted them, as we interpreted the rainbow in terms of rain and sunlight. But this we have already done. If in seeing the rainbow we are seeing the drops of rain and the white sunlight, in the embattled lines we are seeing the bilious attack, and in the green light the labouring heart: as, when a man goes red in the face, we see his anger, and when the trees wave their branches we see the wind.

A third type of case. A boy dreams of a fire which destroys his home while he looks helplessly on. This is a clear case of imagination, complicated no doubt at the moment by illusion; when he wakes the illusion is dispelled, but the imagination (if he 'remembers' the dream, that is, continues to experience it in imagination) remains. Is the fire 'really there'? Again, in the first sense, yes. To answer for the second sense, we must interpret the dream: and how we shall answer depends on how we interpret. If we interpret it as meaning that his father's house will shortly be burnt, or that a friend's house is now being burnt, we shall have to say

that the fire is not real, and shall join our voice to that of the many who 'seyen that in sweveninges there nis no truth, but they ben al lesinges'; which merely means that we have an interpretation, but recognize it to be false, and can suggest none better. Modern psychologists will connect the dream with the awakening passions of adolescence which are tormenting the boy's body and frightening his soul, while they destroy the safe and sheltered life he has hitherto lived. If that interpretation is right, the fire is as real as the rainbow and the embattled lines. It is the way in which the boy sees the crisis that has come upon him.

This, then, is the result of our examination. Sensa cannot be divided, by any test whatever, into real and imaginary; sensations cannot be divided into real sensations and imaginations. That experience which we call sensation is of one kind only, and is not amenable to the distinctions between real and unreal, true and false, veridical and illusory. That which is true or false is thought; and our sensa are called real and illusory in so far as we think truly or falsely about them. To think about them is to interpret them, which means stating the relations in which they stand to other sensa, actual or possible. A real sensum means a sensum correctly interpreted; an illusory sensum, one falsely interpreted. And an imaginary sensum means one which has not been interpreted at all: either because we have tried to interpret it and have failed, or because we have not tried. These are not three kinds of sensa, nor are they sensa corresponding with three kinds of sensory act. Nor are they sensa which, on being correctly interpreted, are found to be related to their fellows in three different ways. They are sensa in respect of which the interpretative work of thought has been done well, or done ill, or left undone.

The common-sense distinction between real and imaginary sensa is therefore not false. There is a distinction. But it is not a distinction among sensa. It is a distinction among the various ways in which sensa may be related to the interpretative work of thought.

IMAGINATION AND CONSCIOUSNESS

§ 1. *Imagination as Active*

WE have not yet finished with the introspection theory. The germs of this theory we found in Locke; its first clear statement in Berkeley; and in Hume, as we saw, it carried the entire weight of his theory of knowledge. We rejected it, because the examples of *idées fixes* and hallucinations make it impossible for us to correlate the distinction between real and imaginary sensa with the distinction between sensations that are not under the control of our will and those that are under such control. But this was our only reason for rejecting it; and we must, in fairness to the theory, ask ourselves whether it is rejected as altogether mistaken, or only as overstating something which, when the overstatement is removed, turns out to be true.

Locke himself, as so often, hesitates in his language between a moderate and an extreme view. To call fantastical ideas 'Fictions at Pleasure' implies an extreme view; to say that 'the Mind of Man uses some kind of Liberty' in forming them implies a far more moderate one; for what kind of liberty is used? That is the question we are now to raise.

The thesis to be examined is that, in some way not yet clearly defined, imagination contrasts with sensation as something active with something passive, something we do with something we undergo, something under our control with something we cannot help, a making with a receiving. I am being purposely vague, because I am trying at present merely to restate a common-sense idea which, as common sense holds it, is nothing if not vague. If we agree to accept it provisionally in this vague shape, we may hope to make it more precise afterwards.

Most people quite unthinkingly take the idea for granted. One can see this from the popularity of the term 'sense-

datum'. People who use that word, or in equivalent English speak of what is 'given' in sensation, perhaps do not ask themselves what exactly they mean. Obviously, they are not thinking of the natural and ordinary sense of the verb 'to give'. That would imply that they conceived a patch of colour, for example, as something transferred on a given occasion from the ownership of one person called the donor to that of another called the recipient, to whom he 'gives' it either out of sheer generosity or because he has seen as much of it as he wants. There is also a technical sense of *dari* in scholastic Latin, arising out of the terminology of logical debate, where *datur* means 'it is granted', that is to say, you are allowed to assert something. Here *datum* means what you are allowed to assert at this point in the debate. In this sense, if a scholastic philosopher has succeeded to his own satisfaction in proving the existence of God, he ends his argument: *ergo datur Deus*. But people who talk about sense-data clearly mean more than this, though less than the other sense. It seems that they are using the term in some mysterious sense of their own, meaning by its use (we may perhaps guess) to call our attention to a contrast between imagination and sensation which somehow vaguely reminds them of the contrast between making (say) a paper-knife for yourself and receiving one as a present from a friend.

There certainly is a contrast of this kind. As usual, common sense is justified in pointing to a distinction, but incapable of telling us what the distinction is. When we begin trying to answer that question for ourselves, we seem at first only able to say what it is not.

For example, it is not a distinction between activity and passivity as such. Sensation itself is an activity. Even if we do it only because we are stimulated to it by forces outside our control, it is still something which we do. Response to stimulus is in some sense passive, in so far as it cannot arise without the stimulus; but it is also active, in so far as it is a response. If I am a kind of factory for converting wave-lengths into colours, air-disturbances into sounds, and so

forth, as the materialists believe (and Locke with them), there is work done in that conversion; the machinery is active, even if it is controlled by no manager or foreman. Even wax and water are active in their own special ways, or they would not take and retain the seal, or break into waves at the stone's impact.

Nor is it a distinction among passivities (things that happen to us, as distinct from things we do) according as they are done to us by external bodies impinging on our own, or by changes arising within our own organism, as Malebranche maintained. For sensation, as well as imagination, is on its bodily side a change arising within our own organism, and due to the energies of that organism itself. The afferent nerves through whose activity we feel a pressure on a finger-tip are not solid rods conveying that pressure itself to the brain; they are functioning in their own way as a special kind of living tissue; if they ceased to function in that way, no amount of pressure on the finger could give rise to a sensation.

Nor is it a distinction among activities (things we do) between those we do of our own choice and those we cannot help doing. It is in fact easier to stop seeing this paper, by shutting one's eyes, than to stop imagining the frightful accident which one saw yesterday.

If we reject these false solutions, and yet cling to the belief that the original distinction was not wholly groundless, our problem takes shape thus. In some sense or other, imagination is more free than sensation. Even sensation is not entirely unfree; it is a spontaneous activity of the living and sentient organism; but the freedom of imagination goes a step further. And even imagination is not free in the way in which the conscious carrying-out of an intention is free; the freedom it possesses is not the freedom of choice; yet for all that it is a kind of freedom which is denied to sensation. Regarded as an activity or manifestation of freedom, then, imagination seems to occupy a place intermediate between the less free activity of mere feeling and the more

free activity of what is generally called thought. Our task is to define this intermediate place.

§ 2. *The Traditional Confusion of Sense with Imagination*

At this point we must return to the difficulty stated at the end of Chapter VIII. That difficulty arose out of the question: How can we think about relations between sensa? As a possible solution, I suggested that when people (including ourselves) talk about relations between sensa they are really talking not about sensa but about things of another kind, like sensa in certain ways, but unlike them in others; and that these other things belong to a region of experience which we call not sensation but imagination. Thus, it was suggested, imagination forms a kind of link between sensation and intellect, as Aristotle and Kant agreed in maintaining. If this suggestion can be made good, we shall be in a fair way towards answering the question how in respect of its freedom imagination is intermediate between feeling, as less free than itself, and intellect as more free.

We found in Chapter VIII that sensation must be regarded as a flux of activity in which, however few or however many distinct sensory acts are going on together at any one time, each is no sooner achieved than it gives place to another. In each act we sense a colour, a sound, a scent, or the like, which can be present to us only in our performance of the corresponding act. As soon as the act is over, the sensum has vanished, never to return. Its *esse* is *sentiri*.

Objection may easily be raised to this last phrase as an overstatement. 'Naturally', it may be said, 'we cannot see a colour without seeing it. But what could be more absurd than to argue that, because we have stopped seeing it, the colour has ceased to exist? For all we know, colours may perfectly well go on existing when we are not looking at them.'[1] The objection is an excellent example of 'metaphysics' in the sense in which that word has at various times

[1] I paraphrase Professor G. E. Moore, 'The Nature and Reality of Objects of Perception', in his *Philosophical Studies*, pp. 31 seqq.

become a term of merited abuse. For all we know, chim-
eras may bombinate in a vacuum, and a hundred angels
stand on the point of a needle. And there is a kind of
pleasure to be got by indulging in these metaphysical fairy-
tales, somewhat like the pleasure of talking nonsense. It is
the pleasure of allowing an overstrained and jaded intellect
to kick up its heels without a load on its back. There is also
a pleasure to be got by philosophical thinking; but a very
different one. The fairy-tale about the existence of un-
sensed sensa, no doubt, is believed by the people who
indulge in it to be a piece of philosophical thinking. Their
reason for this belief is that unless it were true they think
propositions like the following would be nonsense: 'If
these conditions had been fulfilled, I should have been per-
ceiving a sense-datum intrinsically related to *this* sense-
datum in *this* way.'[1] But even if the belief in question were
true, propositions of this kind would still be nonsense unless
it were true not merely that a sensum exists apart from our
sensation of it, but that in this state of apartness it is open
to our inspection; we have it before our mind in such a way
that we can appreciate its qualities, compare them with
those of other sensa, and so forth. The question is not one of
metaphysics, whether colours exist or not when we do not
see them; it is a question of epistemology, whether we can
'have them before our mind' in the above sense otherwise
than by seeing them; and, if so, how. If we cannot, proposi-
tions of the kind in question are all nonsensical; if we can,
the description of colours as 'sense-data' (or 'sensa') is either
false, or is saved from being false only by an ambiguity in the
word 'sensation' and its cognates.

I have quoted Professor Moore not because he is unusual
in this respect but because he is typical; and not because he
is an exceptionally confused thinker but because he is an
exceptionally clear one. He is merely expounding a tradi-
tional theory of sensation in which the systematic confusion

[1] Prof. Moore, 'Defence of Common Sense', in *Contemporary British
Philosophy*, vol. ii, pp. 221–2.

of sensation with imagination has, in spite of Hume's pro-
test, become a dogma. The only way in which a sensum can
be present to us is by our sensing it; and if there is anything
which enables us to speak of 'sensa' not now being sensed,
this cannot be strictly sensation, and the sensa in question
cannot be strictly sensa. This is an obvious truth; but the
denial of it has become an orthodoxy; and we must expect
any statement of it to be greeted with blank stupefaction or
indignant accusations of paradox-mongering.

The error dates back to Locke. It is roundly stated on the
first page of his constructive argument (*Essay*, book ii, ch. i,
ad init.). 'Let us suppose the Mind to be, as we say, White
Paper, void of all characters, without any Ideas; how comes
it to be furnish'd? How comes it by that vast store which
the busy and boundless Fancy of Man has painted on it with
an almost endless variety?' The answer is given by stating
the doctrine of ideas, with their two classes, ideas of sensation
and ideas of reflection. From the first source, our senses,
we have ideas of '*Yellow*, *White*, *Heat*, *Cold*, *Soft*, *Hard*,
Bitter, *Sweet*, and all those which we call sensible Qualities';
from the second, our ideas of '*Perception*, *Thinking*, *Doubting*,
Believing, *Reasoning*, *Knowing*, *Willing*, and all the different
Actings of our own Minds'. The origin he attributes to 'the
idea of *Yellow*' would make it a sensum, an individual patch
of yellow which appears and is gone as soon as it has ap-
peared. The function he imposes on it would make it some-
thing very different; something recurrent and recognizable,
a permanent addition to our experience. Sensation 'furnishes'
the mind with nothing whatever; it writes no legible char-
acters on any white paper within us. What sensation writes
is written in water. The task of building up furniture for the
mind out of sensa, which is the task Locke imposes on the
understanding, is like ordering a joiner to make furniture
for a room out of the shadows cast by the window-bars in
sunlight on the floor.

It was Hume who first perceived the problem, and tried
to solve it by distinguishing ideas from impressions. He

was right when he laid it down that the immediate concern of thought is not with impressions but with ideas; that it is ideas, not impressions, that are associated with one another and thus built up into the fabric of knowledge; and that ideas, though 'derived' from impressions, are not mere relics of them like an after-taste of onions or an after-image of the sun (as Lockians like Condillac supposed), but something different in kind: different, if not in what he calls their 'nature', in the way in which they are related to the active powers of the mind. But because he was not able, as we have seen, to give a satisfactory account of this difference, we find to-day that philosophers who attempt to follow him lose sight of his partial but very real achievement; either identifying the idea with a special kind of impression, like Condillac, or denying the idea altogether, and reducing what Hume called the relations between ideas to relations between the words which we use when we talk about ideas.[1]

The confusions which in the minds of most modern philosophers beset the whole idea of sensation are thus so inveterate, in English thought at least, that it may seem hopeless to demand a return to Hume and a serious attempt to clear them up. Nevertheless, that is my programme.

[1] Condillac, *Traité des Sensations*, i. ii, § 6. 'Mais l'odeur qu'elle [sc. the hypothetical statue of his argument, endowed at this stage with the sense of smell and no other faculties except what are involved in its exercising that sense] sent ne lui échappe pas entièrement, aussitôt que le corps odoriférant cesse d'agir sur son organe. . . . Voilà la mémoire.' This is as much as to say that when, on reaching land after a rough voyage, the after-effects of the tossing I have experienced make me feel as if the land were heaving, my memory that the sea was rough simply is this swaying sensation I now feel. Cf. Semon's account of 'mnemic feelings' (*Die mnemischen Empfindungen*, 1909). Such feelings are (to speak with Hume) impressions; a memory is an idea; and the belief that memory can be described in such a way is an example of identifying the idea with one kind of impression. The alternative way of ignoring Hume is to merge the idea in the word by which we designate it, and thus reduce what Hume calls relations between ideas to relations between words. This is the doctrine of certain 'logical positivists', who hold that the propositions which Hume describes as asserting relations between ideas merely 'record our determination to use symbols' that is, words 'in a certain fashion' (A. J. Ayer, *Language, Truth, and Logic* (1935),

§ 3. *Impressions and Ideas*

Modern philosophers, when they talk of sensation, sensa, and the like are talking about at least two kinds of things which they fail to distinguish. First, something which they are really talking about sometimes, and profess to be talking about always, when they use such language: 'real' colours and the act of seeing them, sounds and the act of hearing them, scents and the act of smelling them, and so forth. Secondly, something very different, namely acts of imagining and the 'imaginary' colours, sounds, scents, and so forth which we imagine. It is the second class of things to which they are referring whenever they talk about the sensa which in certain circumstances we should perceive or should have perceived; the sensa which we have perceived in the past; the sensa which we expect to perceive in the future.[1] It is to these they are referring whenever they talk about a family or class or collection or manifold of sensa.

There must be a distinction between these two kinds of things; for if there were not, the statements which are made about relations between sensa, quite apart from the question whether they are true or not, could not even be made; for nobody could in that case even imagine himself to be comparing different sensa. The problems discussed by these philosophers would not only be incapable of solution, they could never have been raised. There must, in other words, be a form of experience other than sensation, but closely related to it; so closely as to be easily mistaken for it, but different in that the colours, sounds, and so on which in this experience we 'perceive' are retained in some way or other before the mind, anticipated, recalled, although these same colours and sounds, in their capacity as sensa, have ceased to be seen and heard.

This other form of experience is what we ordinarily call imagination; ordinarily, because its existence as a form of experience different from sensation, yet closely akin to it,

[1] I borrow the Humian term 'perceive' from Professor Moore.

is something with which we are all perfectly familiar and for which we have this familiar name. How it is related to the thing called imagination at the end of the last chapter remains to be seen. For the present, we must cling to the notion that something of the kind exists, and recollect that its existence was a cardinal point in the philosophy of Hume. It was in order to distinguish it from sensation that Hume distinguished ideas from impressions; and it was his great merit to have realized that what modern philosophers miscall relations between sensa (that is, between what he calls impressions) are relations not between impressions but between ideas. The place which Hume's ideas inhabit is the empty room of Locke, progressively furnished with what 'the busy and boundless Fancy of man' provides. And it is imagination, not sensation, to which appeal is made when empiricists appeal to 'experience'.

§ 4. *Attention*

Thought, I said in chapter VIII, detects 'relations between sensa'; finds in this patch of colour a qualitative similarity with others, and in virtue of that similarity calls this patch red. But in order that we may detect resemblances or any other relations between things, we must first identify each of them: distinguish each as a thing by itself and appreciate its qualities as those qualities we find it to possess, even though as yet (not having determined their relations to qualities found elsewhere) we are not in a position to name them. Before I can say 'This is red' I must first have appreciated the colour-quality which, because it is like certain others, I thus call by the same name. This act of appreciating something, just as it stands, before I can begin to classify it, is what we call attending to it.

It may be objected that what I have called appreciating the colour-quality of a red patch is the same as seeing it: in other words, that what I am here calling attention to is nothing but sensation itself. Before answering this objection, I will begin by pointing out that looking is different from

seeing, and listening from hearing. Seeing and hearing are species of sensation; looking and listening are the corresponding species of attention.

I have followed the current tradition in quoting 'a red patch' as an example of a sensum. But what presents itself to our eyes, in so far as we merely see, is never a red patch. It is always a visual field, more or less parti-coloured; having no definite edges, but fading into confusion and dimness away from the focus of vision. A patch is a piece cut out of this field, which presents itself to us only in so far as we look at it. To describe it as a patch implies that the field is divided into an object of attention, and a background or penumbra from which attention is withdrawn.

Attention divides, but it does not abstract. We attend, for example, only to this red patch out of all the variegated field of vision; but what we attend to is the red patch as it presents itself to us, a concrete individual. Similarly, we may attend to the red patch as we see it, as distinct from the emotion which we feel in seeing it. On the other hand, if we abstract from it the quality of redness, a quality which can be shared by other individual patches, we do so not by attending but by thinking. The activity of thinking or intellectual activity always presupposes the activity of attention, not in the sense that it can only happen after it, but in the sense that it rests upon it as upon a foundation. Attention is going on concurrently with intellection; an attention combined with intellection, and modified by it in such way as that combination requires.

Thus, when to the merely psychic experience of feeling (purely sensuous-emotional experience) there is added the activity of attention, the block of feeling present to the mind is split in two. That part of it to which we pay attention is called the 'conscious' part (properly speaking, it is not it that is conscious, it is we that are conscious of it); the rest is the 'unconscious' part. What is called 'the unconscious' is not the psychical level of experience as such, but the negative counterpart or penumbra of that upon which atten-

tion is focused. This is relatively, not absolutely, uncon-
scious. It is not absent from attention; it is removed from
its focus, ignored. And obviously we cannot ignore a thing
unless we give it a certain degree and a peculiar kind of
attention.

At the merely psychical level, the distinction between
conscious and unconscious does not exist. To describe this
level as unconscious, therefore, is to describe it in terms of
an antithesis which does not apply to it, and thus to place it
in a false perspective. The mind here exists only in the shape
of sentience. What we are doing at this level is what
Descartes described as 'using his senses', or what Professor
Alexander calls 'enjoying ourselves'. Descartes[1] calls this
the immediate experience of the union of the mind with the
body; Alexander regards it as a relation to ourselves which
is too intimate to be knowledge. We can never catch our-
selves thus engaged, to draw up an account of our employ-
ment. When the light of consciousness falls on such
occupations, they change their character; what was sentience
becomes imagination. Hence we cannot study psychical
experience, or even assure ourselves that it exists, by in-
quiring of our own consciousness; that can only tell us
clearly of the things to which it attends, and obscurely of
those which it ignores. Those which are utterly outside its
ken must be studied by other methods. But what are these
methods to be? Behaviourism has dealt with the problem,
and gone some way towards a correct solution, by dismissing
'introspection', that is, inquiry made of consciousness, as
futile, and identifying the psychical with the physiological.

[1] 'C'est en usant seulement de la vie et des conversations ordinaires, et en
s'abstenant de méditer et d'étudier aux choses qui exercent l'imagination
[viz., mathematics], qu'on apprend à concevoir l'union de l'âme et du corps
. . . la principale règle que j'ai toujours observée en mes études . . . a été que
je n'ai jamais employé que fort peu d'heures, par jour, aux pensées qui
occupent l'imagination [mathematics], et fort peu d'heures, par an, à celles
qui occupent l'entendement seul [metaphysics], et que j'ai donné tout le
reste de mon temps au relâche des sens et au repos de l'esprit. . . . C'est ce
qui m'a fait retirer aux champs.'—Letter of 28 June 1643 to the Princess
Elisabeth.

The method thus devised is perfectly sound, but for one flaw. Unless we had independent knowledge both that there is such a thing as psychical experience and what kind of a thing it is, the problem which the behaviourist solves by his method could never arise. This independent knowledge is derived neither from observing bodily 'behaviour' nor from questioning consciousness, but from analysing consciousness, and thus discovering its relation to a more elementary kind of experience which it presupposes.

The principle of this analysis depends on the fact that attention (or, as we may now indifferently call it, consciousness or awareness) has a double object where sentience has a single. What we hear, for example, is merely sound. What we attend to is two things at once: a sound, and our act of hearing it. The act of sensation is not present to itself, but it is present, together with its own sensum, to the act of attention. This is, in fact, the special significance of the *con-* in the word consciousness: it indicates the togetherness of the two things, sensation and sensum, both of which are present to the conscious mind. A man *conscius sibi irae*[1] is not one who simply feels anger; he is one who is aware of the anger as his own, and is aware of himself as feeling it. Thus, the difference between seeing and looking, or hearing and listening, is that a person who is said to be looking is described as aware of his own seeing as well as of the thing he sees. There is the same focusing on both sides. As in looking I focus my attention on part of the visual field, seeing the rest but seeing it 'unconsciously', so at the same time I focus my attention on part of the multiform sensory action which at the moment is the totality of my seeing, and thus that part of it becomes a conscious seeing or looking, the rest becomes 'unconscious' seeing.

§ 5. *The Modification of Feeling by Consciousness*

Colour, or anger, which is no longer merely seen or felt but attended to, is still colour or anger. When we become

[1] Suetonius, *Claudius*.

conscious of it, it is still the very same colour and the very same anger. But the total experience of seeing or feeling it has undergone a change, and in that change what we see or feel is correspondingly changed. This is the change which Hume describes by speaking of the difference between an impression and an idea.

With the entry of consciousness into experience, a new principle has established itself. Attention is focused upon one thing to the exclusion of the rest. The mere fact that something is present to sense does not give it a claim on attention. Even what is most vividly present to sense can do no more than solicit attention; it cannot secure it. Thus, the focus of attention is by no means necessarily identical with the focus of vision. I can fix my eyes in one direction, and my attention upon what lies at a considerable angle away from it. I can deliberately refuse attention to the loudest of the noises I am hearing, and concentrate upon a much less conspicuous one. Often, no doubt, we idly allow our attention to be attracted by whatever is most prominent in sensation and emotion; the brightest light, the loudest noise, the pain or anger or fear that comes most strongly upon us; but there is no reason for this in principle, and it only happens so long as our consciousness is a faint and confused one.

Thus attention is in no sense a response to stimulus. It takes no orders from sensation. Consciousness, master in its own house, dominates feeling. Now feeling as so dominated, feeling as compelled to accept whatever place consciousness gives it, focal or peripheral, in the field of attention, is no longer impression, it is idea. Consciousness is absolutely autonomous: its decision alone determines whether a given sensum or emotion shall be attended to or not. A conscious being is not thereby free to decide what feelings he shall have; but he is free to decide what feeling he shall place in the focus of his consciousness.

Yet he is not free to choose whether he shall exercise this power of decision or not. In so far as he is conscious, he is obliged to decide; for that decision is consciousness itself.

Further: in so far as he is simply conscious, he does not review his various feelings and then decide which of them he shall attend to. Such a review would be a successive attention to these various feelings. In order to choose, in the strict sense of that word, which feeling he shall attend to, he must first have attended to them all. The freedom of consciousness is thus not a freedom of choice between alternatives; that is a further kind of freedom, which arises only when experience reaches the level of intellect.

The freedom of mere consciousness is thus an elementary kind of freedom; but it is a very real kind. At the level of psychic experience, the self is dominated by its own feelings. What Berkeley or Hume calls their 'force' or 'liveliness' consists in the fact of this dominance. A child feels pain and screams; fear, and cringes; anger, and howls or bites; each in perfectly automatic reaction to the emotion of the moment. At the level of consciousness, the feelings are dominated by the self that owns them. When the child becomes conscious, he not only finds himself feeling in various ways, but attends to some of these feelings and not to others. If he now howls with rage, it is not because of the rage simply, but because of his attending to it. The howl becomes a different one, audibly different to an experienced ear: not the automatic howl of sheer rage, but the self-conscious howl of a child who, attending to his own rage, seems anxious to draw the attention of others to it. As this consciousness of himself becomes firmer and more habitual, he finds that he can dominate the rage by the sheer act of attending to what he is doing, and thus stop howling, master his feelings instead of letting them master him.

The consciousness of self as something other than the feeling of the moment, something to which that feeling belongs, is thus the assertion of the self as able in principle to dominate the feeling. Neither is a consequence of the other. It is not because the child first becomes conscious of himself that he then proceeds to act on that consciousness; it is not because he first dominates his feelings that, reflecting on this

experience, he becomes aware of his own existence. The theoretical and practical activities, self-consciousness and self-assertion, form together a single indivisible experience.

The effect of this experience on the feelings themselves is to make them less violent. They do not suffer alteration in quality or diminution of intensity; but their violence, or power of determining our actions (including our thoughts, so far as we can be said to think at this primitive stage), is abated. They are no longer like storms or earthquakes, devastating our life. They become domesticated; real experiences still, and experiences of the same kind as before; but fitted into the fabric of our life instead of proceeding on their own way regardless of its structure. True, we do not yet conceive this as a structure of a definite kind, involving certain ends to which our various acts must be subordinated; that belongs to a later stage. But in asserting ourselves as against our feelings we have asserted in principle a structure of some kind, though as yet an indeterminate one. In becoming aware of myself I do not yet know at all what I am; but I do know that I am something to which this feeling belongs, not something belonging to it.

This domestication has a further result. We become able to perpetuate feelings (including sensa) at will. Attending to a feeling means holding it before the mind; rescuing it from the flux of mere sensation, and conserving it for so long as may be necessary in order that we should take note of it. This, again, means perpetuating the act by which we feel it; for a given sensum can appear only to the appropriate act, and a sustained sensum implies a sustained act of sensation. If the reference here had been to pure sensation, this language would have been meaningless; but the reference is to sensation as modified by consciousness. We have already seen how, in general, that modification works. The conscious self is no longer dominated by its feelings; it can select and isolate any one element contained in them, placing that element in the focus of attention. Moreover, when this is done, the feeling which is thus attended to has the character

relatively to the self's total experience not of impression but of idea: it does not command, it obeys; it does not determine the reaction of the self, it exemplifies the self's mastery over its own possessions.

If this is applied to the special case of sensa, we get the following result. In the flux of sensations, one pattern of the total sensory field is being replaced by another. Attention now focuses itself on one element in that field: for example, this scarlet patch. As I look, the red is actually fading; it is being obscured by the superimposition of its own after-image, which dulls the scarlet moment by moment. But by attending to the scarlet and neglecting everything else I create a kind of compensation for this fading. This progressive refocusing of attention is so familiar and habitual a thing that we only with difficulty recognize it as going on. It requires a certain effort to discover that every colour we see begins to fade from the moment we begin to see it. By thus adjusting our attention we do not make our organs of sense work in a different way; we do not lift any sensa, as such, out of their native flux; but we obtain a new kind of experience by moving as it were with the flux, so that the self and the object are (so to speak) at rest relatively to each other for an appreciable time. What we have done is no doubt very little; but that little is very important; we have liberated ourselves for a moment from the flux of sensation and kept something before us long enough to get a fair sight of it. At the same time we have converted it from impression into idea; we have become conscious of ourselves as its masters, and broken its mastery over us. We have told it to stay still, and it has stayed, though only for a moment.

A moment means a short space of time; but how short? How far must the flux of sense have carried a sound or a colour, before the attempt to compensate for its gradual disappearance by the operation of consciousness must fail? Obviously, no definite answer can be given. A fit of anger, passing away, leaves a fading trace of itself in our actual feeling, progressively swamped beneath feelings of other

kinds, for an indeterminable length of time. So long as any such trace remains, attention may single it out and, by a similar process, reconstitute the original feeling in the shape of an idea. These traces last far longer than we are apt to suppose; and it is probable that what we call remembering an emotion is never anything but thus focusing our attention on the traces it has left in our present feeling. The same is perhaps true of recalling a colour, or sound, or scent. Memory, in this sense of a somewhat ambiguous word, is perhaps only fresh attention to the traces of a sensuous-emotional experience which has not yet entirely passed away. This would explain why lapse of time makes it harder to remember such experiences. Hume's 'idea of red which we form in the dark' becomes harder and harder to evoke, according to the length of time since last we had an impression of red, until at last we find ourselves unable to evoke it at all.

This is the meaning which we can still attach to Hume's formula, that all ideas are derived from impressions, and accept that formula as the statement of a truth which is not invalidated by Hume's misapplication of it to the case of concepts.

§ 6. *Consciousness and Imagination*

We have still a long way to go before we can wholly justify the brave language philosophers use about 'sensa'. They speak like men accustomed to call spirits from the vasty deep, who feel sure that they will come. They are not content with the longer or shorter perpetuation of impression into idea, through the work of consciousness, which I have attempted to describe in the preceding section. They want not only to recall sensa which are vanishing, but to envisage others which have never been present to them; to know what sensa they would have in hypothetical conditions, and what other people are having now. These miracles can, no doubt, be done. But they are not done by the mere operation of consciousness. They are done only

so far as consciousness is developed into, or supplemented by, intellect. The 'experience' to which these philosophers appeal is so far from being merely sensuous that it depends for its existence on fully developed thinking.

But that would take us beyond the subject of this book. Our present business is to ask how the concept of imagination expounded in this chapter is related to that which was put forward in Chapter IX. The two things certainly appear very different; and if both have been arrived at by analysing Hume's distinction between impression and idea, one might conclude that, unless our analysis has been faulty, Hume was confusing two quite different distinctions in one and the same pair of terms. We have now to ask whether that conclusion would be justified.

In the last chapter we understood the distinction between impressions and ideas as equivalent to that between real and imaginary sensa, and we decided that this meant the distinction between sensa interpreted by thought and sensa not so interpreted. Here we have understood it as equivalent to the distinction between sheer feeling and feeling as modified by consciousness with the double result of dominating it and perpetuating it.

Let us begin by considering the second discrepancy: that between idea as a feeling not interpreted by thought, and idea as a feeling perpetuated and dominated by consciousness. Now, it has already been urged (see above, p. 203, § 4) that the work of determining the relations between things must depend on something prior to it, namely having these things held before the mind in such a way that we can compare them with one another, and so become able to see how they resemble one another and so forth. We must know what each is in itself before we can decide how they are related. To know what a given thing is in itself is not, of course, the same as knowing what kind of a thing it is. To say of what we see, 'This is a patch of red', is going far beyond knowing what it is in itself: it is considering it in relation to an established system of colours with established names. To

say 'red here now' is to go even farther, and consider it also as located in a system of spatial and temporal relations with other things. Our knowledge of what it is in itself, if we try to express that in words, will be stated in some such phrase as '*this* is what I see', or, since to call my act one of seeing is already to distinguish, '*this* is how I feel'. This is the kind of thing we must be able to say before we begin interpreting, that is, discussing relations. And we become able to say this, not through bare sensation, but through consciousness of sensation. What makes us able to say it is that we have, by the work of attention, at once selected and perpetuated some element which we find in the field of sensation, and some corresponding element in the sensory act.

The two accounts I have given of 'imaginations' or 'ideas' are thus not incompatible. For a feeling of which we have become conscious is only one ready for interpretation, not one we have begun to interpret. And conversely, an un-interpreted feeling, if that means a feeling which is ready for interpretation, can only be a feeling of which we have become conscious. The two accounts are not only compatible, they are complementary, and must refer to the same thing.

With the first discrepancy, that between impression as real sensum (i.e. sensum interpreted by thought) and impression as sheer feeling, it is otherwise. We have in effect distinguished three stages in the life of a feeling. (1) First, as bare feeling, below the level of consciousness. (2) Secondly, as a feeling of which we have become conscious. (3) Thirdly, as a feeling which, in addition to becoming conscious of it, we have placed in its relation to others. Whether these three stages are sometimes or always separated in time, we need not ask. Their essential relation is not temporal, but logical. Where A is logically presupposed by B, A need not have existed by itself before B came into existence; the logical relation may stand, even though they came into existence at the same time.

Of these three stages, we have identified (2) as what Hume means by idea. The two characteristics which appeared

discrepant, but which we have found to be compatible and indeed correlative, are the relations in which (2) stands to (1) and (3) respectively. The reason why they appeared contradictory was that we had not yet distinguished between (1) and (3). In the preceding chapter, we ended by interpreting the word 'impression' in sense (3); in this chapter, we have interpreted it in sense (1). The truth is that Hume does not distinguish the two meanings. An impression, for him, is distinguished from an idea only by its force or liveliness; but this force may be of two kinds. It may be the brute violence of crude sensation, as yet undominated by thought. Or it may be the solid strength of a sensum firmly placed in its context by the interpretative work of thought. Hume did not recognize the difference; and his failure has been a *damnosa hereditas* for all subsequent philosophy, at least for those philosophies which stand on the empiricist wing of our tradition. For such philosophies it has become a commonplace that the world we know is somehow constructed out of sense-data, and that our statements about it are in the first instance based upon experience, and subsequently verified by reference to the same; where experience is taken to mean a store or supply of something called sense-data. We saw that in the current use of this and kindred words Hume's distinction between impressions and ideas had been ignored with disastrous results. At the beginning of the present section we have seen something further: namely, that the word is actually applied, not only to both (1) and (2), but also and frequently to (3). The word sense-datum or sensum is applied not only to something given by sensation, in which case it would at once be taken away again; not only to something perpetuated by consciousness or imagination, in which case the only region from which it could be called up would be that of past sensation; but to something constructed inferentially by the work of intellect. If all these three things are habitually confused, part of the blame, unless my reading of him is at fault, must lie with Hume.

§ 7. *Consciousness and Truth*

The activity of consciousness, we have seen, converts impression into idea, that is, crude sensation into imagination. Regarded as names for a certain kind or level of experience, the words consciousness and imagination are synonymous: they stand for the same thing, namely, the level of experience at which this conversion occurs. But within a single experience of this kind there is a distinction between that which effects the conversion and that which has undergone it. Consciousness is the first of these, imagination is the second. Imagination is thus the new form which feeling takes when transformed by the activity of consciousness.

This makes good the suggestion thrown out at the end of Chapter VIII, that imagination is a distinct level of experience intermediate between sensation and intellect, the point at which the life of thought makes contact with the life of purely psychical experience. As we should now restate that suggestion: it is not sensa as such that provide the data for intellect, it is sensa transformed into ideas of imagination by the work of consciousness.

In Chapter VIII, I gave a preliminary account of the structure of experience based on a two-term distinction between feeling and thought. I now seem to have retracted this and substituted a three-term distinction in which consciousness appears as an intermediate level of experience connecting the two. But that is not my intention. Consciousness is not something other than thought; it is thought itself; but it is a level of thought which is not yet intellect. What I was describing under the name of thought in Chapter VIII was, we can now see, not thought in the widest sense, which includes consciousness, but thought in a narrower sense, thought *par excellence*, or intellection. Everything which was said about thought, however, in the first section of that chapter applies not only to intellection but to thought generally and therefore to consciousness. The aim of this section is to develop this point.

The work of intellect is to apprehend or construct relations. This work, as I explained in Chapter VIII, takes two shapes, one primary and the other secondary. Intellect in its primary function apprehends relations between terms which in Chapter VIII were called feelings; but we now know that this was inaccurate; they are not the crude feelings of purely psychical experience which I am now calling impressions, they are these feelings as modified by consciousness and so converted into ideas. Intellect in its secondary function apprehends relations between acts of primary intellection or between what in such acts we think.

Consciousness is the activity of thought without which we should have no terms between which intellect in its primary form could detect or construct relations. Thus consciousness is thought in its absolutely fundamental and original shape.

As thought, it must have that bipolarity which belongs to thought as such. It is an activity which may be well or ill done; what it thinks may be true or false. But this seems paradoxical; for since it is not concerned with the relations between things, and hence does not think in terms of concepts or generalizations, it cannot err, as intellect can, by referring things to the wrong concepts. It cannot, for instance, think 'This is a dog', when the object before it is a cat. If, as we said above, the kind of phrase which expresses what it thinks is something like 'This is how I feel', such a statement might seem incapable of being false, in which case consciousness would have the peculiar privilege of being a kind of thought not liable to error, and this would amount to saying that it was not a kind of thought at all.

But the statement 'This is how I feel' does imply bipolarity. It has an opposite: 'This is not how I feel'; and to assert it is to deny this opposite. Even if consciousness never actually erred, it would still have this in common with all forms of thought, that it lives by rejecting error. A true consciousness is the confession to ourselves of our feelings; a false consciousness would be disowning them, i.e. thinking about one of them 'That feeling is not mine'.

The possibility of such disowning is already implicit in the division of sensuous-emotional experience into what is attended to and what is not attended to, and the recognition of the former as 'mine'. If a given feeling is thus recognized, it is converted from impression into idea, and thus dominated or domesticated by consciousness. If it is not recognized, it is simply relegated to the other side of the dividing line: left unattended to, or ignored. But there is a third alternative. The recognition may take place abortively. It may be attempted, but prove a failure. It is as if we should bring a wild animal indoors, hoping to domesticate it, and then, when it bites, lose our nerve and let go. Instead of becoming a friend, what we have brought into the house has become an enemy.

I must try to pay cash for the paper money of that simile. First, we direct our attention towards a certain feeling, or become conscious of it. Then we take fright at what we have recognized: not because the feeling, as an impression, is an alarming impression, but because the idea into which we are converting it proves an alarming idea. We cannot see our way to dominate it, and shrink from persevering in the attempt. We therefore give it up, and turn our attention to something less intimidating.

I call this the 'corruption' of consciousness; because consciousness permits itself to be bribed or corrupted in the discharge of its function, being distracted from a formidable task towards an easier one. So far from being a bare possibility, it is an extremely common fact. Let us return to the case of a child who, after howling automatically from mere rage, becomes conscious of himself and recognizes the rage as a feeling of his own. This new state of things, if properly developed, makes him able to dominate the rage. But if all that is desired is to escape being dominated by it, there are two ways in which this may come about. The nettle may be either dodged or grasped. In the first case, we avoid the domination of one feeling by attending to a different feeling. The child's attention is distracted from his rage, and the howls cease. In the second, we avoid being dominated by

fixing our attention on the very feeling which threatens to dominate us, and so learn to dominate it.

The feeling from which attention is distracted, whether by a foolish parent or nurse or by our own self-mismanagement, does not lapse from attention altogether. Consciousness does not ignore it; it disowns it. Very soon we learn to bolster up this self-deceit by attributing the disowned experience to other people. Coming down to breakfast out of temper, but refusing to allow that the ill humour so evident in the atmosphere is our own, we are distressed to find the whole family suffering agonies of crossness.

The bipolarity which belongs to consciousness as a form of thought, infects the imaginations which it constructs. When consciousness is corrupted, imagination shares the corruption. In the mere imagining of something, whatever it may be, this corruption cannot exist. An imagination is merely an element in my sensuous-emotional experience upon which I fix my attention, and thus stabilize and perpetuate it as an idea. There can be no element in my experience which has not a right to be so treated, and hence imagination as such can never be corrupt. But whenever some element in experience is disowned by consciousness, that other element upon which attention is fixed, and which consciousness claims as its own, becomes a sham. In itself, it does genuinely belong to the consciousness that claims it; in saying 'This is how I feel', consciousness is telling the truth; but the disowned element, with its corresponding statement 'And that is how I do not feel', infects this truth with error. The picture which consciousness has painted of its own experience is not only a selected picture (that is, a true one so far as it goes), it is a bowdlerized picture, or one whose omissions are falsifications.

This corruption of consciousness has already been described by psychologists in their own way. The disowning of experiences they call repression; the ascription of these to other persons, projection; their consolidation into a mass of experience, homogeneous in itself (as it well may be, if the

disowning is systematically done), dissociation; and the building-up of a bowdlerized experience which we will admit to be our own, fantasy-building. They have shown, too, the disastrous effect which these corruptions of consciousness have, if they become habitual, on the person suffering from them. The same lesson was taught long ago by Spinoza, who has expounded better than any other man the conception of the truthful consciousness and its importance as a foundation for a healthy mental life. The problem of ethics, for him, is the question how man, being ridden by feelings, can so master them that his life, from being a continuous *passio*, an undergoing of things, can become a continuous *actio*, or doing of things. The answer he gives is a curiously simple one. 'Affectus qui passio est, desinit esse passio, simulatque eius claram et distinctam formamus ideam' (*Ethics*, part v, prop. 3). As soon as we form a clear and distinct idea of a passion, it ceases to be a passion.

The untruth of a corrupt consciousness belongs to neither of the commonly recognized species of untruth. We divide untruths into two kinds, errors and lies. When experience reaches the intellectual level, the distinction is valid. Concealment of the truth is one thing, a bona fide mistake is another. But at the level of consciousness the distinction between these two things does not exist: what exists is the protoplasm of untruth out of which, when further developed, they are to grow. The untruthful consciousness, in disowning certain features of its own experience, is not making a bona fide mistake, for its faith is not good; it is shirking something which its business is to face. But it is not concealing the truth, for there is no truth which it knows and is concealing. Paradoxically, we may say that it is deceiving itself; but this is only a clumsy attempt to explain what is happening within a single consciousness on the analogy of what may happen as between one intellect and another.[1]

[1] The untruthful consciousness is, I suppose, what Plato means in the phrase which is unhappily translated 'the lie in the soul' (*Republic*, 382 A–C).

The condition of a corrupt consciousness is not only an example of untruth, it is an example of evil. The detailed tracing of particular evils to this source by psycho-analysts is one of the most remarkable and valuable lines of investigation initiated by modern science, bearing the same relation to the general principles of mental hygiene laid down by Spinoza that the detailed inquiries of relativistic physics bear to the project for a 'universal science' of mathematical physics as laid down by Descartes.

Now, just as we divide untruths into errors and lies, so we divide evils into those a man suffers and those he does. Where they affect not his relation to his surroundings but his own condition, whether bodily or mental, this division becomes one between disease and wrongdoing.

The symptoms and consequences of a corrupt consciousness come under neither of these headings. They are not exactly crimes or vices, because their victim does not choose to involve himself in them, and cannot escape from them by deciding to amend his conduct. They are not exactly diseases, because they are due not to functional disorder or to the impact of hostile forces upon the sufferer, but to his own self-mismanagement. As compared with disease, they are more like vice; as compared with vice, they are more like disease.

The truth is that they are a kind of sheer or undifferentiated evil, evil in itself, as yet undifferentiated into evil suffered or misfortune and evil done or wickedness. The question whether a man in whom they exist suffers through his misfortune or through his fault is a question that does not arise. He is in a worse state than either of these alternatives would imply; for an unfortunate man may still have integrity of character, and a wicked man may still be fortunate. A man whose consciousness is corrupt has no mitigations, either within or without. So far as that corruption masters him, he is a lost soul, concerning whom hell is no fable. And whether or no the psycho-analysts have found the means to rescue him, or to save those in whom this evil has advanced

less far, their attempt to do so is an enterprise that has
already won a great place in the history of man's warfare
with the powers of darkness.

§ 8. *Summary*

We have now reached a point where the results of the
argument can be summarized into a general theory of imagi-
nation. All thought presupposes feeling; and all the proposi-
tions which express the results of our thought belong to one
of two types: they are either statements about feelings, in
which case they are called empirical, or statements about the
procedure of thought itself, in which case they are called
a priori. 'Thought', here, means intellect; 'feeling' means
not feeling proper, but imagination.

Feeling proper, or psychical experience, has a double
character: it is sensation and emotion. We may attend
chiefly or exclusively to one or the other aspect, but in the
experience of feeling as it actually comes to us the two are
firmly united. Every feeling is both sensuous and emotional.
Now, feeling proper is an experience in which what we now feel
monopolizes the whole field of our view. What we have felt
in the past, or shall feel in the future, or might feel on a
different kind of occasion, is not present to us at all, and has
no meaning for us. Actually, of course, these things have a
meaning for us, and we can form some idea of them, some-
times no doubt a fairly correct one; but that is because we
are able to do other things besides merely feeling.

If I assert any relation between what I feel now and what
I have felt in the past, or what I should expect to feel in
different circumstances, my assertion cannot be based on
mere feeling; for mere feeling, even if it can tell me what
I now feel, cannot acquaint me with the other term of the
relation. Hence the so-called sense-data which are described
as organized into families or the like are not feelings as they
actually come to us, sensa with their own emotional charges;
they are not even the sensuous element in these feelings
sterilized of its emotional charge; they are something quite

different. But further: mere feeling cannot even tell me what I now feel. If I try to fasten my attention on this present feeling, so as to give myself some account of its character, it has already changed before I can do so. If, to take the other alternative, I succeed in doing so (and it is clear that we do succeed, otherwise we could never know the things about feeling which have already been stated), the feeling to which I attend must be somehow stabilized or perpetuated in order that I may study it, which means that it must cease to be mere feeling and enter upon a new stage of its existence.

This new stage is reached not by some process antecedent to the act of attention, but by that act itself. Attention or awareness is a kind of activity different from mere feeling, and presupposing it. The essence of it is that instead of having our field of view wholly occupied by the sensations and emotions of the moment, we also become aware of ourselves, as the activity of feeling these things. Theoretically considered, this new activity is an enlargement of our field of view, which now takes in the act of feeling as well as the thing felt. Practically considered, it is the assertion of ourselves as the owners of our feelings. By this self-assertion we dominate our feelings: they become no longer experiences forcing themselves upon us unawares, but experiences in which we experience our own activity. Their brute power over us is thus replaced by our power over them: we become able on the one hand to stand up to them so that they no longer unconditionally determine our conduct, and, on the other, to prolong and evoke them at will. From being impressions of sense, they thus become ideas of imagination.

In this new capacity, as losing their power over us and becoming subject to our will, they are still feelings, and feelings of the same kind as before; but they have ceased to be mere sensations and have become what we call imaginations. From one point of view, imagination does not differ from sensation: what we imagine is the very same kinds of things (colours, &c.) which present themselves to us in mere

sensation. From another point of view, it is very different through being, in the way above described, tamed or domesticated. That which tames it is the activity of consciousness, and this is a kind of thought.

Specifically, it is the kind of thought which stands closest to sensation or mere feeling. Every further development of thought is based upon it, and deals not with feeling in its crude form but with feeling as thus transformed into imagination.[1] In order to consider likenesses and differences between feelings, classify them or group them in other kinds of arrangement than classes, envisage them as arranged in a time-series, and so forth, it is necessary first that each one of the feelings thus reflected upon should be attended to and held before the mind as something with a character of its own; and this converts it into imagination.

Consciousness itself does not do any of these things. It only prepares the ground for them. In itself, it does nothing but attend to some feeling which I have here and now. In attending to a present feeling, it perpetuates that feeling, though at the cost of turning it into something new, no longer sheer or crude feeling (impression) but domesticated feeling or imagination (idea). But it does not compare one idea with another. If, while I am thus enjoying one idea, I proceed to summon up another, the new idea is not held alongside the old, as two distinct experiences, between which I can detect relations. The two ideas fuse into one, the new one presenting itself as a peculiar colouring or modification of the old. Thus imagination resembles feeling in this, that its object is never a plurality of terms with relations between them, but a single indivisible unity: a sheer here-and-now.

[1] Cf. Kant, *Critique of Pure Reason*, A 78, B 103 (tr. N. K. Smith, p. 112), where imagination is described as a 'blind but indispensable function' intermediate between sensation (which means the activity correlative to sensa proper, not to the idealized 'sense-data' of modern empiricism) and understanding. This is the Humian doctrine that knowledge is concerned with ideas, not impressions; but Kant did not develop the notion he here suggested, except in the highly important (and for the same reason commonly misunderstood) chapter on the 'Schematism of the Categories'.

The conceptions of past, future, the possible, the hypothetical, are as meaningless for imagination as they are for feeling itself. They are conceptions which appear only with a further development of thought.

When, therefore, it is said that imagination can summon up feelings at will, this does not mean that when I imagine I first form some idea of a feeling and then, as it were, summon it into my presence as a real feeling; still less, that I can review in fancy the various feelings which I might enjoy, and choose to evoke in myself the one which I prefer. To form an idea of a feeling is already to feel it in imagination. Thus imagination is 'blind', i.e. cannot anticipate its own results by conceiving them as purposes in advance of executing them. The freedom which it enjoys is not the freedom to carry out a plan, or to choose between alternative possible plans. These are developments belonging to a later stage.

To the same later stage belongs the distinction between truth and error, regarded as the distinction between true and false accounts of the relations between things. But there is a special way in which that distinction applies to consciousness, and therefore to imagination. Consciousness can never attend to more than a part of the total sensuous-emotional field; but either it may recognize this as belonging to itself, or it may refuse so to recognize it. In the latter case, certain feelings are not ignored, they are disowned; the conscious self disclaims responsibility for them, and thus tries to escape being dominated by them without the trouble of dominating them. This is the 'corrupt consciousness', which is the source of what psychologists call repression. Its imaginations share in its corruption; they are 'fantasies', sentimentalized or bowdlerized pictures of experience, Spinoza's 'inadequate ideas of affections'; and the mind that takes refuge in them from the facts of experience delivers itself into the power of the feelings it has refused to face.

LANGUAGE

§ 1. *Symbol and Expression*

LANGUAGE comes into existence with imagination, as a feature of experience at the conscious level. It is here that it receives its original characteristics, which it never altogether loses, however much it is modified (a process we shall have to examine later on) in adapting itself to the requirements of the intellect.

In its original or native state, language is imaginative or expressive: to call it imaginative is to describe what it is, to call it expressive is to describe what it does. It is an imaginative activity whose function is to express emotion. Intellectual language is this same thing intellectualized, or modified so as to express thought. I shall try to show in the sequel that the expression of any given thought is effected through the expression of the emotion accompanying it.

The distinction between these two functions of language has been stated in a good many ways which need not be enumerated.[1] One way of putting it is to distinguish language proper from symbolism. A symbol (as the Greek word indicates) is something arrived at by agreement and accepted by the parties to the agreement as valid for a certain purpose. This is a fair account of how the words in an intellectualized language come by their meanings, so far as they are thoroughly intellectualized, which in fact is seldom very far; but it cannot be a true account of language as such, for the supposed agreement by which the meaning of a given word is settled implies a previous discussion out of which the agreement is arrived at; and unless language already exists and is already capable of stating the point at issue the discussion cannot arise.

[1] Dr. Richards's distinction between 'the scientific use of language' and 'the emotive use of language' is considered below, in § 8.

Symbolism or intellectualized language thus presupposes imaginative language or language proper. There must, therefore, be a corresponding relation between the theories of the two. But in the traditional theory of language these relations are reversed, with disastrous results. Language as such is identified with symbolism; and if its expressive function is not altogether overlooked an attempt is made to explain it as a secondary function somehow arrived at by modifying the symbolic function. When Hobbes (*Leviathan*, I. iv) says that the primary use of speech is for 'acquisition of science', for which purpose 'the right definition of names' is the first requisite, clearly, he is identifying language in general with intellectualized language or symbolism. Locke, in defining a word as a sound which is made the sign of an idea (*Essay*, III. i, § 3), is less explicit in his statement of the error; but none the less, on the whole, he takes it for granted. Berkeley, though in general he takes the same view, recognizes a second use of words, 'to wit, the influencing of our conduct and actions; which may be done either by forming rules for us to act by, or by raising certain passions, dispositions, and emotions in our minds' (*Alciphron*, vii; *Works*, ed. Fraser, ii. 327). The distinction is important; but this second usage is still an intellectualized use, in so far as the activity of finding means to a given end (the influencing of some one's conduct, &c.) is an intellectual activity. To use language as a means for raising a certain passion in another is not the same thing as using it to express one's own.

To-day it is almost an orthodoxy that language as such is symbolic in the above sense of the word. If that is so, certain results follow. Every symbol, for the sake of accuracy in usage, ought to be used in a single invariable sense, and defined with precision. Consequently, if we are to use language well, every word should be thus used and thus defined. If this is found impracticable (and it always will be found impracticable) the inference is that 'ordinary' languages are ill designed for their purpose, and ought to be replaced for the expression of accurate thinking by a scientifically

planned 'philosophical language'. Another consequence is that just as every one, before he can begin to use a symbol in mathematics or the like, must be told what it means, so in a child's original acquisition of his mother tongue every word he is to use must first be explained to him; and it is actually supposed that this comes about by its mother, or other instructor, pointing to the fire and saying 'fire', giving it milk and saying 'milk', touching its toe and saying 'toe', and so forth. When the fact comes out that when a mother points to the fire she probably says 'pretty', when giving it milk, 'nice', and when touching its toe, 'this little pig went to market', the conclusion can only be expressed in the words of a (possibly mythical) schoolmaster: 'parents are the last people in the world who ought to be allowed to have children.'

The reason why no mother teaches language in this way is that it could not possibly be done; for the supposed gestures of pointing and so forth are themselves in the nature of a language. Either the child has first to be taught this language of gestures, in order to help it in learning English, or it must be supposed to 'tumble to' the gesture language for itself. But if it can do that, we want to know how it does it, when a cat cannot (for you can never teach a cat what you mean by pointing), and, if so, why it cannot (as in fact it does) 'tumble' in the same way to English.

Actually, if the linguistic theorist can obtain access to a nursery, he will find something very different going on. He will hear the mother not enunciating single words to her child, but pouring out a flood of talk mostly devoted not to the naming of certain things but to the expression of her pleasure in its society; the child replies with gurglings and cooings; as time goes on, these become more articulate, and sooner or later the child is heard imitating in a garbled form phrases which it has heard on certain kinds of occasion, when new occasions arise which seem to call for them. Its mother may have been in the habit of saying in her baby-talk, when removing its bonnet, 'Hatty off!'; and, if so,

when it takes its own bonnet off and throws it out of the
perambulator it will say in tones of great satisfaction,
'Hattiaw!'

Now, the sound 'hattiaw' is not a symbol. The mother
and child have not agreed between themselves that it shall
mean 'removal of hat'. The child regards it as a noise made
when one takes a hat off. Hearing its mother make that noise
goes with having her remove its hat; and consequently
making that noise for itself goes with removing the hat for
itself. The relation between making the noise and removing
the hat has for it no resemblance whatever to the relation (of
which it has yet no conception) between the symbol + and
the act of adding two numbers. Still less, of course, does it
conceive the sound as a combination of two symbols, one
signifying a hat and the other removal. Unhatting itself is
a single act, and the sound which one makes in performing
it is a single sound. Phonetic analysis of the sound into a
number of consonants and vowels, or grammatical analysis
of it into a number of words, is as far beyond the child as
anatomical analysis of the act into a number of muscular
movements.

It would be nearer the truth, in denying that 'hattiaw'
is a symbol, to call it an expression. It does not express the
act of removing the hat, but it expresses the peculiar satis-
faction which for some reason the child takes in removing
it. That is to say, it expresses the feeling which it has in
doing that act. More strictly, it is not the sound 'hattiaw',
but the act of making this sound, that is expressive. To say
that one act expresses another act would be to talk nonsense;
to say that it expresses a feeling certainly means something.
We must try to determine what it means.

§ 2. *Psychical Expression*

In order to do this, we must begin by observing that
linguistic expression is not the only kind of expression, and
not the most primitive kind. There is another kind, which
unlike linguistic expression occurs independently of con-

sciousness and is a feature of experience at its purely psychical level. This I shall call psychical expression.

It consists in the doing of involuntary and perhaps even wholly unconscious bodily acts, related in a peculiar way to the emotions they are said to express. Thus, certain distortions of the face express pain; a slackening of muscles and a cold pallor of the skin express fear; and so forth. In these cases, we feel the emotion expressed and also feel the bodily act, or complex of acts, expressing it. The relation between these, to which we refer when we say that the act expresses the emotion, is of course a relation of necessary connexion, and asymmetrical: we grimace 'because' we feel pain, not vice versa. But the word 'because' is used to indicate any kind of dependence, and does not distinguish one kind from another.

The connexion is in one way like that between a sensum and its emotional charge, namely, in the fact of its immediacy; the two things connected are not two distinct experiences, but are elements in one indivisible experience. The sensum of muscular tension, when one's face is screwed up with pain, is as intimately connected with the pain as the sensum of scarlet which terrified a child, in our earlier example, with the terror it produced. But though the two cases are alike in the intimacy of the union between their elements, the structural order of the elements is different, and indeed opposite. The terror is the emotional charge of the colour, and the colour sensum is logically (though not temporally) prior to it. The pain is not the emotional charge of the tension in the facial muscles; the sensum is here not prior but posterior to the emotion.

The two cases have, in fact, been incompletely described. In the first, we have omitted the original sensum (for example, an intestinal gripe); in the second, we have omitted the expression of the child's terror, a complex reaction which may be described as cringing. These omissions once made good, the two cases are parallel; and we get an analysis which, by recognizing the element of psychical expression,

supplements the account of the frightened child given in Chapter VIII.

We have now (1) a sensum of scarlet (or rather, a visual field containing that colour), (2) terror as the emotional charge on that field, (3) the cringing which expresses that terror. In the other case we have (1) the abdominal gripe as a sensum (or rather, a field of organic sensation containing that visceral sensum), (2) the pain which is the emotional charge upon it, (3) the grimace expressing that pain. Each case is one single experience, in which analysis reveals three elements in a definite structural order.

Every kind and shade of emotion which occurs at the purely psychical level of experience has its counterpart in some change of the muscular or circulatory or glandular[1] system which, in the sense of the word now under discussion, expresses it. Whether these changes are observed and correctly interpreted depends on the skill of the observer. So far as we can see, nothing but lack of this skill prevents us from reading like an open book the psychical emotions of every one with whom we have to do. But observing and interpreting is an intellectual process; and this is not the only way in which psychical expression conveys a meaning. There is a kind of emotional contagion which takes effect without any intellectual activity; without the presence even of consciousness. This is a familiar fact, alarming because it seems so inexplicable, in man. The spread of panic through a crowd is not due to each person's being independently frightened, nor to any communication by speech; it happens in the complete absence of these things, each person becoming terrified simply because his neighbour is terrified. The psychical expression of fear in one person appears to another as a complex of sensa immediately charged with terror. Fear is not the only emotion that is thus contagious;

[1] Not the endocrine system only. Even men, whose sense of smell is so feeble, can discover that certain emotions in their fellow men occasion peculiar scents by causing glandular discharges. To an animal whose sense of smell is so acute as a dog's, I suppose there is a 'language' of scent as expressive as the 'language' of involuntary facial gesture is to us.

the same thing happens with any emotion belonging to the level of psychical experience. Thus the mere sight of some one in pain, or the sound of his groans, produces in us an echo of his pain, whose expression in our own body we can feel in the tingling or shrinking of skin areas, certain visceral sensa, and so forth.

This 'sympathy' (the simplest and best name for the contagion I have described) exists visibly among animals other than man, and between animals of different species; notably, for example, between man and his domestic animals. A dog will snap at a man because it is afraid of him; and the best way to make a dog bite you is to feel frightened of it. However successfully you think you are concealing your nervousness, the dog feels it; or rather he feels the nervousness in himself which he has thus caught from you. The same relation exists between men and wild animals.

How this contagion 'takes' will depend, of course, on the psychical structure of the mind that takes it. Terror in a rabbit will communicate itself to a pursuing dog not as terror but as a desire to kill, for a dog has the psychical 'nature' of a hunting animal. Every one knows that dogs chase cats because cats run away; the cat's exhibition of fear produces in the dog, not an argument running thus: 'this cat is afraid of me; it evidently thinks I can kill it, so I suppose I can; here goes', but an immediate response in the shape of aggressive emotion.

Psychical expression is the only expression of which psychical emotions are capable (they can only be expressed otherwise by being themselves transformed through the activity of consciousness from impressions into ideas, as we shall see in the next section); but psychical emotions are not the only ones that can be psychically expressed. There is a certain group of emotions which arise only through the consciousness of self. Hatred, love, anger, and shame may be taken as examples. Hatred is a feeling of antagonism; it is an attitude towards something which we regard as

thwarting our own desires, or inflicting pain upon us,[1] and this presupposes awareness of ourselves. Love is a feeling towards something with which we feel our own existence to be bound up, so that a benefit or injury to it is a benefit or injury to ourselves. Anger, though unlike hate it does not involve the idea of any particular thing or person that angers us, is like it in being a consciousness of ourselves as baulked or opposed. Shame is the consciousness of our own weakness or ineffectiveness.

These 'emotions of consciousness', unlike the purely psychical emotions, admit of expression in language: in a phrase, a controlled gesture, or the like. But they also have their own special psychical expressions, for example, the blush of shame, accompanied by muscular relaxation; or the flush of anger with muscular tension and rigidity. Now, a psychical emotion is the emotional charge on a sensum; but an emotion of consciousness is the emotional charge not on a sensum but on a certain mode of consciousness. Hence, if we ask 'What is the sensum upon which shame is the emotional charge?' and find (quite correctly) that no sensum is present except those of hot skin and relaxed muscles, we may reject the common-sense view that we blush because we are ashamed, and propound the startling discovery that we are ashamed because we blush. But all we have done is to beget a paradox on a misunderstanding. To the series (1) scarlet colour, (2) fear, (3) cringing, in the case of psychical emotions, the corresponding series in an emotion of consciousness is (1) consciousness of our own inferiority (which is not a sensum but a mode of consciousness), (2) shame, (3) blushing. The common-sense view is right, and the James–Lange theory wrong.

Why should emotions of consciousness be thus expressible in two quite different ways? The answer lies in the relation between any one level of experience and the next above it. The higher level differs from the lower in having a new

[1] 'Odium est tristitia (sc. transitus a maiore ad minorem perfectionem) concomitante idea causae externae.' Spinoza, *Ethics*, III, *Affectuum definitiones*, vii.

principle of organization; this does not supersede the old, it is superimposed on it. The lower type of experience is perpetuated in the higher type in a way somewhat like (though not identical with) the way in which a pre-existing matter is perpetuated when a new form is imposed on it. We shall avail ourselves of this resemblance and use it metaphorically as a description. In this metaphorical sense of the words, any new and higher level of experience can be described in either of two ways. Formally, it is something quite new and unique, capable of being described only in terms of itself. Materially, it is only a peculiar combination of elements already existing at the lower level, and susceptible of description in terms of these lower elements. Consciousness (to apply this distinction) is formally unique, altogether unlike anything that can be found in merely psychical experience. Materially, it is only a certain new arrangement of psychical experiences. A mode of consciousness like shame is thus, formally, a mode of consciousness and nothing else; materially, it is a constellation or synthesis of psychical experiences.

The two ways in which it can be expressed correspond with these two sides of its nature. But when it is called a constellation or synthesis, this does not mean that there is a putting together of elements which first existed separately, and that the new quality of consciousness (in this case, shame) was a mere resultant 'emerging' from that combination. Had that been the case, the James–Lange theory would never have been invented; for we could easily have identified the various sensa upon which, as thus combined, shame is the emotional charge. The fact that this cannot be done is experimental proof that the 'emergence' theory is, in this case at least, mistaken; and that so far from consciousness being merely a new pattern-quality emerging from a particular way of combining psychical experiences, it is an activity by which those elements are combined in this particular way.

One other aspect of this dual expressiveness may be mentioned. If experience is really organized into different

levels so that each provides for the next a matter upon which new form is to be imposed, each level must organize itself according to its own principles before a transition can be made to the next; for until that has been done, the raw material needed for the creation of the next is not forthcoming. Emotions of consciousness can be expressed, we have seen, in two ways: formally, as modes of consciousness; materially, as constellations of psychic elements. If the level of consciousness is a level beyond which there lies another, namely the level of intellect, as we have been supposing, it follows that the emotions of consciousness must be formally or linguistically expressed, not only materially or psychically expressed, before a transition can be made from the level of consciousness to that of intellect: for their formal or linguistic expression is a necessary element in the consolidation of experience at the level of consciousness. The merely material expression of such emotions, on the contrary, is a retrograde step, which by reducing the conscious level to terms of the psychical impedes the development of experience towards its higher levels. Not that this material expression is in itself retrograde; on the contrary, it is the way in which consciousness asserts its domination over psychical experience as such, by creating a new combination of its elements; but if it could go unsupplemented by formal expression, it would indicate a mind unwilling to test its fate in further adventures.

§ 3. *Imaginative Expression*

The peculiarity of psychical expression lies in its being completely uncontrollable. Physiologically considered, a grimace of pain or a start of fear is an action; but as it occurs in us, it is something that simply comes to us and overwhelms us. It has the same character of brute givenness[1] which belongs to the emotions it expresses, and the sensa of which these are the emotional charge. This is merely the general character of experience at its purely psychical level.

[1] For the meaning of this, see pp. 206–14: e.g. 'brute violence', p. 214.

At the level of awareness a certain change occurs. For brute givenness is substituted the consciousness of experience as our own experience, something belonging to us and dominated by our power of thought. This change affects all the three elements distinguished in the foregoing section. The way in which it affects the sensuous and emotional elements has been discussed at length in the preceding chapters. We saw that the work of consciousness converts impressions of brute sense and brute emotion into ideas, something which we no longer simply feel but feel in that new way which we call imagining. We have now to consider how the same change affects the bodily act of expression, raising it from the crudely psychical level to the imaginative.

The general nature of this change can be expressed by saying that just as our emotions no longer arise in us as brute facts, but are now dominated in such a way that we can summon them up, suppress them, or alter them by an act of which we are conscious as our own act and therefore as free, even though it cannot be called purposive or selective; so the bodily acts which express these emotions, instead of being simply automatisms of our psycho-physical organism, are experienced in our new self-consciousness as activities belonging to ourselves, and controlled in the same sense as the emotions they express.

Bodily actions expressing certain emotions, in so far as they come under our control and are conceived by us, in our awareness of controlling them, as our way of expressing these emotions, are language. The word 'language' is here used not in its narrow and etymologically proper sense to denote activities of our vocal organs, but in a wider sense in which it includes any activity of any organ which is expressive in the same way in which speech is expressive. In this wide sense, language is simply bodily expression of emotion, dominated by thought in its primitive form as consciousness.

Language here exists in its absolutely original shape. It has a long way still to travel. Later, it has to be profoundly modified in order to meet the demands of intellect. But any

theory of language must begin here. If we begin by studying the result of these further modifications, the language we use for expressing our thoughts concerning the world around us and the structure of thought itself, and take this highly developed and highly specialized form of language as representing the universal and fundamental character of language as such, we shall get nowhere. The grammatical and logical articulations of intellectualized language are no more fundamental to language as such than the articulations of bone and limb are fundamental to living tissue. Beneath all the elaboration of specialized organisms lies the primitive life of the cell; beneath all the machinery of word and sentence lies the primitive language of mere utterance, the controlled act in which we express our emotions.

Materially, this act does not differ at all from that of psychical expression. As an idea differs from an impression not in its own intrinsic nature, but in its relation to the general structure of experience, so an expressive act may be an act of precisely the same kind, whether its expressiveness is psychical or imaginative. Every one who is accustomed to looking after small children, in addition to distinguishing the cry of pain from the cry of hunger and so forth—various kinds of psychical expression—learns to distinguish the automatic cry of uncontrolled emotion from the self-conscious cry which seems (through a certain exaggeration on the listener's part) deliberately uttered in order to call attention to its needs and to scold the person to whom it seems addressed for not attending to them. The second cry is still a mere cry; it is not yet speech; but it is language. It stands in a new relation to the child's experience as a whole. It is the cry of a child aware of itself and asserting itself. With that utterance, language is born; its articulation into fully developed speech in English or French or some other vernacular is only a matter of detail. The crucial difference lies in this, that the child, instead of making a certain noise automatically and involuntarily, has learnt to make it, as we say, 'on purpose'; by which we mean, not that it has a

purpose in the strict sense, a plan *propositum sibi*, a fore-knowledge of what is to be done in advance of setting out to do it, but that its action is controlled instead of being automatic.

The merely psychical expression of emotion is already highly differentiated; but this is nothing to the differentiation achieved by language. Before it begins to control its cries and convert them into utterances, a child certainly cries in a considerable number of ways, to express emotions of different kinds. But these ways are very few, compared with the kinds of sound which it learns to make when once it has learnt the art of controlled utterance. These differentiations would not be made and retained[1] unless they were needed; and the reason why so many are needed is because the emotional life of conscious experience is so immensely richer than that of experience at its psychical level. Quite apart from the specifically new emotions of consciousness, of which something was said in the preceding section, the conversion of impression into idea by the work of consciousness immensely multiplies the emotions that demand expression. At the level of merely psychical experience, what I hear at the present moment is one noise, carrying one emotional charge. If I bring my attention to bear on this, I can hear in it several different traffic-noises, several different bird-songs, the tick of my clock, the scratch of my pen, a step on the stair, each isolated from the rest by the focusing work of attention, and each carrying an emotional charge of its own. By further acts of attention I can recover sounds which still ring in my memory, though I should describe myself as not actually hearing them at the moment: the harsh January song of the thrush to whose mellow May notes I am now listening, the typewriter which is sometimes at work in the next room, and so forth. For all

[1] I have heard a child spend an hour or two each morning, at the age of about six months, experimenting in the production of vocal sounds, and discovering for itself in this way numerous sounds not existing in English (e.g. Arabic consonants) which it gradually ceased to practise when it found them not required in its mother-tongue.

these experiences the conscious mind must devise expressions, where purely psychical experience, hearing one noise with one emotional tone, would need only one. Thus the imaginative experience creates for itself, by an infinite work of refraction and reflection and condensation and dispersal, an infinity of emotions demanding for their expression an infinite subtlety in the articulations of the language it creates in expressing them.

To whatever level of experience an emotion may belong, it cannot be felt without being expressed. There are no unexpressed emotions. At the psychical level this is easy to see; a psychical emotion, if felt at all, is psychically expressed by an automatic reaction of the animal that feels it. At the conscious level it is not so obvious. We are accustomed, indeed, to believe the opposite; we commonly think that the artist's business is to find expressions for emotions which he already feels before expressing them. But this belief cannot be true, if the expressions which he invents are appropriate to the emotions they express; for his expressions are conscious expressions, consciously invented, and these can be appropriate only to emotions which themselves belong to the conscious level of experience. It is not all emotions that can be expressed in language, but only emotions of consciousness or psychical emotions raised to the level of consciousness; and the same consciousness which generates these emotions or converts them from impressions into ideas generates also and simultaneously their appropriate linguistic expression.

What, then, do we mean when we say that the artist finds expression for an emotion hitherto unexpressed? We mean that an emotion belonging to the conscious level of experience has a dual nature, 'material' and 'formal'. Materially it is a certain constellation of psychic emotions; formally, it is a conscious emotion. Now a constellation of psychic emotions is simply a number of psychic emotions, each of which has already its appropriate psychic expression. A person who becomes conscious of himself as feeling these

psychic emotions is thereby generating in himself a conscious
emotion, formally distinct from each and all of them; and
simultaneously generating a conscious expression for it.
Thus, what are called unexpressed emotions are emotions at
one level of experience, already expressed in the way appro-
priate to that level, of which the person who feels them is
trying to become conscious: that is, trying to convert into the
material of an experience at a higher level, which when he
achieves it will be at once an emotion at this higher level
and an expression appropriate to it.

Let us now return to the case which I described at the
beginning of this chapter, and ask what light has been
thrown upon it by the intervening discussions. A child
throws its bonnet off its head and into the road with the
exclamation 'Hattiaw'. By comparison with the self-
conscious cry discussed earlier in the present section, this
represents a highly developed and sophisticated use of
language. To begin with, consider the emotion involved.
The child might remove its bonnet because it felt physically
uncomfortable in it, hot or tickled or the like; but the
satisfaction expressed by the cry of 'Hattiaw' is not a merely
psycho-physical pleasure like that of rubbing a fly off the
nose. What is expressed is a sense of triumph, an emotion
arising out of the possession of self-consciousness. The
child is proving itself as good a man as its mother, who has
previously taken its bonnet off with the words it is now
imitating; better than its mother, because now she has put
the bonnet on and wants it to stay on, so there is a conflict
of wills in which the child feels himself victor.

This feeling, like any feeling, has to be expressed in a
bodily action. As it is a feeling arising from self-conscious-
ness, that is, at the imaginative level of experience, it must
be expressed in a controlled action, an action done 'on
purpose', not a merely automatic one. But there are two
controlled actions in the case. There is the throwing off of
the bonnet, and there is the cry of triumph. Why should not
one be enough for the purpose?

The relation between the removal of the bonnet and the cry is parallel to the relation, in the preceding section, between the terrifying colour and the terrified start. These, it will be remembered, occupied the first and third places in a series constituting a single indivisible experience, where the second place was filled by the emotion of fear. In the present case, the removal of the bonnet stands in the first place; the emotion of triumph in the second; the cry in the third. These together form a single experience, the experience of triumph over the child's mother.

This experience is an achievement of the child's self-consciousness. It arises out of another experience belonging to the same level, namely, the child's finding itself in the condition of being all dressed up and wheeled about in a perambulator with a safety-strap round its waist. By the operation of its own self-consciousness, it discovers itself to be in this state, and recognizes the state as one brought about by its mother's will, without its own consent. It therefore feels humiliated. At this stage two courses are open to it, though of course it does not know that; it does not choose, it simply acts as its nature prompts it. It might find some way of escaping from the situation, by taking refuge in some action not really relevant to it; for example, bursting into peevish tears of futile because undeserved self-pity. Or it might respond directly to the situation by some act proving that, after all, it is not a baby but a real person. It takes the second alternative. It throws off the symbol of its babyhood; its heart leaps up with a sense of triumph; and, to express that emotion, with admirable and ironic fitness it steals its mother's thunder, using (as nearly as it can command them) the very words with which she has expressed her superiority over itself.

We may state this, if we like, by saying that the child is 'imitating' its mother. But that is a bad word to use, because it tends to burke inquiry into why and how such imitation takes place. Attempts have been made to explain the origin of language in the child by reference to a supposed instinct

of imitation, which leads it to copy whatever it finds others doing, and thus, when it finds them speaking, to acquire the same art itself. But, supposing there were such an instinct, the behaviour prompted by it would never become language unless it were so far released from the automatic control of the supposed instinct as to come under the conscious control of the child's will, so as to express what the child wants it to express. This can happen only if and when the child becomes self-conscious. But when that happens, the child will begin to talk without the operation of this instinct. The supposed instinct of imitation, therefore, being one of those entities which ought not to be multiplied beyond necessity, is an idle fiction. The only possible use it can have is to explain how the child, before reaching the self-conscious level of experience, could already familiarize itself with a large number of bodily movements which, when that level is reached, could be used as language. Actually, a child begins to acquire the detailed movements of speech only when its consciousness has already developed to the point of needing them. It imitates the speech of others because it already realizes that they are speaking.

§ 4. *Language and Languages*

We have been using the word 'language' to signify any controlled and expressive bodily activity, no matter what part of the body is involved. There is a tendency to think that there is only one such activity, or at least one which enormously outdistances any other in expressiveness, namely speech, or the activities of the vocal organs. Sometimes it is suggested that there is a physiological reason for this supposed fact, namely, that by using our vocal organs we can perform a variety of actions more subtly differentiated, and therefore more suitable for development into a language, than by using any other combination of organs. It seems more than doubtful whether either the original belief, or the reason given for it, is true. Probably any one of a number of kinds of bodily action is as suitable for

expressive use, intrinsically, as any other; and the pre-eminence of one over the rest would seem to depend on the historical development of this or that civilization. All speakers do not use all parts of the vocal machinery alike. Germans speak more with the larynx, Frenchmen more with the lips. It is very probable that, because of this difference, Frenchmen have a finer control over lip-movements and Germans over throat-movements; but it is certainly not true that the difference itself is based on a physiological difference independent of it and prior to it, a difference of organic structure in virtue of which Germans are more sensitive in the larynx and Frenchmen in the front of the mouth. Had that been the case, these special sensitivities would be biological characteristics, inherited like skull-shape and pigmentation; and the ability to speak French or German in the proper way would depend on the speaker's pedigree. This is notoriously not the case. The groupings recognized by physical anthropology do not coincide with those of cultural anthropology.

If Frenchmen find lip-movements more expressive than throat-movements, and Germans the opposite, the same kind of difference may exist as between movements of the vocal organs and various other kinds of movement. A dispute between Italian peasants is conducted hardly more in words than in a highly elaborated language of manual gesture. Here again, there is no physiological basis for the difference. Italians do not possess more sensitive fingers than northern Europeans. But they have a long tradition of controlled finger-gesture, going back to the ancient game of *micare digitis*.

Vocal language is thus only one among many possible languages or orders of languages. Any of these might, by a particular civilization, be developed into a highly organized form of emotional expression. It is sometimes fancied that although any one of these languages might express emotion, vocal language has an exclusive, or at least a pre-eminent, function in the expression of thought. Even if this were

true, it would not be of interest at the present stage in our discussion, for we are now dealing with language as it is before being adapted to serve the purposes of thought. As a matter of fact, it is probably not true. There is a story that Buddha once, at the climax of a philosophical discussion, broke into gesture-language as an Oxford philosopher may break into Greek: he took a flower in his hand, and looked at it; one of his disciples smiled, and the master said to him, 'You have understood me.'

Speech is after all only a system of gestures, having the peculiarity that each gesture produces a characteristic sound, so that it can be perceived through the ear as well as through the eye. Listening to a speaker instead of looking at him tends to make us think of speech as essentially a system of sounds; but it is not; essentially it is a system of gestures made with the lungs and larynx, and the cavities of the mouth and nose. We get still farther away from the fundamental facts about speech when we think of it as something that can be written and read, forgetting that what writing, in our clumsy notations, can represent is only a small part of the spoken sound, where pitch and stress, tempo and rhythm, are almost entirely ignored. But even a writer or reader, unless the words are to fall flat and meaningless, must speak them soundlessly to himself. The written or printed book is only a series of hints, as elliptical as the neumes of Byzantine music, from which the reader thus works out for himself the speech-gestures which alone have the gift of expression.

All the different kinds of language have a relation of this kind to bodily gesture. The art of painting is intimately bound up with the expressiveness of the gestures made by the hand in drawing, and of the imaginary gestures through which a spectator of a painting appreciates its 'tactile values'. Instrumental music has a similar relation to silent movements of the larynx, gestures of the player's hand, and real or imaginary movements, as of dancing, in the audience. Every kind of language is in this way a specialized form of bodily

gesture, and in this sense it may be said that the dance is the mother of all languages.

This is what justifies the paradox of the behaviourists, that thought is nothing but the movements of the vocal organs which are commonly said to express it. For thought we must read in the present context emotion, and emotion at the imaginative level, not the merely psychic. For the vocal organs we must read the entire body; since speech is only one form of gesture. As thus corrected, the doctrine is true in this important sense: that the expression of emotion is not, as it were, a dress made to fit an emotion already existing, but is an activity without which the experience of that emotion cannot exist. Take away the language, and you take away what it expressed; there is nothing left but crude feeling at the merely psychic level.

Different civilizations have developed for their own use different languages; not merely different forms of speech, distinguished as English from French and so on, but different in a much deeper way. We have seen how Buddha expressed a philosophical idea in a gesture, and how the Italian peasant uses his fingers hardly less expressively than his tongue. The habit of going heavily clothed cramps the expressiveness of all bodily parts except the face; if the clothing were heavy enough, only those gestures would retain their expressiveness which can be appreciated without being seen, such as those of the vocal organs; except so far as the clothes themselves were expressive. The cosmopolitan civilization of modern Europe and America, with its tendency towards rigidly uniform dress,[1] has limited our expressive activities almost

[1] Even so, dress is a kind of language; but when it is rigidly uniform the only emotions which it can express are emotions common to those who wear it. The habit of wearing it focuses the attention of the wearer on emotions of this kind, and at once generates and expresses a permanant 'set' or habit of consciously feeling in the corresponding way. Rupert Brooke noticed that Americans 'walk better than we; more freely, with a taking swing, and almost with grace. How much of this', he adds, 'is due to living in a democracy, and how much to wearing no braces, it is very difficult to determine' (*Letters from America*, p. 16). Dropping the uniform carries with it a curious breach in the emotional habit; Mulvaney found that on discarding his

entirely to the voice, and naturally tries to justify itself by
asserting that the voice is the best medium for expression.

But different languages are not related to one and the
same set of feelings like his different suits of clothes to one
and the same man. If there is no such thing as an unex-
pressed feeling, there is no way of expressing the same feeling
in two different media. This is true both of the relation
between different systems of speech and of the relation
between vocal language and other forms of language. An
Englishman who can talk French, if he reflects on his own
experience, knows very well that he feels differently when
he talks a different tongue. The English tongue will only
express English emotions; to talk French you must adopt
the emotions of a Frenchman. To be multilingual is to be
a chameleon of the emotions. Still more clearly is it true
that the emotions which we express in music can never be
expressed in speech, and vice versa. Music is one order of
languages and speech is another; each expresses what it does
express with absolute clarity and precision; but what they
express is two different types of emotion, each proper to
itself. The same is true of manual gesture. Contempt may
be expressed by shouting an insult at a man or by snapping
your fingers under his nose, as joy may be expressed in a
poem or a symphony; but with a difference; the precise
kind of contempt which is expressed in the one way cannot
be expressed in the other.

Now, if a person acquires the ability to express one kind
of emotions and not another, the result will be that he knows

trousers and donning a loin-cloth he began to feel like an Indian native
(Kipling, *The Incarnation of Krishna Mulvaney*). The consciousness of
sharing uniform dress with a circle of others is thus a consciousness of emo-
tional solidarity with them; and this, on its negative side, takes the form of
emotional hostility towards persons outside that circle. To illustrate this
from the history of parties and classes is superfluous. It may be worth while
to point out that in the liberal political theory, where rivalry between policies
is dissociated from emotional hostility between the persons supporting them,
it is essential that parties should not be distinguished by uniforms. Put your
parties into uniform, and the difference of their policies becomes at once a less
important division between them than their emotional hostility.

the one kind to be in him, but not the other. These others will be in him as mere brute feelings, never mastered and controlled, but either concealed in the darkness of his own self-ignorance or breaking in upon him in the shape of passion-storms which he can neither control nor understand. Consequently, if a civilization loses all power of expression except through the voice, and then asserts that the voice is the best expressive medium, it is simply saying that it knows of nothing in itself that is worth expressing except what can be thus expressed; and that is a tautology, for it merely means 'what we (members of this particular society) do not know we do not know', except so far as it suggests the addition: 'and we do not wish to find out.'

I said that 'the dance is the mother of all languages'; this demands further explanation. I meant that every kind or order of language (speech, gesture, and so forth) was an off-shoot from an original language of total bodily gesture. This would have to be a language in which every movement and every stationary poise of every part of the body had the same kind of significance which movements of the vocal organs possess in a spoken language. A person using it would be speaking with every part of himself. Now, in calling this an 'original' language, I am not indulging (God forbid) in that kind of *a priori* archaeology which attempts to reconstruct man's distant past without any archaeological data. I do not place it in the remote past. I place it in the present. I mean that each one of us, whenever he expresses himself, is doing so with his whole body, and is thus actually talking in this 'original' language of total bodily gesture. This may seem absurd. Some peoples, we know, cannot talk without waving their hands and shrugging their shoulders and waving their bodies about, but others can and do. That is no objection to what I am saying. Rigidity is a gesture, no less than movement. If there were people who never talked unless they were standing stiffly at attention, it would be because that gesture was expressive of a permanent emotional habit which they felt obliged to express concurrently with any

other emotion they might happen to be expressing. This 'original' language of total bodily gesture is thus the one and only real language, which everybody who is in any way expressing himself is using all the time. What we call speech and the other kinds of language are only parts of it which have undergone specialized development; in this specialized development they never come altogether detached from the parent organism.

This parent organism is nothing but the totality of our motor activities, raised from the psychical level to the conscious level. It is our bodily activity as that of which we are conscious. But that which is raised from the psychical level to the conscious level is converted by the work of consciousness from impression to idea, from object of sensation to object of imagination. The language of total bodily gesture is thus the motor side of our total imaginative experience. This last phrase was used in Chapter VII, § 6, as a name for the work of art proper. We are now beginning to see that the theory of art which is going to emerge from Book II will either consist in, or at least involve, the identification of art with language.

§ 5. Speaker and Hearer[1]

In its most elementary form, language is not addressed to any audience. A child's first utterances are so completely unaddressed that one cannot even describe them as addressed to the world at large or to itself. The distinction between speaking to oneself, speaking to the world at large, and speaking to a particular person or group, is a later differentiation introduced into an original act which was simply the act of speaking. Now, speech is a function of self-consciousness; therefore, even at this early stage, a speaker is conscious of himself as speaking, and is thus a listener to himself. The experience of speaking is also an experience of listening.

The origin of self-consciousness, whether that phrase is understood psychologically, to mean the stages by which it

[1] In this section, whatever is said of speech is meant of language in general.

comes into existence, or metaphysically, to mean the reasons why it begins to exist, is a problem I shall not discuss. There is one thing, however, which ought here to be said about it. Consciousness does not begin as a mere self-consciousness, establishing in each one of us the idea of himself, as a person or centre of experience, and then proceed by some process, whether of 'projection' or of argument by analogy, to construct or infer other persons. Each one of us is a finite being, surrounded by others of the same kind; and the consciousness of our own existence is also the consciousness of the existence of these others. Being a form of thought, consciousness is liable to error (Chapter X, § 7); and when first a child discovers its own existence it simultaneously discovers the existence not only of its mother or nurse but of other persons like a cat, a tree, a firelight shadow, a piece of wood, where errors in admitting this or that neighbour to the category of person are no doubt correlative to errors in its conception of its own personality. But, however much the discovery (like any other discovery) is at first involved in error, the fact remains that the child's discovery of itself as a person is also its discovery of itself as a member of a world of persons.

Self-consciousness makes a person of what, apart from that, would be merely a sentient organism. The relations between sentient organisms as such are constituted by the various modes of sympathy which arise out of psychical expression of their feelings. Since persons are organisms, they too are connected by relations of this kind. But, as persons, they construct a new set of relations between themselves, arising out of their consciousness of themselves and one another; these are linguistic relations. The discovery of myself as a person is the discovery that I can speak, and am thus a *persona* or speaker; in speaking, I am both speaker and hearer; and since the discovery of myself as a person is also the discovery of other persons around me, it is the discovery of speakers and hearers other than myself. Thus, from the first, the experience of speech contains in itself in

principle the experiences of speaking to others and of hearing others speak to me. How this principle works out in practice depends on how, in detail, I identify persons among my surroundings.

The relation between speaker and hearer, as two distinct persons, is one which, because of its very familiarity, is easily misunderstood. We are apt to think of it as one in which the speaker 'communicates' his emotions to the hearer. But emotions cannot be shared like food or drink, or handed over like old clothes. To speak of communicating an emotion, if it means anything, must mean causing another person to have emotions like those which I have myself. But independently of language neither he nor I nor any third person can compare his emotions with mine, so as to find out whether they are like or unlike. If we speak of such comparison, we speak of something that is done by the use of language; so that the comparison must be defined in terms of speaking and hearing, not speaking and hearing in terms of such comparison. If, however, the relation between emotion and language has been correctly described in § 3, sense can be made of these phrases. They will then be analysed as follows.

When language is said to express emotion, this means that there is a single experience which has two elements in it. First, there is an emotion of a specific kind, not a psychic emotion or impression, but an emotion of which the person who has it is conscious, and which by this consciousness he has converted from impression into idea. Secondly, there is a controlled bodily action in which he expresses this idea. The expression is not an afterthought to the idea; the two are inseparably united, so that the idea is had as an idea only in so far as it is expressed. The expression is speech, and the speaker is his own first hearer. As hearing himself speak, he is conscious of himself as the possessor of the idea which he hears himself expressing. Thus two statements are both true, which might easily be thought to contradict each other: (1) it is only because we know what we feel that we can express it in words; (2) it is only because we express them in

words that we know what our emotions are. In the first, we describe our situation as speakers; in the second, our situation as hearers of what we ourselves say. The two statements refer to the same union of idea with expression, but they consider this union from opposite ends.

The person to whom speech is addressed is already familiar with this double situation. If he were not, it would be useless to address him. He, too, is a speaker, and is accustomed to make his emotions known to himself by speaking to himself. Each of the two persons concerned is conscious of the other's personality as correlative to his own; each is conscious of himself as a person in a world of persons, and for the present purpose this world consists of these two. The hearer, therefore, conscious that he is being addressed by another person like himself (without that original consciousness the so-called communication of emotion by language could never take place), takes what he hears exactly as if it were speech of his own: he speaks to himself with the words that he hears addressed to him, and thus constructs in himself the idea which those words express. At the same time, being conscious of the speaker as a person other than himself, he attributes that idea to this other person. Understanding what some one says to you is thus attributing to him the idea which his words arouse in yourself; and this implies treating them as words of your own.

This might seem to presuppose community of language between the speaker and hearer; for unless they were accustomed to use the same words, the hearer in using them to himself would not mean the same thing by them. But community of language is not another situation independent of the situation we have been describing, and prior to it: it is one name by which we refer to that situation itself. One does not first acquire a language and then use it. To possess it and to use it are the same. We only come to possess it by repeatedly and progressively attempting to use it.

The reader may object that if what is here maintained were true there could never be any absolute assurance, either

for the hearer or for the speaker, that the one had understood
the other. That is so; but in fact there is no such assurance.
The only assurance we possess is an empirical and relative
assurance, becoming progressively stronger as conversation
proceeds, and based on the fact that neither party seems to
the other to be talking nonsense. The question whether they
understand each other *solvitur interloquendo*. If they under-
stand each other well enough to go on talking, they under-
stand each other as well as they need; and there is no better
kind of understanding which they can regret not having
attained.

The possibility of such understanding depends on the
hearer's ability to reconstruct in his own consciousness the
idea expressed by the words he hears. This reconstruction
is an act of imagination; and it cannot be performed unless
the hearer's experience has been such as to equip him for it.
We have already seen (Chapter X, § 4, end) that, as all ideas
are derived from impressions, no idea can be formed as such
in consciousness except by a mind whose sensuous-emotional
experience contains the corresponding impression, at least
in a faint and submerged shape, at that very moment. If
words, however eloquent and well chosen, are addressed to a
hearer in whose mind there is no impression corresponding to
the idea they are meant to convey, he will either treat them as
nonsense, or will attribute to them (possibly with the caution
that the speaker has not expressed himself very well) a mean-
ing derived from his own experience and forced upon them
in spite of an obvious misfit. The same thing will happen if,
although the hearer has the right impression in his mind, he
suffers from a corruption of consciousness (Chapter X, § 6)
which will not allow him to attend to it.

Misunderstanding is not necessarily the hearer's fault; it
may be the speaker's. This will be the case if through
corruption in his own consciousness the idea which he
expresses is a falsified one; certain elements, which are in
fact essential to the expressed idea, being disowned. Any
attempt on the hearer's part to reconstruct the idea for himself

will (unless his own consciousness happens to be similarly corrupted) result in his rediscovering, as an integral part of the idea, this disowned element; and thus speaker and hearer will be again at cross-purposes.

§ 6. *Language and Thought*

In one sense language is wholly an activity of thought, and thought is all it can ever express; for the level of experience to which it belongs is that of awareness or consciousness or imagination, and this level has been shown to belong not to the realm of sensation or psychical experience, but to the realm of thought. But if thought is taken in its narrower sense of intellect, language together with imaginative experience as such falls outside it and below it. Language in its original nature expresses not thought in this narrower sense, but only emotions; though these are not crude impressions, but are transmuted into ideas through the activity of consciousness.

I have already said that there is a secondary stage in its development, where language undergoes modification to serve the purposes of intellect. It might be supposed that, because art is the imaginative expression of emotion (Chapters VI, VII), this secondary development is of no interest to the aesthetician as such. This would be a mistake. Even if art never expresses thought as such, but only emotion, the emotions it expresses are not only the emotions of a merely conscious experient, they include the emotions of a thinker; and consequently a theory of art must consider the question: how, if at all, must language be modified in order to bring the expression of these emotions within its scope?

The general distinction between imagination and intellect is that imagination presents to itself an object which it experiences as one and indivisible: whereas intellect goes beyond that single object and presents to itself a world of many such with relations of determinate kinds between them.

Everything which imagination presents to itself is a here,

a now; something complete in itself, absolutely self-contained, unconnected with anything else by the relations between what it is and what it is not, what it is and that because of which it is what it is, what it is and what it might have been, what it is and what it ought to be. If any of these distinctions are imported into the object of imagination, it absorbs them; the duality of terms with a relation between them disappears, and leaves only a trace of itself in the shape of a modification in the quality of the whole. For example: I listen to a thrush singing. By mere sensation I hear at any given moment only one note or one fragment of a note. By imagination what I have been hearing continues to vibrate in my thought as an idea, so that the whole sung phrase is present to me as an idea at a single moment. I may now go on to a further act, by which I imagine alongside of this present May thrush-song the thrush-song of January. So far as the entire experience remains at the level of imagination, as distinct from that of intellect, these two songs are not imagined separately as two things with a relation between them. The January song coalesces with the May song, and confers upon it a new quality of mature mellowness. Thus what I imagine, however complex it may be, is imagined as a single whole, where relations between the parts are present simply as qualities of the whole.

If, starting from the same experience of listening to a bird-song, I now begin to think about it, in the narrower sense of that word, I analyse it into parts. From being an indivisible unity it becomes a manifold, a network of things with relations between them. Here is one note, and here another, higher or lower, softer or louder. Each is different from the other, and different in a definite way. I can think of these qualities by themselves, and reflect that a note might be higher and louder than another, or higher and softer. I can describe the difference between two songs by saying that one has a sweeter tone than the other, or is longer, or contains more notes. This is analytic thought.

Another thing that I can do is to go beyond what I am

imagining and consider its relation to other things which I am not imagining. For example, I may be unable at the moment to call up to my mind any remembrance (that is, any imagination) of what the January thrush-song is like; but I can remember facts about it, even if I cannot remember itself; I can, for example, remember the fact that I heard it four months ago at dawn. Memory in this second sense is a kind of intellectual paper-money which I cannot exchange for the gold of memory in the first sense; it is the thought of something as occupying a certain place in the scheme of things (here, in space and time) without the thought of what the thing which occupies that place actually and in itself is. This thought of something indeterminate, which if it were determinate would occupy a certain position, is abstract thought.

These are not the only kinds of thought (for I shall now begin to use that word only in its narrower sense). They are given merely as examples of what thought does which imagination, never analytic and never abstract, cannot do. Language has to be adapted to the expression of these new kinds of experience. For this purpose it has itself to undergo parallel changes.

§ 7. *The Grammatical Analysis of Language*

First, language is analysed, by the work of the intellect itself, grammatically. In this process there are three stages.

(1) Language is an activity; it is expressing oneself, or speaking. But this activity is not what the grammarian analyses. He analyses a product of this activity, 'speech' or 'discourse' not in the sense of a speaking or a discoursing, but in the sense of something brought into existence by that activity. This product of the activity of speaking is nothing real; it is a metaphysical fiction. It is believed to exist only because the theory of language is approached from the stand-point of the philosophy of craft, and the assumption un-questioningly made that any activity is essentially a kind of fabricating. That being so, the activity of expression will be

essentially the fabricating of a thing called language, and the endeavour to understand that activity will take the form of an endeavour to understand its product. This may seem a futile undertaking. What possible result, good or bad, can come of trying to understand a thing which does not exist? The answer (which is already clear to an attentive reader of Chapter VI, § 1) is that these metaphysical fictions are in one sense real enough. The person who tries to understand them is fixing his attention on a real thing, but is distorting his ideas about it by attempting to harmonize them with a preconception which is in fact false. Thus, what the grammarian is really doing is to think, not about a product of the activity of speaking, but about that activity itself, distorted in his thoughts about it by the assumption that it is not an activity, but a product or 'thing'.[1]

(2) Next, this 'thing' must be scientifically studied; and this involves a double process. The first stage of this process is to cut the 'thing' up into parts. Some readers will object to this phrase on the ground that I have used a verb of acting when I ought to have used a verb of thinking; a dangerous habit, they will remind me, because when you get to the point of saying 'thought constructs the world' when you mean 'some one thinks how the world is constructed', you have slipped into idealism through mere looseness of language; and that, they will add, is the way idealists are made. There is much that might be said in answer to this objection; as, that philosophical controversies are not to be settled by a kind of police-regulation governing people's choice of words, and that a school of thought (to dignify it by that name) which depends for its existence on enforcing a particular jargon is a school which I neither respect nor fear. But I prefer to reply merely that I said cut because I meant cut. The division of the 'thing' known as language into words is a division not discovered, but devised, in the process of analysing it.

[1] I use quotation marks in order to show that the word is being used not in its actual English sense, but as a technical term in metaphysics.

(3) The final process is to devise a scheme of relations between the parts thus divided. Here again we must refuse to be frightened by the bogy of idealism. The relations are not discovered, they are, we must insist, devised. If the terms are devised, the relations between them are devised too; the more so because the processes here numbered (2) and (3) are not separate, but concurrent, since any modification in either of them entails modifications in the other. The scheme of relations falls under certain customary heads.

(*a*) *Lexicography*. Every word, as it actually occurs in discourse, occurs once and once only. But if the dissection is skilfully carried out, there will be words here and there which are so like one another that they can be treated as recurrences of the same word. Thus we get a new fiction: the recurring word, the entity which forms the lexicographer's unit. That this is a fiction is, I think, not difficult to grasp. In the sentence I have just written, the word 'is' occurs twice. But the relation between these two is not one of identity. Both phonetically and logically the two are alike, but not more than alike.

The lexicographer has a second task, namely, to settle the 'meanings' of these fictitious entities. He does this, of course, by using words; so that this part of his work is carried out by establishing relations of synonymity. These relations are as fictitious as the terms which they relate; and the conscientious lexicographer soon becomes aware of this. Even granted the division of language into words and the primary classification of these into lexicographical units, no one of these units is ever quite synonymous with any other.

(*b*) *Accidence*. When lexicography has established the units *dominus, domine, dominum*, these are regarded not as separate words, but as modifications of a single word taking place according to definite rules. These rules, again, are palpable fictions; for it is notorious that exceptions to them occur; and consequently they can be assimilated to scientific laws only if a theory of science be accepted according to which its laws hold good not universally, but only (in

Aristotle's phrase) 'for the most part'. This, in fact, was the theory which presided over the birth of grammar; and although it is not now accepted by anybody, it still tacitly underlies whatever claim grammar may possess to the name of a science.

(*c*) *Syntax*. Words as actually 'used' are parts of larger units called sentences. The grammatical modification which each word undergoes in a given sentence is a function of its relation to others either expressly present or implied in the sentence. The rules determining these functions are called rules of syntax.

The grammatical manipulation of language is so familiar to ourselves, who have learnt it from the Greeks as an essential part of those transmitted and developing customs which make up our civilization, that we take it for granted and forget to inquire into its motives. We vaguely suppose it to be a science; we think that the grammarian, when he takes a discourse and divides it into parts, is finding out the truth about it, and that when he lays down rules for the relations between these parts he is telling us how people's minds work when they speak. This is very far from being the truth. A grammarian is not a kind of scientist studying the actual structure of language; he is a kind of butcher, converting it from organic tissue into marketable and edible joints. Language as it lives and grows no more consists of verbs, nouns, and so forth than animals as they live and grow consist of forehands, gammons, rump-steaks, and other joints. The grammarian's real function (I do not call it purpose, because he does not propose it to himself as a conscious aim) is not to understand language, but to alter it: to convert it from a state (its original and native state) in which it expresses emotion into a secondary state in which it can express thought.

This function is actually fulfilled; but only in a limited and qualified way. Language would not remain language unless it remained expressive; and it can do this only by resisting the grammarian's efforts so far as to retain a measure of its original vitality. The division of speech into words is

precarious and arbitrary; in actual speech these divided portions coagulate again into phrases which will not come apart, and which the grammarian is obliged to treat in defiance of his own principles as if they were single words. Such a coagulation of several words into a single whole, quite different from the sum of the words that compose it in their recognized grammatical relations to each other, is called an 'idiom'. The word is a curious one. It means something personal and private, something which reveals a rebellion on the part of its user against the public usage of his society. An idiom, therefore, ought to be a mode of speech unintelligible to any one except the speaker. But, in fact, idioms are perfectly intelligible; and all the grammarian has done by calling them idioms is to admit that his own grammatical science cannot cope with them, and that the people who use them have spoken intelligibly when, according to him, what they say should be meaningless. Again, the lexicographer's credit depends on his power of making good the assumption that a word, as he defines it, is a genuine linguistic unity, maintaining its identity both of sound and of meaning through all changes of context. But he is continually being forced to admit that this assumption is false. In proportion as language is more thoroughly intellectualized, the occasions on which it breaks down become rarer; but even the most completely intellectualized language will suddenly remember the pit whence it was digged, and laugh at lexicographers by shifting the meanings of its words according to the context in which they stand. In the ordinary speech of everyday life, where intellectualization is relatively low, the lexicographer can never be victorious in his running fight with the vagaries of context.

Considerations like these are fatal to the prejudice which would regard the grammarian's work as scientific. It does not follow that grammar is of no use. It is of great use; but its use is not theoretical, it is practical. The grammarian's business is to adapt language to the function of expressing thought; and the reason why we tolerate these inconsistencies

and compromises in his work is that we realize the importance of his not overdoing it so far as to destroy the ability of language to express anything at all.

I likened the grammarian to a butcher; but, if so, he is a butcher of a curious kind. Travellers say that certain African peoples will cut a steak from a living animal, and cook it for dinner, the animal being not much the worse. This may serve to amend the original comparison.

§ 8. *The Logical Analysis of Language*

All this, however, is only one side of a process whose other side is known as 'the traditional logic'. This consists in a certain technique first systematically expounded, so far as its earliest expositions are preserved, in Aristotle's *Organon*; perpetuated and developed by a long line of medieval logicians; rejected as a futile logomachy by the anti-Aristotelian movement of the Renaissance and the seventeenth century; reaffirmed, with many qualifications due partly to the influence of that movement and partly to a renewed study of Aristotle himself, by the so-called idealists of the eighteenth and nineteenth centuries from Kant to Bradley and beyond; and restored with fewer qualifications by the logical analysts and positivists of the present day.

The aim of this technique is to make language into a perfect vehicle for the expression of thought. We may explain its nature and purpose by means of a preamble followed by a resolution: 'Whereas the aim of persons who use language in good faith is thereby to express their thoughts; and whereas this aim is now frustrated by the inaccuracies and ambiguities besetting the ordinary use of language; Now therefore let it be resolved that all such persons do in future express their thoughts by the use of certain linguistic forms, to be known as "logical forms".' The constitutive peculiarities of these so-called logical forms may, of course, be differently defined by different schools of thought. For the earlier or Aristotelian school, logical form meant subject-predicate form, and the logical expression

of thought meant the expression of it in the form S is P. For the modern or analytic school this is both inadequate and misleading, and the main problem of logical expression is the analysis of a given statement into all the propositions (not necessarily subject-predicate propositions) which the person making it is thereby affirming. I am not here concerned with this or any of the other differences that divide the technique of analytic logic from that of its Aristotelian ancestor; only with their fundamental identity of purpose; and with that only so far as it affects the theory of language.

Any logical technique, whether Aristotelian or analytic or any other, begins by assuming that the grammatical transformation of language has been successfully accomplished. The activity of speech has been converted into a 'thing'; this 'thing' has been cut up into words; these words have been sorted out according to resemblances into groups, the words in each group being treated as repetitions of a single lexicographical unit; these units have been tied down each to its proper and constant meaning; and so forth. The logician's work begins with the laying down of three further assumptions.

First comes what I shall call the propositional assumption. This is the assumption that, among the various 'sentences' already distinguished by grammarians, there are some which, instead of expressing emotions, make statements. It is to these that the logician confines his attention.

Second, the principle of homolingual translation. This is an assumption about sentences corresponding to the lexicographer's assumption about words (or, to be precise, about what I have called lexicographical units) when he 'defines the meaning' of a given word by equating it with that of another, or of a group of words taken together. According to the principle of homolingual translation, one sentence may have precisely the same meaning as another single sentence, or group of sentences taken together, in the same language, so that one may be substituted for the other without change of meaning.

The third assumption is that of logical preferability: namely that, of two sentences or sentence-groups having the same meaning, one may be preferable, from a logician's point of view, to the other. What determines this preferability depends upon what the logician is trying to do: that is, upon the aims and principles of his technique. In spite of what logicians have sometimes said, the preferred sentence or sentence-group is never preferred as being easier to understand. That criterion is used not by the logician, but by the stylist. The preferred version is preferred because it is one which the rules of the logician's technique enable him to manipulate.

The Aristotelian logic is mainly concerned with inference. Its manipulation of propositions is directed to the end of fitting them into the framework of the syllogism. The Aristotelian logician is manœuvring for a position in which he can say: 'You are wrong to maintain this view; for you defend it on such and such grounds, and when you reduce your premisses to logical form you can see for yourself that they do not prove the alleged conclusion.' The modern analytic logician is interested not in the formal validity of inferences, but in the 'content' of the statements he analyses. He, too, is interested in polemics; but his method is based on the conception of error as due not to syllogistic fallacies, but to *confusa cognitio*. He therefore manœuvres for a position in which he can say: 'You are wrong to maintain this view; for in asserting it you are simultaneously asserting five different propositions, a, b, c, d, and e; now you will agree, when you look at them separately for yourself, that a, b, c, and d are true, but that e is false.' The logical technique of these two schools consists of a method for achieving their respective tactical positions; and the preferability of one homolingual translation over another is relative to the rules of the technique adopted.

It is even more obvious here than in the case of grammatical analysis that we are concerned with a modification of language, not a theory of it. As Jowett is said to have

remarked, the traditional logic is 'neither a science nor an art, but a dodge'. It is a dodge for converting language into symbolism. Its assumptions are neither certainly nor probably, nor even possibly, true. They are, in fact, not assumptions, but proposals; and what they propose is the conversion of language into something which, if it could be realized, would not be language at all. This is partly understood by the analytic logicians, who in practice adopt a symbolism like that of mathematics to facilitate their logical manipulations, and in theory assert a convergence, if not an identity, between logic and mathematics.

Like the grammarian's modification of language, the logician's modification of it can be to a certain extent carried out. But it can never be carried out in its entirety. When the attempt is made to do this, what happens is that language is subjected to a strain tending to pull it apart into two quite different things, language proper and symbolism. If the division could be completed, the result would be the state of things which Dr. Richards is presumably trying to describe when he distinguishes[1] 'the two uses of language'. He states the distinction thus (op. cit., p. 267): 'A statement may be used for the sake of the *reference*, true or false, which it causes. This is the *scientific* use of language. But it may also be used for the sake of the effects in emotion and attitude produced by the reference it occasions. This is the *emotive* use of language.' Dr. Richards assumes, apparently without realizing that any one could do otherwise, that language is not an activity, but something which is 'used', and can be 'used' in quite different ways while remaining the same 'thing', like a chisel that is used either for cutting wood or for lifting tacks. With this technical theory of language he combines a technical theory of art. The 'emotive use of language' he regards as its artistic use. To continue the above quotation after omitting two sentences: 'Many arrangements of words evoke attitudes without any reference being required *en route*. They operate like musical phrases.' This makes clear

[1] *The Principles of Literary Criticism*, ed. 2 (1926), ch. xxxiv.

the connexion between his technical theory of language and his technical theory of art. It comes to this, that according to Dr. Richards there is a complete division between the 'scientific use of language', i.e. its use for the making of statements, true or false, and a purely aesthetic quasi-musical 'use' which is the extreme case of what he calls the 'emotive use', i.e. its use to evoke emotion. The technical theory of language is as complete an error as the technical theory of art, if indeed they are two errors and not one; but what Dr. Richards is here saying can be restated, eliminating these errors, by saying that discourse is either scientific discourse in which statements, true or false, are made, and thought is expressed; or artistic discourse in which emotion is expressed.

Is this distinction a real one, or is it only a statement of the two forces between which a tension, but a not altogether disruptive tension, is introduced into language by the attempt to intellectualize it? I shall try to show that the latter alternative is the truth; that language intellectualized by the work of grammar and logic is never more than partially intellectualized, and that it retains its function as language only in so far as the intellectualization is incomplete. Language may by the work of the grammarian and logician become 'ballasted with logic', as Bergson says that space is 'ballasted with geometry'; but if it were filled up solid with ballast it would no longer be seaworthy; it would simply founder. To drop the metaphor, scientific discourse in so far as it is scientific tries to rid itself of its own function as discourse or language, emotional expressiveness; but if it succeeded in this attempt it would no longer be discourse. From the point of view of language, therefore, the distinction Dr. Richards has drawn (if my reinterpretation of it is correct, of which I am not sure; for it is by no means, as he says, 'simple' when 'once clearly grasped') is not a distinction separating scientific discourse from artistic; it is a distinction within artistic discourse, between artistic discourse as such and artistic discourse subserving the purposes of intellect. How exactly it subserves these purposes we must ask later on.

In the first place, it is a matter of fact that discourse in which a determined attempt is made to state truths retains an element of emotional expressiveness. No serious writer or speaker ever utters a thought unless he thinks it worth uttering. What makes it worth uttering is not its truth (the fact that something is true is never a sufficient reason for saying it), but the fact of its being the one truth which is important in the present situation. Nor does he ever utter it except with a choice of words, and in a tone of voice, that express his sense of this importance. If he is soliloquizing, his words and his tone convey not only 'this is important', but 'this is important to me'. If he is addressing an audience, words and tone convey not only 'this is important', but 'this is important for you'. In proportion as a writer is skilful in getting his audience to grasp his meaning, attention to his choice of words and tone of voice will reveal a subtly appropriate texture of emotional expression. The writer is sometimes easily confident, sometimes nervous, sometimes pleading, sometimes amused, sometimes indignant. When Dr. Richards wants to say that a certain view of Tolstoy's about art is mistaken, he says: 'This is plainly untrue.' Scientific use of language, certainly. But how delicately emotive! One hears the lecturing voice, and sees the shape of the lecturer's fastidious Cambridge mouth as he speaks the words. One is reminded of a cat, shaking from its paw a drop of the water into which it has been unfortunately obliged to step. Tolstoy's theory does not smell quite nice. A person of refinement will not remain in its company longer than he can help. Hence the abruptness: those four brief words say to the audience: 'Do not think I am going to disgust you by dragging to light all the follies into which unreflective haste led this great man. Take courage; I dislike this chapter as much as you do; but it is going to be very short.'

The only obstacle to recognizing this truth is one which, naturally inherent in the practice of writing down our words instead of speaking them, has been artificially exaggerated by an unholy alliance between bad logic and bad literature.

When some one utters scientific discourse, saying, for example: 'The chemical formula of water is H_2O,' the tone and tempo of his voice make his emotional attitude towards the thought he is expressing clear to any attentive listener. He may be bored with it, and concerned only to get through the routine of a chemistry lesson; then he will say the words in a flat, dull tone. He may wish to impress the class with something they must remember for the sake of their examinations; then he will use a forced and hectoring tone. Or he may be excited by it, as a triumph of scientific thought which for him has never lost its freshness; then he will use an alert and lively tone, and fifty years afterwards an F.R.S. will say to a friend: 'It was old Jones, you know, who really taught me chemistry.' But in our writing and printing there is no notation for these differences, and consequently the reader of a sentence like 'The chemical formula of water is H_2O' has no clue to them. In his capacity as a logician, he now stands on the brink of a precipice. He is tempted to believe that the scientific discourse is the written or printed words, and that the spoken words are either simply this over again, or this *plus* something else, namely emotional expression. Good logic or good literature would save him; good logic, by calling his attention to the fact that even the logical structure of a proposition is not always clear from its written or printed form[1]; good literature, because one great part of a writer's skill consists in so framing his sentences that an ordinarily intelligent reader cannot make nonsense of them by reading them, aloud or to himself, with the wrong intonation or tempo. Failing these helps, and misled by the modern practice of silent reading, logicians fling themselves headlong in hordes, like lemmings; and suicidally discuss the import of 'propositions' such as 'the king of Utopia died last Sunday', without stopping to ask: 'In what tone of voice

[1] Cook Wilson used to point out in his lectures that the written sentence 'That building is the Bodleian' indifferently represents two quite different propositions, '*That* building is the Bodleian' (answering the question, 'Which of these is the Bodleian?') and 'That building is the *Bodleian*' (answering the question 'What is that building?'). Cf. *Statement and Inference*, pp. 117–18.

am I supposed to say this? The tone of a person beginning a fairy tale, in which case I hand the job over to an aesthetician; or the tone of a person stating a fact of which he wishes to convince his audience, in which case it is a job for an alienist; or the tone of a person merely making noises with his mouth which may interest a physiologist but do not interest me; or the tone of a person trying to pull a logician's leg, in which case *solvuntur risu tabulae*?' If you don't know what tone to say them in, you can't say them at all: they are not words, not even noises.

'The proposition', understood as a form of words expressing thought and not emotion, and as constituting the unit of scientific discourse, is a fictitious entity. This will be easily granted by any one who thinks for a moment about scientific discourse in its actual and living reality, instead of thinking only about the conventional marks on paper which represent or misrepresent it. But I now come to a second and more difficult thesis.

I have been speaking hitherto as if discourse had two functions, one to express thought, the other to express emotion; and as if the misconception I want to remove were the doctrine that scientific discourse or intellectualized language has the first function without the second. I do want to remove that misconception; but I want to go a good deal farther. An emotion is always the emotional charge upon some activity. For every different kind of activity there is a different kind of emotion. For every different kind of emotion there is a different kind of expression. Taking first the broad distinction between sensation and thought, the emotional charges upon sense-experience, felt as they are at a purely psychical level, are psychically expressed by automatic reactions. The emotional charges upon thought-experiences are expressed by the controlled activity of language. Taking next the distinction within thought of consciousness and intellect, the emotions of consciousness are expressed by language in its primitive and original form; but intellect has its emotions too, and these must have an

appropriate expression, which must be language in its intellectualized form.

Intellect has its own emotions. The excitement which drove Archimedes from his bath naked through the streets was not a mere generalized excitement, it was specifically the excitement of a man who had just solved a scientific problem. But it was even more definite than that. It was the excitement of the man who had just solved the problem of specific gravity. The cry of 'Eureka' which expressed that emotion looks, when written down, exactly like the 'Eureka' of a man who has found his oil-flask; but to an attentive listener it was assuredly very different. It announced not just any discovery, but a scientific discovery. And if there had been among the passers-by a physicist as great as Archimedes himself, who had come to Syracuse in order to tell Archimedes that he had discovered specific gravity, it is not impossible that he might have understood the whole thing, and burst from the crowd, shouting, 'So have I!'

An extreme and fantastic case may serve to point the principle. If it is once granted that intellectualized language does express emotion, and that this emotion is not a vague or generalized emotion, but the perfectly definite emotion proper to a perfectly definite act of thought, the consequence follows that in expressing the emotion the act of thought is expressed too. There is no need for two separate expressions, one of the thought and the other of the emotion accompanying it. There is only one expression. We may say if we like that a thought is expressed in words and that these same words also express the peculiar emotions proper to it; but these two things are not expressed in the same sense of that word. The expression of a thought in words is never a direct or immediate expression. It is mediated through the peculiar emotion which is the emotional charge on the thought. Thus, when one person expounds his thought in words to another, what he is directly and immediately doing is to express to his hearer the peculiar emotion with which he thinks it, and persuade him to think out this emotion for

himself, that is, to rediscover for himself a thought which, when he has discovered it, he recognizes as the thought whose peculiar emotional tone the speaker has expressed.

§ 9. *Language and Symbolism*

We can now return to the distinction between language and symbolism. A symbol is language and yet not language. A mathematical or logical or any other kind of symbol is invented to serve a purpose purely scientific; it is supposed to have no emotional expressiveness whatever. But when once a particular symbolism has been taken into use and mastered, it reacquires the emotional expressiveness of language proper. Every mathematician knows this. At the same time, the emotions which mathematicians find expressed in their symbols are not emotions in general, they are the peculiar emotions belonging to mathematical thinking.

The same applies to technical terms. These are invented solely to serve the purpose of a particular scientific theory; but as they begin to pass current in the scientist's speech or writing they express to him and to those who understand him the peculiar emotions which that theory yields. Often, when invented by a man of literary ability, they are chosen from the first with an eye to expressing these emotions as directly and obviously as possible. Thus, a logician may use a term like 'atomic propositions' as part of his technical vocabulary. The word 'atomic' is a technical term, that is, a word borrowed from elsewhere and turned into a symbol by undergoing precise definition in terms of the theory. Sentences in which it occurs can be subjected to homo-lingual translation. But, as we find it occurring in the logician's discourse, it is full of emotional expressiveness. It conveys to the reader, and is meant to convey, a warning and a threat, a hope and a promise. 'Do not try to analyse these; renounce the dream of analysing to infinity; that way delusion lies, and the ridicule of people like myself. Walk boldly, trusting in the *solida simplicitas* of these propositions; if you use them confidently as bricks out

of which to build your logical constructions, they will never betray you.'

Symbolism is thus intellectualized language: language, because it expresses emotions; intellectualized, because adapted to the expression of intellectual emotions. Language in its original imaginative form may be said to have expressiveness, but no meaning. About such language we cannot distinguish between what the speaker says and what he means. You may say that he means precisely what he says; or you may say that he means nothing, he is only speaking (where speaking, of course, means not making vocal noises, but expressing emotion). Language in its intellectualized form has both expressiveness and meaning. As language, it expresses a certain emotion. As symbolism, it refers beyond that emotion to the thought whose emotional charge it is. This is the familiar distinction between 'what we say' and 'what we mean'. 'What we say' is what we immediately express: the eager or reluctant or triumphant or regretful utterance in which these emotions and the gestures or sounds that express them are inseparable parts of a single experience. 'What we mean' is the intellectual activity upon which these are the emotional charge, and towards which the words expressing the emotions are a kind of finger-post, pointing for ourselves in the direction from which we have come, and for another in the direction to which he must go if he wishes to 'understand what we say', that is, to reconstruct for himself and in himself the intellectual experience which has led us to say what we did.

The progressive intellectualization of language, its progressive conversion by the work of grammar and logic into a scientific symbolism, thus represents not a progressive drying-up of emotion, but its progressive articulation and specialization. We are not getting away from an emotional atmosphere into a dry, rational atmosphere; we are acquiring new emotions and new means of expressing them.

BOOK III
THE THEORY OF ART

ART AS LANGUAGE

§ 1. *Skeleton of a Theory*

THE empirical or descriptive work of Book I left us with the conclusion that art proper, as distinct from amusement or magic, was (i) expressive (ii) imaginative. Both these terms, however, awaited definition: we might know how to apply them (that being a question of usage, or ability to speak not so much English as the common tongue of European peoples), but we did not know to what theory concerning the thing so designated this application might commit us. It was to fill this gap in our knowledge that we went on to the analytical work of Book II. The result of that book is that we now have a theory of art. We can answer the question: 'What kind of a thing must art be, if it is to have the two characteristics of being expressive and imaginative?' The answer is: 'Art must be language.'

The activity which generates an artistic experience is the activity of consciousness. This rules out all theories of art which place its origin in sensation or its emotions, i.e. in man's psychical nature: its origin lies not there but in his nature as a thinking being. At the same time, it rules out all theories which place its origin in the intellect, and make it something to do with concepts. Each of these theories, however, may be valued as a protest against the other; for as consciousness is a level of experience intermediate between the psychic and the intellectual, art may be referred to either of these levels as a way of saying that it is not referable to the other.

The artistic experience is not generated out of nothing. It presupposes a psychical, or sensuous-emotional, experience. By an illegitimate comparison with craft, this psychical experience is often called its 'matter'; and it is actually transformed, somewhat (but not exactly) as a raw material is

transformed, by the act which generates the artistic experience. It is transformed from sense into imagination, or from impression into idea.

At the level of imaginative experience, the crude emotion of the psychical level is translated into idealized emotion, or the so-called aesthetic emotion, which is thus not an emotion pre-existing to the expression of it, but the emotional charge on the experience of expressing a given emotion, felt as a new colouring which that emotion receives in being expressed. Similarly, the psycho-physical activity on which the given emotion was a charge is converted into a controlled activity of the organism, dominated by the consciousness which controls it, and this activity is language or art. It is an imaginative experience as distinct from a merely psycho-physical one, not in the sense that it involves nothing psycho-physical, for it always and necessarily does involve such elements, but in the sense that none of these elements survive in their crude state; they are all converted into ideas and incorporated into an experience which as a whole, as generated and presided over by consciousness, is an imaginative experience.

This imaginative activity, as the activity of speech, stands in a twofold relation to emotion. In one way it expresses an emotion which the agent, by thus expressing it, discovers himself to have been feeling independently of expressing it. This is the purely psychical emotion which existed in him before he expressed it by means of language, though of course it had already its appropriate psychical expression by means of involuntary changes in his organism. In another way it expresses an emotion which the agent only feels at all in so far as he thus expresses it. This is an emotion of consciousness, the emotion belonging to the act of expression. But these are not two quite independent emotions. The second is not a purely general emotion attendant on a purely general activity of expression, it is a quite individual emotion attendant on the individual act of expressing this psychic emotion and no other. It is thus the psychic emotion itself, converted by the act of consciousness into a corresponding imaginative or aesthetic emotion.

This no doubt sounds very dry and abstruse to a reader who has not read, or has forgotten, the contents of the preceding chapters. To a reader who remembers the argument of those chapters, it will be quite clear. Even so, it is, of course, highly abstract. I will remedy that by proceeding to apply it to certain particular problems.

§ 2. *Art Proper and Art falsely so called*

The aesthetic experience, or artistic activity, is the experience of expressing one's emotions; and that which expresses them is the total imaginative activity called indifferently language or art. This is art proper. Now, in so far as the activity of expression creates a deposit of habits in the agent, and of by-products in his world, these habits and by-products become things utilizable by himself and others for ulterior ends. When we speak of 'using' language for certain purposes, what is so used cannot be language itself, for language is not a utilizable thing but a pure activity. It is something which in Chapter III, § 2, I described as art (that is, language) 'denatured'. Language in itself cannot be thus denatured; what can be is the deposits, internal and external, left by the linguistic activity: the habit of uttering certain words and phrases; the habit of making certain kinds of gesture, together with the kinds of audible noise, coloured canvass, and so forth, which these gestures produce.

The artistic activity which creates these habits and constructs these external records of itself, supersedes and jettisons them as soon as they are formed. We commonly express this by saying that art does not tolerate *clichés*. Every genuine expression must be an original one. However much it resembles others, this resemblance is due not to the fact that the others exist, but to the fact that the emotion now being expressed resembles emotions that have been expressed before. The artistic activity does not 'use' a 'ready-made language', it 'creates' language as it goes along. Once we have got rid of a false conception of 'originality', no objection to this statement arises from the fact that one linguistic

expression is often very like another. There is nothing in creation which favours dissimilarity between creatures as against similarity. But the by-products of this creative activity, ready-made words and phrases, types of pictorial and sculptural form, turns of musical idiom, and so forth, can be 'used' as means to ends; and among these ends there cannot be counted the expressing of emotion, because expression (unless art is after all a craft) cannot ever be an end to which there are means.

Thus the dead body, so to speak, of the aesthetic activity becomes a repertory of materials out of which an activity of a different kind can find means adaptable to its own ends. This non-aesthetic activity, in so far as it uses means which were once the living body of art, galvanizing these into an appearance of life which makes it seem as if their spirit had after all not left them, is a pseudo-aesthetic activity. It is not art, but it simulates art, and is thus art falsely so called.

In itself it is not art, but (because it uses means to a pre-conceived end) craft. All craft, as we saw in Chapter II, § 2, is aimed ultimately at producing certain states of mind in certain persons. Art falsely so called is, therefore, the utilization of 'language' (not the living language which alone is really language, but the ready-made 'language' which consists of a repertory of *clichés*) to produce states of mind in the persons upon whom these *clichés* are used.

These states of mind (since the activity we are considering is an entirely reasonable one) are of course produced for a sufficient reason. And they are produced with the consent of the person who is being acted upon, so that in the last resort it is he that is the judge of this reason. To whatever kind of state of mind they belong, it must be (*a*) one capable of being thus produced, (*b*) produced either as an end in itself or as means to some further end.

(*a*) There is no way by which any one person can produce in another either an act of will or an act of thinking. When we say that one person 'makes' another think or act, we mean at most that he holds out inducements to act in such a way;

but that will not do here. What one person can produce in another is emotion.

(*b*) If the emotion produced is one which the person in whom it is produced welcomes for its own sake, that is, as pleasant, the producing of it is amusement. If he welcomes it as a means to some further end, that is, as useful, the producing of it is magic.

These things are not bad art. They are merely something else which may be and often is mistaken for it. The bipolarity in virtue of which an act of thought may be well done or ill done (Chapter VIII, § 1) is a differentiation within that activity itself, a dialectical relation or opposition belonging to its own essential structure; it cannot be reduced to a distinction between the activity in question and some other activity. If one activity A is mistaken for another, B, the making of the mistake testifies to a bipolarity in the act of thought which thus mistakes it, but not to a bipolarity in B. So a person who mistakes amusement for art is doing his thinking badly, but that about which he makes the mistake is not bad art. What he is doing is to mistake the *clichés* or corpses of language used in this business for language itself. The difference between the things thus confused is like the difference between a living man and a dead man; the difference between good art and bad art is like the relation between two living men, one good and the other bad.

Nor are these things a kind of raw material out of which art is made by infusing into them the spirit of the aesthetic consciousness. I have said repeatedly that such an infusion is always possible; but if we consider more closely what that statement means, we shall see it to mean not that amusement or magic is a precondition of art, but that a person engaged in such occupations may, in addition to being engaged in them, turn to the very different work of expressing the emotions which an occupation of this kind gives him. If, for example, a portrait-painter who has been asked to produce a good likeness of a sitter, instead, or in addition, paints a portrait expressing the emotions which the sitter arouses in

him, he will produce not a commercial portrait or pot-boiler, but a work of art. As a pot-boiler, the picture cannot ever become a work of art. It can only become a work of art by ceasing to be a pot-boiler.

The point is important, because I have ventured to assert that most of what generally goes by the name of art nowadays is not art at all, but amusement. Now, a reader might very well say: 'This amusement art is surely, after all, only art at a low level; or at any rate, something containing in itself the living germs of art. If we want to know, therefore, how to escape from the situation described (for I admit the correctness of the description) into one in which genuine art is being produced, or produced more frequently and of higher quality, the answer is that we must go ahead with our amusement trade and insist on doing it better. Or, if amusement art does not promise such development, let us concentrate on magical art. Let us by all means cease to be merely amusing; let us have instead an art designed to stimulate emotions valuable for practical life; for instance, an art dedicated to the service of communism. At the same time, let us insist on doing our communistic art really well, and out of that endeavour we shall find ourselves developing a new art properly so called.'

Such a reader would be simply cherishing illusions. He would be in effect confusing the relation between art and not art with the relation between good art and bad art. I say this with no hostility whatever towards magical art in general, or in particular towards an art inspired by the wish to inculcate communistic sentiments. On the contrary, I have insisted that magic is a thing which every community must have; and in a civilization that is rotten with amusement, the more magic we produce the better. If we were talking about the moral regeneration of our world, I should urge the deliberate creation of a system of magic, using as its vehicles such things as the theatre and the profession of letters, as one indispensable kind of means to that end. But that is not the point in question. We are talking not about the necessity for magic, but about whether magic, by some dialectic inherent

in itself, will develop, if heartily pursued, into art. The answer is that it will not.

A certain confusion of mind on this subject is very common at the present time among persons who are anxious to help in creating both a better art and a better political system. In connexion with their desire for a better art, they have rejected the notion, current in the late nineteenth and early twentieth centuries, that what makes a work of art is not its subject-matter, but its technical qualities, with the corollary that a genuine artist should be quite indifferent to his subject-matter, and should care about it only to the extent of choosing one which will give him scope for a display of his artistic powers. As against this view, they hold that no artist can produce a fine work of art whose subject-matter he does not take seriously. On this they are absolutely right. What they are saying is what I have said myself when I said that the emotion expressed by a work of art cannot be merely an 'aesthetic emotion', but that this so-called aesthetic emotion is itself a translation into imaginative form of an emotion which must pre-exist to the activity of expressing it. It is an obvious corollary of this, that an artist who is not furnished, independently of being an artist, with deep and powerful emotions will never produce anything except shallow and frivolous works of art.

It is clear, then, on my own premises, that an artist with strong political views and feelings will be to that extent better qualified to produce works of art than one without. But the question is, what is he to do with these political views and feelings? If the function of his art is to express them, to make a clean breast of them, because unless he can do this he cannot discover to himself or others what they are, he will be turning them into art. But if he begins by knowing what they are, and uses his art for the purpose of converting others to them, he will not be feeding his art on his political emotions, he will be stifling it beneath them. And by going on to stifle it harder and harder he will not be getting nearer to being a good artist. He will be getting farther away.

He may be doing good service to politics, but he will be doing bad service to art.

There is only one condition on which a man can simultaneously do good service to politics and to art. It is, that the work of exploring and expressing one's political emotions should be regarded as serviceable to politics. If there is any kind of political order whose realization involves the use of the muzzle, no one can serve that kind and at the same time serve art.

§ 3. *Good Art and Bad Art*

The definition of any given kind of thing is also the definition of a good thing of that kind: for a thing that is good in its kind is only a thing which possesses the attributes of that kind. To call things good and bad is to imply success and failure. When we call things good or bad not in themselves but relatively to us, as when we speak of a good harvest or a bad thunderstorm, the success or failure implied is our own; we mean that these things enable us to realize our purposes, or prevent us from doing so. When we call things good or bad in themselves, the success or failure implied is theirs. We are implying that they acquire the attributes of their kind by an effort on their own part, and that this effort may be either more or less successful.

I am not raising the question whether it is true, as the Greeks thought, that there are natural kinds, and that what we call a dog is something that is trying to be a dog. For all my present argument is concerned, either that view may be true (in which case dogs can be good or bad in themselves), or the alternative view may be true, that the idea of a dog is only a way in which we choose to classify the things we come across, in which case dogs can be good or bad only in relation to us. I am only concerned with good and bad works of art. Now, a work of art is an activity of a certain kind; the agent is trying to do something definite, and in that attempt he may succeed or he may fail. It is, moreover, a conscious activity; the agent is not only trying to do some-

thing definite, he also knows what it is that he is trying to do; though knowing here does not necessarily imply being able to describe, since to describe is to generalize, and generalizing is the function of the intellect, and consciousness does not, as such, involve intellect.

A work of art, therefore, may be either a good one or a bad one. And because the agent is necessarily a conscious agent, he necessarily knows which it is. Or rather, he necessarily knows this so far as his consciousness in respect of this work of art is uncorrupted; for we have seen (Chapter X, § 7) that there is such a thing as untruthful or corrupt consciousness.

Any theory of art should be required to show, if it wishes to be taken seriously, how an artist, in pursuing his artistic labour, is able to tell whether he is pursuing it successfully or unsuccessfully: how, for example, it is possible for him to say, 'I am not satisfied with that line; let us try it this way . . . and this way . . . and this way . . . there! that will do.' A theory which pushes the artistic experience too far down the scale, to a point below the region where experience has the character of knowledge, is unable to meet this demand. It can only evade it by pretending that the artist in such cases is acting not as an artist, but as a critic and even (if criticism of art is identified with philosophy of art) as a philosopher. But this pretence should deceive nobody. The watching of his own work with a vigilant and discriminating eye, which decides at every moment of the process whether it is being successful or not, is not a critical activity subsequent to, and reflective upon, the artistic work, it is an integral part of that work itself. A person who can doubt this, if he has any grounds at all for his doubt, is presumably confusing the way an artist works with the way an incompetent student in an art-school works; painting blindly, and waiting for the master to show him what it is that he has been doing. In point of fact, what a student learns in an art-school is not so much to paint as to watch himself painting: to raise the psycho-physical activity of painting to the level of art by becoming conscious

of it, and so converting it from a psychical experience into an imaginative one.

What the artist is trying to do is to express a given emotion. To express it, and to express it well, are the same thing. To express it badly is not one way of expressing it (not, for example, expressing it, but not *selon les règles*), it is failing to express it. A bad work of art is an activity in which the agent tries to express a given emotion, but fails. This is the difference between bad art and art falsely so called, to which reference was made on p. 277. In art falsely so called there is no failure to express, because there is no attempt at expression; there is only an attempt (whether successful or not) to do something else.

But expressing an emotion is the same thing as becoming conscious of it. A bad work of art is the unsuccessful attempt to become conscious of a given emotion: it is what Spinoza calls an inadequate idea of an affection. Now, a consciousness which thus fails to grasp its own emotions is a corrupt or untruthful consciousness. For its failure (like any other failure) is not a mere blankness; it is not a doing nothing; it is a misdoing something; it is activity, but blundering or frustrated activity. A person who tries to become conscious of a given emotion, and fails, is no longer in a state of sheer unconsciousness or innocence about that emotion; he has done something about it, but that something is not to express it. What he has done is either to shirk it or dodge it: to disguise it from himself by pretending either that the emotion he feels is not that one but a different one, or that the person who feels it is not himself, but some one else: two alternatives which are so far from being mutually exclusive that in fact they are always concurrent and correlative.

If we ask whether this pretence is conscious or unconscious, the answer is, neither. It is a process which occurs not in the region below consciousness (where it could not, of course, take place, since consciousness is involved in the process itself), nor yet in the region of consciousness (where equally it could not take place, because a man cannot literally

tell himself a lie; in so far as he is conscious of the truth he cannot literally deceive himself about it); it occurs on the threshold that divides the psychical level of experience from the conscious level. It is the malperformance of the act which converts what is merely psychic (impression) into what is conscious (idea).

The corruption of consciousness in virtue of which a man fails to express a given emotion makes him at the same time unable to know whether he has expressed it or not. He is, therefore, for one and the same reason, a bad artist and a bad judge of his own art. A person who is capable of producing bad art cannot, so far as he is capable of producing it, recognize it for what it is. He cannot, on the other hand, really think it good art; he cannot think that he has expressed himself when he has not. To mistake bad art for good art would imply having in one's mind an idea of what good art is, and one has such an idea only so far as one knows what it is to have an uncorrupt consciousness; but no one can know this except a person who possesses one. An insincere mind, so far as it is insincere, has no conception of sincerity.

But nobody's consciousness can be wholly corrupt. If it were, he would be in a condition as much worse than the most complete insanity we can discover or imagine, as that is worse than the most complete sanity we can conceive. He would suffer simultaneously every possible kind of mental derangement, and every bodily disease that such derangements can bring in their train. Corruptions of consciousness are always partial and temporary lapses in an activity which, on the whole, is successful in doing what it tries to do. A person who on one occasion fails to express himself is a person quite accustomed to express himself successfully on other occasions, and to know that he is doing it. Through comparison of this occasion with his memory of these others, therefore, he ought to be able to see that he has failed, this time, to express himself. And this is precisely what every artist is doing when he says, 'This line won't do'. He remembers what the experience of expressing himself is like, and in the

light of that memory he realizes that the attempt embodied in this particular line has been a failure. Corruption of consciousness is not a recondite sin or a remote calamity which overcomes only an unfortunate or accursed few; it is a constant experience in the life of every artist, and his life is a constant and, on the whole, a successful warfare against it. But this warfare always involves a very present possibility of defeat; and then a certain corruption becomes inveterate.

What we recognize as definite kinds of bad art are such inveterate corruptions of consciousness. Bad art is never the result of expressing what is in itself evil, or what is innocent perhaps in itself, but in a given society a thing inexpedient to be publicly said. Every one of us feels emotions which, if his neighbours became aware of them, would make them shrink from him with horror: emotions which, if he became aware of them, would make him horrified at himself. It is not the expression of these emotions that is bad art. Nor is it the expression of the horror they excite. On the contrary, bad art arises when instead of expressing these emotions we disown them, wishing to think ourselves innocent of the emotions that horrify us, or wishing to think ourselves too broad-minded to be horrified by them.

Art is not a luxury, and bad art not a thing we can afford to tolerate. To know ourselves is the foundation of all life that develops beyond the merely psychical level of experience. Unless consciousness does its work successfully, the facts which it offers to intellect, the only things upon which intellect can build its fabric of thought, are false from the beginning. A truthful consciousness gives intellect a firm foundation upon which to build; a corrupt consciousness forces intellect to build on a quicksand. The falsehoods which an untruthful consciousness imposes on the intellect are falsehoods which intellect can never correct for itself. In so far as consciousness is corrupted, the very wells of truth are poisoned. Intellect can build nothing firm. Moral ideals are castles in the air. Political and economic systems are mere cobwebs. Even common sanity and bodily health are

no longer secure. But corruption of consciousness is the same
thing as bad art.

I do not speak of these grave issues in order to magnify
the office of any small section in our communities which
arrogates to itself the name of artists. That would be absurd.
Just as the life of a community depends for its very existence
on honest dealing between man and man, the guardianship
of this honesty being vested not in any one class or section,
but in all and sundry, so the effort towards expression of
emotions, the effort to overcome corruption of consciousness,
is an effort that has to be made not by specialists only but by
every one who uses language, whenever he uses it. Every
utterance and every gesture that each one of us makes is a
work of art. It is important to each one of us that in making
them, however much he deceives others, he should not
deceive himself. If he deceives himself in this matter, he has
sown in himself a seed which, unless he roots it up again,
may grow into any kind of wickedness, any kind of mental
disease, any kind of stupidity and folly and insanity. Bad
art, the corrupt consciousness, is the true *radix malorum*.

ART AND TRUTH

§ 1. *Imagination and Truth*

IF imagination were confused with make-believe, a theory identifying art with imagination would seem to imply that the artist is a kind of liar; a skilful, ingenious, pleasant, or even salutary liar, perhaps, but still a liar. That confusion, however, has already been repudiated.

If imagination were sufficiently described, as it was in Chapter VII, § 4, as a form of experience which presents the real and the unreal in a kind of undistinguished amalgam or solution from which, later, the work of intellect is to precipitate or crystallize the truth, art as imagination would have a genuine and important function in human life; a function analogous to that whereby a scientist envisages the various possible hypotheses which later experiment and observation will enable him to reject or raise to the level of a theory. The business of art, on this view, would be to construct possible worlds, some of which, later on, thought will find real or action will make real.

There would be a good deal of truth in this view of art, but it would still not be satisfactory. At the end of Book I we were left with two functions characteristic of art proper: the one imaginative, the other expressive. The view just stated develops the first of these, but ignores the second. And it develops the first in such a way that the second is, as it were, disfranchised from the start. An imagination which contented itself with constructing possible worlds could never be at the same time an expression of emotion. For an imaginative construction which expresses a given emotion is not merely possible, it is necessary. It is necessitated by that emotion; for it is the only one which will express it.

The work of art which on a given occasion a given artist creates is, that is to say, created by him not merely because

he can create it but because he must. If we call it one only
out of a number of possible others each of which he might
have created instead, we are saying what is not true. He is
creating it at a certain point in his life, and he could not have
created it at any other point, nor any other at that point.
This is not because his works form a series in which each
depends on the one before and leads on to the one after; that
is a very superficial way of looking at the history of art,
whether on a large scale or a small; it is because each is created
to express an emotion arising within him at that point in his
life and no other. His career as an artist is certainly one of
the things which have helped to bring him into that emotional
state, but only one.

If what an artist says on a given occasion is the only thing
which on that occasion he can say; and if the generative act
which produces that utterance is an act of consciousness, and
hence an act of thought; it follows that this utterance, so far
from being indifferent to the distinction between truth and
falsehood, is necessarily an attempt to state the truth. So
far as the utterance is a good work of art, it is a true utter-
ance; its artistic merit and its truth are the same thing.

This is often denied; but it is denied because of mis-
apprehension. We have distinguished two forms of thought:
consciousness and intellect. Now intellect is concerned with
the relations between things; therefore intellect, since its truth
is a peculiar kind of truth, namely, a relational truth, has a
peculiar way of apprehending it, namely, arguing or inferring.
Consciousness as such, and therefore art as such, not being
intellect, does not and cannot argue. It cannot say, 'this,
therefore that', or, 'this, therefore not that'. Now, if any one
thinks (we need not ask why) that intellect is the only possible
form of thought, he will think that whatever does not contain
arguments cannot be a form of thought, and therefore cannot
be concerned with truth. Observing that art does not argue,
he will infer that art has nothing to do with truth. A poet
will say at one time that his lady is a paragon of all the virtues;
at another time that she has a heart as black as hell. At one

time he will say that the world is a fine place; at another, that it is a dust-heap and a dunghill and a pestilent con- glomeration of vapours. To the intellect, these are incon- sistencies. A lady, we are told, cannot be a paragon of virtue at one time and as black as hell at another; therefore a person who says she is must be making it up. He cannot be telling the truth; he must be dealing with appearances and not realities; emotions and not facts.[1]

It is hardly worth while to refute this argument, by pointing out that truthfulness about one's emotions is still truthfulness. A poet who is disgusted with life to-day, and says so, is not saying that he undertakes to be still disgusted to-morrow. But it is not any the less true that, to-day, life disgusts him. His disgust may be an emotion, but it is a fact that he feels it; the disgustingness of life may be an appear- ance, but the fact of its appearing is a reality. And on the poet's behalf it may be replied, to some one who argues that a lady cannot be both adorably virtuous and repellently vicious, or that the world cannot be both a paradise and a dust-heap, that the arguer seems to know more about logic than he does about ladies, or about the world.

Art is not indifferent to truth; it is essentially the pursuit of truth. But the truth it pursues is not a truth of relation, it is a truth of individual fact. The truths art discovers are those single and self-contained individualities which from the intellectual point of view become the 'terms' between which it is the business of intellect to establish or apprehend relations. Each of these individualities, as art discovers it, is a perfectly concrete individual, one from which nothing has yet been abstracted by the work of intellect. Each is an experience in which the distinction between what is due to myself and what is due to my world has not yet been made. If that experience consists in admiring a lady, I do not as poet ask whether this happens because in herself she is

[1] I am not so much criticizing anybody else, as doing penance for youthful follies of my own. See *Outline of a Philosophy of Art* (1925), p. 23; *Speculum Mentis* (1924), pp. 59–60.

somehow different from other ladies, or because I am for
some reason in an admiring mood. I am doing something
quite different from asking such questions; I am discovering
a thing of the kind about which, later on, such questions may
have to be asked. If it turns out that we cannot answer them,
it will not follow that the things about which they are asked
were incorrectly observed.

§ 2. *Art as Theory and Art as Practice*

Art is knowledge; knowledge of the individual. It is not
on that account a purely 'theoretical' activity as distinct from
a 'practical'. The distinction between theoretical and prac-
tical activities has, of course, a certain value, but it must not
be applied indiscriminately. We are accustomed to apply it,
and to find that it makes sense, in cases where we are con-
cerned with a relation between ourselves and our environ-
ment. An activity in ourselves which produces a change in
us but none in our environment we call theoretical; one which
produces a change in our environment but none in ourselves
we call practical. But there are plenty of cases in which we
are either unaware of any distinction between ourselves and
our environment, or in which, if we are aware of it, we are
not concerned with it.

When we really begin to understand the problems of
morality, for example, we find that they have nothing to do
with changes we can produce in the world around us, our-
selves remaining unchanged. They have to do with changes
to be produced in ourselves. Thus, the question whether I
shall return a book to the man I borrowed it from, or keep it
and deny having borrowed it if he asks me to give it back,
raises no serious moral problem. Which of the two things
I shall in fact do depends on the kind of man I am. But the
question whether I shall be an honest man or a dishonest one
is a question that raises moral problems of the most acute
kind. If I find myself to be dishonest, and decide to become
honest, I am tackling, or setting out to tackle, a genuinely
moral difficulty. But if I solve this difficulty the result will

not be a change in myself only. It will involve changes in my environment too; for out of the new character which I shall acquire there will flow actions which will certainly to some extent alter my world. Hence morality belongs to a region of experience which is neither theoretical nor practical, but both at once. It is theoretical because it consists in part of finding things out about ourselves; not merely doing things, but thinking what we are doing. It is practical because it consists not merely of thinking, but of putting our thoughts into practice.

In the case of art, the distinction between theory and practice or thought and action has not been left behind, as it has in the case of any morality that deserves the name (I say nothing of the petty moralities that often usurp it); that distinction has not yet arisen. Such a distinction only presents itself to us when, by the abstractive work of intellect, we learn to dissect a given experience into two parts, one belonging to 'the subject' and the other to 'the object'. The individual of which art is the knowledge is an individual situation in which we find ourselves. We are only conscious of the situation as our situation, and we are only conscious of ourselves as involved in the situation. Other people may be involved in it too, but these, like ourselves, are present to our consciousness only as factors in the situation, not as persons who outside the situation have lives of their own.

Because the artistic consciousness (that is, consciousness as such) does not distinguish between itself and its world, its world being for it simply what is here and now experienced, and itself being simply the fact that this is here and now experienced, its distinctive activity is properly neither theoretical nor practical. For a person cannot properly be said to act either theoretically or practically except in so far as he thinks of himself as so acting. To an observer, the artist appears as acting both theoretically and practically; to himself, he appears as acting in neither way, because either way of acting implies distinctions which, as artist, he does not draw. All that we, as aesthetic theorists, can do is to recognize

features in his activity which we should call theoretical, and others which we should call practical, and at the same time to recognize that for him the distinction does not arise.

Theoretically, the artist is a person who comes to know himself, to know his own emotion. This is also knowing his world, that is, the sights and sounds and so forth which together make up his total imaginative experience. The two knowledges are to him one knowledge, because these sights and sounds are to him steeped in the emotion with which he contemplates them: they are the language in which that emotion utters itself to his consciousness. His world is his language. What it says to him it says about himself; his imaginative vision of it is his self-knowledge.

But this knowing of himself is a making of himself. At first he is mere psyche, the possessor of merely psychical experiences or impressions. The act of coming to know himself is the act of converting his impressions into ideas, and so of converting himself from mere psyche into consciousness. The coming to know his emotions is the coming to dominate them, to assert himself as their master. He has not yet, it is true, entered upon the life of morality; but he has taken an indispensable step forward towards it. He has learnt to acquire by his own efforts a new set of mental endowments. That is an accomplishment which must be learnt first, if later he is to acquire by his own effort mental endowments whose possession will bring him nearer to his moral ideal.

Moreover, his knowing of this new world is also the making of the new world which he is coming to know. The world he has come to know is a world consisting of language; a world where everything has the property of expressing emotion. In so far as this world is thus expressive or significant, it is he that has made it so. He has not, of course, made it 'out of nothing'. He is not God, but a finite mind still at a very elementary stage in the development of its powers. He has made it 'out of' what is presented to him in the still more elementary stage of purely psychical experience:

colours, sounds, and so forth. I know that many readers, in loyalty to certain brands of metaphysic now popular, will wish to deny this. It might seem advisable for me to consider their denials, which are very familiar, and refute them, which would be very easy. But I will not do this. I am writing not to make converts, but to say what I think. If any reader thinks he knows better, I would rather he went on working out his own lines of thought than tried to adopt mine.

To return. The aesthetic experience, as we look back at it from a point of view where we distinguish theoretical from practical activity, thus presents characteristics of both kinds. It is a knowing of oneself and of one's world, these two knowns and knowings being not yet distinguished, so that the self is expressed in the world, the world consisting of language whose meaning is that emotional experience which constitutes the self, and the self consisting of emotions which are known only as expressed in the language which is the world. It is also a making of oneself and of one's world, the self which was psyche being remade in the shape of consciousness, and the world, which was crude sensa, being remade in the shape of language, or sensa converted into imagery and charged with emotional significance. The step forward in the development of experience which leads from the psychic level to the level of consciousness (and that step is the specific achievement of art) is thus a step forward both in theory and in practice, although it is one step only and not two; as a progress along a railway-line towards a certain junction is a progress towards both the regions served by the two lines which divide at that junction. For that matter, it is also a progress towards the region in which, later, those two lines reunite.

§ 3. *Art and Intellect*

Art as such contains nothing that is due to intellect. Its essence is that of an activity by which we become conscious of our own emotions. Now, there are emotions which exist

in us, but of which we are not yet conscious, at the level of psychical experience. Therefore art finds in purely psychical experience a situation of the type with which it essentially deals, and a problem of the kind which its essential business is to solve.

This might seem to be not only a problem such as art exists to solve, but the only problem which it can solve. It might seem, in other words, that psychical emotions are the only emotions which art can express. For all other emotions are generated at levels of experience subsequent to the emergence of consciousness, and therefore (it might be thought) under the eyes of consciousness. They are born, it might seem, in the light of consciousness, with expressions ready-made for them at birth. There can, therefore, be no need to express them through works of art.

The logical consequence of this argument would be that no work of art, if it is a genuine work of art, can contain in its subject-matter anything that is due to the work of intellect. This is not what I said in the first sentence of this section. Art as such might contain nothing that is due to intellect, and yet certain works of art might contain much that is due to intellect, not because they are works of art, but because they are works of a certain kind; that is, because they express emotions of a certain kind, namely, emotions that can arise only as the emotional charges upon intellectual activities.

Here, then, we have two alternatives. Either the subject-matter of a work of art (that is, the emotion it expresses) is drawn exclusively from the psychical level of experience, because that is the only level at which there exists any experience of which we are not conscious; or it may also include elements drawn from other levels, in which case these levels, too, will contain elements of which, until we find expression for them, we are not conscious.

If these two alternatives are considered in the light of the question: what emotions do this and that work of art actually express? it will hardly be doubted, I think, that the second alternative is right. If we examine almost any work of art

we like to choose, and consider what emotions it expresses, we shall find that they include some, and those not the least important, which are intellectual emotions: emotions which can only be felt by an intellectual being, and are in fact felt because such a being uses his intellect in certain ways. They are the emotional charges not upon a merely psychical experience, nor upon experience at the level of mere consciousness, but upon intellectual experience or thought in the narrower sense of the word.

And this, if we come to think of it, is inevitable. For even if a certain emotion is, as I put it, endowed at birth with its own proper expression, this is only a way of saying that the work of expression has already been done in its case; and if done, done by the artistic consciousness. And every emotion is, if not born with the silver spoon of expression in its mouth, at least reborn in that state on the occasion of its second birth as idea, as distinct from impression. Since the emotional life of the conscious and intellectual levels of experience is far richer than that of the merely psychical level, therefore (Chapter XI, § 3), it is only natural that the emotional subject-matter of works of art should be drawn mostly from emotions belonging to these higher levels.

For example, Romeo and Juliet form the subject of a play not because they are two organisms sexually attracted, however powerfully, to each other; nor because they are two human beings experiencing this attraction and conscious of the experience, that is, two human beings in love; but because their love is woven into the fabric of a complicated social and political situation, and is broken by the strains to which that situation subjects it. The emotion experienced by Shakespeare and expressed by him in the play is not an emotion arising simply out of sexual passion or his sympathy with it, but an emotion arising out of his (intellectual) apprehension of the way in which passion may thus cut across social and political conditions. Similarly, Lear is envisaged, by Shakespeare and by ourselves, not simply as an old man suffering cold and hunger,

but as a father suffering these things at the hands of his daughters. Apart from the idea of the family, intellectually conceived as a principle of social morality, the tragedy of Lear would not exist. The emotions expressed in these plays are thus emotions arising out of a situation which could not generate them unless it were intellectually apprehended.

The poet converts human experience into poetry not by first expurgating it, cutting out the intellectual elements and preserving the emotional, and then expressing this residue; but by fusing thought itself into emotion: thinking in a certain way and then expressing how it feels to think in that way. Thus Dante has fused the Thomistic philosophy into a poem expressing what it feels like to be a Thomist.[1] Shelley, when he made the earth say, 'I spin beneath my pyramid of night', expressed what it feels like to be a Copernican. Donne (and this is why he has become so congenial to ourselves in the last twenty or thirty years) has expressed how it feels to live in a world full of shattered ideas, *disjecta membra* of old systems of life and thought, where intellectual activity is itself correspondingly shattered into momentary fulgurations of thinking, related to each other only by an absence of all logical connexion, and where the prevailing emotional tone of thought is simply the sense of this shatteredness: a tone expressed over and over again in his poems, for example in 'The Glasse', and in the shape of a moral idea by his many verses in praise of inconstancy. And Mr. Eliot, in the one great English poem of this century, has expressed his idea (not his alone) of the decay of our civilization, manifested outwardly as a break-down of social structures and inwardly as a drying-up of the emotional springs of life.

I am not saying that every poet has a philosophical system, and that his poetry expounds it. But my reason for refusing to say this is not so much because it would be untrue as because it would be misleading. What most people think of as a philosophical system is a collection of doctrines deliberately invented by an individual philosopher in the

[1] Or however else one labels his (not wholly Thomistic) philosophy.

attempt to reduce the whole of his experience to private
formulae. I do not believe that such things exist. What I
find in the writings of any one philosopher is nothing like
that; it is more like a series of attempts to think, more clearly
and consistently than his contemporaries, in ways more or
less common to them all.

The poets share these ways of thinking, and express them
in their poetry. How then does this poetic expression of
them differ from their philosophical expression? The
difference does not consist in the fact, if it is a fact, that the
poet writes or speaks in verse and the philosopher in prose.
Philosophers have written in verse, and have not on that
account been poets; imaginative artists have written in prose,
and have been poets none the less. It does not consist in a
supposed distinction between the 'emotive use of language'
and the 'scientific'. We saw in an earlier chapter that any
such distinction is chimerical. It does not consist in a
distinction between language expressing emotion and lan-
guage expressing thought, for all language expresses emotion.
It does not consist in a distinction between language in its
original form, as expressing the emotions of consciousness,
and intellectualized language, as expressing intellectual
emotions; for, as we have just seen, the poet is under no
embargo on the expression of intellectual emotions; on the
contrary, these are what he normally expresses.

We shall come no nearer to a satisfactory distinction if
we think of the poet as merely imagining himself to conceive
ideas which if he were a philosopher he would be either
holding or rejecting in earnest. No doubt, there have been
people called artists who have thus dramatized themselves
into a kind of make-believe philosopher, posing to them-
selves as holding views which in fact they have not under-
stood. But these have not been artists proper. They belong
not to the aesthetic world of imaginative experience, but to
the pseudo-aesthetic world of make-believe. Dante was
perfectly in earnest with his Thomism, and Shelley with his
Copernicanism. And it is part of a philosopher's business to

take up and think out hypothetically, accepting them provisionally 'for the sake of argument', that is, in order to find out what they involve, views which he need not either accept or reject.

A more promising method of differentiating would be to distinguish exposition from argument, as a static from a dynamic aspect of thought. The business of St. Thomas himself is not to expound Thomism, but to arrive at it: to build up arguments whose purpose is to criticize other philosophical views and by criticizing them to lead himself and his readers towards what he hopes will be a satisfactory one. Ever since Pythagoras (or so we are told) invented the word philosophy, in order to express the notion of the philosopher not as one who possesses wisdom but as one who aspires to it, students of philosophy have recognized that the essence of their business lies not in holding this view or that, but in aiming at some view not yet achieved: in the labour and adventure of thinking, not in the results of it. What a genuine philosopher (as distinct from a teacher of philosophy for purposes of examination) tries to express when he writes is the experience he enjoys in the course of this adventure, where theories and systems are only incidents in the journey. For the poet, there is, perhaps, none of this dynamism of thinking. He finds himself equipped, as it were, with certain ideas, and expresses the way in which it feels to possess them. Poetry, then, in so far as it is the poetry of a thinking man and addressed to a thinking audience, may be described as expressing the intellectual emotion attendant upon thinking in a certain way: philosophy, the intellectual emotion attendant upon trying to think better.

I do not know how else to distinguish the two, as species of literary composition, except either by substituting pseudo-philosophy for philosophy (or pseudo-poetry for poetry, or both), or by using distinctions which I know to be false. But the distinction I have stated is, I would insist, arbitrary and precarious. I see no reason why the intellectual experience of building up or criticizing a philosophical view should not

afford the poet a subject-matter no less fertile than that of merely holding it. And I am sure that a philosopher who expressed the experience of developing a view, without making it clear to himself and his readers what view he was developing, would be doing only half his work. The result would seem to be that the distinction between philosophical writing (and what I say applies equally to historical and scientific writing) and poetical or artistic writing is either wholly illusory, or else it applies only to a distinction between bad philosophical writing and good poetic, or bad poetic and good philosophical, or bad philosophical and bad poetic. Good philosophy and good poetry are not two different kinds of writing, but one; each is simply good writing. In so far as each is good, each converges, as regards style and literary form, with the other; and in the limiting case where each was as good as it ought to be, the distinction would disappear.

This seems paradoxical only because we inherit a vicious late nineteenth-century tradition according to which the artist conceives himself as aloof from the general interests and activities of his time, a member of a coterie whose only concern is art for art's sake. To writers suffering from that delusion (which, as I showed in a previous chapter, arose from the conception of art as amusement) there seems to be an artistic way of writing, quite distinct from the inartistic way adopted by scientists and philosophers and others outside the coterie. But when once it is realized that art and language are the same thing, this distinction vanishes. There can be no such thing as inartistic writing, unless that means merely bad writing. And there can be no such thing as artistic writing; there is only writing.

To put this in terms of practice: we have got into the habit of thinking that a writer must belong to one of two classes. Either he is a 'pure' writer, concerned to write as well as he can, in which case he is a literary man; or he is an 'applied' writer (to adapt the old distinction between pure and applied science), concerned to express certain definite thoughts, and anxious to write only well enough to make his

thoughts clear, and no better. This distinction must go. Each of these ideals, if there is to be any future for literature, must fertilize the other. The scientist and historian and philosopher must go to school with the man of letters, and study to write as well as writing can be done. The literary man must go to school with the scientist and his likes, and study to expound a subject instead of merely exhibiting a style. Subject without style is barbarism; style without subject is dilettantism. Art is the two together.

THE ARTIST AND THE COMMUNITY

§ 1. *Externalization*

THE work of art, as we have seen, is not a bodily or percep-
tible thing, but an activity of the artist; and not an activity of
his 'body' or sensuous nature, but an activity of his conscious-
ness. A problem arises out of this statement, concerning the
artist's relation to his audience.

It seems to be a normal part of the artist's work that he
should communicate his experience to other people. In order
to do that, he must have means of communication with them;
and these means are something bodily and perceptible, a
painted canvass, a carved stone, a written paper, and so forth.

On the technical theory of art, all this is quite simple. The
artist is an artist in so far as he succeeds in affecting his
audience in certain ways. The painted canvass or the like
is the means which he adopts to this end. The painted
canvass is in fact the work of art: the work of art is a bodily
and perceptible thing, and earns the title of work of art by
producing in the audience the desired result. The artist's
relation to his audience is thus essential to his being an artist.

On the theory of art propounded in this book, this relation
to the audience seems at first sight to become inessential.
It seems to disappear altogether from the province of art as
such. If it still exists, it is due not to aesthetic considerations,
but to considerations of another kind. For art, on this theory,
is the expression of emotion, or language. Now language as
such is not necessarily addressed to any one. The artist as
such, therefore, is a person who talks or expresses himself,
and his expression in no way depends upon or demands the
co-operation of an audience. The audience would seem to
consist at best of persons whom the artist permits to overhear
him as he speaks. Whether anybody so overhears him or not
makes no difference to the fact that he has expressed his

emotions and has therefore completed the work in virtue of which he is an artist.

In order to round off this view, we must next ask: then why does the artist take pains (as he admittedly does in normal cases) to bring himself into relation with an audience? His motives are, *ex hypothesi*, non-aesthetic: he does not do it because otherwise his own aesthetic experience is incomplete; but they need not always be of one and the same kind. In some cases he does it because, as a moral being, he desires that other people should share an experience which he finds so valuable; in some, because he must make a living. That is to say, in relation to his audience he is either a missionary or a salesman of the aesthetic experience.

This view seems at first sight, as I say, to be implied in the theory of art as expression. Actually, it is inconsistent with that theory: it is a relic of the technical theory. For what the artist gives as missionary or sells as tradesman is not an aesthetic experience, but certain bodily and perceptible things: painted canvasses, carved stones, and the like; and these things are given and taken, it is assumed, because they have the power of evoking certain aesthetic experiences in a person who contemplates them. It is further assumed that the receiver cannot enjoy these experiences otherwise. They are, that is to say, means, and indispensable means, to his enjoyment of these experiences: and this is the technical theory of art.

We are, in fact, assuming two different theories of aesthetic experience, one for the artist, another for the audience. The aesthetic experience in itself, we are assuming, is in both cases a purely inward experience, taking place wholly in the mind of the person who enjoys it. But this inward experience is supposed to stand in a double relation to something outward or bodily. (*a*) For the artist, the inward experience may be externalized or converted into a perceptible object; though there is no intrinsic reason why it should be. (*b*) For the audience, there is a converse process: the outward experience comes first, and this is converted into that inward experience

which alone is aesthetic. But if the relation between inward
and outward is casual and fortuitous in (*a*), how can it be
indispensable in (*b*)? If the bodily and perceptible 'work of
art' is unnecessary to aesthetic experience in the case of the
artist, why should it be necessary to it in the case of the
audience? If it can be in no way helpful to the one, how can
it be in any way helpful to the other? Most serious of all, if
aesthetic experience in the artist is something wholly inde-
pendent of such outward things, but in the audience is some-
thing dependent upon them and derived from contemplation
of them, how is it an experience of the same kind in the two
cases, and how is there any communication?

The view of the artist's relation to his audience which I
have put forward in this section combines a technical theory of
art, where the audience is concerned, with a non-technical or
expressive theory for the case of the artist, and is therefore
inconsistent with itself. But the error lies deeper than this.
If the implications of the expressive theory had been com-
pletely grasped in the case of the artist, there would have
been no need to fall back upon the technical theory in dis-
cussing his relation with his audience. Our first problem,
therefore, concerns the artist. We must ask: what is the
relation between the artist's aesthetic experience and the
painted canvasses, carved stones, and so forth, in which,
according to the view I have stated and criticized, he
'externalizes' it?

§ 2. *Painting and Seeing*

An artist who sits down in front of a subject and begins to
paint it is generally, like any one doing anything, acting
from very mixed motives. If he cannot give a short and
simple answer to the question, 'Why are you painting that
subject?' it is not because he is an unphilosophical person,
unaccustomed to analysing his own actions. It is because
there is no short and simple answer to give. In order to
get the question answered, we must define it much more
closely.

We are not asking what led him to become, or leads him to remain, a painter; we assume that he is one. We are not asking why he chose that subject; we assume the subject chosen. We are not asking him what he means to do with the sketch when he has painted it; we assume that he cannot decide until it is finished. We are not asking him whether he gets an aesthetic experience from looking at his subject; we assume that he would not be painting it unless he did. What we are asking him about is the nature of the connexion that exists between the fact of his getting an aesthetic experience from looking at the subject and the fact of his painting it. Our question, then, comes to this: 'Are you painting that subject in order to enable other people (including yourself on a future occasion) to enjoy an aesthetic experience which, independently of painting it, you get completely from just looking at the subject itself; or are you painting it because the experience itself only develops and defines itself in your mind as you paint?'

Any artist who understood the terms of our question would answer promptly and decidedly, 'The second, of course'. He would probably continue, if he felt disposed to talk, by saying: 'One paints a thing in order to see it. People who don't paint, naturally, won't believe that; it would be too humiliating to themselves. They like to fancy that everybody, or at least everybody of refinement and taste like themselves, sees just as much as an artist sees, and that the artist only differs in having the technical accomplishment of painting what he sees. But that is nonsense. You see something in your subject, of course, before you begin to paint it (though how much, even of that, you would see if you weren't already a painter is a difficult question); and that, no doubt, is what induces you to begin painting; but only a person with experience of painting, and of painting well, can realize how little that is, compared with what you come to see in it as your painting progresses. If you paint badly, of course, that doesn't happen. Your own daub comes between you and the subject, and you can only see the mess you are making. But

a good painter—any good painter will tell you the same—
paints things because until he has painted them he doesn't
know what they are like.'

Before we dismiss these observations as mere professional
conceit, we must bear in mind that when the painter talks of
seeing he is not referring to mere visual sensation. He does
not think that one's eyes become sharper through the exercise
of painting. Seeing, in his vocabulary, refers not to sensation
but to awareness. It means noticing what you see. And
further: this act of awareness, as he is talking about it, in-
cludes the noticing of much that is not visual. It includes an
awareness of 'tactile values' or the solid shapes of things,
their relative distances, and other spatial facts which could be
sensuously apprehended only through muscular motion. It
includes, too, an awareness of things like warmth and cool-
ness, stillness and noise. In other words, it is a comprehensive
awareness of the kind which I described in Chapter VII,
§ 6, as a total imaginative experience.

What our painter is saying, then, comes to this. The
painted picture is not produced by a further activity upon
which he embarks, when his aesthetic activity has already
arrived at completion, in order to achieve by its means a non-
aesthetic end. Nor is it produced by an activity anterior to
the aesthetic, as means towards the achievement of aesthetic
experience. It is produced by an activity which is somehow
or other bound up with the development of that experience
itself. The two activities are not identical; he distinguishes
them by the names of 'painting' and 'seeing' respectively;
but they are connected in such a way that, he assures us, each
is conditional upon the other. Only a person who paints well
can see well; and conversely (as he would tell us with equal
confidence if we asked him) only a person who sees well can
paint well. There is no question of 'externalizing' an inward
experience which is complete in itself and by itself. There
are two experiences, an inward or imaginative one called
seeing and an outward or bodily one called painting, which
in the painter's life are inseparable, and form one single

indivisible experience, an experience which may be described as painting imaginatively.

§ 3. *The Bodily 'Work of Art'*

In the preceding section we have only considered the testimony of a painter, who (I need hardly say) is not an imaginary character, concerning the relation between the inward aesthetic experience and the outward activity of painting. We have now to consider the relation which that testimony bears to the general theory of art maintained in this book.

In Chapter VII it was said that a work of art in the proper sense of that phrase is not an artifact, not a bodily or perceptible thing fabricated by the artist, but something existing solely in the artist's head, a creature of his imagination; and not only a visual or auditory imagination, but a total imaginative experience. It follows that the painted picture is not the work of art in the proper sense of that phrase. No reader, I hope, has been inattentive enough to imagine that in the preceding section this doctrine has been forgotten or denied. What has been asserted is not that the painting is a work of art, which would be as much as to say that the artist's aesthetic activity is identical with painting it; but that its production is somehow necessarily connected with the aesthetic activity, that is, with the creation of the imaginative experience which is the work of art. What we are now asking is whether, on our theory, there must indeed be such a connexion.

The question can only be answered in the light of a general theory of imagination and language. It was maintained in Book II that a distinction exists between various 'levels' of experience, two of which were respectively called the psychical level and the conscious level. Each level, it was said, presupposes the one below it, not in the sense that the lower is left behind when the higher is reached, but in the sense that the lower is related to the higher somewhat as a raw material is related to something made out of it by

imposing upon it a new form. The higher thus contains the lower within itself as its own matter, the special principles of the higher being, as it were, a form according to which this matter is now organized. By this reorganization the lower is modified in certain ways. For example, the transition from the psychical level to the conscious level entails the conversion of impressions, which are the elements of which psychical experience consists, into ideas, or (which is the same thing) of sensuous experience into imaginative experience. What converts impressions into ideas, or sensation into imagination, is the activity of awareness or consciousness.[1]

If this is so, there can be no ideas without impressions; for every idea is an impression which the work of consciousness converts into an idea. The impression from which a given idea is, as Hume puts it, 'derived', is not a past impression degraded by mere passage of time into an idea; it is a present impression elevated into an idea by the work of consciousness. Wherever there is an idea, or imaginative experience, there are also the following elements: (1) an impression, or sensuous experience, corresponding with it; (2) an act of consciousness converting that impression into an idea. When the impression is said to correspond with the idea, what is meant is that it is the impression which an act of consciousness would convert into that idea and no other.

We get, therefore, this result. Every imaginative experience is a sensuous experience raised to the imaginative level by an act of consciousness; or, every imaginative experience is a sensuous experience together with consciousness of the same. Now the aesthetic experience is an imaginative experience. It is wholly and entirely imaginative; it contains no elements that are not imaginative, and the only power which can generate it is the power of the experient's consciousness. But it is not generated out of nothing. Being an imaginative experience, it presupposes a corresponding sensuous experience; where to say that it presupposes this does not mean that it arises subsequently to this, but that it is generated by the

[1] For all this, see Chapter X, especially §§ 5, 6.

act which converts this into it. The sensuous experience need not exist by itself first. It may come into being under the very eyes, so to speak, of consciousness, so that it no sooner comes into being than it is transmuted into imagination. Nevertheless, there is always a distinction between what transmutes (consciousness), what is transmuted (sensation), and what it is transmuted into (imagination).

The transmuted or sensuous element in the aesthetic experience is the so-called outward element: in the case under examination, the artist's psycho-physical activity of painting; his visual sensation of the colours and shapes of his subject, his felt gestures as he manipulates his brush, the seen shapes of paint patches that these gestures leave on his canvass: in short, the total sensuous (or rather, sensuous-emotional) experience of a man at work before his easel. Unless this sensuous experience were actually present, there would be nothing out of which consciousness could generate the aesthetic experience which is 'externalized' or 'recorded' or 'expressed' by the painted picture. But this sensuous experience, although it is actually present, is never present by itself. Every element in it comes into existence under the eyes of the painter's consciousness; or rather, this happens in so far as he is a good painter; it is only bad painters who paint without knowing what they are doing; and every element in it is therefore converted into imaginative experience at birth. Nevertheless, reflection distinguishes between the imaginative experience and the sensuous experience out of which it is thus made, and discovers that 'nihil est in imaginatione quod non fuerit in sensu'.

What of the case where a man looks at the subject without painting? He, too, has an aesthetic experience in so far as his impressions are transmuted into ideas by the activity of his imagination. But our artist was right to claim that there is far less in that experience than in the experience of a man who has painted the subject; for the sensuous elements involved in merely looking, even where looking is accompanied by a smile of pleasure, gestures, and so forth, are

necessarily much scantier and poorer, and also much less highly organized in their totality, than the sensuous elements involved in painting. If you want to get more out of an experience, you must put more into it. The painter puts a great deal more into his experience of the subject than a man who merely looks at it; he puts into it, in addition, the whole consciously performed activity of painting it; what he gets out of it, therefore, is proportionately more. And this increment is an essential part of what he 'externalizes' or 'records' in his picture: he records there not the experience of looking at the subject without painting it, but the far richer and in some ways very different experience of looking at it and painting it together.

§ 4. *The Audience as Understander*

What is meant by saying that the painter 'records' in his picture the experience which he had in painting it? With this question we come to the subject of the audience, for the audience consists of anybody and everybody to whom such records are significant.

It means that the picture, when seen by some one else or by the painter himself subsequently, produces in him (we need not ask how) sensuous-emotional or psychical experiences which, when raised from impressions to ideas by the activity of the spectator's consciousness, are transmuted into a total imaginative experience identical with that of the painter. This experience of the spectator's does not repeat the comparatively poor experience of a person who merely looks at the subject; it repeats the richer and more highly organized experience of a person who has not only looked at it but has painted it as well.

That is why, as so many people have observed, we 'see more in' a really good picture of a given subject than we do in the subject itself. That is why, too, many people prefer what is called 'nature' or 'real life' to the finest pictures, because they prefer not to be shown so much, in order to keep their apprehensions at a lower and more manageable

level, where they can embroider what they see with likes and dislikes, fancies and emotions of their own, not intrinsically connected with the subject. A great portrait painter, in the time it takes him to paint a sitter, intensely active in absorbing impressions and converting them into an imaginative vision of the man, may easily see through the mask that is good enough to deceive a less active and less pertinacious observer, and detect in a mouth or an eye or the turn of a head things that have long been concealed. There is nothing mysterious about this insight. Every one judges men by the impressions he gets of them and his power of becoming aware of these impressions; and the artist is a man whose life's work consists in doing that. The wonder is rather that so few artists do it revealingly. That is perhaps because people do not want it done, and artists fall in with their desire for what is called a good likeness, a picture that reveals nothing new, but only recalls what they have already felt in the sitter's presence.

How is any one to know that the imaginative experience which the spectator, by the work of his consciousness, makes out of the sensations he receives from a painting 'repeats', or is 'identical' with, the experience which the artist had in painting it? That question has already been raised about language in general (Ch. XI, § 5) and answered by saying that there is no possibility of an absolute assurance; the only assurance we can have 'is an empirical and relative assurance, becoming progressively stronger as conversation proceeds, and based on the fact that neither party seems to the other to be talking nonsense'. The same answer holds good here. We can never absolutely know that the imaginative experience we obtain from a work of art is identical with that of the artist. In proportion as the artist is a great one, we can be pretty certain that we have only caught his meaning partially and imperfectly. But the same applies to any case in which we hear what a man says or read what he writes. And a partial and imperfect understanding is not the same thing as a complete failure to understand.

For example, a man reading the first canto of the *Inferno* may have no idea what Dante meant by the three beasts. Are they deadly sins, or are they potentates, or what are they? he may ask. In that perplexity, however, he has not completely lost contact with his author. There is still a great deal in the canto which he can understand, that is to say, transmute from impression into idea by the work of his consciousness; and all this, he can be fairly confident, he grasps as Dante meant it. And even the three beasts, though he does not understand them completely (something remains obstinately a mere untransmuted impression) he understands in part; he sees that they are something the poet dreads, and he imaginatively experiences the dread, though he does not know what it is that is dreaded.

Or take (since Dante may be ruled out as allegorical and therefore unfair) an example from modern poetry. I do not know how many readers of Mr. Eliot's poem *Sweeney among the Nightingales* have the least idea what precisely the situation is which the poet is depicting. I have never heard or read any expression of such an idea. Sweeney has dropped asleep in a restaurant, vaguely puzzled by the fact that the Convent of the Sacred Heart, next door, has reminded him of something, he cannot tell what. A wounded Heart, and waiting husbandless women. As he snores all through the second verse a prostitute in a long cloak comes and sits on his knees, and at that moment he dreams the answer. It is Agamemnon's cry—'O, I am wounded mortally to the heart'—wounded to death at his homecoming by the false wife he had left behind. He wakes, stretching and laughing (tilting the girl off his knee), as he realizes that in the queer working of his mind the hooded husbandless nuns and the cloaked husbandless girl, waiting there like a spider for her prey, are both Klytaemnestra, the faithless wife who threw her cloak (the 'net of death') round her lord and stabbed him.

I quote this case because I had known and enjoyed the poem for years before I saw that this was what it was all

about; and nevertheless I understood enough to value it highly. And I am willing to believe that the distinguished critic who thinks that the 'liquid siftings' of the nightingales were not their excrement, but their songs, values it highly too, and not everywhere so unintelligently as that sample would suggest.[1]

The imaginative experience contained in a work of art is not a closed whole. There is no sense in putting the dilemma that a man either understands it (that is, has made that entire experience his own) or does not. Understanding it is always a complex business, consisting of many phases, each complete in itself but each leading on to the next. A determined and intelligent audience will penetrate into this complex far enough, if the work of art is a good one, to get something of value; but it need not on that account think it has extracted 'the' meaning of the work, for there is no such thing. The doctrine of a plurality of meanings, expounded for the case of holy scripture by St. Thomas Aquinas, is in principle perfectly sound: as he states it, the only trouble is that it does not go far enough. In some shape or other, it is true of all language.

§ 5. *The Audience as Collaborator*

The audience as understander, attempting an exact reconstruction in its own mind of the artist's imaginative experience, is engaged on an endless quest. It can carry out this reconstruction only in part. This looks as if the artist were a kind of transcendent genius whose meaning is always too profound for his audience of humbler mortals to grasp in a more than fragmentary way. And an artist inclined to give himself airs will no doubt interpret the situation like that. But another interpretation is possible. The artist may take his audience's limitations into account when composing his work; in which case they will appear to him not as limitations

[1] And it was not until a few days after I had written the above, that I recognized 'gloomy Orion' as a borrowing from Marlowe's *Dido*—another tragedy about a husbandless woman.

on the extent to which his work will prove comprehensible, but as conditions determining the subject-matter or meaning of the work itself. In so far as the artist feels himself at one with his audience, this will involve no condescension on his part; it will mean that he takes it as his business to express not his own private emotions, irrespectively of whether any one else feels them or not, but the emotions he shares with his audience. Instead of conceiving himself as a mystagogue, leading his audience as far as it can follow along the dark and difficult paths of his own mind, he will conceive himself as his audience's spokesman, saying for it the things it wants to say but cannot say unaided. Instead of setting up for the great man who (as Hegel said) imposes upon the world the task of understanding him, he will be a humbler person, imposing upon himself the task of understanding his world, and thus enabling it to understand itself.

In this case his relation to his audience will no longer be a mere by-product of his aesthetic experience, as it still was in the situation described in the preceding section; it will be an integral part of that experience itself. If what he is trying to do is to express emotions that are not his own merely, but his audience's as well, his success in doing this will be tested by his audience's reception of what he has to say. What he says will be something that his audience says through his mouth; and his satisfaction in having expressed what he feels will be at the same time, in so far as he communicates this expression to them, their satisfaction in having expressed what they feel. There will thus be something more than mere communication from artist to audience, there will be collaboration between audience and artist.

We have inherited a long tradition, beginning in the late eighteenth century with the cult of 'genius', and lasting all through the nineteenth, which is inimical to this second alternative. But I have already said that this tradition is dying away. Artists are less inclined to give themselves airs than they used to be; and there are many indications that they are more willing than they were, even a generation ago,

to regard their audiences as collaborators. It is perhaps no longer foolish to hope that this way of conceiving the relation between artist and audience may be worth discussing.

There are grounds for thinking that this idea of the relation is the right one. As in § 2, we must look at the facts; and we shall find that, whatever airs they may give themselves, artists have always been in the habit of treating the public as collaborators. On a technical theory of art, this is, in a sense, comprehensible. If the artist is trying to arouse certain emotions in his audience, a refusal on the part of the audience to develop these emotions proves that the artist has failed. But this is one of the many points in which the technical theory does not so much miss the truth as misrepresent it. An artist need not be a slave to the technical theory, in order to feel that his audience's approbation is relevant to the question whether he has done his work well or ill. There have been painters who would not exhibit, poets who would not publish, musicians who would not have their works performed; but those who have made this great refusal, so far as one knows them, have not been of the highest quality. There has been a lack of genuineness about their work, corresponding to this strain of secretiveness in their character, which is inconsistent with good art. The man who feels that he has something to say is not only willing to say it in public: he craves to say it in public, and feels that until it has been thus said it has not been said at all. The public is always, no doubt, a circumscribed one: it may consist only of a few friends, and at most it includes only people who can buy or borrow a book or get hold of a theatre ticket; but every artist knows that publication of some kind is a necessity to him.

Every artist knows, too, that the reception he gets from his public is not a matter of indifference to him. He may train himself to take rebuffs with a stiff lip, and go on working in spite of bad sales and hostile reviews. He must so train himself, if he is to do his best work; because with the best will in the world (quite apart from venality in reviewers and

frivolity in readers) no one enjoys having his unconscious emotions dragged into the light of consciousness, and consequently there is often a strongly painful element in a genuine aesthetic experience, and a strong temptation to reject it. But the reason why the artist finds it so hard to train himself in this way is because these rebuffs wound him not in his personal vanity, but in his judgement as to the soundness of the work he has done.

Here we come to the point. One might suppose that the artist by himself is in his own eyes a sufficient judge of his work's value. If he is satisfied with it, why should he mind what others think? But things do not work like that. The artist, like any one else who comes before an audience, must put a bold face on it; he must do the best he can, and pretend that he knows it is good. But probably no artist has ever been so conceited as to be wholly taken in by his own pretence. Unless he sees his own proclamation, 'This is good', echoed on the faces of his audience—'Yes, that is good'—he wonders whether he was speaking the truth or not. He thought he had enjoyed and recorded a genuine aesthetic experience, but has he? Was he suffering from a corruption of consciousness? Has his audience judged him better than he judged himself?

These are facts which no artist, I think, will deny, unless in that feverish way in which we all deny what we know to be true and will not accept. If they are facts, they prove that, in spite of all disclaimers, artists do look upon their audiences as collaborators with themselves in the attempt to answer the question: is this a genuine work of art or not? But this is the thin end of a wedge. Once the audience's collaboration is admitted thus far, it must be admitted farther.

The artist's business is to express emotions; and the only emotions he can express are those which he feels, namely, his own. No one can judge whether he has expressed them except some one who feels them. If they are his own and no one else's, there is no one except himself who can judge whether he has expressed them or not. If he attaches any

importance to the judgement of his audience, it can only be because he thinks that the emotions he has tried to express are emotions not peculiar to himself, but shared by his audience, and that the expression of them he has achieved (if indeed he has achieved it) is as valid for the audience as it is for himself. In other words, he undertakes his artistic labour not as a personal effort on his own private behalf, but as a public labour on behalf of the community to which he belongs. Whatever statement of emotion he utters is prefaced by the implicit rubric, not 'I feel', but 'we feel'. And it is not strictly even a labour undertaken by himself on behalf of the community. It is a labour in which he invites the community to participate; for their function as audience is not passively to accept his work, but to do it over again for themselves. If he invites them to do this, it is because he has reason to think they will accept his invitation, that is, because he thinks he is inviting them to do what they already want to do.

In so far as the artist feels all this (and an artist who did not feel it would not feel the craving to publish his work, or take seriously the public's opinion of it), he feels it not only after his work is completed, but from its inception and throughout its composition. The audience is perpetually present to him as a factor in his artistic labour; not as an anti-aesthetic factor, corrupting the sincerity of his work by considerations of reputation and reward, but as an aesthetic factor, defining what the problem is which as an artist he is trying to solve—what emotions he is to express—and what constitutes a solution of it. The audience which the artist thus feels as collaborating with himself may be a large one or a small one, but it is never absent.

§ 6. *Aesthetic Individualism*

The understanding of the audience's function as collaborator is a matter of importance for the future both of aesthetic theory and of art itself. The obstacle to understanding it is a traditional individualistic psychology through which, as through distorting glasses, we are in the habit of looking

at artistic work. We think of the artist as a self-contained personality, sole author of everything he does: of the emotions he expresses as his personal emotions, and of his expression of them as his personal expression. We even forget what it is that he thus expresses, and speak of his work as 'self-expression', persuading ourselves that what makes a poem great is the fact that it 'expresses a great personality', whereas, if self-expression is the order of the day, whatever value we set on such a poem is due to its expressing not the poet—what is Shakespeare to us, or we to Shakespeare?—but ourselves.

It would be tedious to enumerate the tangles of misunderstanding which this nonsense about self-expression has generated. To take one such only: it has set us off looking for 'the man Shakespeare' in his poems, and trying to reconstruct his life and opinions from them, as if that were possible, or as if, were it possible, it would help us to appreciate his work. It has degraded criticism to the level of personal gossip, and confused art with exhibitionism. What I prefer to attempt is not a tale of misdeeds, but a refutation.

In principle, this refutation is simple. Individualism conceives a man as if he were God, a self-contained and self-sufficient creative power whose only task is to be himself and to exhibit his nature in whatever works are appropriate to it. But a man, in his art as in everything else, is a finite being. Everything that he does is done in relation to others like himself. As artist, he is a speaker; but a man speaks as he has been taught; he speaks the tongue in which he was born. The musician did not invent his scale or his instruments; even if he invents a new scale or a new instrument he is only modifying what he has learnt from others. The painter did not invent the idea of painting pictures or the pigments and brushes with which he paints them. Even the most precocious poet hears and reads poetry before he writes it. Moreover, just as every artist stands in relation to other artists from whom he has acquired his art, so he stands in

relation to some audience to whom he addresses it. The child learning his mother tongue, as we have seen, learns simultaneously to be a speaker and to be a listener; he listens to others speaking, and speaks to others listening. It is the same with artists. They become poets or painters or musicians not by some process of development from within, as they grow beards; but by living in a society where these languages are current. Like other speakers, they speak to those who understand.

The aesthetic activity is the activity of speaking. Speech is speech only so far as it is both spoken and heard. A man may, no doubt, speak to himself and be his own hearer; but what he says to himself is in principle capable of being said to any one sharing his language. As a finite being, man becomes aware of himself as a person only so far as he finds himself standing in relation to others of whom he simultaneously becomes aware as persons. And there is no point in his life at which a man has finished becoming aware of himself as a person. That awareness is constantly being reinforced, developed, applied in new ways. On every such occasion the old appeal must be made: he must find others whom he can recognize as persons in this new fashion, or he cannot as a finite being assure himself that this new phase of personality is genuinely in his possession. If he has a new thought, he must explain it to others, in order that, finding them able to understand it, he may be sure it is a good one. If he has a new emotion, he must express it to others, in order that, finding them able to share it, he may be sure his consciousness of it is not corrupt.

This is not inconsistent with the doctrine, stated elsewhere in this book, that the aesthetic experience or aesthetic activity is one which goes on in the artist's mind. The experience of being listened to is an experience which goes on in the mind of the speaker, although in order to its existence a listener is necessary, so that the activity is a collaboration. Mutual love is a collaborative activity; but the experience of this activity in the mind of each lover taken

singly is a different experience from that of loving and being spurned.

A final refutation of aesthetic individualism will, therefore, turn on analysis of the relation between the artist and his audience, developing the view stated in the last section that this is a case of collaboration. But I propose to lead up to this by way of two other arguments. I shall try to show that the individualistic theory of artistic creation is false (1) as regards the relation between a given artist and those fellow artists who in terms of the individualistic theory are said to 'influence' him; (2) as regards his relation with those who are said to 'perform his works'; and (3) as regards his relation with the persons known as his 'audience'. In each case, I shall maintain, the relation is really collaborative.

§ 7. *Collaboration between Artists*

Individualism would have it that the work of a genuine artist is altogether 'original', that is to say, purely his own work and not in any way that of other artists. The emotions expressed must be simply and solely his own, and so must his way of expressing them. It is a shock to persons labouring under this prejudice when they find that Shakespeare's plays, and notably *Hamlet*, that happy hunting-ground of self-expressionists, are merely adaptations of plays by other writers, scraps of Holinshed, Lives by Plutarch, or excerpts from the *Gesta Romanorum*; that Handel copied out into his own works whole movements by Arne; that the Scherzo of Beethoven's C minor Symphony begins by reproducing the Finale of Mozart's G minor, differently barred; or that Turner was in the habit of lifting his composition from the works of Claude Lorrain. Shakespeare or Handel or Beethoven or Turner would have thought it odd that anybody should be shocked. All artists have modelled their style upon that of others, used subjects that others have used, and treated them as others have treated them already. A work of art so constructed is a work of collaboration. It is partly by the man whose name it bears, partly by those from whom

he has borrowed. What we call the works of Shakespeare, for example, proceed in this way not simply and solely from the individual mind of the man William Shakespeare of Stratford (or, for that matter, the man Francis Bacon of Verulam) but partly from Kyd, partly from Marlowe, and so forth.

The individualistic theory of authorship would lead to the most absurd conclusions. If we regard the *Iliad* as a fine poem, the question whether it was written by one man or by many is automatically, for us, settled. If we regard Chartres cathedral as a work of art, we must contradict the architects who tell us that one spire was built in the twelfth century and the other in the sixteenth, and convince ourselves that it was all built at once. Or again: English prose of the early seventeenth century may be admired when it is original; but not the Authorized Version, for that is a translation, and a translation, because no one man is solely responsible for it, cannot be a work of art. I am very willing to allow with Descartes that 'often there is less perfection in works put together out of several parts, and made by the hands of different masters, than in those at which one only has worked'; but not to replace his 'often' by 'always'. I am very willing to recognize that, under the reign of nineteenth-century individualism, good artists have seldom been willing to translate, because they have gone chasing after 'originality'; but not to deny the name of poetry to Catullus's rendering of Sappho merely because I happen to know it for a translation.

If we look candidly at the history of art, or even the little of it that we happen to know, we shall see that collaboration between artists has always been the rule. I refer especially to that kind of collaboration in which one artist grafts his own work upon that of another, or (if you wish to be abusive) plagiarizes another's for incorporation in his own. A new code of artistic morality grew up in the nineteenth century, according to which plagiarism was a crime. I will not ask how much that had to do, whether as cause or as effect, with

the artistic barrenness and mediocrity of the age (though it is obvious, I think, that a man who can be annoyed with another for stealing his ideas must be pretty poor in ideas, as well as much less concerned for the intrinsic value of what ideas he has than for his own reputation); I will only say that this fooling about personal property must cease. Let painters and writers and musicians steal with both hands whatever they can use, wherever they can find it. And if any one objects to having his own precious ideas borrowed by others, the remedy is easy. He can keep them to himself by not publishing; and the public will probably have cause to thank him.

§ 8. *Collaboration between Author and Performer*

Certain kinds of artist, notably the dramatist and the musician, compose for performance. Individualism would maintain that their works, however 'influenced', as the phrase goes, by those of other artists, issue from the writer's pen complete and finished; they are plays by Shakespeare and symphonies by Beethoven, and these men are great artists, who have written on their own responsibility a text which, as the work of a great artist, imposes on the theatre and the orchestra a duty to perform it exactly as it stands.

But the book of a play or the score of a symphony, however cumbered with stage-directions, expression-marks, metronome figures, and so forth, cannot possibly indicate in every detail how the work is to be performed. Tell the performer that he must perform the thing exactly as it is written, and he knows you are talking nonsense. He knows that however much he tries to obey you there are still countless points he must decide for himself. And the author, if he is qualified to write a play or a symphony, knows it too, and reckons on it. He demands of his performers a spirit of constructive and intelligent co-operation. He recognizes that what he is putting on paper is not a play or a symphony, or even complete directions for performing one, but only a rough outline of such directions, where the performers, with

the help, no doubt, of producer and conductor, are not only permitted but required to fill in the details. Every performer is co-author of the work he performs.

This is obvious enough, but in our tradition of the last hundred years and more we have been constantly shutting our eyes to it. Authors and performers have found themselves driven into a state of mutual suspicion and hostility. Performers have been told that they must not claim the status of collaborators, and must accept the sacred text just as they find it; authors have tried to guard against any danger of collaboration from performers by making their book or their text fool-proof. The result has been not to stop performers from collaborating (that is impossible), but to breed up a generation of performers who are not qualified to collaborate boldly and competently. When Mozart leaves it to his soloist to improvise the cadenza of a concerto, he is in effect insisting that the soloist shall be more than a mere executant; he is to be something of a composer, and therefore trained to collaborate intelligently. Authors who try to produce a fool-proof text are choosing fools as their collaborators.

§ 9. *The Artist and his Audience*

The individualism of the artist, partly broken down by collaboration with his fellow artists and still further by collaboration with his performers, where he has them, is not yet wholly vanquished. There still remains the most difficult and important problem of all, namely, that of his relation to his audience. We have seen in § 6 that this, too, must in theory be a case of collaboration; but it is one thing to argue the point in theory, and quite another to show it at work in practice. In order to do this, I will begin with the case where the artist is a collaborative unit consisting of author and performers, as in the theatre, and consider how, as a matter of empirical fact, this unit is related to the audience.

If one wants to answer this question for oneself, the best way to proceed is to attend the dress rehearsal of a play. In the

rehearsal of any given passage, scenery, lighting, and dresses may all be exactly as they are at a public performance; the actors may move and speak exactly as they will 'on the night'; there may be few interruptions for criticism by the producer; and yet the spectator will realize that everything is different. The company are going through the motions of acting a play, and yet no play is being acted. This is not because there have been interruptions, breaking the thread of the performance. A work of art is very tolerant of interruption. The intervals between acts at a play do not break the thread, they rest the audience. Nobody ever read the *Iliad* or the *Commedia* at a sitting, but many people know what they are like. What happens at the dress rehearsal is something quite different from interruption. It can be described by saying that every line, every gesture, falls dead in the empty house. The company is not acting a play at all; it is performing certain actions which will become a play when there is an audience present to act as a sounding-board. It becomes clear, then, that the aesthetic activity which is the play is not an activity on the part of the author and the company together, which this unit can perform in the audience's absence. It is an activity in which the audience is a partner.

Any one, probably, can learn this by watching a dress rehearsal; but the principle does not apply to the theatre alone. It applies to rehearsals by a choir or orchestra, or to a skilled and successful public speaker rehearsing a speech. A careful study of such things will convince any one who is open to conviction that the position of the audience is very far from being that of a licensed eavesdropper, overhearing something that would be complete without him. Performers know it already. They know that their audience is not passively receptive of what they give it, but is determining by its reception of them how their performance is to be carried on. A person accustomed to extempore speaking, for example, knows that if once he can make contact with his audience it will somehow tell him what he is to say, so that he finds himself saying things he had never thought of

before. These are the things which, on that particular subject, he and nobody else ought to be saying to that audience and no other. People to whom this is not a familiar experience are, of course, common; but they have no business to speak in public.

It is a weakness of printed literature that this reciprocity between writer and reader is difficult to maintain. The printing-press separates the writer from his audience and fosters cross-purposes between them. The organization of the literary profession and the 'technique' of good writing, as that is understood among ourselves, consist to a great extent of methods for mitigating this evil; but the evil is only mitigated and not removed. It is intensified by every new mechanization of art. The reason why gramophone music is so unsatisfactory to any one accustomed to real music is not because the mechanical reproduction of the sounds is bad—that could be easily compensated by the hearer's imagination—but because the performers and the audience are out of touch. The audience is not collaborating, it is only overhearing. The same thing happens in the cinema, where collaboration as between author and producer is intense, but as between this unit and the audience non-existent. Performances on the wireless have the same defect. The consequence is that the gramophone, the cinema, and the wireless are perfectly serviceable as vehicles of amusement or of propaganda, for here the audience's function is merely receptive and not concreative; but as vehicles of art they are subject to all the defects of the printing-press in an aggravated form. 'Why', one hears it asked, 'should not the modern popular entertainment of the cinema, like the Renaissance popular entertainment of the theatre, produce a new form of great art?' The answer is simple. In the Renaissance theatre collaboration between author and actors on the one hand, and audience on the other, was a lively reality. In the cinema it is impossible.

The conclusion of this chapter may be summarized briefly. The work of artistic creation is not a work performed

in any exclusive or complete fashion in the mind of the person whom we call the artist. That idea is a delusion bred of individualistic psychology, together with a false view of the relation not so much between body and mind as between experience at the psychical level and experience at the level of thought. The aesthetic activity is an activity of thought in the form of consciousness, converting into imagination an experience which, apart from being so converted, is sensuous. This activity is a corporate activity belonging not to any one human being but to a community. It is performed not only by the man whom we individualistically call the artist, but partly by all the other artists of whom we speak as 'influencing' him, where we really mean collaborating with him. It is performed not only by this corporate body of artists, but (in the case of the arts of performance) by executants, who are not merely acting under the artist's orders, but are collaborating with him to produce the finished work. And even now the activity of artistic creation is not complete; for that, there must be an audience, whose function is therefore not a merely receptive one, but collaborative too. The artist (although under the spell of individualistic prejudices he may try to deny it) stands thus in collaborative relations with an entire community; not an ideal community of all human beings as such, but the actual community of fellow artists from whom he borrows, executants whom he employs, and audience to whom he speaks. By recognizing these relations and counting upon them in his work, he strengthens and enriches that work itself; by denying them he impoverishes it.

XV

CONCLUSION

THE aesthetician, if I understand his business aright, is not concerned with dateless realities lodged in some metaphysical heaven, but with the facts of his own place and his own time. These, at any rate, are what I have concerned myself with in writing this book. The problems I have discussed are those which force themselves upon me when I look round at the present condition of the arts in our own civilization; and the reason I have tried to solve them is because I do not see how that condition (both of the arts and of the civilization to which they belong) can be bettered unless a solution is found. Our business, as I said before, is to cultivate our garden; but gardens may get into such a state that they are no longer cultivable without help from chemists and engineers and other experts on whom, in happier times, the gardener would look with a hostile eye.

My final question, then, is: how does the theory advanced in this book bear upon the present situation, and illuminate the path to be taken by artists in the immediate future?

To begin by developing a general point already made in the preceding chapter: we must get rid of the conception of artistic ownership. In this sphere, whatever may be true of others, *la propriété c'est le vol*. We try to secure a livelihood for our artists (and God knows they need it) by copyright laws protecting them against plagiarism; but the reason why our artists are in such a poor way is because of that very individualism which these laws enforce. If an artist may say nothing except what he has invented by his own sole efforts, it stands to reason he will be poor in ideas. If he could take what he wants wherever he could find it, as Euripides and Dante and Michelangelo and Shakespeare and Bach were free, his larder would always be full, and his cookery might be worth tasting.

This is a simple matter, and one in which artists can act for themselves without asking help (which I am afraid they would ask in vain) from lawyers and legislators. Let every artist make a vow, and here among artists I include all such as write or speak on scientific or learned subjects, never to prosecute or lend himself to a prosecution under the law of copyright. Let any artist who appeals to that law be cut by his friends, asked to resign from his clubs, and cold-shouldered by any society in which right-thinking artists have influence. It would not be many years before the law was a dead letter, and the strangle-hold of artistic individualism in this one respect a thing of the past.

This, however, will not be enough unless the freedom so won is used. Let all such artists as understand one another, therefore, plagiarize each other's work like men. Let each borrow his friends' best ideas, and try to improve on them. If A thinks himself a better poet than B, let him stop hinting it in the pages of an essay; let him re-write B's poems and publish his own improved version. If X is dissatisfied with Y's this-year Academy picture, let him paint one caricaturing it; not a sketch in *Punch*, but a full-sized picture for next year's Academy. I will not rely upon the hanging committee's sense of humour to the extent of guaranteeing that they would accept it; but if they did, we should get brighter Academy exhibitions. Or if he cannot improve on his friends' ideas, at least let him borrow them; it will do him good to try fitting them into works of his own, and it will be an advertisement for the creditor. An absurd suggestion? Well, I am only proposing that modern artists should treat each other as Greek dramatists or Renaissance painters or Elizabethan poets did. If any one thinks that the law of copyright has fostered better art than those barbarous times could produce, I will not try to convert him.

Next, with regard to the arts of performance, where one man designs a work of art and another, or a group of others, executes it. Ruskin (who was not always wrong) insisted long ago that in the special case of architecture the best work

demanded a genuine collaboration between designer and executants: not a relation in which the workmen simply carried out orders, but one in which they had a share in the work of designing. Ruskin did not succeed in his project of reviving English architecture, because he only saw his own idea dimly and could not think out its implications, which was better done afterwards by William Morris; but the idea he partly grasped is one application of the idea I shall try to state.

In these arts (I am especially thinking of music and drama) we must get rid, to put it briefly, of the stage-direction as developed by Mr. Bernard Shaw. When we see a play swathed and larded with these excrescences, we must rub our eyes and ask: 'What is this? Is the author, by his own confession, so bad a writer that he cannot make his intention clear to his producer and cast without composing a commentary on his play that makes it look like an edition for use in schools? Or is it that producers and actors, when this queer old stuff was written, were such idiots that they could not put a play on unless they were told with this intolerable deal of verbiage exactly how to do it? The author's evident anxiety to show what a sharp fellow he was makes the first alternative perhaps the more probable; but really there is no need for us to choose. Whether it was the author or the company that was chiefly to blame, we can see that such stuff (clever though the dialogue is, in its way) must have been written at a time when dramatic art in England was at its lowest ebb.'

I am only using Mr. Shaw as an example of a general tendency. The same tendency is to be seen at work in most plays of the later nineteenth century; and it is just as conspicuous in music. Compare any musical score of the late nineteenth century with any of the eighteenth (not, of course, a nineteenth-century edition), and see how it is sprinkled with expression-marks, as if the composer assumed either that he had expressed himself too obscurely for any executant to make sense of the music, or that the executants for whom

he writes were half-witted. I do not say that every stage-direction in the book of a play, or every expression-mark in a musical score, is a mark of incompetence either in the author or in the performer. I dare say a certain number of them are necessary. But I do say that the attempt to make a text fool-proof by multiplying them indicates a distrust of his performers[1] on the part of the author which must somehow be got rid of if these arts are to flourish again as they have flourished in the past. This cannot be done at a blow. It can only be done at all if we fix our eyes on the kind of result we want to achieve, and work deliberately towards it.

We must face the fact that every performer is of necessity a co-author, and develop its implications. We must have authors who are willing to admit their performers into their counsels: authors who will re-write in the theatre or concert-room as rehearsals proceed, keeping their text fluid while the producer and the actors, or conductor and orchestra, help to shape it for performance; authors who understand the business of performance so well that the text they finally produce is intelligible without stage-directions or expression-marks. We must have performers (including producers and conductors, but including also the humblest members of cast and orchestra) who take an intelligent and instructed interest in the problems of authorship, and are consequently deserving of their author's confidence and entitled to have their say as partners in the collaboration. These two results can probably be best obtained by establishing a more or less permanent connexion between certain authors and certain groups of performers. In the theatre, a few partnerships of this kind are already in existence, and promise a future for the drama that must yield better work on both sides than was possible in the bad old days (not yet, unfortunately, at an end) when a play was hawked from manager to manager

[1] If any one says that these stage-directions are intended not for the theatre, but for the reader, I still object to them on grounds arising out of the author's relation to his audience. I dare say Mr. Shaw thinks that it is not so much the actors, as the public, that are fools. I shall show later on that this is no better.

until at last, perhaps with a bribe of cash, it was accepted for performance. But the drama or music which these partnerships will produce must in certain ways be a new kind of art; and we must also, therefore, have audiences trained to accept and demand it; audiences which do not ask for the slick shop-finish of a ready-made article fed to them through a theatrical or orchestral machine, but are able to appreciate and enjoy the more vivid and sensitive quality of a performance in which the company or the orchestra are performing what they themselves have helped to compose. Such a performance will never be so amusing as the standard West-end play or the ordinary symphony concert to an after-dinner audience of the overfed rich. The audience to which it appeals must be one in search not of amusement, but of art.

This brings me to the third point at which reform is necessary: the relation between the artist, or rather the collaborative unit of artist and performers, and the audience. To deal first with the arts of performance, what is here required is that the audience should feel itself (and not only feel itself, but actually and effectively become) a partner in the work of artistic creation. In England at the present time this is recognized as a principle by Mr. Rupert Doone and his colleagues of the Group Theatre. But it is not enough merely to recognize it as a principle; and how to carry out the principle in detail is a difficult question. Mr. Doone assures his audience that they are participants and not mere spectators, and asks them to behave accordingly; but the audience are apt to be a little puzzled as to what they are expected to do. What is needed is to create small and more or less stable audiences, not like those which attend a repertory theatre or a series of subscription concerts (for it is one thing to dine frequently at a certain restaurant, and quite another to be welcomed in the kitchen), but more like that of a theatrical or musical club, where the audience are in the habit of attending not only performances but rehearsals, make friends with authors and performers, know about the aims and projects of the group to which they all

alike belong, and feel themselves responsible, each in his degree, for its successes and failures. Obviously this can be done only if all parties entirely get rid of the idea that the art in question is a kind of amusement, and see it as a serious job, art proper.

With the arts of publication (notably painting and non-dramatic writing) the principle is the same, but the situation is more difficult. The promiscuous dissemination of books and paintings by the press and public exhibition creates a shapeless and anonymous audience whose collaborative function it is impossible to exploit. Out of this formless dust of humanity a painter or writer can, indeed, crystallize an audience of his own; but only when he has already made his mark. Consequently, it is no help to him just when he most needs its help, while his artistic powers are still immature. The specialist writer on learned subjects is in a happier position; he has from the first an audience of fellow specialists, whom he addresses, and from whom an echo reaches him; and only one who has written in this way for a narrow, specialized public can realize how that echo helps him with his work and gives him the confidence that comes from knowing what his public expects and thinks of him. But the non-specialist writer and the painter of pictures are to-day in a position where their public is as good as useless to them. The evils are obvious; such men are driven into a choice between commercialism and barren eccentricity. There are critics and reviewers, literary and artistic journals, which ought to be at work mitigating these evils and establishing contact between a writer or painter and the kind of audience he needs. But in practice they seldom seem to understand that this is, or should be, their function, and either they do nothing at all or they do more harm than good. The fact is becoming notorious; publishers are ceasing to be interested in the reviews their books get, and beginning to decide that they make no difference to the sales.

Unless this situation can be altered, there is a real likelihood that painting and non-dramatic literature, as forms of

art, may cease to exist, their heritage being absorbed partly into various kinds of entertainment, advertisement, instruction, or propaganda, partly into other forms of art like drama and architecture, where the artist is in direct contact with his audience. Indeed, this has begun to happen already. The novel, once an important literary form, has all but disappeared, except as an amusement for the semi-literate. The easel-picture is still being painted, but only for exhibition purposes. It is not being sold. Those who can remember the interiors of the eighteen-nineties, with their densely picture-hung walls, realize that the painters of to-day are working to supply a market that no longer exists. They are not likely to go on doing it for long.

The rescue of these two arts from their threatened extinction, as arts, depends upon bringing them back into contact with their audience. The kind of contact that is required is a collaborative contact in which the audience genuinely shares in the creative activity. It is, therefore, not to be achieved by any improvement in salesmanship,[1] for this assumes that the works of art are already complete before being offered to the public, and that the audience's function is limited to understanding them.

In the case of literature, the only way which I can see of establishing such contact is for authors to give up the idea of 'pure literature', or literature whose interest depends not on its subject-matter, but solely on its 'technical' qualities, and write on subjects about which people want to read. This does not mean turning away from art proper to amusement or magic; for the kind of subjects about which I am thinking does not consist of subjects chosen for their power of arousing emotion, whether for discharge in the reading itself or for discharge in the affairs of real life. They are subjects about which people already have emotions, but obscure and

[1] A good publisher may, however, help to establish the kind of contact we are seeking, in so far as, instead of merely publishing what authors give him, he tells them (as he should be able to do) what kind of books are wanted. The best publishers already do a good deal of this, and writers who are not too conceited to co-operate with them find it extremely valuable.

confused ones; and in wanting to read about these subjects they are wanting to raise these emotions to the level of consciousness, to become imaginatively aware of them.

For this reason (and this, too, will differentiate such literature from that of amusement and from that of magic) it is not so much a question of the author's 'choosing' a subject; it is a question rather of his letting a subject choose him: I mean, a question of his spontaneously sharing the interest which people around him feel in a certain subject, and allowing that interest to determine what he writes. By so doing, he will have accepted the collaboration of his public from the very inception of his work, and the public thus accepted as collaborators will inevitably become his audience. Some writers will regard this as a lowering of their artistic standard. But that is only because their artistic standard is entangled in a false aesthetic theory. Art is not contemplation, it is action. If art were contemplation, it could be pursued by an artist who constitutes himself a mere spectator of the world around him, and depicts or describes what he sees. But, as the expression of emotion and addressed to a public, it requires of the artist that he should participate in his public's emotions, and therefore in the activities with which these emotions are bound up. Writers are to-day beginning to realize that important literature cannot be written without an important subject-matter.[1] In that realization lies the hope of a thriving literature yet to be written; for the subject-matter is the point at which the audience's collaboration can fertilize the writer's work.

In the case of painting, the same line of advance is open; but the prospect of its being exploited is less good. I write chiefly for English readers and about conditions in England; and it is notorious that English painting is traditionally far less vigorous and far less securely rooted in the life of the country than English literature. In painting, we have hardly begun to emerge from the stupid welter of eccen-

[1] Cf. Louis MacNiece, 'Subject in Modern Poetry', in *Essays and Studies by Members of the English Association*, vol. xxii (1937), pp. 146–58.

tricities and 'isms' which marked the decay of individualistic nineteenth-century art. I see no such tendency in English painting to-day as I see in English writing, towards utilizing the collaborative energies of the audience by painting subjects which English people, or some large and important section of them, want to see painted.

Nevertheless, painting in this country has improved a great deal in recent years. The Royal Academy's exhibition of 1937 testified to a degree of average competence in a large number of exhibitors which was quite unthinkable ten years ago. Something is certainly happening to English painting; something not unworthy to be compared with what is happening to English literature. Each of them is ceasing to rely on its amusement value to an audience of wealthy philistines, and is substituting for that aim not one of amusement value to an audience of wage-earners or dole-drawers, nor yet one of magical value, but one of genuine artistic competence. But the question is whether this ideal of artistic competence is directed backwards into the blind alley of nineteenth-century individualism, where the artist's only purpose was to express 'himself', or forwards into a new path where the artist, laying aside his individualistic pretensions, walks as the spokesman of his audience.

In literature, those who chiefly matter have made the choice, and made it rightly. The credit for this belongs in the main to one great poet, who has set the example by taking as his theme in a long series of poems a subject that interests every one, the decay of our civilization. Apart from one or two trifles, Mr. Eliot has never published a line of 'pure literature'. Looking back, one sees the whole of his early verse as a succession of sketches and studies for *The Waste Land*.[1] First with a gentle irony in *Prufrock*, pretending to be merely a minor poet with a disillusioned eye for

[1] He has said it himself. The words 'why then Ile fit you', at the end of *The Waste Land*, introduce the passage in *The Spanish Tragedy* where Hieronimo brings out the play he wrote 'when in *Tolledo* there I studied', explaining that this youthful work will fit the present occasion (Act IV, scene i).

the emotions of others, then with deepening intensity in *Gerontion* and growing savagery in the Sweeney poems, he found himself (that self which to the outward eye seemed arch-highbrow, another Henry James, steeped in literature and innocent—as he was called by one who should have known better—of public-spiritedness) by degrees shaping his mouth to the tremendous howl of Marlowe's Mephisto-philis—'Why this is hell'.

The decay of our civilization, as depicted in *The Waste Land*, is not an affair of violence and wrong-doing. It is not exhibited in the persecution of the virtuous and in the flourishing of the wicked like a green bay tree. It is not even a triumph of the meaner sins, avarice and lust. The drowned Phœnician sailor has forgotten the profit and loss; the rape of Philomel by the barbarous king is only a carved picture, a withered stump of time. These things are for remembrance, to contrast with a present where nothing is but stony rubbish, dead tree, dry rock, revealed in their nakedness by an April that breeds lilacs out of the dead land, but no new life in the dead heart of man. There is no question here of expressing private emotions; the picture to be painted is not the picture of any individual, or of any individual shadow, however lengthened into spurious history by morning or evening sun; it is the picture of a whole world of men, shadows themselves, flowing over London Bridge in the winter fog of that Limbo which involves those who, because they never lived, are equally hateful to God and to his enemies.

The picture unrolls. First the rich, the idle man and his idle mistress, surrounded by all the apparatus of luxury and learning; but in their hearts there is not even lust, nothing but fretted nerves and the exasperation of boredom. Then the public-house at night; the poor, no less empty-hearted: idle recrimination, futile longing for a good time, barren wombs and faded, fruitless youth, and an awful anonymous voice punctuating the chatter with a warning 'Hurry up please it's time'. Time for all these things to end; time's winged chariot, the grave a fine and private place, and mad

Ophelia's good-night, the river waiting for her. And then the river itself, with its memories of idle summer love-making, futile passionless seductions, the lover whose vanity makes a welcome of indifference, the mistress brought up to expect nothing; with contrasting memories of the splendours once created by Sir Christopher Wren, the pageantry of Elizabeth, and Saint Augustine for whom lust was real and a thing worth fighting.

Enough of detail. The poem depicts a world where the wholesome flowing water of emotion, which alone fertilizes all human activity, has dried up. Passions that once ran so strongly as to threaten the defeat of prudence, the destruction of human individuality, the wreck of men's little ships, are shrunk to nothing. No one gives; no one will risk himself by sympathizing; no one has anything to control. We are imprisoned in ourselves, becalmed in a windless selfishness. The only emotion left us is fear: fear of emotion itself, fear of death by drowning in it, fear in a handful of dust.

This poem is not in the least amusing. Nor is it in the least magical. The reader who expects it to be satire, or an entertaining description of vices, is as disappointed with it as the reader who expects it to be propaganda, or an exhortation to get up and do something. To the annoyance of both parties, it contains no indictments and no proposals. To the amateurs of literature, brought up on the idea of poetry as a genteel amusement, the thing is an affront. To the little neo-Kiplings who think of poetry as an incitement to political virtue, it is even worse; for it describes an evil where no one and nothing is to blame, an evil not curable by shooting capitalists or destroying a social system, a disease which has so eaten into civilization that political remedies are about as useful as poulticing a cancer.

To readers who want not amusement or magic, but poetry, and who want to know what poetry can be, if it is to be neither of these things, *The Waste Land* supplies an answer. And by reflecting on it we can perhaps detect one more characteristic which art must have, if it is to forgo

both entertainment-value and magical value, and draw a subject-matter from its audience themselves. It must be prophetic. The artist must prophesy not in the sense that he foretells things to come, but in the sense that he tells his audience, at risk of their displeasure, the secrets of their own hearts. His business as an artist is to speak out, to make a clean breast. But what he has to utter is not, as the individualistic theory of art would have us think, his own secrets. As spokesman of his community, the secrets he must utter are theirs. The reason why they need him is that no community altogether knows its own heart; and by failing in this knowledge a community deceives itself on the one subject concerning which ignorance means death. For the evils which come from that ignorance the poet as prophet suggests no remedy, because he has already given one. The remedy is the poem itself. Art is the community's medicine for the worst disease of mind, the corruption of consciousness.

INDEX